THE USE AND ABUSE OF CINEMA

FILM AND CULTURE SERIES

FILM AND CULTURE
A series of Columbia University Press
Edited by John Belton

For the list of titles in this series, see page 453.

THE USE AND
ABUSE OF CINEMA

GERMAN LEGACIES FROM
THE WEIMAR ERA TO THE PRESENT

ERIC RENTSCHLER

COLUMBIA UNIVERSITY PRESS
NEW YORK

Columbia University Press
Publishers Since 1893
New York Chichester, West Sussex
cup.columbia.edu
Copyright © 2015 Columbia University Press
All rights reserved

Library of Congress Cataloging-in-Publication Data
Rentschler, Eric.
The use and abuse of cinema :
German legacies from the Weimar era to the present / Eric Rentschler.
pages cm
Includes bibliographical references and index.
ISBN 978-0-231-07362-2 (cloth : alk. paper) —
ISBN 978-0-231-07363-9 (pbk. : alk. paper) —
ISBN 978-0-231-53939-5 (e-book)
1. Motion pictures—Germany—History—20th century. I. Title.

PN1993.5.G3R43 2015
791.430943'0904—dc23

2014038202

Columbia University Press books are printed on permanent and durable acid-free paper.
This book is printed on paper with recycled content.
Printed in the United States of America
c 10 9 8 7 6 5 4 3 2 1
p 10 9 8 7 6 5 4 3 2 1

COVER PHOTO: DEFA-Stiftung Archive

COVER DESIGN: Milenda Nan Ok Lee

References to websites (URLs) were accurate at the time of writing. Neither the author nor
Columbia University Press is responsible for URLs that may have expired or changed
since the manuscript was prepared.

CONTENTS

THE USE AND ABUSE OF CINEMA

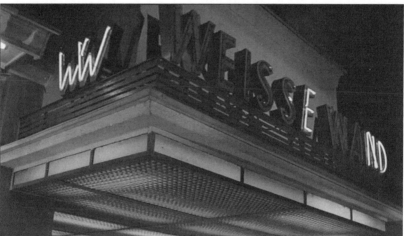

FIGURE 0.1 (top) The time traveler (Benedikt Zulauf) of Jean-Marie Straub and Danièle Huillet's *Geschichtsunterricht* (*History Lessons*, 1972), like a detective in a Raymond Chandler novel, navigates his way through Rome in search of historical traces.

FIGURE 0.2 The start of the grandiose final shot of Wim Wenders's *Im Lauf der Zeit* (*Kings of the Road*, 1976): The malfunctioning marquee of a provincial cinema offers a hopeful preview of coming attractions. The "Weisse Wand" is a tabula rasa and "WW" marks the signature of the director whose stirring road movie takes stock of an untenable film culture and, in so doing, itself demonstrates what a new cinema might look like.

INTRODUCTION:
HISTORY LESSONS AND COURSES IN TIME

I.

The various chapters of this book took their initial shape as free-standing contributions to journals (sometimes special issues), collections, and catalogues. Nonetheless, in sometimes-curious, often-surprising, and even unwitting ways, these isolated endeavors, reconfigured in these pages, cohere and interact and function as an ensemble. The different sections provide constellations that, despite the diverse origins, discursive contexts, and temporal determinations of the separate entries, assume a dialogical relationship—or, to use Alexander Kluge's inimitable phrase, produce a *Zusammenhang* (which translates roughly, albeit inelegantly, as a sense of connectedness). These excursions traverse a wide range of territories, negotiating German cinema from the Weimar era to the immediate present, returning to particular junctures with undeniable persistence, mulling over questions and sustaining conversations with a host of critical interlocutors, fellow time travelers in this volume's twenty historical passages.

II.

The point of departure for the first set of excursions, "Critical Venues," dates back to my initial encounter with Siegfried Kracauer's *From Caligari*

to Hitler: A Psychological History of the German Film in the fall of 1968. As a nineteen-year-old foreign student in Stuttgart, I often lingered between classes in the local Amerika Haus on Lautenschlagerstraße (next door to the city's American Express office, not far from the university and several blocks from the train station), in whose library I came across the study. I remember telling friends that the book was like a detective novel, a page-turner that one simply could not put down. At the time, I had seen only a very small number of the titles scrutinized by Kracauer; it would not be until the eighties and the end of the Cold War, that I would have the chance to familiarize myself with most of the films under discussion. To be sure, the spontaneous reference to the work as a detective novel would become more apt than I might have imagined. For the book's symptomatic criticism, with its unceasing suspiciousness about the political meanings of film fantasies, truly enacts an investigator's unrelenting resolve to see past appearances, to discern the actual state of things behind films' ever-so-elusive and enthralling surfaces, and to discover social truths and expose ideological agendas.

Kracauer's programmatic statement of 1932, "the film critic of note is conceivable only as a social critic,"[1] would have an essential and a formative impact on my work. The impetus sustained me even when my colleagues at University of California, Irvine, where well into the nineties poststructuralist propensities held sway, smirked at what they considered to be my analytical naiveté and theoretical shortsightedness, my Frankfurt School–driven conviction that signs and discourses did have social determinations and historical meanings and that aesthetic shapes could (and at times should) be spoken of in the same breath as political configurations. Many conversations in both Frankfurt and Berlin with Karsten Witte, along with Gertrud Koch, Heide Schlüpmann, and Wolfram Schütte, one of Germany's most formidable "critical critics," enhanced my appreciation of Kracauer's inimitable blend of curiosity, critique, and evocation, his decidedly nuanced and complex relation to the fantasy production of a nascent visual culture. As a commentator, editor, and translator, Witte would be essential in the rediscovery, reconsideration, and ultimate redemption of Kracauer's work. An invaluable lesson for Witte was the writer's incentive to seek "all forms of politics in a politics of forms."[2] Over time I came to share Witte's high regard for the "ABK" of German film

theory, his profound indebtedness to Rudolf Arnheim, Béla Balázs, and Siegfried Kracauer, from whom he chiefly derived his extraordinary ability to discern the expressive powers of cinematic constructs.

Invited to participate in a 2009 tribute at Harvard to Rudolf Arnheim, whose presence had been so influential in the formation and pursuit of visual studies at my home institution, I eagerly turned to his Weimar-era film criticism, which, at long last, had become available in translation for English-language readers. Like most people working in North American film studies, even among those few who spoke German, I had come to know Arnheim as a formalist with fixed notions of what film should be (namely: art!). This was the dominant wisdom and next to no one felt a need to question it. Studying his essays of the twenties and thirties carefully, however, I was taken aback when I found so much humor, irreverence, and above all, such an acute political awareness. In fact, Arnheim's notices seemed at times to have an even stronger ideological sensitivity than Kracauer's; it was disarming to realize that early Arnheim had far more in common with the symptomatic film critic than I ever had imagined. The question for me, and the impetus that fueled much of the paper I presented as well as the essay that followed, was why this social dimension virtually disappeared in the writer's work after the mid-thirties. The answer, I surmised, had much to do with the reality of immigration and Arnheim's tenuous place in Cold War America.

Another conundrum lay in Kracauer's own apparent turn from the symptomatic criticism of both the Weimar years and his Caligari book to what Theodor W. Adorno would deride as the sociological abstemiousness of *Theory of Film* (1960).[3] In the midst of many negative responses after the book was published, Arnheim had written a sensitive and appreciative review, somewhat of a surprise given the considerable disparity between his formative impetus and Kracauer's idiosyncratic realism.[4] I never had shared the virulent and, in some instances, downright cruel dismissiveness toward *Theory of Film* among North American film critics like Pauline Kael and cinema scholars, such as Dudley Andrew and, later, Noël Carroll and Malcolm Turvey. My consternation became all the stronger as I, with much surprise, came across more sensitive and even rhapsodic responses to the admittedly eccentric work among post-1968 West German commentators. Seen through this altogether different

prism, *Theory of Film* became both an influential primer for cinephilia as well as a book that could be—and needed to be—read in light of historical crises. Indeed, if one did so, it allowed for an incisive elaboration of cinema's appeal to and impact on the human sensorium. *Theory of Film* was both the product of a fallen post–World War II world and an invocation of cinema's formidable potential as a means to reanimate and reenchant human experience.

A further striking variance of opinion between West German critics and Anglo-American commentators arose in the seventies. Unlike the British (and later American) rediscovery of Douglas Sirk, which for the most part was high-spirited, West German revisitations of Sirk's Universal Studio melodramas catalyzed intriguing and at times heated debates. The so-called "Sirk boom" would play a strong role within a nascent film studies seeking to formulate a critical approach to genre cinema and to Hollywood in general; it also would have a significant impact on the development of Rainer Werner Fassbinder and other young German filmmakers. How, I wondered, could Sirk generate such excitement among Anglo-American observers and, yet in West Germany, become at times the object of virulent disapproval? Bearing the legacy of the Sirk boom in mind, I wondered how one was to assess attempts to grant the director's work made in Nazi Germany, as one had his American features of the fifties, the status of subversive endeavors? Witte, of course, recognized well that under National Socialism critical expression often was instrumentalized by the powers that be so that collusion and resistance might, and indeed surely did, coexist.[5] Nor, I had come to realize, could or did Joseph Goebbels and the Ministry of Propaganda ever control all meaning. For these reasons, analyses of films from the Hitler era must remain mindful of the coexistence of affirmation and opposition that is to be found in a number of features. In the case of Sirk's complex and memorable entries from the thirties, it is every bit as problematic to reduce them to ideological poison as it is to overestimate their resistant potential.

From a retrospective reading of Sirk's films to a reappraisal of the Ufa legacy is a very short step. The appearance of Klaus Kreimeier's impressive history of the studio, *Die Ufa-Story*,[6] coincided with a plethora of books, films, television programs, and articles throughout the German media devoted to the seventy-fifth anniversary of Ufa and the eightieth

birthday of Babelsberg. Visitors swarmed to the remnants of the studio just outside of Berlin and packed the expansive spaces of the city's Historical Museum where a vast exhibit put the studio's accomplishments on display and the Zeughaus-Kino screened seventy of the six hundred Ufa features produced between 1917 and 1945. I had first come to know Kreimeier as an outspoken and at times militant critical critic, a former student activist who had become an independent commentator, a so-called "freischaffender Kritiker." Like Kracauer and Witte, the younger Kreimeier viewed ideological criticism as a form of detective work. And yet there was a different tone and more measured approach at work in *Die-Ufa Story*. To deal with Ufa, Kreimeier argued, was to reckon with German film history as well as with German film historiography. It was also to reckon with the notion of a self-consciously national cinema and the possibility of such an entity in the postwall situation from which his study emanated and in which it resonated. His book offered an answer to and critique of *From Caligari to Hitler*. In seeking to temper Kracauer's dark teleology and radical determinism, Kreimeier endeavored to be nuanced, measured, and fair—and his book was just that, sometimes to a fault.

III.

The film reviews of Arnheim, Kracauer, and Witte also had a substantial impact on the second constellation, "Serials and Cycles." These critics make one mindful of mass culture's mixed blessings, both its enticements and amenities as well as its political smokescreens and Potëmkin villages. Kracauer and Witte, far more than Arnheim, truly loved the cinema, but their love was not granted blindly and did not come easily; on frequent occasion, it yielded to dismay, disillusion, and even disdain. Nonetheless, they recognized the wishful thinking that sustained cinematic illusions and insisted on the validity of human desires for a better life and a better world, while also realizing the many ways in which strong feelings and historical longings might lend themselves to political abuse and mass manipulation. But even if one was schooled by Kracauer, one could not overlook the critical master's own limitations. When I turned to mountain films in the late 1980s, for instance, I was struck by his demonization

of the genre in *From Caligari to Hitler*, the way in which Arnold Fanck's Alpine fantasies figured so seminally in a fatal itinerary that would lead to a blind embrace of destiny and higher powers under the aegis of National Socialism. This vilification was all the more striking given various passages in Kracauer's writing that betrayed an unabashed enthusiasm for these films' awe-inspiring panoramas—above and beyond considerable evidence that leftist commentators (of whom Balázs was one of many) had extolled *Bergfilme* during the Weimar era. What was being disavowed and why? That was yet another question that would guide me as I tried both to fathom Kracauer's phobias and work beyond his oversights, to employ his symptomatic criticism while considering the critic's own responses themselves as historical symptoms.

In a similar way, the three critics all provided significant entries about the Ufa musicals of the late Weimar era. The reservations of each resound strongly in my revisitation of these generic exercises that issued from a moment of intense political and economic crisis. These silly symphonies, in Arnheim's mind, were toxic substances disguised as mass confections. Fantasy vehicles like Erik Charell's *Der Kongreß tanzt* (*The Congress Dances*, 1932) argued Witte, celebrated "the glorious promise of the status quo ante."[7] Such mindless gatherings of decorations fueled nonsynchronous illusions and desires and, in the words of Kracauer, could "only serve the forces of reaction."[8] And yet, in reviewing the films in question as well as these caustic notices, I also recalled Kracauer's insight about how distraction might in fact further understanding by exposing society's fragile and broken state. Even if the Ufa musicals from the early thirties did not serve such radical ends, they went a long way toward foregrounding their own illusory constitution as a response to historical needs and strongly felt desires. In their frequent baring of the apparatus, they also drew attention to their own imaginary status and cautioned the viewer not to be duped into believing that these enchanting cinematic dreams of a better life offered social solutions.

Made in a postwar world that was shattered and undone, screened for vastly displaced audiences in search of a domicile, German rubble films also dramatized the need for and the difficulty of finding a way out of an untenable situation. The mountains of ruins and jagged shatters framed against clouded skies both mimicked pristine Alpine sanctuaries and, in

their decimated visages, seemed by implicit comparison to be mocked by Fanck's sublime panoramas. *Bergfilme*, Ufa musicals, and *Trümmerfilme* all sought to escape sociopolitical impasse, to counter disenchantment, and to supply succor and hope in trying times. In such an endeavor, rubble films negotiate, often quite complexly and precariously, affirmative resolves and existential vicissitudes, providing glimmers of a better life as well as occasional glimpses of how the forces that have undone the German nation in some respects still continue to control its destiny. Here, too, one sees how the attempt to look beyond destruction and move beyond a harrowing past makes for an arduous and, ultimately, a not altogether convincing enterprise. In that regard, Kracauer is correct that the quest for distraction often produces its own antidote in the form of illusions whose emptiness bears witness to their spurious constitution. The final portion of this section sustains this perspective in a survey of West Germany's very popular cinema of diversion and distraction as well as an assessment of its historical staying power.

IV.

New German Cinema militated against the powers of amusement and distraction; above all its illustrious reputation would derive from its confrontations with an unsavory legacy of militarism and mass murder. Unreconciled and obstinate (evocative words that recall the title of Jean-Marie Straub and Danièle Huillet's debut feature [*Nicht versöhnt*, 1965] and abide as a central impetus in the multimedial work of Kluge[9]), its key proponents probed the forces that had diminished and compromised the culture in which they lived. Espousers of unpopular minority opinions would, over the years, come to enjoy the status of prominent artists and public intellectuals. The narrative intimated in the title to the third part of this book, "From Oberhausen to Bitburg," relates the process wherein progressive filmmakers, self-styled agents of critical memory, would become implicated in and, to a degree, complicitous with a wider tendency toward historical revisionism during the eighties. In the endeavor to forge a "new German feature film," the Oberhausen activists set an ambitious agenda that involved a historical reckoning with Ufa and its infamous legacy that

stretched from military propaganda in World War I to Weimar's golden age of artistic achievement, as well as to a consummate cinema of distraction to film under the auspices of the Nazi regime and Adenauer-era escapist fare. This meant contesting a cinema that relied on genres, stars, and production values; that sought to proffer diversion; and that eschewed dissenting views and controversial perspectives. The Young German Film wanted to do things differently; it dared to be overtly political, stylistically radical and experimental, mindful of and responsive to current developments in the other arts and in other countries, and, at times, even unabashedly intellectual. For that reason, it never would become a truly popular or even well-regarded domestic cinema. It did, however, travel well and would serve as an influential foreign ambassador.

The Oberhausen insurgents did not possess a monopoly on alternative enterprise. They had numerous adversaries—and not only in the established film industry. Nonetheless, Alexander Kluge, as the preeminent driving force behind this recalcitrant countercinema, employed the Frankfurt School's critique of mass culture as a seminal impetus, modeling the film academy in Ulm along the lines of the Bauhaus, bringing Adorno into the picture and even convincing the iconophobic philosopher to champion Young German Film, militating for closer links with representatives of the new music and writers from the prominent Gruppe 47. For other young filmmakers in West Germany, the productions that came in the wake of Oberhausen (like Kluge's) seemed stylistically bland, unbearably pedantic, and sorely lacking in spunk and spontaneity. Fassbinder was an intellectual but also a lover of mass culture; he wanted to make films that could replicate the emotional appeal of Hollywood movies shorn of their falseness. Wim Wenders shared Fassbinder's romance with American cinema, albeit with different intensities and consequences. In his own way, and studiously diverging from the path taken by the Oberhausen signatories, he would become suspicious of this foreign dream factory and concerned about its abuse of images and its colonization of fantasy life.

As Young German Film grew into New German Cinema, the latter would gain an international following at festivals and in film journals, art houses, and university classrooms. The once-alternative designs would become an official source of cultural capital, referred to with pride by the

Social Democrat government and shuttled around the world by a vast network of Goethe Institutes. Indeed, the cachet enjoyed abroad guaranteed New German Cinema continuing life despite its economic incapacity and domestic lack of popularity. The bitter irony of this success story would be how, in becoming representatives of a better Germany and in probing the German past and German suffering, filmmakers like Kluge, Helma Sanders-Brahms, and Edgar Reitz would come to be seen by some critics as agents of revisionism. In that regard, *Heimat* (1984), Reitz's fifteen-and-a-half hour epic about modern German history seemed, especially for commentators in New York and for the editorial board of *New German Critique* (with which I at the time was—and to this day still am—closely associated), a problematic act of memory work, a film that seemed to suggest that one might say homeland without mentioning the Holocaust. If Reitz had included the Holocaust in his epic, he argued, the film would "have taken a different turn," in effect defending the shape and direction of the narrative by foregrounding his stunning act of exclusion. The culmination of New German Cinema's historical mission, Reitz's national epic is both the dramatic acme and problematic extension of the Oberhausen Manifesto's desire to create "the new German film." Nevertheless, the impetus of the 1962 intervention remains to this day significant and pertinent; its important legacy was duly recognized (and, in some cases, shamelessly exploited by opportunistic German politicians otherwise-disinclined toward alternative filmmaking) during its fiftieth anniversary in 2012.

V.

In the wake of the New German Cinema came a long period of stagnation. That story is well-known, although it has thus far been sketched only in broad strokes. From the mid-eighties to the late nineties, German films all but disappeared from the prominent international film festivals as well as the programs of art cinemas and the catalogues of foreign film distributors. In fact, if one rescans Kohl-era productions, one will find many buried treasures, exemplars of a lesser-known and still-to-be written subterranean history of German cinema. In the eighties, for instance,

I vividly remember invigorating encounters (chiefly at the Berlinale or in the Arsenal Cinema) with films like Reinhard Münster's *Dorado* (*One Way*, 1983), Sohrab-Shahid Saless's *Utopia* (1983), Hellmuth Costard and Jürgen Ebert's *Echtzeit* (*Real Time*, 1983), Thomas Harlan's *Wundkanal* (1984), Pia von Frankenberg's *Nicht nichts ohne Dich* (*Ain't Nothin' Without You*, 1986), Marcel Gisler's *Tagediebe* (*Hanging Around*, 1986), Alfred Behrens's *Walkman Blues* (1986), Martin Theo Krieger's *Zischke* (1986), Michael Bartlett's *Konzert für die rechte Hand* (*Concerto for the Right Hand*, 1986), Nina Grosse's *Der gläserne Himmel* (*The Glass Sky*, 1987), Wolfgang Becker's *Schmetterlinge* (*Butterflies*, 1988), Thomas Brasch's *Der Passagier* (*Welcome to Germany*, 1988), and Nico Hofmann's *Land der Väter, Land der Söhne* (*Land of the Fathers, Land of the Sons*, 1988). During the Kohl years (i.e., from 1982 to 1998), I found myself eagerly awaiting each new endeavor by Michael Klier, Uwe Schrader, Jan Schütte, Peter Sehr, Philip Gröning, Heinz Emigholz, Tevfik Baser, and Dominik Graf, and later Fred Kelemen, Tom Tykwer, Thomas Heise, Lars Becker, Romuald Karmakar, Oskar Roehler, and Andres Veiel. With great gain and ongoing engagement (albeit in several cases with slightly diminished enthusiasm), I continued to follow the careers of established auteurs like Kluge, Reitz, Herzog, Wenders, Straub and Huillet, Volker Schlöndorff, Reinhard Hauff, Rudolf Thome, Michael Verhoeven, Peter Lilienthal, Percy Adlon, Werner Schroeter, Werner Nekes, Klaus Wyborny, Jutta Brückner, Ulrike Ottinger, Helke Sander, Margarethe von Trotta, Harun Farocki, Hartmut Bitomsky, Eberhard Fechner, and Klaus Wildenhahn; as well as the zany productions of so-called ragamuffins (*Schmuddelkinder*) like Herbert Achternbusch, Monika Treut, Elfi Mikesch, Christoph Schlingensief, Lothar Lambert, and Rosa von Praunheim; much less the survivors of Deutsche Film-Aktiengesellschaft (DEFA), such as Andreas Dresen, Frank Beyer, Egon Günther, Volker Koepp, Jürgen Böttcher, Roland Gräf, and Helke Misselwitz. Particularly memorable for me as well was the surfacing of the banned *Kaninchenfilme* from the mid-sixties after the opening of the wall and the so-called *Wendeflicks* that both scrutinized and mourned the passing of the German Democratic Republic.[10]

The final section of this volume, "Postwall Prospects," leaps forward in time and focuses on works from the two most visible sectors of contemporary German cinema, films that have emerged after the Kohl era.

Berlin School features, which have become increasingly prominent since the turn of the century, almost without exception take place in the present and probe the changing spaces, uncertain conditions, and impacted experiences of people living in a New Germany and an ever-expanding European community. The resolve of the Berlin School is serious, its regard is precise, and its focus is unblinking; directors like Christian Petzold and Christoph Hochhäusler are less concerned with representing the real (for them, like Kluge, reality is always produced rather than given) than in rendering things visible. With unflinching soberness, they take measure of the status quo and, with a blend of critical and utopian initiative characteristic of Kracauer, show how provisional and thus potentially open to change the state of things is. Their cinema is both critical and yet hopeful in the ways that it discloses other lives and different worlds; it could not be more out of keeping with the impetus of recent heritage films, the most successful of which is Florian Henckel von Donnersmarck's *Das Leben der Anderen* (*The Lives of Others*, 2006). The heritage film, a term whose pertinence for German features is problematic and in need of more careful calibration, revisits bad German history, especially the Nazi and Stasi eras, and seeks to transform painful memories into evocative and gripping narratives. Von Donnersmarck views his signature feature as a heritage for postwall times, a conciliatory tale that comforts his audiences and seeks to heal the wounds of the past. Despite their altogether divergent investments, impetuses, and emphases, the Berlin School's ethnographic surveys of the present and the heritage film's retrospective readings of the past enjoy an intriguing dialectical relationship.

VI.

There is a curious, one might even call it an odd, coupling in my choice of Kracauer and Kluge as key points of orientation in this volume's time travels. Kracauer's singular work commingles suspicions about the insidious effects of mass-mediated culture and hopes regarding cinema's redemptive capacities. Sometimes, he observes, films go mad and "spew images that expose society's true countenance."[11] Kluge's intellectual promiscuity as well as his insistence on film's syncretic, impure, and eclectic constitution

Wir lassen nie vom Suchen ab,
und doch, am Ende allen unseren Suchens,
sind wir am Ausgangspunkt zurück
und werden diesen Ort zum ersten Mal erfassen.

T.S. Eliot

FIGURE 0.3 The end as a new beginning: a quotation from T. S. Eliot's "Little Gidding" in the opening of Tom Tykwer's *Lola rennt* (*Run Lola Run*, 1998).

provide equally important incentives. Indeed, they have had a powerful impact on my own understanding of and appreciation for cinema's critical and utopian dimensions. Human fantasy, Kluge maintains (and in this regard he surely disagrees with Kracauer), can be controlled only to a point; it is downright obstinate and ultimately unwieldy in the way it connects people to the subjunctive and the optative, which is to say to possibilities and wishes. Seen through Kluge's eyes, cinema and the history of film become airborne and often rise to heady heights; throughout his own endeavors as a director and a producer, he has remained eager and ever ready to serve as a test pilot.[12] My own idiosyncratic forays through German film history are driven both by critical investments and utopian designs, indeed by equal measures of critique and hope, an interest in the ways in which German films have both forwarded constructive resolves and figured in less productive regards. It is important that these passages devoted to German legacies and the use and abuse of cinema be understood as possible and at times overtly personal itineraries chosen from a multitude of potential (and, in so many regards, still unprobed) courses

in time rather than as definitive or comprehensive guides. This book presents histories, not a history.

<p style="text-align:center">VII.</p>

The chapters in this volume are the result of many sojourns in West Germany and later Germany followed by sustained reflection on my return to the United States, to my home bases in Irvine, California (until mid-1998) and thereafter Cambridge, Massachusetts. Annual forays to the Berlinale (which I first visited in 1979 and have missed only once since 1985) and the Munich Film Festival (from 1996 to 2007), occasional trips to the Hof Film Days (in 1986, 1989, and 1990), and a sole venture to Pordenone (1990) as well as lengthy summer and sabbatical stays (mainly in Berlin, but occasionally in Frankfurt am Main and Munich) have allowed me access to the majority of each year's production and also granted me welcome and ample opportunities to partake of shorts, features, and documentaries. The intensified and expanding availability of films on DVD and the Internet as well as my constantly growing private collection have enhanced my sense of possibility. Although the magnitude of materials at my disposal has without question energized my research, it also has left me with the gnawing and nagging awareness that these endeavors are forever doomed to be partial and perforce incomplete. For that reason, this book's courses in time remain works in progress, history lessons subject to reconsideration and revision, search missions catalyzing inescapable feelings that, for all that one has found and whatever one has done with it, there invariably remains further evidence to factor in and yet more to be accomplished. "And the end of all our exploring," to recall T. S. Eliot's lines that Tom Tykwer cites at the start of *Lola rennt* (*Run Lola Run*, 1998), "Will be to arrive where we started/And know the place for the first time." The quest of the film historian is never over; at the conclusion of each outing, one always arrives at a new point of departure, eager to continue, and both curious and uncertain about what perspectives subsequent passages might hold in store.

I
CRITICAL VENUES

FIGURE 1.1 Rudolf Arnheim's book of 1932, *Film als Kunst* (seen here in its initial English translation), will be reissued more than two decades later in an altogether transformed and decidedly reduced version.

HOW A SOCIAL CRITIC BECAME
A FORMATIVE THEORIST

I.

To this day the variance between Rudolf Arnheim the formalist and Siegfried Kracauer the realist is fundamental to the history of film theory. Film cannot become an art, argues Arnheim in his canonical *Film as Art* (1932), if it only records reality and, in that way, simply duplicates the world. Precisely the technical limitations that render it an imperfect means of reproduction grant it the formative capacity to become an art.[1] Kracauer, as we know well, begged to differ. For the author of the equally canonical *Theory of Film* (1960), the medium shares with photography the propensity for capturing unaltered reality. This is its chief characteristic; for this reason, realism constitutes for Kracauer the very essence of film, indeed its principal criterion of aesthetic value.[2] The clear-cut opposition between Arnheim's formalism and Kracauer's realism seems hardly controversial and virtually unassailable. University course offerings on classical film theory, relying on the disposition of Dudley Andrew's still widely used monograph, *The Major Film Theories* (1976), employ this dramatic disparity between Arnheim's constructivism and Kracauer's noninterventionism as an organizing principle.[3] And yet there are curious and intriguing affinities between these two seminal thinkers that complicate

such a construction and, at least to a degree, compel us to reconsider our understanding of Arnheim's work on film.

Since Thomas Levin's translation of Kracauer's collection, *The Mass Ornament*, in 1995,[4] Anglo-American scholars who do not read German have gained access to a significant selection from the author's massive corpus of Weimar writings; in the process, a strikingly different Kracauer (beyond the well-known realist of *Theory of Film* and the film-mirrors-reality determinist of *From Caligari to Hitler*) has emerged and catalyzed productive discussions within the film studies community. His portrayals of Weimar culture and its social surfaces provide a compendium of modern mythologies long before Roland Barthes's famous collection of 1957.[5] The articles focus on the commodified amusements, public diversions, and popular rituals of a nascent mass culture and anticipate, by more than a half century, an emphasis that now has become institutionalized within academia under the rubric of cultural studies. These contributions make it clear how marked the discrepancy is between the Kracauer who wrote criticism on an almost daily basis in Germany during the twenties and early thirties and the Kracauer who, living as a refugee in New York, authored the books *From Caligari to Hitler* and *Theory of Film*.

A sampling of Arnheim's Weimar film criticism appeared in Brenda Benthien's translation a dozen years ago.[6] These notices assume an estimable place within lively German-language dialogues about film's formative, discursive, and political potential during a time of constant crisis. They arise within the larger context of Arnheim's activity as a cultural journalist (*Feuilletonist*) and an observer of interwar German society. Curiously, the work of the critic has not had much of an impact on the way in which scholars view the theorist. Arnheim's earliest writings on film, I argue, deserve closer attention and more careful reading. They enable us both to nuance and enrich our understanding of his relationship to the cinema and give us reason to refine the accepted wisdom that, in matters of film, he was an essentializing and ahistorical formalist.[7] Here we find an Arnheim who is neither rigid nor apodictic,[8] an Arnheim who is often playful and even irreverent, and an Arnheim who is most certainly a public citizen and a political creature. In crucial regards, the film critic and cultural commentator of the Weimar era represents an unrecognized and, at least in North American quadrants, even an unknown Arnheim.

II.

At the age of twenty-one and still a student, Arnheim began writing film criticism for the satirical monthly, *Das Stachelschwein*, and the weekly, *Die Weltbühne*, an influential journal run by prominent Jewish leftists who, in a nonpartisan fashion, defended the "republic and democratic ideas in opposition to the strong monarchist tendencies in Germany that sought to reestablish the Kaiser-Reich."[9] From 1928 to 1933, he was an assistant editor of *Die Weltbühne* and was responsible for its art and film criticism.[10] A collection of his early pieces, *Stimme von der Galerie*, appeared in 1928, the year that Arnheim, now twenty-four, received his doctorate. In the introduction, Hans Reimann, editor of *Das Stachelschwein*, offered an affectionate portrait of the irrepressibly energetic young pundit:

> Arnheim is a bright boy.
> He knows what's going on.
> He knows what's up.
> He's always in the picture.
> No matter, if he ends up at the Oktoberfest, at a police exhibition, or a
> boxing match; whether his object of discussion is painting, servant
> girls, Greta Garbo, a parvenu, or psychoanalysis; he is always unfail-
> ingly on target.
> He is a careful observer. And he has a sense of humor.[11]

Among Arnheim's journalistic entries on the cinema, we find general reflections on film criticism as well as discussions of single productions (mainly German, American, French, and Soviet features) and portraits of international stars, with extensive comments on the quality and nuance of actors' performances. As we might expect, he remains carefully attuned to films' formal shapes, their artistic accomplishments and aesthetic lapses, as well as—and surprisingly so—their political meanings. He registered the impact of contemporary developments and participated in significant public debates. In the Weimar Republic, he would remark in 1977, there was "no safe place for disinterested bystanders."[12] Looking back at his youthful effusions decades later, Arnheim was struck by how strongly the fledgling critic "was bound to all the manifestations of the manners of the

day, the art business, the politics, the personalities, and the anecdotes of the big city."[13]

The Weimar Republic stands out, in Peter Sloterdijk's assessment, as "the most self-aware epoch of history; it was a highly reflective, thoughtful, imaginative, and expressive age."[14] It was an intensely critical period in which many intellectuals, especially on the left, cultivated a cold regard and a cynical reason, ardently seeking to see through illusion and deception. After a lost world war and the confusion in its wake, these sobered spirits swore to never again let themselves be deceived.[15] Characterizing the period's clashing discourses, its competing imperatives of official legitimations, advertising strategies, and propaganda slogans, author Robert Musil speaks of a Babylonian madhouse, "the nervewracking particularism and syncretism of political and ideological groups that screamed at each other in public."[16] Given Weimar's mindboggling gallimaufry of positions and persuasions, identities (including those of critics) vacillated and meandered between perspectives. From one moment to the next, the ground could shift seismically, which is why one needs to be so attentive to the precise situations from which judgments issued. The constellations of 1924 were worlds apart from those of 1928 much less what transpired in 1931. In such an amphibian reality, political frontlines and discursive boundaries are often very difficult to distinguish; the universe, concludes Sloterdijk, "becomes a multiverse and the individual becomes a multividual."[17]

During the Weimar years, the most significant film criticism by and large was not to be found in the prominent daily newspapers, but rather in the leftist cultural periodicals like *Die Weltbühne* and *Das Tagebuch*. In that regard, Kracauer's extensive reviews for the *Frankfurter Zeitung* were the exception and Arnheim's feuilletons at *Die Weltbühne* the rule. Common to both daily notices and thought pieces published in cultural weeklies and monthlies was a fundamental skepticism regarding the economic legitimations and industrial biases of the film trade press. During the twenties, there was a number of quite prominent and influential trade papers, most notably *Der Kinematograph, Bild und Film, Lichtbildbühne,* and *Film-Kurier*. The status of film as a commercial commodity was clearly recognized, particularly as the German film industry competed fiercely with American studios for larger shares of the domestic box office.

Indeed, contemporary notices frequently reflected on the links between the business of film and the production of ideology. In this way, Weimar film criticism often became a vehicle of social commentary and even sociological criticism.

The enlightened resolve that guided German film critics of the twenties owed much to the eighteenth century. Continuing the legacy of Lessing and Schiller, these critics sought to further the improvement of art works as well as militate against bad taste and educate their audiences.[18] Critics protected the best interests of a spectatorship that, more often than not, was considered to be unschooled, immature, and easily misled.[19] The film critic, submitted Arnheim, must be a professional (not a mere enthusiast or an opinionated tastemaker) who knows how the film industry operates, but one who does not defer to it; the critic should "evaluate the finished work without prejudice" and function "as an impartial authority" (*FEC*, 103). German film critics of the twenties, to be sure, no longer felt the need to legitimate the cinematic medium as an art. Nonetheless, the precise terms of film's ideal aesthetic shape and ultimate social calling still remained a topic of debate. For all their differences, most German film critics viewed themselves as advocates of a medium that was emancipating itself from the other arts and searching for its true identity; for this reason, they challenged those forces that undermined or diminished cinema's viability and threatened its future. More conservative voices, among them some of the so-called cinema reformers (who had been so active and influential during the previous decade), sought to ensure that German cultural values would inform the new medium; in response, progressives like Kracauer aimed to disclose the social interests at work in film fantasies.

Film, Kracauer argues in his seminal essay of 1932, "The Task of the Film Critic," is a commodity in a capitalist society that circulates among other commodities.[20] When one reviews films, one should not simply provide normative judgments about how good or well-constructed they are, which is precisely what Arnheim seemed to have in mind when he espoused "aesthetic criticism" in an essay of 1929 (*FEC*, 103). Films, whether they are low-budget or mainstream productions, are anything but indifferent entities; they have material origins as well as social consequences. The critic must interrogate with care and precision what films

convey to mass audiences and how they influence spectators. Even films that appear to have no political implications have commercial determinations and, as such, represent political interests. Producers are part of the dominant economic system and their continuing success depends on the box office and on the preservation of business as usual. The film critic must draw attention to social intentions that manifest themselves, often inconspicuously and therefore all the more perniciously, in cinematic fantasies and make these designs visible. The critic should compare filmic illusions with social realities and elaborate how the former obscures, disguises, and falsifies the latter. "Briefly stated," Kracauer submits, "the film critic of note is conceivable only as a social critic. His mission is to unveil the social images and ideologies hidden in mainstream films and through this unveiling to undermine the influence of the films themselves wherever possible."[21] This resolve corresponds to what David Bordwell speaks of as "symptomatic criticism";[22] ever on the lookout for concealed social contents, Kracauer's social critic is a discursive detective who searches for the repressed contents and political agendas of film features; he discovers "film as a social fact" and decodes it as ideology.[23] In the assessment of Theodor W. Adorno, Kracauer set a standard for German film criticism "by reading film as a cipher for social tendencies, thought control, and ideological other-direction." Such an approach, maintains Adorno, constitutes "the self-understood precondition for any reflection about the cinematic medium."[24]

III.

Although the young Arnheim worked and wrote in the same culture as Kracauer, his perspective was in a number of ways quite different. To a degree, however, Arnheim's early notices shared the impetus of the influential social critic; indeed, there are numerous points of correspondence. Let us consider Arnheim's profile as a Weimar film critic and outline the central preoccupations of his early work as well as its combination of both aesthetic and social incentives.

Arnheim took great pride that he shared responsibility for the *Weltbühne*'s reputation as a site of a "joyful style of fencing" ("fröhlicher

Florettstil").[25] His early prose is vital and vibrant, devoid of hackneyed touches or schematic formulations, peppered with biting irony, bitter sarcasm, and an undeniable brashness. He has a decidedly wry wit and a wicked sense of humor. In the words of Karl Prümm, he is "always on the lookout for the lively and original turn of phrase, for the truly new and contemporary."[26] Arnheim is an elegant stylist as well as, at times, an impassioned polemicist and engagé social critic. One finds protracted paratactic sentences that nimbly juggle oppositions as well as acidic one-liners and hilarious punch lines. *Der Kongreß tanzt* (*The Congress Dances,* 1931), he notes, "is one of the most expensive German films in years. And one of the poorest" (*FEC,* 174). "Fritz Lang's films are parvenus, trashy novels that have come into money" (*FEC,* 152). Lang and his collaborator Thea von Harbou, Arnheim says elsewhere, love to "train politics and science for the circus ring, to Wagnerize topical problems." In their film epics, "decorative beards and human masses surged endlessly across the screen, and thus sober reality was corrected with the aid of costly cosmetic surgery" (*FEC,* 165). Arnheim has a penchant for constellating films, typically playing off a positive example against a negative one, or often reckoning with two or more films at once. He describes, for instance, the bizarre juxtaposition of the jungle movie *Trader Horn* (W. S. Van Dyke, 1931) with the Ufa musical, *The Congress Dances:* "The screen had no sooner been cleared of mistreated animals and Negroes," he quips, "than it was populated with many hundreds of extras in Viennese dress, who began dancing waltzes in such detail that one might have thought they were trying to propagate a new art form" (*FEC,* 174). The Ufa Palast, where Arnheim took in the double feature, was apparently having "a streak of bad luck. It offered us Africa once, Vienna once, boredom both times" (*FEC,* 173).

Quite often the critic Arnheim writes with the assurance of the future theorist. He has no patience for mannerism and considers "indirect portrayal" to be the hallmark of film art; a subdued performance or a subtle approach will always involve the viewer more keenly. He chides Carl Dreyer for what he considers the overuse of close-ups in *La Passion de Jeanne d'Arc* (*The Passion of Joan of Arc,* 1928): "An important structural form was taken to excess in an irritating manner" (*FEC,* 180). He likewise complains about René Clair's haphazard compositions and the director's

lacking sense of structural design. In *À Nous la Liberté* (1931), Clair reminds us of a painter who, when he has reached the image's bottom left, "no longer remembers what he painted on the top right" (*FEC*, 182). *À Nous la Liberté* "is not gushing, untamed raw material, but an untamed game of form, due to its lack of contact with the material, with the subject, with the meaning." Clair's films may be light, but there are various forms of lightness. It is easy to be light "when you are not subject to gravity." For Arnheim, Clair's films lack the essential measure of substance that grants to those of Charlie Chaplin a lovely lightness of being (*FEC*, 184). *Morocco*, on the other hand, is extremely artificial, but it still manages to be aesthetically convincing: "It hurts Sternberg's films," he comments, "that life always take place in the space of just a few feet around the character. But this small circle turns into a magic circle." Josef von Sternberg knows what few directors do, namely "that art begins with beauty, not with naturalness" (*FEC*, 172E).

The multiple screens in Abel Gance's *Napoleon* (1927) remind Arnheim of a three-ring circus. Such "imperialism of space" is inappropriate, for "the restriction to a rigid frame is the first prerequisite for any sort of pictorial effect" (*FEC*, 127). He expresses chagrin at an early Tobis Studio sound production, Robert Land's *Das Land ohne Frauen* (*Bride 68*, 1929); its sonic track is downright harrowing. Among the cast that includes Conrad Veidt and a lisping female player, only a camel seems "to have found the right pitch for the Tobis machine." After the camel finished his work on the film, Arnheim adds, it returned to the zoo and mingled with its fellow caged creatures, proclaiming "Boy, what a night I had!" "The critic," he concludes, "escaped with similar feelings" (*FEC*, 151). In a review of 1930, Arnheim laments that the anachronisms of vaudeville theater one had been glad to be rid of were now making a comeback in sound film. He praises Charlie Chaplin's *City Lights*, a film of 1931 that mercifully refuses to get with the sound program—and does so to great artistic effect: "Chaplin's quiet art speaks to us as it always did" (*FEC*, 158).

One encounters, nonetheless, a number of moments in which the young Arnheim seems less tightly bound to the formative paradigm. The later mortal enemy of sound, while speaking of *The Phantom of the Opera* (Rupert Julian, 1925), expresses regret that the viewer does not get to hear the phantom's "deep, soft voice" (*FEC*, 114). And that same mortal

enemy will grant that in *M* (Fritz Lang, 1931) "the tools of sound film are occasionally used with skill" (*FEC*, 165E).[27] (It is ironic that the inveterate Lang-basher reserves praise of the director for a sound film.) He lauds E. A. Dupont for the "astonishing courage he has in showing reality" and, in fact, even stresses the ways in which artistic choice and the material immediacy of an object work as an ensemble to startle the viewer. In *Varieté* (*Variety*, 1925), Emil Jannings wears "an everyday, funny, rumpled" hat when he murders his rival. When he moves away from his victim, "this hat is battered from the struggle, crumpled—something that would be a laughable sight in almost any other circumstances. That here the most trivial absurdity can be turned into utter horror is evidence of more than just a good choice on the director's part" (*FEC*, 117).

Vsevolod Pudovkin's *The Mother* (1926) allows us to partake of things in fresh and unusual ways, so much so that we experience them directly. Instead of conventional film images, "we see the thing itself, laden with all the powerful emotion of reality" (*FEC*, 122). In such a formulation, more redolent of Kracauer's *Theory of Film* than his own *Film as Art*, reality seems to enjoy a privileged status. And, so too, does one of Kracauer's other privileged categories, namely the adventitious.[28] "Everybody," Arnheim writes in a review of Pudovkin's *The End of St. Petersburg* (1927), "needs the kind of inspiration that often strikes by coincidence, and he who always spends time with film people from morning to midnight easily becomes a 'professional,' automatically reeling off his films with the help of a fixed 'archive'" (*FEC*, 132). As a documentary, he writes in 1931, F. W. Murnau's *Tabu* (1931) "offers less—primarily less in the way of unstaged reality—than we demand today" (*FEC*, 167).

The young critic disliked the postsynching in *Tabu*, which he deemed "extraordinarily dangerous. When true images imperfectly become lies through false sounds, confusion and deception result" (*FEC*, 168). "What a work of art most desperately needs," Arnheim claims that same year, "are limitations. He who heads out to catch the whole of life will return home with a pile of chaos in his fishing-net, but he who sticks to a small part of it will, perhaps unexpectedly, catch the whole world." The formalist knows that film has a "pedantic sense of reality—against which one may not sin!" (*FEC*, 162). Kracauer also had a pedantic sense of reality. He recognized in *Theory of Film*, Arnheim wrote in 1974, "that in order to produce the

strongest effect, raw material is not repressed, but rather emphasized, because the half-formed, the open and the infinite reveal the world to us in a novel way. The French critic André Bazin has also expressed thoughts along these lines."[29] Clearly, in these passages at least, Arnheim is seeking to negotiate the formative impulse with a respect for reality's integrity; this balancing act goes a long way toward explaining why Arnheim initially praised *Theory of Film*[30] and continued to do so long after the book's appearance.

There is no doubt that Arnheim preferred productions that set out to further film art and do more than just entertain. Some features, he notes, "achieve their aims in a satisfactory and non-controversial manner, by using tested, safe means"; others experiment and "seek to wrest from the film apparatus new forms of expression" (*FEC*, 161). Nonetheless, the *Weltbühne* critic surely was not altogether dismissive of mass culture. He sounds a little like Pauline Kael when he remarks that "a bit of pure, rollicking trash which goes beyond good and evil provides a more pleasant, decent sight than does a cultural asset gaudily made-up to suit the public's taste" (*FEC*, 188). Arnheim disparages what he calls "the hopelessly old-fashioned productions by Fritz Lang, Paul Czinner, Henny Porten, etc. in which even excellent partial accomplishments cannot erase the impression that there is nothing of film art here" (*FEC*, 139). Repeatedly, he maligns Lang for trying to inflate trivial materials into something grander and more significant. The director's films, carps Arnheim, are certainly busy and very complicated; their fussy obsession with machines, media, and gadgets is, however, both irksome and tedious. Lightning may well flash here, quite often in fact, but it does not strike, so that the viewer only gets "cold fireworks" (*FEC*, 135). In *Spione* (*Spies*, 1928), Lang stages everything "cleverly and cleanly, but without our imagining for a second that this might be film art. The deluxe edition of a ten-penny detective novel, nothing more!" (*FEC*, 136). In Arnheim's view, Lang's films fail because they are pompous and self-important, akin to what Manny Farber would later call white elephant art; they "blow up every situation and character like an affable inner tube" and seek to imbue each frame "with glinting, darting Style and creative Vivacity."[31] On the other hand, Arnheim applauds the vitality and spontaneity at work in the collective work *Menschen am Sonntag* (*People on Sunday*, 1930) and calls the production an "outsider film," looking ahead

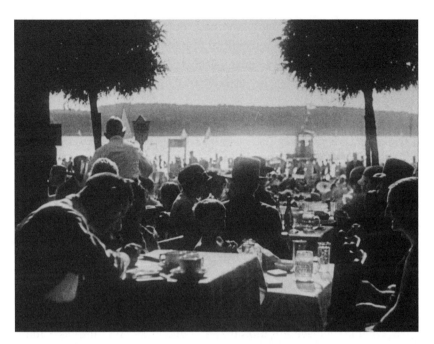

FIGURE 1.2 Although the young critic Arnheim wished that a stronger formal impetus were on view in the collective production *Menschen am Sonntag* (*People on Sunday*, 1930), he was willing to "trade all the Hungarian rhapsodies of Privy Councillor Hugenberg [the head of the Ufa studio] with a light heart if we could see such an experimental film every week."

to Farber's notion of "termite art" with its resolutely unpretentious and seemingly slapdash "signs of eager, industrious, unkempt activity."[32] Live and spontaneous expressions flit across untrained faces (*FEC*, 155) in a welcome departure from the contrived features that rely on acting agencies for their criminals and prostitutes. "A studio," Arnheim insists, "should be more impudent, should try its hand at the most refined camera art, and should be bold in its selection of topics and intellectual motifs in areas forbidden to the industry producers" (*FEC*, 155).

IV.

One of the major discoveries in reading Arnheim's Weimar notices is the critic's marked sense of historical context as well as his strong social

engagement. In his various programmatic statements, Arnheim is mindful of the critic's historical responsibility; he often expressly foregrounds the historicity of films as well as imagines the perspectives of future historians. Looking back in 1929, he relates that old Chaplin films

> have their style, which some day in the history of film art will be called the early style; for they still basically developed with a very primitive idea of the possibilities of film: the camera serves as a reproductive organ for a situation which, seen purely spatially . . . could just as well take place in reality or on a stage. The setting of the action remains constant throughout entire scenes, the continual long shot is scarcely broken up by close-ups, there are no elegant shots, no characterizations using boldly isolated details (*FEC*, 146).

These reflections on a cinema of attractions before the codification of continuity editing anticipate, by a half century, the scholarship on early silent cinema. The evolution of film, in Arnheim's mind (and here, to be sure, his perspective assumes teleological contours), involves the medium's path "from reportage to a world of its own" (*FEC*, 147). Silent cinema has provided us the opportunity to watch a new art come into being, a notion that we also find in the work of Béla Balázs.[33] The film critic, in writing about new things, does just the opposite of a paleontologist, who deals with old things: "He must preconstruct film art from occasional fossilizations, from impressions of sometimes not very noble parts; the laws of construction with which the film of the future will perhaps, in happy moments, completely comply must also be applied to contemporary film" (*FEC*, 184).

Like his colleague Kracauer, Arnheim frequently took critical stock of German cinema and conducted discursive analyses of current features. Arnheim is taken aback, for instance, at how *Metropolis* (Fritz Lang, 1927) fuses old and new worlds. On one hand, the film puts on display engineer-Americanism; on the other, the whole dust-collecting arts-and-crafts of European emotional life. We partake of "mundane genre scenes with nightmarish medieval portraits, painted in machine oil. There is no trace of the new functionalism, not the least sign of an airing out of the soul via the dispassionate-hygienic technological style" (*FEC*, 119). The

film's upbeat conclusion, he goes on ("The heart must mediate between head and hands!"), suggests that one can find a resolution to class conflict without being burdened by material considerations. Thea von Harbou, the scriptwriter, has a bit of King Midas insofar as just about everything she touches turns into gold; when she comes upon serious material, however, it invariably turns into kitsch. Clearly, Arnheim suggests, she would be well advised to keep her "manicured fingers off socialism" (FEC, 118–119).

In a country where effective political and social critique was in rare supply and public complacency an everyday reality, Arnheim submits, Friedrich Zelnik's Die Weber (The Weavers, 1927) is a great disappointment. If anything, it reduces Gerhart Hauptmann's historical drama about a Silesian workers' revolt to pretty pictures and fetching performances that provide a diverting evening in the dark. The film, claims Arnheim (whose ideological reading is much harsher than Kracauer's),[34] seeks to replicate the box office successes of Soviet films like Battleship Potemkin (Sergei Eisenstein, 1925) and The Mother (1926) by profiting from the cachet of the famous dramatist Hauptmann and by promising spectacular scenes of mass violence. No doubt, the feature managed to stimulate "genuine and spontaneous emotion," but that also happens when people watch bike races; in fact, it happens all the time. "Professional athletics are a luxury, art is a luxury, but revolution is not." At once a betrayal of cinematic art and of revolutionary thought, The Weavers is nothing less than "a profanity. A revolutionary people deserves a revolutionary art" (FEC, 125). Arnheim's sensitivity for the political dimensions of films, I would add, made him acutely aware of anti-Semitic insinuations.[35] We also find a sensitivity for primitivist and colonial discourse in Arnheim's review of Tabu: "The film people, the missionaries of the Maltese cross, show the islanders how it is supposed to look on a romantic South Sea island." In this way, the "ideology of bourgeois film production" finds its way into the film; "the naked wild man must make the westerners' national morality palatable to them" (FEC, 167).

In his notice, "The Russians Are Playing" (1931), Arnheim describes a changed cultural ambience in which one no longer finds on German screens and stages the Potemkin-inflected projects of the mid-twenties, the "dilettante theater of current events." Instead of "thundering grenades" and "rough noise from the fields," audiences now partake of "lively

parties, frightful marches into winsome dance music" (*FEC*, 168). Arnheim's characterization of the incongruous profusion of light touches at a moment of acute political crisis is both ironic and incisive. No wonder, he laments, that serious Soviet films like Dziga Vertov's *Enthusiasm* (1931) now seem so out of place. Writing a year later, Arnheim wondered whether one might still be able to make the ambitious films of 1931. All indications suggested not. He deplores "the ever-increasing contamination of the public's taste" as well as the neo-Nazi films with Otto Gebühr. "The intensification of censorship, the National-Socialist cell formation in the circles of cinema-owners, the fear of protest demonstrations in the cinema . . . does not even permit people the modest progress of the past few years." Directors are taking flight and turning out frantic escapist vehicles, fleeing "from the horror of reality into the horror of unreality" (*FEC*, 188).

<center>V.</center>

When Arnheim's *Film als Kunst* appeared in 1932, Kracauer was one of its most positive reviewers.[36] He lauded it as an aesthetics of film and acknowledged its relationship to the theoretical work of Béla Balázs, Vsevolod Pudovkin, and Léon Moussinac. With its systematic approach to the laws of the silent cinema, the study, in Kracauer's estimation, is admirably sensitive to formal structures. To be sure, remarked the otherwise-respectful colleague, Arnheim does not demonstrate equal care when it comes to the contents of films: "At the very least his reading of the 'confection film' is not very original, and it seems as if he lacks a knowledge of the relevant sociological categories. Herein lie the book's limits."[37] There is something decidedly territorial about these harsh words in an otherwise-appreciative response, as if the reviewer felt that Arnheim's chapter on film content ("Was gefilmt wird") with its discussion of the psychology of mass productions and a subsequent section on the masses and the film industry[38] were treading on Kracauer's turf, as if the two were somehow in competition not only as film reviewers but also as sociological critics.

Histories of German film criticism (like histories of film theory) view Arnheim and Kracauer as diametrically opposed voices,[39] the former

insisting that film criticism is foremostly aesthetic criticism (*FEC*, 107), the latter stating that "the film critic of note is conceivable only as a social critic."[40] As we have seen, however, the young Arnheim had both aesthetic and social investments. Even as late as 1935, while still maintaining the primary importance of aesthetic scrutiny, he would argue that the critic's "second great task is the consideration of film as an economic product, and as an expression of political and moral viewpoints" (*FEC*, 108). A film is never the independent work of an individual artist and therefore cannot be judged as one would a painting or a novel. "In industrialized production, a film today is characterized far more by the company who makes it than by the director." Indeed, a film "is not so much the expression of individual opinions as it is the expression of general political and moral views." (One is reminded here of the introduction to Kracauer's *From Caligari to Hitler*.)[41] Nations dominated by particular ideologies (the German word Arnheim uses is *Weltanschauung*) exercise a strong influence over the political and moral content of film productions. And it is the task of the film critic, he stresses, "to analyze these contents and to evaluate them, positively or negatively" (*FEC*, 109–110). Film is not the product of individual artists, but rather nations, classes, and political conceptions. Here, too, he comes very close to Kracauer's later notion of film as a collective production.

It is important that we bear in mind the strong difference between *Film als Kunst* of 1932 and its English adaptation of 1957, *Film as Art*. The latter edition, which almost exclusively has dominated understandings of Arnheim's approach to film in Anglo-American circles, incorporates only a small portion of the original edition and appends four articles that Arnheim wrote later in the thirties after leaving Germany. As Sabine Hake points out, the American text virtually eliminated any "traces of a political consciousness and deleted numerous contemporaneous references."[42] One of the sections to disappear was a significant reflection on film and ideology, which stresses the importance of social and economic conditions for the production of films and also comments on the symptomatic functions of specific stereotypes and genres.[43] The elision makes us lose sight of a salient earmark in Arnheim's early film criticism. In losing sight of the social dimension of his writing, we become unable to appreciate the structured complementarity between Arnheim's formative impulse and his

awareness of historical and political reality. As a result, Arnheim comes to us, in part of his own doing, as the ahistorical and unpolitical film theorist. Future studies might quite productively probe a similar complementarity between the regard for form and the recognition of social and political determinants in the work of Balázs and Kracauer. Indeed, Karsten Witte once described Arnheim, Balázs, and Kracauer as the "ABKs" of German film theory, a formulation that suggests we might productively consider them as a collective corpus rather than as embodiments of altogether different perspectives.[44] If we do so, it would be useful to bear in mind Sloterdijk's insights regarding the amphibian quality of discourse within the Weimar Republic and the compelling ways in which it eludes easy generalization and comfortable cubbyholing. "Mostly," Sloterdijk remarks, "the contemporaries found out only afterward what kind of times they had really lived in—and what was simultaneous with them."[45]

Like the two other great German-language film theorists, claims Gertrud Koch, Arnheim derived his film theory from his work as a film critic. His theoretical texts, she argues, "are shot through with material lifted, unrevised" from his journalistic criticism.[46] The claim certainly is correct, but only if one, like Koch, is working with the original German edition of *Film als Kunst*, which was reissued by Hanser Verlag without any change in 1974 and reprinted as a Suhrkamp paperback in 2002. In fact, when we look at the 1957 University of California Press edition of *Film as Art*, we find few remnants of the early journalism and none of its historical and ideological inflections. In his Weimar-era criticism as well as in much of the original *Film als Kunst*, Arnheim frequently writes in ways that would cause us to think again before we characterize his approach to cinema unrelentingly prescriptive and "rather parochial."[47] As we have seen, Arnheim often sounds like Kracauer (especially like the ideological critic and at times like the later realist) and, one might add, at times like Balázs. Some passages seem decidedly out of keeping with his more normative later pronouncements and surely do not correspond to what scholars often have characterized as his "rigidity in aesthetic matters."[48]

A vexing question remains: How are we to account for the stifling of the social critic? Arnheim claims that he made the omissions in *Film as Art* "because some of the chapters tangled with tasks for which respectable techniques are now available, such as my sketchy 'content analysis' of

the standard movie ideology."[49] At first blush, this sounds plausible and convincing; Arnheim suggests that the strength of the work, which he intends to be read as "a book of standards,"[50] lies in its formal emphasis and that the section on content in the meanwhile has been superseded by the more substantial and informed investigations of others. But the fear that this portion of the book might not withstand the test of time certainly did not prevent him from allowing it to appear in subsequent postwar German editions. Is the evanescence of his political voice simply a function of his having matured and moved on? Or might the McCarthy era and its suspicion toward progressive sensibilities, especially those of a Jewish emigrant from Germany with a leftist past, have played a role in Arnheim's decision to make the considerable cuts? Lacking evidence, of course, one can only speculate, at least in the case of Arnheim. We do know, however, that given the difficult tenor of the Cold War epoch, Kracauer made certain that all traces of his former political convictions vanished from his work. History, argues Miriam Hansen, disappeared from the postwar writings of Kracauer, both at the level of history at large as well as his intellectual biography; in a fundamental way, the emigrant distanced himself from the Weimar critic.[51]

A valuable resource for the study of classical German cinema as well as an impassioned defense of silent film art in general, Arnheim's early criticism both enriches and complicates our reading of his subsequent film theory. It demonstrates a public citizen's sophisticated awareness of the contemporary historical context in which he was writing and in which films were being made. It also affords us repeated glimpses of a man of strong political persuasions. Addressing a protest rally against the official ban of *Kuhle Wampe* (Slatan Dudow, 1932) in April 1932, Arnheim contributed to a fierce debate about government film censorship. "Our task," he insisted, "is to enlighten, to show the contradictions between what this state does and what it proclaims in constitutions and constitutional celebrations."[52] "He who wants to improve the film must first improve the social order," claims Arnheim in 1932 on the last page, indeed, in the moving last lines of *Film als Kunst*: "The future of film depends on the future of economics and politics. To predict this does not come within the scope of the present work. What will happen to film depends upon what happens to ourselves."[53] These final sentences, read retrospectively, anticipate

developments that will dramatically alter Arnheim's life and, among other things, will necessitate his departure from Germany. As we know, this invaluable documentation of film culture before Hitler will be banned by the Nazis. That the author himself would decide to expurgate the work a quarter of a century later and, in so doing, to alter his own historic voice is yet a further and poignantly ironic sign, both of separation and of loss.

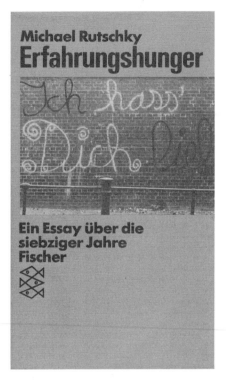

FIGURE 2.1 Michael Rutschky's *Hunger for Experience* commends Siegfried Kracauer's *Theory of Film* as an antidote to post-1968 malaise. Taking his cue from Kracauer, Rutschky valorizes the cinema as an existential sanctuary where one can "take in everything without being expected to interpret, judge, and act. One might call it a utopia for sensory experience."

HUNGER FOR EXPERIENCE, SPECTATORSHIP, AND THE SEVENTIES

I.

During the seventies, Siegfried Kracauer's work on film had a strong reso-
nance in the Federal Republic of Germany (FRG); indeed, it exercised
a marked influence on the decade's film culture. A central notion from
his *Theory of Film* (1960), "hunger for experience," became the impetus
for the most compelling depiction of leftist subjectivity in West Germany
during the post-1968 epoch, Michael Rutschky's as yet untranslated
monograph, *Erfahrungshunger: Ein Essay über die siebziger Jahre* (1980).[1]
In Anglo-American circles, by comparison, Kracauer barely figured in the
seminal exchanges of the so-called Screen Studies era. At best *Theory of
Film* gained scholarly attention as a belated contribution to classical film
theory. In the main, however, Kracauer (even more so than André Bazin)[2]
functioned either as a convenient strawman for eschewers of a naïve real-
ism or, as the author of *From Caligari to Hitler*, a popular target for oppo-
nents of a reductive sociological film historiography.

How are we to understand this disparity of reception? One might
simply write off the enthusiasm for Kracauer in the FRG as an anomaly
or an anachronism, a function of the underdeveloped state of discourse
about film in postwar Germany (both East and West), where well into
the eighties, most significant sustained discussion about the medium took

place in journalistic venues.[3] Through the seventies, academic film studies remained virtually nonexistent on West German campuses; likewise, there was a conspicuous lack of significant film theorizing.[4] One might well be tempted to surmise that this surprising regard for Kracauer came from the New Left with its penchant for ideological criticism, especially when we bear in mind the renewed significance of the Frankfurt School's media theory for the student movement. As stated, however, it was *Theory of Film* and not the exemplar of symptomatic analysis, *From Caligari to Hitler*, that would play the more significant role in the FRG during the seventies.

The following observations elaborate how and why Kracauer appealed so vividly to post-68 sensibilities in the Federal Republic and explain how *Theory of Film*, in this specific national and temporal context, came to take on meanings unknown to and unappreciated by Anglo-American film theorists.

II.

In North American film studies, until the mid-eighties, Kracauer had a generally contested and largely diminished status; his work was far more often referred to than relied on. In fact, with the exception of the translation of his essay, "Das Ornament der Masse," in the spring 1975 issue of *New German Critique*,[5] knowledge of his writings on film derived chiefly from the two lengthy studies that bore the marks of exile and, as books, reflected organizational frameworks much different from Kracauer's journalistic entries of the twenties and thirties.[6] *From Caligari to Hitler*,[7] in the age of the New Film History, of sophisticated notions of cinema's constitution by complex constellations of institutional, social, and aesthetic forces,[8] seemed hopelessly insufficient and, in some minds, altogether spurious in its attempt to demonstrate how a national cinema mirrors and prefigures a national destiny. The films of the Weimar Republic, at least the ones selected by Kracauer, become a preview of coming fascist attractions. The book, claimed the positivist Barry Salt, not mincing his words in the least, "is a strong runner in two crowded competitions: for the most worthless work of 'cultural criticism' ever written, and for the worst piece

FIGURE 2.2 (*left*) The axiom of *From Caligari to Hitler*, "seeing feature films as the privileged expression of a society, shaped our film criticism in the fifties and sixties, including, with good reason, the *Autorenfilm*" (Volker Schlöndorff).

FIGURE 2.3 (*right*) The cover of the 1979 German edition of *From Caligari to Hitler*: The study at long last appeared in a complete and politically unexpurgated version, overseen and translated by Karsten Witte.

of film history."[9] Even though commentators regularly rejected the volume's premises and faulted both its essentialism and its teleology, *From Caligari to Hitler* would figure strongly in refining notions of the collective character of a national cinema, for instance, in the work of Philip Rosen, Patrice Petro, and Thomas Elsaesser.[10] For all its faults, argues the latter, the study constitutes "the most thorough attempt at outlining the historical determinants of a body of films whose common denominator is neither author nor genre but a historical period."[11]

Theory of Film, to put it mildly, did not fare as well. It was assailed by a host of commentators, ranging from scathing reviews by film critics like Pauline Kael to less invective, but equally dismissive, appraisals by such scholars as Peter Harcourt, Richard Corliss, Andrew Tudor, Dudley Andrew, and, more recently, Noël Carroll and Malcolm Turvey.[12] Kracauer came under attack for his painstaking (and, in numerous minds, pedantic) insistence on film's calling as a reflector and redeemer of a poorly defined, indeed amorphous, reality. Castigated because of its overwhelming drive for system and its bland universalism, *Theory of Film* was seen as monomaniacal, willful, and at times risible[13]; the author's fanatic stress on mimesis, according to Tudor, "shows us some of the strange places to which the realist aesthetic can lead."[14] For Carroll, the study may well appear to have a clear structure, but its argument, upon closer examination, is muddled and confusing. In fact, "the book as a whole has a very ad hoc flavor to it."[15] In a sarcastic and dismissive play on Kracauer's valorization of the incidental and the inanimate, Kael quips, "How can you build an *aesthetic* on *accident*—on the *ripple of the leaves*?"[16] West German respondents of the seventies, as we shall see, would do just that.

III.

The history of discourse about cinema in the FRG, one might argue, has to a great extent depended on which of Kracauer's two film books was privileged. If *From Caligari to Hitler* influenced much writing about film from the late fifties through the late sixties, it would be *Theory of Film* that had the stronger impact in the next decade. The most noteworthy West German film journals of the sixties (*Filmkritik, Film,* and *Filmstudio*) consciously deferred to and sought to continue Kracauer's critical project, i.e., to illuminate the ideological contents and social meanings of contemporary film production.[17] Although commentators paid lip service to the importance of formal concerns, their actual critical praxis remained exceedingly content-bound, so much so that Kracauer, in an otherwise-supportive letter of March 1956 to the editors of *film 56*, a forerunner of *Filmkritik*, suggested that its young writers would do well to expand their focus: "I believe that this sociological approach to film production is most

necessary; nonetheless, I would be happier if in the future you would be more systematic about seeking out what is socially and politically false in the aesthetic realm as well. At present it seems to me as if you are being too one-sided in your emphasis on manifest content."[18]

Enno Patalas's and Wilfried Berghahn's programmatic essay of 1961, "Gibt es eine linke Kritik?" encapsulates Kracauer's impetus; the authors cite *From Caligari to Hitler* as *Filmkritik*'s decisive critical role model. Contrasting an old school of culinary film appreciation (e.g., Gunter Groll, Karl Korn, and Friedrich Luft) with a progressive new criticism, the editors of *Filmkritik* privileged an approach more interested in social content than aesthetic form, even if they considered form to be a part of the content. The critic should seek to comprehend the audience and its wishes, especially because the spectator had heretofore remained underappreciated. The new criticism "searches for unspecific, latent messages," "reveals the predilections of the director," "hopes for a socially responsible film," "pays attention to production-related concerns," and "criticizes the society that produces certain films."[19] Patalas would nuance this initiative in his "Plädoyer für eine ästhetische Linke" of July 1966. There he called for a film criticism that is more sensitive to structures and processes, that equally takes into account a work's ideological inscriptions as well as its formal dimensions. Sociological criticism, he maintains, should understand "aesthetic operations as social activities" and "activate aesthetic behavior."[20] The problem of Kracauer's symptomatic approach, argued Helmut Färber in the April 1967 issue of *Filmkritik*, was that it concentrated on the *Zeitgeist* of a film without adequately comprehending its *Geist*.[21] Frieda Grafe's essay of 1970, "Doktor Caligari against Doktor Kracauer" represented, as the polemic title suggests, a further challenge to the realistic-sociological school of film criticism in West Germany.[22]

The tension on the editorial board of *Filmkritik* between political leftists and aesthetic leftists ultimately would lead to a showdown and the subsequent resignation of the political wing in the spring of 1969.[23] Looking through the pages of the journal from the late sixties and early seventies, one finds a marked shift of paradigms, a new penchant for ardent effusions that focus on the subjective dimension of the experience in the dark, a descriptive rather than prescriptive impetus, a preference for fragmentary observations and aphoristic willfulness, a tendency to be less concerned

with the whole of films than privileged moments, and, in keeping with Susan Sontag's exemplary essay of 1964, a turn "against interpretation" because it compromises rather than enhances aesthetic response.[24]

The new editorial collective of *Filmkritik* distanced itself from the ideological emphases of *From Caligari to Hitler*; critics like Wim Wenders, Gerhard Theuring, Klaus Bädekerl, Wolf-Eckart Bühler, and Siegfried Schober were referred to as *Sensibilisten*.[25] As exponents of a private and personal relationship to the film experience, authors fond of saying "I,"[26] they discovered dimensions of meaning in *Theory of Film* that surely had not been appreciated by the book's initial commentators.[27] Indeed, what Kracauer articulated as well as catalyzed was a unique mode of cinephilia. When the study's German translation appeared in 1964,[28] reviewers were surprised that it had so little in common with the Weimar essays that had been reissued in 1963 under the title, *Das Ornament der Masse*.[29] Where, reviewers wondered, was the critique of distraction and the Culture Industry? Why was there not a single mention of Adorno or *The Dialectic of the Enlightenment*? Why would such an otherwise-incisive social critic insist on divesting objects of their historical status and shrouding them in an undialectical, whimsical, and even mystical idealism? As Helmut Lethen observed, *Theory of Film* seemed to provide little intellectual sustenance for readers of the mid-sixties with progressive agendas.[30]

The appropriation of Kracauer by the Munich sensibilists was decidedly selective. They drew on bits and pieces of *Theory of Film*; the whole of the work and its overarching realist argument rarely came under discussion. In that regard, their response provides support for Miriam Hansen's later claim that Kracauer had not written a comprehensive theory of film, but rather "a theory of a particular kind of film experience."[31] Wim Wenders, inspired by *Theory of Film*'s idiosyncratic cinephilia, repeatedly finds himself thunderstruck by images that bring him closer to the concrete world. Kracauer, writes Wenders, "spoke of film as the 'redemption of physical reality,' meaning the tenderness that cinema can show towards reality. Westerns have often brought out this tenderness in a dreamily beautiful and quiet way . . . In their images they spread out a surface that was nothing else but what you could see."[32] Tenderness, in fact, is not a word that Kracauer uses. Rather, he speaks of a restraint that allows images to maintain their integrity and not be forced into a narrative

corset. "There are moments in films," Wenders notes in June 1970, "that are suddenly so unexpectedly direct and overwhelmingly concrete that you hold your breath or sit up straight or put your hand on your mouth." He goes on to provide an inventory of privileged moments from a variety of films, strikingly concrete images from selected features, shots in which an initial perception gives way to a play of affect: "Suddenly there's nothing more to describe, something's become all too clear and leapt out of the picture, become a feeling, a memory . . . For a moment the film was a smell, a taste in the mouth, a tingle in the hands, a draught felt through a wet shirt, a children's book that you haven't seen since you were five years old, a blink of the eye."[33]

Or take, to use a final example, Wenders's 1969 notice on the experimental film *Kelek* (1968). The review begins: "A film by Werner Nekes and by everyone who has seen it so far," linking the film on the screen to the spectator's mental screen. Wenders praises the work whose subject is seeing itself. The film is self-apparent and utterly direct, so much so that "[f]ilm critics will lose their jobs. They won't need to go to the cinema anymore. All that will be left for them to do is go for strolls in the park, look at their toes, or at manhole covers as they walk along, have it off, and when they turn into suburban streets, slowly open and shut their eyes." *Kelek*, claims Wenders, "works on only one level, the level of seeing." It is, in that regard, "an incredibly physical affair." The piece ends with a quote from *Theory of Film*: "All this means that films cling to the surface of things . . . Perhaps the way today leads from, and through, the corporeal to the subjective?"[34]

These rhapsodic sensibilists with their fetishistic embrace of haptic details and found objects by and large remained on the margins of intellectual discussion during the late sixties. As one might imagine, they came under frequent attack for their candid displays of personal preference and their immodest willingness to give voice to what they saw and felt in the dark. In the June 1968 issue of *Film*, Klaus Kreimeier assailed the sensibilists as denizens of "a murky realm with an increasingly complicated and increasingly dead-ended subjectivity." They may call themselves nonconformists, but they are in truth reactionaries; they claim to be in touch with images and things, but in fact they are out of touch with reality.[35] To fixate on films as unique experiences, according to the sensibilists' detractors,

was to take things out of context. "The internalizing and totalizing of individual films," writes Heinz Ungureit in May 1969, divests them of their social determinations. All that remains is "the solitary film, the solitary image, the solitary director."[36]

IV.

In the wake of the failed student revolt of 1967 and 1968, even leftist commentators in West Germany would come to suspect that discourses that ruled out the subjective factor and the power of feelings might well be the function of authoritarian personalities. Unlike the intellectual activists who promulgated conceptual frameworks that could account for social reality in its totality, the sensibilists favored single moments and a selective attention, aiming to escape theoretical cubbyholes that for them remained abstract constructions devoid of experiential immediacy. They went to the movies to see and not to cerebrate, to discover the visual presence of the physical world far away from words and the dimension of verbal meanings. Like Kracauer's eccentric spectator of *Theory of Film*, what they sought in cinema was "perception, experience, contemplation—not interpretation."[37]

Michael Rutschky's *Erfahrungshunger* explicitly acknowledged Kracauer's pertinence for a larger understanding of culture in the FRG after 1968. Describing the widespread disaffection that attended the demise of the student movement, Rutschky saw a collective shift from a will to enact theoretical constructs to a desire to remain undefined by social mechanisms. With the melancholy resulting from the collapse of a leftist public sphere came a retreat into a lonely subjectivism. If anything, this new sensibility (which was referred to at the time, often disparagingly, as the "Neue Innerlichkeit" or the "Neue Subjektivität") was out of touch with everything and everyone. The cinema, in this context, provided a welcome refuge from a threatening material world, where objects, otherwise functionalized and commodified, gained new immediacy and tangibility, where one, in general, could breathe more easily. In the dark, one experiences a dreamlike fascination while enjoying the intensity of isolated images: The corporeal world comes alive, freed from

the conditioning forces that structure the everyday, liberated from the discursive frameworks that bind certain signs to particular associations, redeemed in that it comes to be felt and experienced in all its sensual richness. In the cinema, the world stops making sense and in that way takes on new meanings, meanings Kracauer had appreciated and elaborated in his *Theory of Film*.[38]

The most crucial notion that Rutschky took from *Theory of Film* derived from Kracauer's comments on spectatorship, especially the emphasis on a disengaged specularity, a response that seeks sensuality ("Sinnlichkeit") rather than sense ("Sinn"), a gaze more concerned with haptic stimulation and tactile frisson than conceptual understanding. In chapter 9 of his book, Kracauer refers to Hugo von Hofmannsthal's essay of 1921, "The Substitute for Dreams,"[39] a piece describing the working class's escape to the movies and its search there for a fuller "life in its inexhaustibility which the cinema offers to masses in want of it."[40] Urban dwellers of modernity are out of touch with the "breathing world" around them, "that stream of things and events which . . . would render . . . existence more exciting and significant."[41]

Common to von Hofmannsthal's essay, Kracauer's book, and the new subjectivity of the seventies in general, according to Rutschky, was an all-consuming hunger for experience, the recognition that the modern world has become impossibly abstract and complex, beyond all synthesis and simplification. Cinema affords compensations not found otherwise; there one can fill one's shrinking self with images of life as such. "Material existence, as it manifests itself in film, launches the moviegoer into unending pursuits"[42] that go in two directions, into the image or away from it. On the one hand, we have self-abandonment; on the other, self-absorption. In this way, films catalyze two types of dreaming, one that brings the spectator into the image in a contemplative embrace; another whose sights and sounds fuel the spectator's imagination, spurring associations and stimulating the memory.

Kracauer's mobile spectator either moves into the image or away from it, losing oneself in the diegesis or using the flow of images as a catalyst for one's own reveries. The choice between radical identification and willful free association in fact corresponded to the preferred subject effects of the two dominant paradigms in New German films of the seventies.

On the one hand, we have filmmakers who allowed viewers a contemplative immersion in the image, directors whose mise-en-scène privileged the long take and called on the spectator to inhabit and explore the frame space. Obvious examples in this vein are Wenders, Werner Herzog, Jean-Marie Straub and Danièle Huillet, Rudolf Thome, Herbert Achternbusch, and Werner Schroeter. On the other hand, there were those directors whose montage-driven films sought to spark spectators' memories and spur their imaginations, filmmakers like Alexander Kluge, Helke Sander, Edgar Reitz, and Hans Jürgen Syberberg. Here the single shot enjoys a less privileged status; instead the stress lies on chains of images, a collage-like construction, a notion of film as a marketplace of competing discourses in which the spectator is free to pick and choose as he or she will and create his or her own *Zusammenhang*. Film narratives are not simply limited to captivating us by dint of their suspense, discomfort, and danger. They promote other responses as well: waiting, wandering, hanging out, killing time, being silly.

West German appropriators thus discovered meanings in *Theory of Film* altogether at odds with the dismissive responses it received in Anglo-American circles. As Rutschky puts it: "We found in the details many single observations whose incisiveness would not become clear until the seventies."[43] As one can see, readers like Rutschky drew on bits and pieces of the book and did not consider the whole—and it had been precisely the study's perceived claim to being systematic that would irritate so many American commentators. Clearly, reception history has much to tell us about film theory, about the historical status of certain texts in particular national and temporal constellations, i.e., within concrete expectation horizons. *Theory of Film* valorizes a mode of spectatorship far more dynamic than Anglo-American critics, until quite recently, had been willing to allow, a mode that for this reason had a remarkable resonance among many West German spectators in the seventies.

V.

The afterlife of sensibilism is a curious tale. This discourse of evocative description and passionate appreciation, with a variety of registers, came to dominate the reconstituted new *Filmkritik* throughout the seventies

and into the eighties. Its authors, in the words of Olaf Möller, "rarely used purely evaluative words for films by those they loved, esteemed and honoured. Instead a scene is described for pages on end, very carefully, with each word scrupulously weighed up against its implications, its resonance, its role in the logic and the poetry of the sentence and the text."[44] Creating essayistic webs and intertextual networks, by turns elegant and exhilarating, contributors found unique routes of access to privileged filmmakers, directors above all who do not impose a worldview on their spectators, among others, people like Straub, Roberto Rossellini, Jean Renoir, John Ford, Jean Grémillon, and Max Ophüls. These directors do not, as Möller puts it, "hit you on the head with their visions, leave you lying paralysed ready for a serious brainwash; rather, they approach the world, describe it."[45] In the process, to be sure, the journal paid little attention to contemporary films and current events; perhaps as a result, its readership dwindled radically until publication finally ceased in 1984. To this day, nonetheless, many cinephiles in Germany hold the whimsical and epiphanous pages of the new *Filmkritik* in high esteem as a rich haven of impetus and inspiration.

Sensibilism would take a different course elsewhere in the FRG and have a more lasting (and problematic) impact on a host of regional and urban program guides read by a large young alternative culture. This so-called open form of writing found its acme in the periodical *Filme*, which programmatically espoused a descriptive mode of highly personalized appreciation and became well known for its aphoristic reminiscences of experiences in the dark.[46] As one of the journal's editors, Norbert Jochum, puts it: "For me a review is not so much a matter of how a critic interprets a given film, but rather what he has seen. . . . Film criticism doesn't mean writing down what I know, but rather expressing one's thoughts about a film; this is a process that does not necessarily lead to a conclusion that explains everything."[47] Coeditor Norbert Grob insisted that single moments are much more important than films as a whole. Analysis, he maintained, can potentially destroy the aesthetic power of a film. A film critic is not a judge, but rather an observer and, in that capacity, a stand-in for other viewers. As a critic, Grob simply wants to write about what he sees and feels when he watches a film. In this way, writing becomes the means by which he gives voice to his experience as a spectator.[48]

Over time, this subjectivism would in some quarters assume manneristic contours and even narcissistic extremes. Some of its practitioners would go on to occupy influential positions at such mainstream news organs as *Die Zeit*, the *Süddeutsche Zeitung*, and the *Frankfurter Allgemeine*. The initial cinephilia with its heightened sensitivity to cinema's play of signs and its remarkable meaning potential would give way to an anti-intellectual hedonism that, as in a review by Claudius Seidl, saw filmgoing as a thought-free experience, suggesting that we go to the movies to celebrate and not cerebrate: "Let's just forget art! Let's forget all the clever palaver and socially critical relevance. Instead let us go into ourselves and consider what really is important to us about the cinema! Right: it is feelings, that is to say, our own. And these have nothing to do with whether a film is particularly intellectual or whether a script corresponds to reality. They only attach themselves to moments on the screen which allow us to confront our own dreams. *Tequila Sunrise* is full of such moments."[49]

This dandyistic and showoffish self-indulgence, as Karsten Witte complains, foregrounds the reviewer's emotional constitution and affective predilection.[50] Such lyrical flights of fancy resemble postcards from Poona, quips Joe Hembus in response to a particularly ripe example of the so-called open writing from the pages of *Filme*: "That this scene contains nothing beyond itself: and itself before it came into being: and, in this way, refers to nothing beyond itself, and yet refers to all kinds of things: so that all kinds of things become possible."[51] We are not far from the kind of feuilletonistic preciousness and pretentiousness once so ardently assailed by the editors of *Filmkritik*.

Rutschky's *Erfahrungshunger* and the Munich sensibilists returned to *Theory of Film* and found thoughts that resonated strongly; these appropriations, to be sure, employed a jargon of authenticity decidedly out of keeping with Kracauer's work.[52] The radical solipsism that came in their wake, the onanistic excesses of critics like Seidl, and the precious effusions in journals like *Filme* would be a far cry from the poignant search for concreteness that Kracauer had in mind, his whimsical cinephilia that embraced random encounters and celebrated fleeting images, that praised films' potential to reenchant reality and, at least for moments, make the viewer feel in touch with—and at home in—the world. Revisiting the singular and nonsynchronous West German reception of Kracauer's

monograph, we can now say with the advantage of hindsight, allows a suggestive preview of coming attractions as we partake of recent scholarship that offers a fuller appreciation of Kracauer's redemptive resolve and his insight into the invigorating potential of the cinematic experience. *Theory of Film*, Vivian Sobchack argues, "located the uniqueness of cinema in the medium's essential ability to stimulate us physiologically and sensually; thus he understands the spectator as a 'corporeal-material being,' a 'human being with skin and hair.'"[53] Kracauer's once-so-maligned and misapprehended monograph has in the meanwhile received more discerning and productive readings by film scholars, especially by Heide Schlüpmann and Miriam Hansen, contributions that in a variety of ways help us at long last to fathom the book's historical dimensions as well as its redemptive designs.[54]

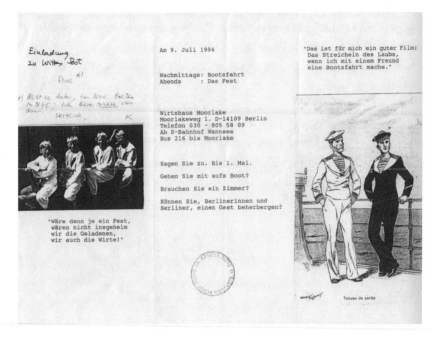

FIGURE 3.1 An invitation to a boat trip celebrating Karsten Witte's fiftieth birthday on July 9, 1994, a little more than a year before his untimely death. His handwritten note inquires about a symposium on Nazi cinema cosponsored by the Goethe Institute in New York to be held that fall at Lincoln Center: "Is it still on, in November Goethe in NYC; I hear *nothing* from them."

THE PASSENGER AND THE CRITICAL CRITIC

I.

For Karsten Witte the passenger was a dynamic figure, "a person between stations, for whom time and space constituted sites of transit."[1] Himself a passenger who shifted with ease and enthusiasm between languages, discourses, and cultures, Witte relished the experience of the unfamiliar and the foreign. It was indeed central to his own expansive sense of person and place. He liked living in Berlin and few of his contemporaries knew the surface manifestations and subterranean reaches of that metropolis as well as he did. Following significant formative years in Frankfurt, the German capital would become Witte's domicile of choice. It represented less a home than a fixed address, a base of operations as well as a point of departure for a life that considered the liminal and the extraterritorial to be special (albeit precarious) states of being.[2] If there is a memory image that captures the presence of this flaneur in motion, it is an on-the-fly snapshot that shows him exiting the Bovril, a restaurant on the Kurfürstendamm, bespectacled and clad in a natty dark overcoat, descending the stairs, heading for the sidewalk while musing over a book.[3]

An intensely private person, Karsten Witte was also a public intellectual long before the term had become fashionable. Highly visible, he had an inimitable style when delivering a talk, moderating a panel, or conducting a seminar: unfailingly polite and by turns patient, ironic, and mercurial,

he was a commanding and most articulate speaker who, even in the case of passionate intellectual differences, remained respectful and attentive to his interlocutors. He was certain to become testy with displays of sloppiness and imprecision, if someone, for instance, identified Helmut Käutner (instead of Wolfgang Liebeneiner) as the director of *Großstadtmelodie* (*Big City Melody*, 1943) or if a reviewer confused Hans Richter, the avantgarde filmmaker, with Hans Richter, the author of *Der Spielfilm* (1920). I remember the strained look on his face when I once asked him if *An Ideal Husband* would be the correct translation for *Der Mustergatte*. The Heinz Rühmann vehicle of 1937 directed by Wolfgang Liebeneiner, he assured me, derived from Avery Hopwood's play *Fair and Warmer* (1919) and had nothing to do with Oscar Wilde; I would be better off using *The Model Husband* to avoid any confusion. This was not pedantry, but rather a function of both a historical sensitivity and a professional ethos.

Karsten Witte had little patience for people who embraced film theory and eschewed the cinema, whose investment in film reflected little regard for or acquaintance with films. How could someone possibly dare to write a book about Nazi cinema, much less claim to be a specialist on the subject, he once mused, if one had seen less than one hundred of the era's features? He was equally disconcerted by cinephiles who rhapsodized about tracking shots and close-ups while bracketing off the historical moments that framed such aesthetic touches. At a conference, he once protested that a paper on *Deutschland im Herbst* (*Germany in Autumn*, 1978), for all the sophistication of its discourse analysis, had ignored the social and political state of emergency that had catalyzed the film's production. Critics, he submitted, need to partake of history rather than to write it off ("Geschichte wahrzunehmen statt wegzuschreiben").[4] As an exemplar of what Karl Jaspers called "intellectual communicability," Witte did not shy away from controversies and confrontations. He was fond of the French addage, "On ne fait pas d'omelette sans casser des oeufs." And, as his many interventions, polemics, and letters to editors or authors bear out, he certainly was quite fond of omelettes.[5]

Even in the heat of a combative moment, he remained a master of form and mise-en-scène, an individual with impeccable manners and nuanced social skills, both a lively conversationalist and a painstaking listener.[6] In so many ways a nonsynchronous spirit, he never really figured out how to program his video recorder and did not start using a computer until very late in

life. He usually wrote with an ink pen or a manual typewriter and maintained a voluminous correspondence. Messages to friends and colleagues, more often than not, were accompanied by a gathering of personalized *trouvailles*. Postcards from Witte would arrive out of the blue from a foreign city where he had come across a quote or an image that recalled a passing remark the recipient might have made in a casual conversation several years ago.

While ever current and well informed, Witte possessed the broad and substantial intellectual background of a *Bildungsbürger*. He had a wide-ranging knowledge of music, opera, and ballet, of art history and architecture; he could speak eloquently about the history of the European theater or in great detail about recent stage productions in Milan, Paris, and Munich. Among his many translations, marked by elegance and precision, are texts by Marcel Proust, Siegfried Kracauer, Jean Cocteau, Marguerite Duras, Christopher Isherwood, and Pier Paolo Pasolini. He had few German peers in matters of Italian literature and Japanese cinema. And no film critic in the Federal Republic matched Witte's familiarity with African culture. (Only Frieda Grafe rivaled Witte's cultivation of gourmet cooking and foreign cuisine.) Critics, he once noted, should see themselves as historians of expressive forms in the widest sense. For that reason, they would do well to develop "a radically promiscuous interest in the other arts."[7] Graced with a keen visual sensitivity, Witte likewise had an acute regard for the aural dimension of cinema. Films make sense; they also appeal to the senses. The title of his collected film criticism promises the reader "texts about seeing and hearing" and candidly admits to his "penchant for going off the beaten track" ("eine Vorliebe zum Abseitigen").[8]

If Witte was a passenger, he was a traveler, not a tourist. His approach to film history was neither that of the colonializer out to conquer all territory nor that of the whimsical gadabout. To traverse cinema's vast field of topographies was to submit himself to excursions and explorations in time and space, and, in that way, to intensify his thoughts and feelings. "The long-term confrontation with alterity," he observed, "can develop an awareness of difference, an expanded imagination, a larger sense of the world."[9] He drew attention to marginalized cinemas, obscured subcultures (not one to hide his homosexuality, he often wrote about gay films and queer filmmakers), old movies, difficult directors (Robert Bresson, Jean-Marie Straub and Danièle Huillet, and Nagisa Oshima were particularly

dear to his heart), inviting his colleagues and readers to transgress borders by opening up their persons to encounters with the unfamiliar. To seek identity in the other and to find it in alterity, as he put it, did not mean a cushioned communion with the exotic, but rather the prospect of meetings that might well yield unsettling and disturbing perspectives, the very means by which one might "unthink" Eurocentrism by becoming mindful of its aporias and blind spots.

II.

As a film historian and critic, Karsten Witte profited from his background in philosophy and his knowledge of intellectual history. On occasion, he took his cue from theory, but he never let it guide him.[10] To be sure, he openly acknowledged his indebtedness to the ABK of German film theory (i.e., Rudolf Arnheim, Béla Balázs, and Siegfried Kracauer), lauding them for their pioneering initiatives in the development of a material aesthetics of the cinema.[11] Arnheim fostered a respect for aesthetic forms and artistic shapes; Balázs elaborated on the expressive power of physiognomies, be they of people or landscapes. It was Kracauer, however, whose writings Witte edited and whose *From Caligari to Hitler* he translated into German, who remained the author's most influential teacher: "I sharpened my critical skills by reading the diverse, and in many cases all but unknown, writings of Siegfried Kracauer. This author's exemplary work taught me always to think of any form of politics as a politics of form. In this way one more easily can liberate oneself from the object under discussion, much less from the methods that are considered to be fashionable and obligatory."[12]

He often cited Kracauer's description of the film critic's calling as that of the social critic who ferrets out the hidden agendas and ideologies in mainstream productions. Good criticism for Witte was tantamount to a dynamic act of translation. One registered what a film had to offer, explained how what one has partaken of was put together, and commented on the logic behind this construction, identifying latent energies and juxtaposing them with intended meanings. Films provide a means to produce critique and to engage in a constant commentary and exploration of the everyday.[13]

Witte, along with his former colleagues at the *Frankfurter Rundschau,* Wolfram Schütte and Gertrud Koch, was derided by younger journalists as a "critical critic," i.e., as an ideological exegete and a symptomatic reader, the product of Frankfurt and its legacy of Critical Theory, of Kracauer, Theodor W. Adorno, and Jürgen Habermas, of the acute dialectical sensitivity that grew out of Manhattan am Main's uneasy coexistence of international capital, Allied occupation, and alternative culture. "Our critical critics, students of the Frankfurt School and their brothers and sisters in arms," in Claudius Seidl's unfriendly assessment, "are always demanding the same thing: enlightenment. They demand enlightenment from films and the goal of their criticism must naturally also be enlightenment." Critical critics, in this view, do not take films seriously except as social phenomena:

> The critical critic mistrusts his eyes and first of all consults his books. There he finds all kinds of information, about political, economic, and who-knows-what-all determinants. Finally he gets around to asking how a film relates to these realities, realities that the critical critic has learned about from books. Not until then does he bother to ask *what* the film actually does. In actual fact the critical critic is an expert on realities of all sorts—and only in that way an expert on film.[14]

Seidl's exercise in bombast and name-calling was definitely snide and snarky, but it was neither incisive or persuasive, much less original. More than a decade earlier, Klaus Eder had chided Witte and Koch for their reliance on Critical Theory and their use of films "as nothing more than links in a chain of argument which has a larger purpose." Why not grant film its own autonomy and allow it to function as film? Because, Koch had retorted in 1978, we do not check our minds at the snack bar before we sit down at the cinema. Those critics who only have film in their heads will never appreciate, much less understand, the complex constitution and syncretic character of the film experience.[15]

For Witte, Seidl and his cohorts were smug "ego-agents" whose fondest assets were a marketable style, a fashionable anti-intellectualism, and a rarified visual connoisseurship. Critics of this persuasion do not seek to mediate between films and spectators, but rather to make themselves the center of attention by casting their written performance as the main attraction.

These young critics record, but do not reflect on, their emotional encounters in the dark and their affective relations to the screen. They fixate first and foremost on what Henri Bergson calls the "données immédiates" and rarely get any further. Their solipsism does not open them to anything but a very limited possibility, of perspectives and of films, especially those made in Hollywood. Under the aegis of such film critics writing in city magazines and in the culture pages of prominent weekly and daily newspapers, competing discourses have been superseded by discourses of consensus; in the process, critical criticism gave way to trendy and affirmative tastemaking.

Seidl's assertions that "films have no history" and that 1939 was the year of American cinema, provoked, as one might expect, Witte's strong displeasure.[16] Film history, just like film criticism and theory, Witte submitted, needs to have its own memory, and that memory has to be mindful not only of films but of history at large as well as previous film historiography. Witte well recognized the limits of film histories organized along narrowly national lines. When writing on Nazi cinema, he insisted that one not talk about fascist film as some sort of ideal type, but rather consider films under various fascisms, to pursue comparative studies of productions of the late thirties and forties from Germany, the Soviet Union, Italy, Spain, and Japan, to think about the different ways in which a world at war rendered the cinema an ideological state apparatus, not only under Hitler and Stalin, but also under Roosevelt and Churchill. Film history, he believed, emulates literary criticism to its disadvantage in its insistence on directors as authors. It would do well to deauthorize itself and to examine films as documents bound up in political and aesthetic configurations. One needs not just to provide historical overviews but to look carefully at the miniscule details of aesthetic manifestations.[17]

Speaking polemically, Witte once proclaimed that there is no film history. There is a production history and there are films. One can research, describe, and review the history of productions, but films resist such a historicizing form of reception. To talk about film history means to engage in time travel, to visit the past with the interests and insights of the present. Place entered into the discussion as well, for the initial production of films more often than not ensues in a national context. This is not necessarily the case, however, with the second production, that of audiences, exhibitors, and distributors. For the spectator, film history assumes a form of presence,

of "Jetztzeit"; every retrospective in that sense becomes a revival, the rebirth of myths that only seem to be dead. Filmic sights and sounds provide a lasting archive of modernity; they belong to what Witte considered to be the collective memory of an imaginary museum.

Hertha Thiele's puzzled response to public screenings of Slatan Dudow's *Kuhle Wampe* (1932) and Carl Froelich's *Der Choral von Leuthen* (*The Chorus of Leuthen*, 1933) in the Berlin Arsenal during a series on "Prussia in Film," her claim that the two late Weimar features had nothing in common, gave rise to Witte's concern and consternation: "How might one best explain to her that the antagonism of unreconcilable film artifacts can in fact produce historical insights?"[18] It was this impetus that made him such an intriguing and suggestive commentator on Nazi cinema, surely to this day film history's most unreconciled legacy. His forays into the "film critic's purgatory" (Wilhelm Roth)[19] granted him an awareness of the inextricable links between its innocuous facade and its regressive potential, its public appeal and its political function. In his numerous entries on the subject over two-and-a-half decades, he endeavored to show how legitimate dreams and utopian energies become the substance of other-directed fantasies and murderous designs. The films of the Third Reich were often popular and, in this respect, have "outlived the Nazi system as traces of a collective memory, leaving emotions with far-reaching and lasting repercussions in their wake." Not every film made under Goebbels, Witte maintained, was automatically a Nazi film, but neither was every banned film an exemplar of aesthetic opposition. Recent revisionists who tease out instances of "resistant discourse" or "reflexive space," who reclaim Veit Harlan or Wolfgang Liebeneiner as masters of the melodrama, will find little confirmation in Witte's work: "No Wysbar, Sierck, Tourjansky, Hochbaum, Pewas, or Käutner will ever keep Steinhoff, Riefenstahl, Ucicky, Ritter, or Harlan in the shadows. This infamous legacy is not divisible."[20]

Nazi cinema represented for Karsten Witte an entity that one could not deal with piecemeal. One either understood it as a functional whole (however complex, contradictory, and convoluted) or one misapprehended it altogether. As a passenger, Witte certainly did not think of his excursions through Nazi cinema as pleasure cruises. This critical critic's journeys remain so invigorating and incisive because, for all their microscopic detail and formal precision, they always are mindful of the larger picture.

FIGURE 4.1 In the wake of Rainer Werner Fassbinder's tribute to Douglas Sirk, melodramas like *Written on the Wind* (1956) generated great enthusiasm among West German cinephiles, as a special issue of *Filmkritik* attests.

4

THE LIMITS OF AESTHETIC RESISTANCE

I.

The story of Douglas Sirk's[1] belated rise to international acclaim in the seventies is well known: a German reemigrant, whose Ufa films of the thirties and exile work had been all but forgotten, his subsequent endeavors with Universal Studios during the fifties largely dismissed as soap operas and star vehicles, within a very short period reemerged as a legendary figure, the focus of lively exchanges for cinephiles and film scholars. Retrospectives of his work accompanied by interviews with cineastes returned a forsaken corpus to the public light. Festival screenings, tributes in film journals, and academic treatises, transformed this obscured figure into a master auteur.

Sirk's reemergence exerted a strong influence on discussions about:

- Authorship and authorial resistance to the ideological determinations of Hollywood and the studio system;
- The subversive possibilities of industrialized mass culture;
- The political potential of generic pleasure;
- The critical or the resistant text;

- Notions of genre, especially melodrama and, more specifically, feminist explorations of the women's film; and
- The international discovery and subsequent valorization of the New German Cinema.

Among British, American, and French enthusiasts, there were only modest variances of opinion. Even when differing about what was most significant in Sirk's work, there was little question about the fact of its importance. Merging continental *esprit* and Hollywood professionalism, it was said, he managed to function within the dominant cinema and follow generic convention while nonetheless crafting incisive social critiques; his nimble direction worked against and undermined the most tendentious and conventional plot lines.[2] Curiously and consistently, when valorizing his early features in Germany, his adherents tended to understate or disavow Sirk's German heritage. Commentators typically (and wrongly) spoke of him as a Dane—even Rainer Werner Fassbinder, who observed how Sirk had grown up in Denmark under the influence of Nordic films and Asta Nielsen.[3] For the most part, Sirk was seen as a representative of Weimar culture and an emigrant from Germany, the stress lying on his cosmopolitan sensibility and his liminal status, on a Germanness that had nothing in common with the Nazi Germany in which he had made seven features as well as three shorts and that had everything to do with a subversive will that could manifest itself despite the ministrations of Goebbels and his minions.

II.

The cult of Sirk took initial shape in France. During the late fifties, a number of notices appeared in *Cahiers du Cinéma*, which praised Sirk's work, above all its formal properties. François Truffaut lauded the expressive use of color in *Written on the Wind* (1956)[4]; in a review of *A Time to Love and a Time to Die* (1958) from April 1959, Jean-Luc Godard found himself enchanted by the director's logic of delirium, his "mixture of medieval and modern, sentimentality and subtlety, tame compositions and frenzied CinemaScope."[5] Throughout the sixties,

Sirk's confident mise-en-scène and his studied self-reflexivity received acknowledgment by French cinephiles. The "boom period" for Sirk, however, came about in Great Britain during the early seventies. Its highlights included a special issue of *Screen*; the book publication of Jon Halliday's career interview; retrospectives at the National Film Theatre and the Edinburgh Film Festival, the latter accompanied by a memorable collection of essays edited by Halliday and Laura Mulvey; and, finally, *Monogram*'s special issue on melodrama.[6] The Sirk boom brought together auteurists and academics in a celebration of the director's modernist style, his formal pyrotechnics, and his progressive politics.[7]

Discourse about Sirk, in sum, proved instrumental in formulating and promulgating the influential notion of a formally subversive and politically transgressive text that could emerge within the Hollywood studio system. And yet, this redemptive reading rested on an exegesis that deferred uncritically to Sirk's not always accurate accounts.[8] Halliday's interview, William Horrigan remarks in his meticulously researched dissertation, laid the groundwork for Sirk as a function of a few repeated themes as well as a unified transcultural subject: "Sirk, or Distance; Sirk, or Style as Self-Critique; Sirk, or Weimar in Hollywood."[9] British critics recast Sirk as a political creature and an adversary of Cold War sensibility. They studiously ignored his penchant for speaking about "regression, futility, the impossibility of change," and instead presented him as a man of the left.[10] In these discussions, the Hollywood narrative appeared as a standardized monolith and the Eisenhower era as uniformly repressive. Formally oriented analyses of ideology and spectatorship, concludes Barbara Klinger in her important monograph, isolated Sirk's productions from their sociohistorical context.[11] The academic literature of the seventies either belittled popular response as formally blind and politically ignorant—or removed Sirk's films altogether from the realm of mass reception.[12] Quite correctly, Klinger considers this approach problematic, because "films assume different identities and cultural functions" under different circumstances.[13] This is certainly the case, particularly when we look at the culturally specific nature of Sirk's historical reception in Germany as well as critical responses to that reception.

III.

The Sirk renaissance hallowed a Brechtian filmmaker who had made movies within the Hollywood system that challenged the dominant ideology. Sirk's self-representations in his interview with Jon Halliday served as a master text, introducing central categories such as "melodrama as social commentary, reading below the surface for irony, the false and self-reflexive style and distantiation, and pertinent themes."[14] When Anglo-American commentators turned their attention to the Ufa productions, they were quick to grant his work from the Nazi period the same special status: Detlef Sierck, it seemed, had always already been Douglas Sirk. Halliday, not unduly burdened by knowledge of German history beyond Sirk's recollections, hailed "a left-wing director" whose output in the Third Reich had been oppositional and ironic. Going through the features of the thirties, Halliday portrayed a critical director who emerged fully formed as a stylist quite adroit at reshaping recalcitrant materials and transforming conformist scripts into acerbic social parables. Sierck fused "the traditions of Weill, Ophuls, Brecht and Sternberg"[15]—and managed to do so while being monitored by the Nazis. Seen in this light, Detlef Sierck's Ufa films represented rare instances of aesthetic resistance against the Hitler order. Horrigan was essentially alone when he attacked Anglo-American acolytes of Sirk for denying "the existence of Nazi repressiveness altogether by claiming a strong continuity—with no fundamental differences recognized—between that [German] work and the work in America in the 1950s."[16]

German responses to Sierck's first features were far less effusive. In his work with Zarah Leander, it was the Swedish star rather than the director who garnered the praise of reviewers. Sierck demanded respect primarily as a competent "Spielleiter" who could work well with actors and facilitate solid performances, blending "the various emotional and affective elements of the plot into a moving musical unity."[17] If anything, Sierck stands out during these years as a well-regarded professional, one of the era's few trusted and "competent directors" (Goebbels's phrase is "könnende Regisseure"), and if anything, a master of illusion rather than a voice of resistance.[18]

After his departure from Germany, Sirk became a nonentity in his homeland, virtually unnoticed during the Adenauer era. Rarely mentioned by the West German press (and completely ignored in the German Democratic Republic), his films of the fifties seemed at best to be serviceable albeit impersonal products of the Hollywood studio system. In no way did reviewers feel moved to speak of a unique directorial presence or stylistic impetus. Sirk was, in the words of Hans Helmut Prinzler, "reduced to a nobody."[19] Between 1958 and 1973, precious little coverage of Sirk's work appeared in the leading West German cinema journal, *Filmkritik*—and the few notices that did appear, and that repeatedly did not even mention him as a film's director, were derogatory and at times downright devastating.[20]

A marked change of tone and attitude, a function of a seismic shift on *Filmkritik*'s editorial board away from ideological critiques to appreciations of form and style, became apparent in Heinz-Gerd Rasner and Reinhard Wulf's lengthy Sirk interview of November 1973. The director came alive as a filmmaker with a clear sense for what he had accomplished and what he had intended. His West German interlocutors, like Halliday, hung on the master's every word:

> He is a man with an aristocratic appearance and manner, full of nuanced subtleties and fine distinctions. Nothing about him is like Hollywood, none of the usual solicitous joviality, loud ties, perfunctory friendliness, shallow and well-known anecdotes. But also none of the intellectual arrogance or cynical misanthropy. In his films as in his person one finds a simultaneous blend of warm humanity and sharp analytical thought; his melodramas are full of idylls, hopes, and happy ends, but at the same time they contain an awareness that all bourgeois self-satisfaction is ultimately spurious and ephemeral.[21]

Rather than hailing the return of a prodigal son, this homage celebrated an international talent.[22] Albeit belated, the Sirk boom had a substantial impact in West Germany. It was to a great degree, although not exclusively, the consequence of Rainer Werner Fassbinder's spirited recommendation.[23]

For Fassbinder Sirk's appeal was that of a European artist who had worked in Hollywood and made anti-American films. Fassbinder's tribute to Sirk, published first in *Film und Fernsehen* and translated by Thomas Elsaesser for an Edinburgh festival booklet, merges close description, incisive analysis, and visceral reaction. (The essay abounds with exclamations like "It's just too much" or "Really sad!"[24]) Its emphases bear much in common with those of Anglo-American enthusiasts. It focuses solely on the Universal melodramas, not the other genre films; the Eisenhower-era endeavors come under discussion, not the German productions or the early exile films. The focus is on style and subversion, on expressive lighting effects and strained happy ends. The young auteur homes in, as one might well expect, on Sirk's dysfunctional families and disturbed male protagonists. At certain points, Fassbinder's projective appropriation becomes downright narcissistic: Sirk, Fassbinder notes, fled to the cinema as a child, escaping from his bourgeois household. He, as the rising director, would go on to make "films that people in Germany with his level of education would have smirked at."[25] Sirk's films confirm Fassbinder's own suspicions as well as echo the affective dynamics of his earliest features. After watching Douglas Sirk's films, he is more convinced than ever that "love seems to be the best, most sneaky and effective instrument of social oppression."[26]

The widely read and often-quoted homage to Sirk provided an authoritative validation of the master's subversive appeal and his social commentary, all the more so because this homage came from an *enfant terrible* whose radical will and stylistic indulgence were attracting festival and arthouse followings. The tribute, then, served a double function. It resuscitated Sirk for West German audiences, catalyzing a series of retrospectives, tributes, and television programs. Beyond that, it aligned Fassbinder with a more popular genre cinema, taking him out of the underground and expanding his appeal, transforming him from an uncompromising agent of distantiation into a choreographer of surfaces, illusions, and emotions. Fassbinder's major lesson from Sirk was one of strategy, not of style. From films like *All That Heaven Allows* (1955) and *Written on the Wind* he learned how a popular form could be recast to appeal to

audience expectations while simultaneously undermining them. Fassbinder's recourse to Sirk also came as a result of a search for legitimation. In this encounter inhered the implied question of tradition and origins for a young generation of West German filmmakers. Early on, Volker Schlöndorff expressed his veneration for Fritz Lang, both as a classical Weimar filmmaker and a director who had fled Nazi Germany. Wim Wenders repeatedly paid tribute to Lang as he did to F. W. Murnau. Werner Herzog entertained a high-profile relationship with the patron saint of a better German film tradition, Lotte Eisner. Niklaus Schilling posed an exception in his outspoken endorsement of Nazi cinema, although his words of praise cited important films without singling out their directors.[27] Like Walter Bockmayer,[28] Fassbinder identified with Sirk as a director trained in Germany who was at once un-German and anti-American.

The rediscovered auteur Sirk and the New German Cinema of authors fed on and nourished each other. The contemporaneous constructions of cineastes and cinephiles, both would become the privileged objects of a burgeoning film studies. Through Fassbinder's intervention, Sirk secured wide attention; via Sirk's model, Fassbinder aligned himself with a different cinema and a displaced better Germany that while turning its back on the Third Reich, had found a home in Hollywood and yet retained its intellectual and political integrity. Both entities represented more dynamic and radical possibilities for narrative film and the institution of cinema.

V.

In the wake of Fassbinder's homage and Sirk's growing media profile, several prominent German film critics spoke out early in 1974. Their essays in *epd Kirche und Film* saw the Sirk boom as trendy, foolish, and misguided. In a scathing ideological critique, Wolfram Schütte of the *Frankfurter Rundschau* chided his colleagues for fixating blindly on Sirk's McCarthy-era films and failing to understand that beneath the scintillating surfaces of these works lurked a repressed reality and a spurious harmonizing. In his mind, the embrace of Sirk by German critics was a sign of leftist melancholy and social restoration, a post-1968 retreat to interiority

in keeping with the era's so-called New Subjectivity. Sirk's Universal features offer no true resistance or critique; they do not stand up well to Luis Buñuel's works in this vein, which are much more unrelenting and intractable in their acts of rebellion (e.g., *El Bruto* [1953] and *Abismos de Pasión* [1954]). Sirk's melodramas, in comparison, are (and Schütte lets out all the stops and truly goes into a rant) "legitimations of the status quo, the grand humanization of the 'evil' world, mediocre emotional slop, moralistic philistinism, in short: melodrama at its worst, i.e., false thoughts plus false feelings equal false films, films (that for good and bad reasons) are considered to be great ones." German film critics do not realize how truly regressive these films are, especially because they have taken leave of Siegfried Kracauer and replaced symptomatic criticism with auteurism and formalism.[29]

Peter W. Jansen concurred, but he went even further. Sirk's melodramas, he grants, provide critical views on the regressive psychopathology of Eisenhower America. But who says dissatisfaction with the way things are and the affirmation of escapism need be mutually exclusive? "History, especially German history, offers sufficient examples; and it is hardly a coincidence that Sirk's cultural understanding and consciousness have a German foundation."[30] Sirk's undialectical approach to social criticism does not further understanding, but instead it compels the viewer to retreat into interiority when the world outside offers no solace. Sirk's cinema may well reveal the lack of correspondence between reality and hope. But it moves any relation between reality and hope to one in which parallel lines only meet in infinity.

The resonance of Sirk's films must be seen in the context of many other contemporary new subjectivities which, according to Jansen, "all derive from a widespread cultural political rollback, be it among those who embrace hippy or drug culture, be it Jesus People, or those who are reviving the *Heimatfilm*."[31] Sirk's films are "perfect industrial products" of a rationalized mass culture, whose "greatest ambition lies in the absolute clarity and literalness of their appeal." And these films are both products and functions of the culture industry, a pseudo-liberal cinema of pre-digested emotions meant to reconcile its viewers with the ways things are. In the process, the possibility of utopia (which can only be concrete) is forsaken. That may not be the result of these films, but it helps to explain

their effectiveness. "Because the promise that abides in Douglas Sirk's cinema implies ultimately the prospect of liberation from the burden of a concrete political utopia. Only in this way can capitalism gain converts and make profits."[32] In these quadrants at least, the legacy of Max Horkheimer and Theodor W. Adorno continued to exercise a strong—and dismissive—influence. Melodrama, even with Sirk's consummate style and a socially critical inflection, remained for Schütte and Jansen subject to the affirmative logic of mass culture.

Gertrud Koch's analysis of 1988 (published in *frauen und film*) offered an incisive challenge to auteurist dogma. She questioned the tendency to find persistent emphases across Sirk's work by tracing them "from past to present or from present to past, thus always resulting in a teleological whole which suppresses any ruptures." The director's work demonstrates an unfailing continuity in different times and different places only because critics do not bother to question the historical legitimacy of their methodology.[33] Koch conceded that there are continuities of form and theme between Sierck's Ufa films and Sirk's Universal productions, but she saw them in a critical light. His melodramas, for all their ostensible humanism and warmth, privilege an authoritarian and sadistic gaze that transforms female bodies into deformed fetishes. This mortifying force fixes on the living (especially sexualized women who invariably are made to look degenerate and unnatural), devivifies it, and consigns it to a fixed place. The "evil eye" at work in Sierck–Sirk's films has little in common with the nervous mise-en-scène of Weimar cinema and much in common with the perspective of Nazi features, which seeks "a place assigned by tradition often established by a dictatorial camera. The dead gaze of the blind who have lost all orientation is a motif that will preoccupy Sirk throughout his most famous American films."[34]

<center>VI.</center>

It is not surprising that Linda Schulte-Sasse includes Koch among the ranks of "backlash critics" (who include myself and Katie Trumpener) who question previous approaches to Sirk. In subjecting his output of the Third Reich to careful historical inspection, these commentators elaborate

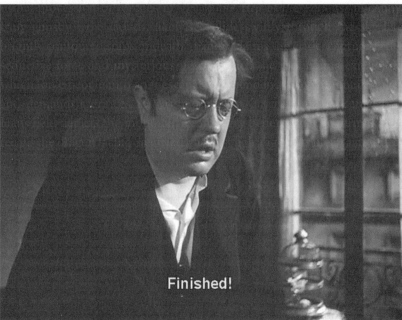

Finished!

FIGURES 4.2 AND 4.3. The deceased Madeleine (Marianne Hoppe) and her despairing hus-
band (Paul Dahlke) in Helmut Käutner's *Romanze in Moll* (*Romance in a Minor Key*, 1943):
a decidedly rare Nazi-era feature that offers neither consolation nor hope but remains, to its
very bitter end, marked by melancholy and shrouded in darkness. A woman seeks desperately,
and ultimately in vain, to escape a humdrum existence. In the film's devastating conclusion,
everyone loses, everyone suffers.

how this work, precisely because of its formal grace, stylistic flair, and apparent lack of politics, could find approval from both studio heads and party luminaries. At the same time, as press coverage from the period indicates, these features were in fact anything but devoid of ideological inscriptions. Schulte-Sasse pays lip service to some of these objections, but is uneasy about replacing what she calls one kind of apodiction with another. In her own curious act of backlash, Schulte-Sasse insists "that it is possible to look for something like resistance in his German work without being motivated by missionary zeal or historical apology. What is at stake in such a query is not only the stature of a canonized *auteur*, but the resistant potential of aesthetic operations themselves, whether within a totalitarian or a democratic context."[35] Proceeding to a close textual analysis of *Schlußakkord* (*Final Chord*, 1936), she shows how the film opens up a "reflexive space" that "forces its audience to move away from a seamless identification with narrative figures and a linear absorption by the plot's trajectory, and which encourages an awareness of the text as form." This space, unlike that of most Nazi features, "is indebted to a refusal of a totalizing narrative with an unambiguous moral anchorage." She lauds the presence of such a site of reflection as a "major accomplishment," deeming it a rarity given the Nazi state's strict coordination (*Gleichschaltung*) of cinematic sights and sounds.[36]

Schulte-Sasse celebrates Sirk's "reflexive space," responding to backlash critics by beating a retreat to the Sirk boom. In Schulte-Sasse's argument, the Nazi feature (as once the Hollywood dominant cinema) appears as a standardized monolith and the age of Hitler (as previously the McCarthy era) as uniformly repressive.[37] Many of the Nazi era's melodramas directed by Willy Forst, Viktor Tourjansky, Veit Harlan, Gustav Ucicky, Helmut Käutner, and Carl Froelich (none of which receives mention in an essay that offers no points of comparison) also present complicated networks of inner- and intertextual meanings as well as profusions of inscribed spectacles and references to the arts and the media. The claims Schulte-Sasse makes about Sierck's singularity could in fact, to varying degrees and with some necessary distinctions, be made (and, in fact, have been made) about the women's films of these other directors. Just because he directed melodramas that are full of gaps and fissures, Sierck is hardly singular or anomalous. "Ideological contradiction is actually the overt

mainspring and specific content of melodrama," Laura Mulvey points out while challenging Paul Willemen's notes on the Sirk system, "not a hidden, unconscious thread to be picked up only by special critical processes. No ideology can ever pretend to totality: it searches for safety-valves for its own inconsistencies."[38]

As I ponder Schulte-Sasse's notion of "reflexive space," I am reminded of Karsten Witte's far more compelling and nuanced contributions on aesthetic resistance.[39] (Indeed, the influence of his seminal work on this subject seems very present in her essay, even if it does not receive credit in her footnotes.) Although Witte nominally grants that moments of formal exception can be found in the productions of Helmut Käutner, Wolfgang Staudte, and Peter Pewas, he does not allow us to forget that these films figured and functioned within a larger apparatus and in no way undermined the operations of that system. To view works in isolation, he points out, is a favored ploy of revisionists who tart up the exception and downplay the rule. "No Wysbar, Sierck, Tourjansky, Hochbaum, Pewas, or Käutner will ever keep Steinhoff, Riefenstahl, Ucicky, Ritter, or Harlan in the shadows. This infamous legacy is not divisible. One either accepts it as a whole or one misunderstands it altogether."[40]

Contemplating Sierck's work in the Third Reich, we need to bear in mind that any consideration of the possibilities and limits of aesthetic resistance must ground endeavors within apposite historical times and places. Textual complexity is not necessarily a mark of ideological subversion, for collusion and resistance can and do coexist. The Ufa films of Sierck readily confirm (and they are hardly unique in this regard) that a certain degree of aesthetic resistance and reflexive space in fact were tolerated and even encouraged by the repressive Nazi ideology. If we talk about space, we surely need to inspect the formal space of films with all due care, but we also must attend to the social space of cinema, which includes the larger space of the public sphere from which films issue and in which they resonate.

FIGURE 5.1 The Ufa studio, "the magical German empire of images" (Klaus Kreimeier) and its expansive international designs.

SPRINGTIME FOR UFA

I.

During the eighties if people wanted to intervene in public debates, they thought above all in terms of images, sequences, and scenes, attempting—like everyone from Gorbachev to the protesters in Leipzig—to create visual spectacles [*Schauprozesse*]. In this precise sense, the decade became one dominated by the media: one shaped and interpreted images in a manner that overshadowed all traditional and coherent textual systems. Texts themselves were full of leaps in logic and gaps, and either resembled film images or tried to describe images. The exchange of texts in cultural controversies became an exchange of "scenarios": prophets of doom painted catastrophe tableaus, growth critics painted horrific ones; "scenarios" also appeared in the form of potential solutions to social or political problems. One can in fact speak of the entire German reunification process as a struggle over appropriate "scenarios."

HANNS-JOSEF ORTHEIL[1]

To look at the Federal Republic of Germany (FRG) today means to scrutinize a country in the process of redefining itself, a democracy challenged by the conflicting priorities of an increasingly diverse populace, particularly since the opening of the Wall and the end of the Cold War. As borders have shifted and new orders have arisen, questions of identity have given way to ones of difference. Things and people are in flux and

master concepts like nation, culture, and tradition, notions slowly and laboriously rehabilitated during the postwar era, have become increasingly inadequate, if not altogether spurious constructions. The thought of a national film culture has become inordinately hard to sustain, even as a rhetorical convenience. German film is more than ever riddled with crisis and mired in malaise; its future prospects remain bleak and at best uncertain.

Likewise, decisive structural changes in the German public sphere have radically transformed the flow of fantasy ware. Critics and film buffs in the Federal Republic complain about the ever-expanding new media, about the devastating effects of a postmodern visual culture dominated by mercenary moguls such as Leo Kirch or Heinz Reich and the entrepreneurial initiatives of corporations like Bertelsmann and Sony. Despite the dire prognoses and bitter complaints about the state of German cinema, film history could not be more present in the newly expanded Federal Republic. All of a sudden, the legacy of the Ufa studio is everywhere one looks, from *Madame Dubarry* (Ernst Lubitsch, 1919) to *Kolberg* (Veit Harlan, 1945). As people take leave of cinema as an institution and dismiss DEFA (Deutsche Film-Aktiengesellschaft) and New German Cinema, they begin to take stock of a more enduring national film culture. Early in 1992, for instance, the eightieth anniversary of the Babelsberg studio facilities occasioned an elaborate retrospective at the Berlin Film Festival, invigorated by newly available prints from Eastern European archives. Employing a suggestive set of references, organizer Wolfgang Jacobsen of the Stiftung Deutsche Kinemathek characterized Babelsberg as a locus of lore and fascination, of "Atlantis and Utopia, Metropolis, Abaton and Stadt Anatol, a realm of dreams and a terra incognita."[2]

Later in 1992, the seventy-fifth birthday of Ufa catalyzed a massive tribute to the fabled studio in Berlin's Historical Museum. A 2.4-million-mark production, "Die Ufa 1917–1945: Das deutsche Bildimperium" constituted the largest film exhibit in the history of the Federal Republic, occupying 2,400 square meters and twenty-one large rooms, featuring a retrospective with seventy of Ufa's six hundred features. A twenty-foot-tall Blue Angel, made of styrofoam, lounged on a barrel with her legs crossed, lording over the proceedings, an awkward concession to public taste, a centerpiece put in place with no apparent awareness of its sexist

FIGURE 5.2 At a cost of 2.4 million marks, an elaborate exhibit in the Berlin Historical Museum opened late in 1992 to observe the seventy-fifth birthday of Ufa and reflect on the studio's both venerable and problematic legacy.

implications. To be sure, the curators had taken great pains to insist that Ufa was not simply synonymous with *Metropolis*, Mabuse, and Marlene and carefully recalled the darker aspects of the studio's history and documented the political realities that coexisted with Ufa fantasies, offering historical elaborations and critical perspectives both in the exhibit and in the accompanying literature. Every effort was made so that this would not be seen as politically irresponsible, as an exercise in escapism or nostalgia. The exhibit received frequent praise for its feats of design, presentation, and research.[3] Jubilation and exuberance prevailed in the press coverage and television reports.[4] The Ufa exhibit ended up on the "Hitlist of Berlin Exhibits for 1992."

In a country otherwise disenamored of its own image production, in a nation that lacks the thriving film cultures and throngs of cinephiles one finds in France, Great Britain, and Italy, the history of Ufa has become the object of massive media attention and collective interest. The Berlin exhibit attracted large and vastly appreciative audiences: About one hundred thousand visitors were counted during the show's three-month run. How are we to understand this sudden acclaim and great ado? Long ago declared dead as the incarnation of "Opas Kino," Ufa has been liquidated (*abgewickelt*), as have the studio facilities in Babelsberg, which now are being transformed into the staging ground of a hoped-for European alternative to Hollywood. Ufa's legendary rhombus remains present as an advertising logo owned by the entrepreneur Riech in whose cinemas German films are as rarely on view as they are in American first-run houses. What abides is a studio's mythos. And it is a powerful—and problematic—one.

Klaus Kreimeier's *Die Ufa-Story: Geschichte eines Filmkonzerns* provided a blueprint and master text for the Berlin exhibit. It is a tour-de-force of German film history marked by scholarly rigor and stylistic verve. Engaging and provocative, *Die Ufa-Story* alternates between panoramic sweeps and close-up perspectives. Kreimeier was a consultant for the Berlin exhibit and advisor for the series of informative and elegant pamphlets that complemented the show, a package of 22 *Ufa Magazine* consciously designed to resemble studio publications put out during its heyday. He appeared in Hartmut Bitomsky's documentary, *Die Ufa* (1992), a modest, yet remarkably intense presence. Kreimeier has become a central figure in

a virtual renaissance of German film history and historiography. Various critics in the FRG have gone so far as to claim that Kreimeier's book has superseded Siegfried Kracauer's *From Caligari to Hitler* as the authoritative study of classical German cinema.

II.

Die Ufa-Story is a far different book than we have might have expected from Klaus Kreimeier two decades ago. A student activist and an outspoken Marxist, he at one time seemed to incarnate a hyperbolic extension of what is referred to today (generally dismissively) as a "critical critic," a commentator who militates against cinema's imaginary enticements and ideological traps, probing the relationships between filmic and social reality.[5] In 1969–1970, Kreimeier produced a seven-part television series for Westdeutscher Rundfunk (WDR, West German Broadcasting) entitled *Das Kino in der Ideologiefabrik* (*Cinema in the Ideology Factory*). For the early Kreimeier (he was born in 1938), ideological fabrication was the central impetus of cinema, not just one aspect among others. He followed in Kracauer's shoes, albeit treading much more heavily. Cinema's falsehoods and fabrications, he maintained, need to be confronted with the reality from which they stem and on which they act.[6] His book on postwar German film, *Kino und Filmindustrie in der BRD: Ideologieproduktion und Klassenwirklichkeit nach 1945* (*Cinema and the Film Industry in the FRG: Ideological Production and Class Reality after 1945*), likewise, was a lengthy exercise in this vein. For the Kreimeier of the early seventies, the West German film industry constituted a "monolithically closed, at the same time mechanically functioning ideological agent of the bourgeois state apparatus in the reconstruction phase of monopoly capitalism."[7] He would pay dearly for his oppositional endeavors. A professorship offered by the University of Oldenburg in 1975 was later denied him after a security check. His student movement activities rendered him an enemy of the state—and a victim of professional proscription (*Berufsverbot*).

The intervening years produced a mellowed and more measured Kreimeier.[8] The fierce reductionism and ideological rhetoric to be found on almost every page of *Kino und Filmindustrie in der BRD* are no longer in

evidence. If *Die Ufa-Story* confronts German film history, it also reckons with previous historiography about German film, including the author's own endeavors. Typical of Kreimeier's approach is his reassessment of *From Caligari to Hitler*, his taking to task of what he perceives to be Kracauer's dark teleology and social determinism. Kracauer, argues Kreimeier, denies history its ambivalences and multiple possibilities, leading to "a closed fatality of events and their reflections" (66). Films of the Weimar Republic did more than just provide a preview of coming fascist attractions. They "perceived the dangers: unconsciously, but nonetheless cognizant of the symptoms; politically blind as well as clear-sighted about the horrors which can emanate from politics" (105). Weimar films did not just function as agents of affirmation and legitimations of the status quo. They also produced counterrealities and "a narcotic, which seemed to restore a balance of feelings and the self-consciousness of a disturbed ego" (206). Kreimeier's study allows us different routes of access to Weimar cinema, suggesting there are other roads to be taken beyond Kracauer's one-way street from Caligari to Hitler.

III.

In Kreimeier's revisionist account, Ufa becomes a force field, a site of competing discourses, no longer an organization solely dedicated to "the idea of putting art to the service of propaganda" (Kracauer).[9] Conceived as a working relationship between the military, big business, mass culture, and art, to be sure, Ufa enacts in nuce the larger drama of the Weimar Republic and the Third Reich. During the twenties, Ufa demonstrates how one Germany battled another, rather than providing fantasy anticipations of a nation's submission to Hitler. Ufa, maintains Kreimeier, was subject to Weimar and its many conflicts and contradictions. And one dare not forget that democrats, cosmopolitans, and Jews provided the film industry's creative core: "The cinema of the twenties was a large project on which very heterogeneous forces expended their energies, forces with different influences, different goals, and different results" (78).

Kreimeier calls his studio history a story. The trajectory of his narrative is at once more complex and less certain than Kracauer's. It blends

economic determinants, political constellations, and collective dispositions, drawing on archival materials (particularly the minutes from the meetings of the Ufa board of directors) and a wide range of films, offering crisp mini-dramas about a host of players, making for a film history that is above all a social history. In Ufa's productions and operations, Kreimeier discovers contradictions and alternatives, missed opportunities and betrayed chances. Ufa history for him amounts to German cultural history, an amalgam of politics, economics, science, technology, mass desire, of kitsch, commerce, and art.

Ufa history is also a history of war and big business, and of big business's investment in war. Two German defeats frame the studio's history: Verdun and Stalingrad. Ufa will wage international battles with Pathé, Gaumont, Cinecittà, and Hollywood in an effort to carve out the domain for a German empire of images. Babelsberg will become a source of international fascination, a world of compelling fakes and distortions whose illusions become second nature, a site of grand constructions that suspends the laws of gravity and denies the march of time. Ufa is many things, a veritable bundle of contradictions: "Visual pleasure and discipline, drill and ballet. Its love of ornamentation was a duty and an optional exercise." A purveyor of propaganda and a hotbed of experimentation, a media concern, a laboratory of film art, a factory of dreams and nightmares: "Ufa embodied all of these things and all of them at the same time,—it was a German (a very German) response to Hollywood" (9).

Insistently self-reflexive about his revisionist enterprise, Kreimeier spells out his methodology so that there can be no mistake:

> The remarkable rise of Ufa would indeed remain an abstract fact if one did not take a microscopic look at the details of everyday life. Parallel and contrastive montage is necessary to visualize how the development of Germany's mightiest cultural province took place within the context of threatening social dissolution and terrifying mass poverty (93).

Cutting between a variety of determinants, Kreimeier eschews a reductionism that views films as reflections of social reality, as celluloid fantasies that mirror collective desires. The crux of Ufa's drama involves the conflicting interests of three central forces: (1) the studio administration,

which tended toward a conservative nationalist consensus; (2) the professional middle management, which consisted by and large of an educated bourgeoisie; and (3) the artistic and technical personnel, which spanned an array of classes and the entire spectrum of political possibility. Anything but a monolithic entity, Ufa had a variety of vertical and horizontal structures, allowing production, distribution, and exhibition to function in some ways independently. Until the National Socialists took full control of the studio and the German film industry in 1942 (and not even completely then), no ideological central office existed to consciously set out to manipulate the masses. One wanted to make money, not to make people stupid nor to educate or refine them. It was crucial that one find points of focus for vagrant feelings in exceedingly chaotic times, points that were no less vague than the feelings themselves, but ones that at least promised diversion and heightened experience.

Die Ufa-Story traverses well-known historical stations, but it rarely grants the reader a sense of obligatory scenarios. The book explores much territory that has remained underappreciated and forsaken. The canonized classics all receive careful consideration, but Kreimeier insists on the diversity of Ufa endeavors, the generic proliferation of historical dramas, literary adaptations, social problem films, and serial comedies. Ufa for Kreimeier is more than just a film studio. It proffered fantasy ware to a diverse clientele with a wide range of needs and desires, serving an urban public ever eager to be distracted in new and different ways. Cinema opened up alternative worlds and presented novel possibilities: "In the experience of cinema itself, as in people's emotions and dreams, 'progressive' and 'regressive' lie closely together and form the strangest alliances" (114).

In an essay written by Kracauer in 1926, Babelsberg appears as a "calico-world," a prototype for Disneyland and Magic Mountain, an amusement park where montage holds sway, chopping up and reshaping physical reality in stimulating and scintillating configurations. There is no respect for history or the past. One builds and destroys cultures at will. Film producers "sit in judgment over entire cities and let fire and brimstone rain down upon them if the film calls for it. For them, nothing is meant to last; the most grandiose creation is built with an eye to its demolition."[10] (Without a doubt, this studio tour affords a glimpse of postmodern attractions.) In the heterogeneous space—in Blochian terminology, a "Mischort"—that

was Ufa, high art and mass culture went hand in hand; in the case of Ufa *Großfilme* like *Die Nibelungen* (Fritz Lang, 1924), *Faust* (F. W. Murnau, 1926), and *Metropolis* (Fritz Lang, 1927), the boundaries between high and low, between art film and popular cinema became suspended. At Ufa, commercial strategy and artistic obsession were not necessarily contradictory categories.

Much of Ufa's legendary allure stemmed from its reputation as a site of experimentation. Set designer Robert Herlth spoke of Ufa's artistic and technical personnel as a medieval guild of craftsmen (*Bauhütte*), who forged a bond between imagination and technology, fashioning collective works of art that above all embodied architectural fantasies. Filmmakers sought to recreate the world in this artificial space of the studio, not to imitate or copy it, but rather to fashion bizarre and romantic landscapes of the mind. Henri Langlois would laud the Ufa's "metaphysics of decor" as would Paul Rotha its "studio constructivism" (124). The messianic mission of the latter-day *Bauhütte*, as Kreimeier points out, corresponded to nonsimultaneous desires. As the bourgeoisie saw its heritage evaporate, these stylized dream worlds recreated and eternalized an old culture while utilizing modern machinery and a different formal language. The hallowed classics of German silent cinema achieve a remarkable synthesis of preindustrial yearning and high-tech sophistication, of Old German shanties and Americanized cities (think of Rotwang's anachronistic dwelling amid the skyscrapers of *Metropolis*), a striking blend of mysticism and modernity, of magic and science. Kreimeier is quick to note that only a handful of the studio's films (about a dozen) realized this program during the Weimar years, even if *Metropolis* and *Faust* abide as the quintessential Ufa productions.

Was there a distinct Ufa style, a discernible Ufa aesthetics? To talk of such matters, we indeed must take into account Ufa's artistic sophistication and formal experimentation, its self-conscious attempts to fabricate grand feelings and pleasant sensations. But one also needs to consider the studio's "philosophy," its market strategies and its calculated relation to collective audiences and political powers. Kreimeier discusses the 5.3-million-mark fiasco *Metropolis* as a demonstration of Ufa's strengths and failings, as a meeting place of the various forces that would lead Ufa— and the Weimar Republic—into perdition:

The capital basis—and the carelessness with which it was squandered. The talent for the grand organizational structures of a general staff—and the desire to lose oneself in microscopic details. Artistic obsession—and its perversion into empty perfectionism. Enthusiasm for technology and its flip side: the bland embrace of technology. Ideological efforts—and the thoughtlessness with which all their virtues were diminished by conceptual shortcomings and intellectual presumptuousness. In many ways the fate of this all too costly film catastrophe symbolized the fate of the first German republic (183).

Such measured (albeit overly schematic) formulations correspond to Kreimeier's insistence on multiple determinants and conflicting energies.

Kreimeier's language is at once analytical and accessible, mindful of theoretical perspectives without taking recourse to jargon or needing to drop names. His privileged witnesses are contemporaries who experienced and lived with these films, Kracauer and peers like Walter Benjamin, Ernst Bloch, Willy Haas, Herbert Jhering, and Joseph Roth. The book abounds with expressive miniportraits, quick character studies that make screen personalities come to life in a few sure strokes. Willy Birgel, for instance, incarnates "ambivalent, brooding, weak-egoed characters of high society, who concealed their damaged persons behind a sovereign demeanor" (345). The energetic dancer and chanteuse Marika Rökk "remained, for all her hard work, a somewhat coarse, disarmingly vital, all too intensely grimacing Hungarian circus rider" (349). Kreimeier's single observations repeatedly lead to wider conclusions. His ironic profile of Heinz Rühmann sketches the performer's blend of timorousness and aggression, linking him to other Nazi "men on the street" like Willy Fritsch and Hans Brausewetter, protagonists in comedies of errors and sentimental dramas, "in which emotions of course were only second-hand—imitations of a past culture in which people used to feel more deeply" (343). These smart and snappy heroes feign elegance and allure, but they lack the verve of Hollywood stars, the physical dynamism, and the sensual aura. His point: "The everyday star of Ufa: that was the German vassal (Untertan), who subjected himself to fascism without considering its consequences—and who retreated into the sanctuary of his labile and all the more anxiously guarded inner being once the consequences could no longer be overlooked" (344).

Kreimeier's study has appealed both to specialists as well as to a general readership. The wide success of the film history, it would seem, has reasons that go beyond a compelling story couched in agreeable prose. Its resonance is hardly an isolated event, but it is an indication of something much larger. Since 1990, there has been a host of other books on Ufa,[11] a proliferation of publications on classical German stars and filmmakers, in addition to extensive press, radio, and television coverage, re-releases of songs from Ufa hit films on compact disc and an ever-expanding video market for German films of the thirties and forties (well over one hundred titles can now be purchased). The lavish song-and-dance spectacle, "Bombenstimmung: Eine Ufa Revue," recently ran at the Berlin Theater des Westens, an homage to evergreens and stars accompanied by an unconvincing and strained critical framework. The Ufa renaissance constitutes both a sensation and an enigma. It is odd: no grand festivities marked the studio's fiftieth birthday in 1967, neither in the FRG nor the German Democratic Republic (GDR). The same month that Kreimeier's book came out, the Stiftung Deutsche Kinemathek published an elegant and comprehensive collection of essays, *Babelsberg. Ein Filmstudio 1912–1992*, and, to the surprise of its editor and publisher, the not-inexpensive brochure sold out within days.

While Kreimeier's tome was finding an approving and enthusiastic reception in feuilleton pages, a large-format competing work arrived in outlets of the alternative media chain store, Zweitausendeins. Hans-Michael Bock and Michael Töteberg's imposing *Das Ufa-Buch* has an equally generic title with an equally ambitious, albeit different, scope. In basic ways, the editors share Kreimeier's central assumptions. What is different is their format: Bock and Töteberg offer a collection of original documents, analyses of films, descriptions of historical moments, authorial portraits. There is no sustained single narrative (this *Buch* is not a *Story*), because Ufa was a function of many different forces and can be fathomed only in its multiplicity and heterogeneity. The editors cite Axel Eggebrecht's characterization of Ufa as a gigantic department store and insist on an inclusive emphasis, taking in the studio's grand productions as well as its run-of-the-mill fare; its trend-setting titles and everyday

offerings; its *Kulturfilme*, newsreels, and advertisements. It also surveys the exhibition and distribution sectors, making forays into the studio's working spaces, the administrative offices, the export division, the sound stages, studio facilities, and even the employee's canteen. Bock and Töteberg's impressive work includes contributions by specialists from around the world, extensive (and in many cases rare) photographs, and even a complete inventory and filmography of every single short and featurelength film produced by Ufa.[12]

Ufa has been equally in evidence on television. Hartmut Bitomsky, the crafter of significant documentary essays on Nazi *Kulturfilme* (*Deutschlandbilder/Images of Germany*, 1983) and the German highway system built under Hitler (*Reichsautobahn*, 1985), sought to diminish the magic of Ufa entertainments with a camera that traverses rows of television monitors sporting the studio's sights and sounds. His austere eighty-eight-minute film essay, *Die Ufa*, combines a critical appreciation and a revisionist exercise, aiming to fathom the studio's ambivalent appeal, maintaining a critical reserve by reducing Ufa spectacles to small-screen entities in a video gallery.[13] In December 1992, Ostdeutscher Rundfunk Brandenburg (ORB) devoted much airtime to film historical reflections. A three-part essay, *Goebbels—der Schirmherr* (*Goebbels—The Protectorate*), screened during the first days of the month. "Our series of essays," claim the filmmakers Fred Gehler and Ullrich Kasten, "about the regime of the 'protectorate' is not a function of an opportunistic nostalgia. We have long been interested in the demise of art, how it became a whore in the service of power and the powerful. The prostitution of German film under the aegis of Goebbels's 'protectorate' offers a dire warning which must be heeded."[14]

The prostitution of German film in the guise of the whore Ufa: this is a singular trope and it will not be the last time we hear it. On December 15, ORB acknowledged Ufa's seventy-fifth anniversary with another Gehler/Kasten film that reflected on the studio's twenty-fifth birthday and the premiere of the big budget color production, *Münchhausen* (1943), *"Ihre Uhr ist kaputt oder die Zeit selber": 25 Jahre Ufa—Anmerkungen zu einem Jubiläum* (*"Either Your Watch is Broken or Time Itself": 25 Years of Ufa—Notes on a Celebration*).

In February 1993, the French-German culture channel, Arte, devoted an entire evening to Ufa and the Ufa exhibition. It reprised the Gehler/ Kasten essay on Goebbels as well as Hans-Christoph Blumenberg's revue, *Wenn ich sonntags in mein Kino gehe . . .* (*When I Go to the Movies on Sunday . . .*), a production of the ZDF from 1992. A decade ago, Blumenberg was Germany's most influential film critic. He has, with mixed success, gone on to make feature films and most recently a series of documentary homages to Ufa icons, including Hans Albers (*In meinem Herzen, Schatz . . . /In My Heart, Dear . . .* , 1989) and Kristina Söderbaum (*Die Reise nach Schweden/The Trip to Sweden*, 1993), as well as to write a book about Wolfgang Liebeneiner's unfinished project, *Das Leben geht weiter* (*Life Goes On*), the last Ufa film.[15] In his Ufa tribute (which also appeared as a book), the studio of lore came to life as a variety show. A buoyant metteur en scène sets the tone: at first one is reminded of the stirring master of ceremonies in Hans Jürgen Syberberg's *Hitler—Ein Film aus Deutschland* (*Our Hitler*, 1977), the clown-commentator played by Heinz Schubert— half-serious, half-ironic, but who can tell? As one listens more carefully, though, a different and less acerbic inflection becomes evident:

> You're invited to a gala evening with stars and hit songs, with artistic triumphs and political catastrophes, with ladies and leaders, with pomp and propaganda. You will meet the best actresses and actors, the idols of German cinema. Our story begins in the crumbling empire of the last emperor and ends twenty-eight years later in the ruins of Berlin. Ufa films accompanied the era between 1917 and 1945, sometimes as an enrichment and always as an influence. Never was cinema so intensely caught up in the desires and political interests of cartels and big business. Ufa operated in a field of force between entertainment and politics. It [she] served many masters. It [she] was seldom a reserved or shy lady, but more often than not a coquettish, worldly diva. She preferred waltzes and fox trots to Prussian military marches. Even during the "Third Reich" Ufa produced films that catalyzed utter horror in the Ministry of Propaganda—many of them were forbidden. In this way Ufa did its duty, in war and peace. In the process it did not remain innocent. But the music was always playing.

The ambivalence here is only apparent: The studio's past may be checkered, but it still holds a distinct allure for the present-day observer. Even more disconcerting, though, is the persistence of a trope. Ufa, once again, becomes figured as a woman of questionable repute, a grande dame whose charms one nonetheless cannot deny or resist.

Kreimeier's book, with its enlightened resolve, careful nuance, and historical hindsight, takes exception with those critics who would reduce Ufa to the tool of an ideological state apparatus. His presentation allows us to see German film history in terms of an ongoing story, a narrative that allows for continuities between the Weimar Republic and the Third Reich. To his credit, Kreimeier makes certain that we remember the victims of National Socialism, cutting between Ufa's twenty-fifth anniversary celebration in 1943 and the fates of those who were perceived as enemies of the Nazi state. In general, though, Nazi cinema takes on a less sinister countenance. According to Kreimeier, film under Goebbels was hardly a matter of constant demagogy, but rather a *gemütlich* and innocuous bringer of small pleasures (253). The Ministry of Propaganda was not a smoothly running political machine; the network of competing instances was in fact so complex that no one really could fully keep track of its workings. Even when the system functioned effectively, it still was at times irrational and inconsistent (268). The dream of an all-encompassing ideological control was at best a Nazi dream—and a postwar myth (331). At such moments, Kreimeier's tone ranges from nuanced to conciliatory and defensive. Distancing himself from a legacy of dogmatism and dismissiveness, Kreimeier goes to the other extreme. On occasion, his treatment of Nazi cinema smacks of redemptive criticism: "Not everything, but much was possible" under Goebbels. "The possible often seemed too risky, while the 'impossible' occasionally was overlooked, silently tolerated or in fact praised" (270).

Cinema played a crucial role in National Socialism, in a dictatorship facilitated and orchestrated by state-of-the-art media, a proto-postmodern cult of distraction in which politics, aesthetics, and entertainment became inextricably bound. If one can retrieve Nazi mass culture, then one is well on the way to normalizing the everyday under Hitler. Kreimeier promotes the separation between official state productions and harmless Nazi entertainments which soothed and stabilized the masses

(279). In so doing, he underestimates the way in which so-called political productions played off of and interacted with generic features, so that the intense geometric patterns of *Der Triumph des Willens* (*Triumph of the Will*, 1935) reappeared in the marching lines of female performers in revue-films like *Wir tanzen um die Welt* (*We're Dancing around the World*, 1939). Films, especially the seemingly light and diverting fare, existed within larger discursive formations. One might have had the illusion of a safe haven in the cinema; in fact, Nazi escapism offered no escape from the Nazi status quo.

V.

Books, like films, always mean more than their authors might have intended. *Die Ufa-Story* is, without a doubt, an important contribution to German film historiography.[16] Kreimeier's narrative figures in a larger contemporary postwall story as well, the tale of two states who have come together and now cast about for points of commonality, among other things, for a viable German film culture. The DEFA films of the former GDR, in the popular mind, bear the scars of Stalinism and state supervision. International cineastes might have once celebrated the New German Cinema of the seventies and early eighties for its formal vigor, topical vibrance, and narrative idiosyncrasy, but it never enjoyed a substantial domestic following. Lavish recent exhibitions in Frankfurt and Berlin have commemorated West German films of the sixties and seventies as well as the work of Fassbinder, making it clear that this portion of German film history is now also a museal entity. With Babelsberg in the hands of a subsidiary of the French concern CGE headed by Volker Schlöndorff and buoyed by his enterprising designs to foster quality international productions, the former seat of Ufa and DEFA augurs to become a massive media complex. Meanwhile, politicians and lobbyists press for an end to an era of state-subsidized independent filmmaking in favor of more distinctly commercial products.

Ufa has reemerged as the answer to many wishes, as the memory of a potent national dream machinery, as the force that once challenged Hollywood's occupation of German hearts and minds. Ufa films of the Third

Reich are being repackaged and marketed by video retailers as classics of German cinema, including the militaristic Fridericus films (e.g., Veit Harlan's *Der große König* [*The Great King*, 1942]), *Heim ins Reich* epics like Herbert Maisch's *Menschen ohne Vaterland* (*People without a Country*, 1937) or Gustav Ucicky's *Flüchtlinge* (*Fugitives*, 1933), and blatantly racist movies such as Max W. Kimmich's *Germanin* (1943) and Helmut Weiß's *Quax in Afrika* (1944). For most of the postwar period, Nazi films circulated widely (even in the GDR), screened in matinees for senior citizens and reprised on television, their presence as undeniable as it was understated. Ufa stars and evergreens from the Third Reich have ceased to be guilty pleasures; they are right now unquestionably "in."

"If fascism is a man, Ufa is a woman," George Seeßlen observed, with no little irony, in his insightful analysis of the Berlin exhibit.[17] Ufa, recast as a grande dame and diva, may have flirted with power and at times even gone astray. Nevertheless, she never fully lost her charm or appeal. The logic of the gendered trope would seem to dictate that Ufa (like Nazi cinema's grandest dame, Leni Riefenstahl) could have cozied up to Hitler and still not submitted to National Socialism.[18] A recent blurb in the Berlin cultural guide *zitty* demonstrates how this rhetoric has become common parlance, even in journals that fancy themselves to be progressive and in the know: "Zarah Leander is an idol, even her loyalty to the Nazis could do nothing to change this. So wonderfully wicked, so harmless and so hip."[19] Ufa has reappeared after the *Wende* as the feminized site of a new Germany's dreams, the embodiment of a national empire of images, and an object of worship and affection in spite of—or, perhaps, because of—its tainted past, a past that to many contemporary Germany beholders looks increasingly attractive. So wonderfully wicked, so harmless, so hip.

II
SERIALS AND CYCLES

FIGURE 6.1 Advanced instrumentation measures and negotiates physical space; in the mountain film, natural forces and modern technology enjoy a salubrious coexistence (Leni Riefenstahl as Hella in *Stürme über dem Montblanc/Avalanche*, 1930).

6

MOUNTAINS AND MODERNITY

I.

A combination of auratic landscapes, breathtaking atmospherics, and fiery emotions, the mountain film (*Bergfilm*) is a prominent Weimar genre often spoken of as a harbinger of National Socialism. These narratives, claim commentators, glorify submission to inexorable destiny and elemental might, anticipating fascist surrender to irrationalism, destiny, and brute force. Regressive parables, they play a central role in Siegfried Kracauer's *From Caligari to Hitler*: in his teleology, the stunning cloud displays of *Stürme über dem Montblanc* (*Avalanche*, 1930) segue into the celestial prologue of *Triumph des Willens* (*Triumph of the Will*, 1935).[1] Even if Kracauer's "psychological history" of Weimar cinema has its many detractors, his criteria to this day govern how we approach much of classical German film—and this is particularly the case with the *Bergfilm*.[2]

As a genre, the mountain film receives mention as a preview of coming fascist attractions, an "anthology of proto-Nazi sentiments,"[3] reactionary fantasies that fed on and fueled antimodern persuasions, stirring documentaries whose allure above all was one of images rather than characters and stories. Kracauer and others in his wake thereby overemphasize how the mountain film points ahead to the Third Reich

and underestimate how it functioned within the Weimar Republic. The status of the mountain film seems all but cast in stone. Kracauer's harsh verdict has had the effect of stifling further discussion; respondents either confirm or reject his conclusions, but they have little else to say. In the midst of much reevaluation of Weimar cinema, we take pause here to reexamine this genre and to question its critics, to comb the archives, and to take a fresh look at rarely screened films. We want to know more about the reception accorded these features upon their initial release and to reconsider, with care and all due skepticism, eyewitness accounts and the memoirs of their creators. Wider perspectives will, this is the hope, enhance our focus, allowing us to discern with more precision the place of the *Bergfilm* within Weimar culture and classical German cinema.

II.

Reviewing the discussion of the mountain film in *From Caligari to Hitler*, we encounter several peculiar lapses, a sudden change of tone and a glaring blind spot, both of which urge us to reopen a seemingly closed case. In his overarching tale of a German collective soul oscillating between images of tyranny and chaos after World War I, Kracauer analyzes various cinematic endeavors that offer a way out of impasse and seek to provide sanctuary for homeless spirits. Read symptomatically, the mountain film manifests a desire to take flight from the troubled streets of modernity, from a state of constant crisis, and to escape into a pristine world of snow-covered peaks and overpowering elements. With much enthusiasm, Kracauer lauds the genre for its eschewal of studio settings and its explorations of "the silent world of high altitudes." Recollections of mountain films give rise to an atypical moment of lyrical effusion, an indication just how profoundly these images resonated in the mind of the German exile many years later:

Whoever saw them will remember the glittering white of glaciers against a sky dark in contrast, the magnificent play of clouds forming mountains above the mountains, the ice stalactites hanging down from

roofs and windowsills of some small chalet, and, inside crevasses, weird ice structures awakened to iridescent life by the torchlights of a nocturnal rescue party (111).

Kracauer quickly puts an end to his flight of exuberance, insisting that these rousing documentary images failed to offer firm spiritual footing in uncertain times; rather, they reflected the rarefied sensibilities of students and academics who would venture into the Alps of Southern Germany on weekend pilgrimages.

The cultish credo of these mountain climbers—popularized in the films' overwrought scenarios—was one of antirationalism, a belief in the laws of a mighty and inscrutable nature, a disdain for the statutes of civilization and the denizens of the city.[4] One such student, the young Joseph Goebbels, rejoiced during a winter outing, finding spiritual renewal in a communion with the elements:

> That was my yearning: for all the divine solitude and calm of the mountains, for white, virginal snow.
> I was weary of the big city.
> I am at home again in the mountains. I spend many hours in their white unspoiledness and find myself again.[5]

The narratives of the mountain films, claims Kracauer, culminate in acts of heroism which involve abandon and self-sacrifice, rehearsing "a mentality kindred to Nazi spirit" in which "immaturity and mountain enthusiasm were one" (112). At center stage in these Alpine dramas stands "the perpetual adolescent" (258), the confused male subject that figures so seminally in the author's psychohistorical treatment of Weimar Germany.[6] Curiously, throughout his entire exegesis, the analyst has precious little to say about matters of sexual difference. Indeed, he reduces women to secondary factors in his terse and frequently ironic plot descriptions and desists from any sustained comment about their constant and conspicuous appearance in these films.[7]

These two instances of disturbance provide a challenge and a point of departure. Why does Kracauer so vehemently disavow his initial fascination for the mountain film? At what cost does his ideological analysis of the *Bergfilm* repress female presence?

Almost universally, commentators praise the mountain film's images and scorn its scenarios. Assailants of the genre's histrionics and plot contrivances nonetheless acknowledge its sterling photography and picturesque vistas, recalling enemies of early narrative production in Germany who supported films displaying "the landscapes of the German fatherland, the characteristic beauty of the homeland."[8] The *Bergfilm's* celebrations of Alpine scenery echo the enthusiasms of eighteenth-century nature aesthetics and share the emphases of German Romantic landscape painting. The genre would become a major force in German film history: Continuities of casts, crews, sources, and titles link the *Bergfilm* with the blood-and-soil productions of the Third Reich as well as the homeland films of the Adenauer era. Arnold Fanck stands out as the great pioneer of the mountain film, a figure who influenced virtually all subsequent efforts in this vein. He trained both Luis Trenker and Leni Riefenstahl, initiating a host of important cameramen, including Sepp Allgeier, Hans Schneeberger, Albert Benitz, and Richard Angst, whose craft would make indelible marks on German cinematography through the fifties. With his preference for authentic locations, athletic daring, and technical resourcefulness, Fanck gained renown as a director of film crews, snowscapes, and seas of clouds.

Career descriptions suggestively proclaim that a heroic impetus shaped Fanck's self-understanding, thereby linking his wartime experience, scientific research, and textbook writing with his activities as a mountain climber, explorer, still photographer, and filmmaker.[9] He viewed himself as an artist whose popular productions brought modern times renewed reverence for nature's incomprehensible majesty.[10] An adversary of Hollywood's linearity and tempo, a filmmaker whose aesthetics accorded preeminence to "contemplation and meditation," Fanck recognized the inevitability of narrative concessions if his films were to reach larger audiences and thus ensure him a steady and continuing basis of production beyond the confined format and limited impact of travelogues and *Kulturfilme*.[11] After initial efforts of a purely documentary cast, his mountain epics assumed narrative contours and a fixed ensemble: high altitude locations, a collective of male comrades, climbers, and guides—and a prominent female presence.

In this way, the mountain film maintained a precarious balance between the expressive shapes of nature and the romantic triangles of melodrama. For Kracauer this blend amounted to an ill-begotten pastiche, something "half-monumental, half-sentimental" (257), an infelicitous mix of "precipices and passions, inaccessible steeps and insoluble human conflicts" (110). For all their masterful imagistic immediacy, these films are seriously inept—and misguided—in their negotiation of narrative terrain. Kracauer's topography, however, is not the most reliable guide either. It affords only a partial and somewhat cloudy view, leaving crucial points half-sighted or uncharted, obscuring how the *Bergfilm* inhabits dialectical fields of force and a much wider discursive territory in the Weimar Republic.

Reviewing the effective history of the mountain film, we cannot help being struck by the wide acclaim the genre received, from one end of the political spectrum to the other.[12] Not only venerated by reactionary and nationalistic sectors, the *Bergfilm* engaged a host of supporters on the Left, indeed finding there some of its most ardent partisans. The reviewer for the Social Democratic *Vorwärts* lauded *Der heilige Berg* (*The Holy Mountain*, 1926) and praised how Fanck "imparts to millions, both in Germany and throughout the entire world, visual delight [*Freude am Schauen*] and a heightened feeling for nature's vast and demonic powers."[13] The Communist Party organ *Die Rote Fahne* celebrated *Die weiße Hölle vom Piz Palü* (*The White Hell of Piz Palü*, 1929) as "undoubtedly one of the best German films ever," honoring the film's visual effects ("outstanding achievements of inordinate beauty and gripping suspense") and its realistic physicality.[14] A commentator in the same newspaper also spoke highly of *Avalanche*: "The director was able to visualize the power of nature (without any idyllic razzle-dazzle in its treatment of nature) in constantly changing, stirring images."[15] These accolades echo the jubilation we encounter across the board, be it in trade journals like *Film-Kurier*, *Lichtbildbühne*, and *Kinematograph* or in dailies like the *Berlin Börsen Courier*, *Berliner Tageblatt*, and the Nazi *Völkischer Beobachter*.[16]

The most eloquent and ardent advocate of the *Bergfilm* was the leftist Béla Balázs, who also wrote the script for Leni Riefenstahl's *Das blaue Licht* (*The Blue Light*, 1932).[17] In his article, "Der Fall Dr. Fanck," Balázs extols Fanck for his redemption of nature's countenance in an age of

instrumentality.[18] Fanck sensitizes mass audiences to the physiognomy of the organic world, granting mountains a subjective vibrancy, making them players in his dramas: "Natural elements become dramatic elements, living companions."[19] Balázs goes on to attack commentaries that impugn Fanck's sentimental narratives, characterizing such responses as a function of an effete and complacent *Sachlichkeit*.[20] Balázs's apologia is fueled by a desire to commune with a less functionalized reality, a nonsynchronous sentiment on which the Right surely had no monopoly. This sentiment bears much in common with Ernst Bloch's 1930 essay, "Alpen ohne Photographie" ("Alps without Photography"), a recollection of a monumental world both tangible and inspiring, an epiphany that grants towering peaks mystery and majesty, an uncanny, unsettling, and therefore all the more invigorating effect. Bloch challenges the reader to imagine an unmediated access to the sublime and to contemplate Alpine spaces untamed and uncontaminated by modern perspectives. (Consider today how we might stand before the Matterhorn if we had never seen a tourist bureau poster of it—or never been to Disneyland.) Bloch's "untimely observations" eschew sterile genre paintings and picture postcards that reduce nature to a miniature form and kitsch object, diminishing and thereby domesticating its demonic and transcendent aspect.[21]

In sum, the mountain films enthralled both Right and Left; they engaged and even involved progressive spirits, indicating common needs and shared desires that crossed party lines. No matter how radically Kracauer and Balázs differed in their assessment of the mountain film, both believed that cinema's calling lay in fostering a more direct experience of reality and a revitalized interaction with the physical world. "What we want," Kracauer would later say, "is to touch reality not only with our fingertips but to seize it and shake hands with it."[22] This fiercely held conviction may well explain why Kracauer—for all his ideological misgivings—could not fully deny the haptic frisson of the mountain film. These dynamics, at any rate, suggest that Kracauer's one-way street from the cult of the mountains to the cult of the Führer leaves out some crucial attractions.

The genre does not simply traffic in a virulent antimodernity nor does it only retreat to a sublime sphere beyond time.[23] Initial reviewers registered keen and acute awareness of the numerous temporal markers in the

Bergfilm. Besides snowscapes, billowing clouds, and unpeopled expanses, these films show us tourists, resort hotels, automobiles, airplanes, observatories, and weather stations. Weimar contemporaries frequently hailed the ability of Fanck's camera at once to hallow and to penetrate nature, to sanctify its secrets and still disclose its uncanny properties. There is no tension between the pristine world of the mountains and a surveying cinematic apparatus; rather, as the contemporary critic Fritz Walter remarked in his notice on *The White Hell of Piz Palü*, the two entities merge to offer scenes "in which the object and its filmic representation blend together in a remarkable, moving unity, in which the authentic, documentary, and real in fact take on stirring, sublime, and beautiful attributes."[24] Walter eulogizes a synthesis of mountains and machines, of natural force and technological power, of bodily energy and spiritual endeavor, all of which come together in a filmic hybrid, a merger between the physical world and the sophisticated scientific devices that measure and elaborate it.

Fanck revered technology as much as he did nature and constantly employed the most advanced machinery available.[25] Modern tools not only produce the sublime; they assume natural qualities: A reviewer of *The White Hell of Piz Palü* describes war hero Ernst Udet's airplane in the same sentence both as a "miraculous machine" and a "bird."[26] Fanck believed that nature remains mute and unexpressive unless captured by a camera. This persuasion is a striking variation on a theme of romantic transcendentalism, a modern restatement of Friedrich Schelling's conviction that man's awareness of himself and the world around him brings "the unconscious life in nature to conscious expression."[27] In this way, mediated effects become natural presence; formal will imparts to raw material its true identity; human machines render the real authentic.[28] The gaze of an optical instrument, in short, grants life and motility to an otherwise inert nature.

The well-known dichotomies between art film and genre cinema, between the avant-garde and mass culture, collapse when we speak of the mountain film. Besides their expressive visual patterns, these films display well-known romantic constellations, demonstrating an indebtedness to nineteenth-century landscape painting, modernist formalism, and melodramatic convention. Fanck was held to be both a cinematic pioneer and a crowd pleaser, as an appreciation of *Avalanche* in *Lichtbildbühne* makes

clear: "An exiting evening. Surmounting the peaks of Europe . . . the peaks of cinematic art. Only an exhilaration that takes people to the outer limits of human capacity can manage to stir our entire being in such a manner."[29] The visual impact of the mountain films rested in a blend of aura and abstraction. Fanck's images drew heavily on the iconography of Romantic painters and the impetus of artists like Caspar David Friedrich, Philipp Otto Runge, and Joseph Anton Koch to imbue landscapes with transcendent and mystical powers. The director's mechanically reproduced images aimed to rekindle in a contemporary mass (and vastly urban) public the "pleasant stirrings" Kant once described as the mark of the beautiful and the sublime.[30] The cinematic medium became a vehicle to simulate unmediated experience, a modern means of restoring premodern wonder and enchantment.

The human body acts as the sole point of comparison in Fanck's mise-en-scène of clouds and mountains; he leaves out anything that might relativize their ineffable proportions and diminish their monumental mass.[31] Nighttime torch processions across snowscapes mesmerize with the *Stimmung* of haunted screen chiaroscuro. Many of Fanck's works (particularly the early ski films) manipulate screen space and dynamize the frame with their ornamental flourishes, silhouette outlines, and expressive blocking. The camera glides and scrambles in his films with athletic dexterity and daring.[32] Scenes of downhill racers and enthusiastic onlookers reflect on the enthralling power of spectacle in a manner characteristic of many other Weimar films. On occasion, the montage of competition scenes gives way to an abstract play of angle, movement, and line, akin to the emphases of Oskar Fischinger and Walter Ruttmann.[33] Figures moving in nature assume geometric shapes and approach the realm of nonrepresentation. Fanck's images defy narrow cubbyholing: They defer to the painting of a previous century as well as to cinematic modernism, recasting nature in a dynamic array of expressive patterns.

Critics readily assented to the coexistence of mountain magic and modern machinery. They could not, however, accept Fanck's narrative constructions, consistently complaining that his romantic plots diminish otherwise-heroic male endeavors. In particular, the melodramatic scenes were seen as anathema to the stunning visuals. The reviewer for the *Berliner Tageblatt* uses biblical language to articulate his high regard

for *SOS Eisberg* (1933), going on to lament that "in virulent contrast to this divine work of nature, the film's contrived plot becomes here quite frankly a prime example of the human intellect's capacity for presumptuousness."[34] In his review of *The Holy Mountain*, Kracauer likewise lauds the film's visual effects, but only has sarcasm for its plot. "In some of the images," he remarks, "the malevolent spirit of story [*der Ungeist der Handlung*] has taken over."[35]

Recent scholars focus with enthusiasm on Weimar film's strained relationship between story and discourse, concentrating on its unstable, elided, and ambiguous narratives, and valorizing it as a significant deviation from the dominant cinema.[36] In mountain films, plot contents regularly take a back seat to pictorial interests. Domestic conflicts and triangulated desire provide at best a loose semblance of organization, binding a variety of nonnarrative elements to a basic scenario, whether they are protracted spectacles (competitions, races, torchlight processions), visual displays framed by advanced tools of seeing (microscopes, telescopes, binoculars, airplanes), or elaborate demonstrations of the modern media (particularly radios and telecommunication). For this reason, the *Bergfilm* abides as a blend of striking images and insipid stories. Fanciful, but not terribly complex, the mountain film seems to constitute a less intriguing by-product of Weimar cinema.

IV.

There is an undeniable discrepancy between the Weimar cinema we find in contemporary trade papers and the one we encounter in recent film historiography. Looking through the pages of *Film-Kurier* and *Lichtbildbühne*, we read about a heterogeneous film culture with a wide range of genres and formats, about matinee idols and mass audiences, and about a national cinema that produced two hundred—and at times many more—feature films annually.[37] Weimar cinema, seen from the perspective of an influential film historian in 1984, revolved "around the very existence of a strong authors' cinema, and the economic as well as ideological conditions that made it possible for Germany to develop a film industry which, for a certain period, included a prestigious thriving sector not primarily

or exclusively oriented towards a mass audience." This approach pares down a vast and unwieldy phenomenon, referring to a very small number of titles and directors, undercutting the wide variety of possibility represented even in extant holdings from the period, leaving us with a rarified art cinema in which personal style, avant-garde praxis, and formative experimentation dominate the scene.[38] A film culture's vigorous heteroglossia becomes transformed into a theorist's select gathering of authorial voices.

The *Bergfilm* was a cinematic praxis quite self-conscious of its double status as an artistic and a popular endeavor. Its appeal lay in a primal nature explored with advanced technology, in premodern longings mediated by modern machines. This is a genre in which visceral and visual pleasure meet, in which the haptic and the optic are of a piece. It reflects all of the romantic motifs, specular obsessions, and narrative peculiarities that Thomas Elsaesser views as singular to Weimar film. And yet, it transcends any apparent dichotomy between art cinema and mass spectacle, operating as a genre with its special emphases in tandem with a host of contemporaneous possibilities. It is hardly a surprise that we encounter numerous points of convergence and shared discursive spaces. To comprehend the *Bergfilm*, we must view it in the context of other Weimar fantasies that unreeled before audiences in the same movie houses.

Contemporary reviewers insistently described the *Bergfilm* in language virtually identical to that reserved for the film of the fantastic. Mountain films impart to natural forces an uncanny, threatening, and monstrous potential, rendering Alpine spaces in a gripping and frequently frenzied manner. A *Frankfurter Zeitung* review (not by Kracauer) speaks of a nocturnal procession of torches in *The White Hell of Piz Palü* as "uncanny, truly ghostly"; the clouds, likewise, "glide swiftly through the sky like brightly contoured ships of death." Fanck, claims the critic, captured "the seductive force and mysterious power which the mountains exude and which force people into an inescapable dependence. The mountain rages and demands sacrifices."[39] Writing in *Film-Kurier* about the same film, Hans Feld depicts the mountain as an angry behemoth (the formulation recalls the dragon facing Siegfried), a beast fighting for its life in a mythical

showdown.[40] In many phrasings, mountains take on the proportions of Nosferatu or destiny incarnate, an essence that is formidable, inscrutable, and inexorable. Inherent in the sublime experience of Alpine reaches rests a simultaneity of beauty and terror, of fascination and horror, of solace and peril.[41] There is a consonance between the expressionist impulse and mountain film narcissism; in both instances, the external world becomes a projection of inner forces and the embodiment of human propensity. In *The Holy Mountain*, Diotima talks to the climber Robert who has just returned from an Alpine excursion:

"It must be beautiful up there."
"Beautiful—severe [hart]—and dangerous."
"And what does one look for up there—in nature?"
"One's self!"

Bergfilme share with films of the fantastic an affective dynamic: Mountains and monsters come alive as functions of human projection.[42]

There is likewise a structured, indeed logical opposition between the seemingly dissimilar likes of the *Straßenfilm* (street film) and the *Bergfilm*, both of which figure crucially in Kracauer's teleology. The streets, roving males, and femmes fatales of the former correspond to the mountains, Alpine wanderers, and female interlopers in the latter. The phantasmagoria of the big city—as marked for instance in the protagonist's opening vision in Karl Grune's *Die Straße* (*The Street*, 1923)—finds its generic counterpart in high-altitude epiphanies. The city, like the mountains, is a perplexing locus of fascination and peril. In its more fearful countenance, the metropolis becomes associated with female eroticism just as the threatening aspect of nature relates to energies coextensive with female sexuality. This parallels the special relationship we find between monsters and women in the film of the fantastic, e.g., *Das Cabinet des Dr. Caligari* (*The Cabinet of Dr. Calgari*, Robert Wiene, 1920); *Der müde Tod* (*Destiny*, Fritz Lang, 1921); and *Nosferatu* (F. W. Murnau, 1922).[43] No single instance essentializes the inherent bonds between the two genres more strikingly than Luis Trenker's *Bergfilm* of 1934, *Der verlorene Sohn* (*The Prodigal Son*): A hero from the mountains languishes

in New York City after allowing himself to be lured abroad by a seductive American socialite; in the end, he will return to the homeland and take his place in a local community as a dutiful son and loyal husband. A single shot, a matched dissolve between the Dolomites and Manhattan skyscrapers, illustrates how Alpine reaches and urban edifices are mirror images. The *Bergfilm*, in short, appears as the *Straßenfilm*'s double.

In her provocative recent discussion of women and melodramatic representation in Weimar Germany, Patrice Petro privileges the melodrama—especially the *Kammerspielfilm* (chamber room film) and the *Strassenfilm*—as an expressive form concerned with everyday experience, questions of gender, and above all, female identity. She excludes the mountain film from her inventory of melodramatic possibility, however, maintaining that it reveals "different narrative emphases and visual preoccupations."[44] Weimar contemporaries, as we have seen, were quick to recognize melodramatic elements in the *Bergfilm*, viewing the romantic plot and heroine as irritations and disturbances. Taken as a corpus, press reviews localize the mountain film's appeal in its masculine authenticity, onscreen heroism that reflects behind-the-scenes feats of strength, the collective product of a male community of athletic actors, daring assistants, and feckless technicians. Wolfgang Ertel-Breithaupt's review of *SOS Eisberg* in the *Berliner Tageblatt* extols fearless outdoorsmen and their unflagging spirit of sacrifice while bitterly deploring how the actress Leni Riefenstahl undermines the film's monumental impact, diminishing documentary verisimilitude by dint of her histrionic presence. "In the midst of a horizontal setting larger than life," he complains, "this romantic silliness struck one as unbearable kitsch."[45] If there is a primary disruptive agency, it in fact emanates from woman.

Although Kracauer ridicules the *Bergfilm*'s plot contrivances and "inflated sentiments" (111), as we have noted, he strangely overlooks its ultimate source of melodramatic initiative.[46] Female players figure keenly in the generic economy of the mountain film; they represent and embody a spirit potentially inimical to male images, whether they are Fanck's imposing vistas or the inner landscapes of his heroes. We turn now to woman and her special effect on three exemplary mountain films, focusing on her relation to nature and the cinematic apparatus, and scrutinizing the place of gender in this genre.

The opening sequence of Fanck's *The Holy Mountain*, his initial collaboration with Leni Riefenstahl, rehearses the affective energies of the mountain film. The first title informs viewers that the film's physical stunts are authentic—not photographic sleight of hand. Our point of departure, as the credits point out, is a contradictory location, a scenario without spatial and temporal designation ("ort- und zeitlos"), which, nonetheless, has its roots in Fanck's Alpine experiences over two decades. The initial image, which follows the film's title, provides a glimpse of rocky peaks and an ocean shore. Later we will learn that this is an imaginary tableau, separate entities brought together in a special effect, discreet natural images whose blend produces an artificial (indeed, fantasy) landscape. The next title bears the ex-soldier male Fanck's dedication to "my friend who was killed in the war, the mountain climber, Dr. Hans Rohde." A personal loss and a battlefield casualty thus offer an additional point of departure.

After the title sequence, the film opens on an extreme frontal close-up of a woman's face. Her eyes are shut; we seem to be looking at a death mask. The subsequent introduction activates and animates her as an essence whose home is the ocean. The initially unnamed woman reappears, first as a silhouette, then as a special effect, a phantom image that arises out of coastal cliffs to assume corporeal substance. The central part of the prologue bears a title and gives the performer a name, proclaiming "Diotima's Dance to the Sea." Diotima is both a natural force and an energy harnessed by an apparatus: Her free ballet by the shore unreels in slow motion and her gestures parallel rhythmic cross-cuts of breaking waves. At the conclusion of her tribute, she looks out to the water and, in a reverse shot, we glimpse what she sees, a reprise of the film's opening shot—but with a difference. The Alpine peak slowly superimposes itself over an image of the ocean.

The film's master shot, the result of a special effect, becomes reproduced and reprojected as a female fantasy. Somehow, a deeper relationship abides between Fanck's camera and his female player's gaze; she, too, reappears as a superimposition. The artificial image that introduces the film becomes her mental creation, a merging of the fluid space by the sea (her homeland) with the mountain landscape, a topography at once

allegorical and erotic. The reiterated image dissolves into a further imaginary landscape, a phallic male outline seen from a low angle, a silhouette figure on top of a rock with clouds and sky behind him, a function of the dancer's intoxicated yearning.[47]

Diotima's fantasy catalyzes the film's story, which revolves around the energies her image and presence arouse in two men. Her evening performance in the Alpine Grand Hotel overcomes Robert (the climber in her dream image) and enchants Vigo, his young comrade. Distraught by the powerful feelings the dancer unleashes in him, Robert retreats into the mountains, as an intertitle puts it, "to gain control over the overwhelming impression." He will later come undone after witnessing another traumatic spectacle, the image of Diotima embracing another man, whom he will be shocked to learn is in fact his best friend Vigo. Robert's reaction is one of horror; he shuts his eyes and falls back, stunned and petrified. A close-up renders his face a death mask (and recalls our first glimpse of Diotima), cutting to a mental image of a mountain landscape that explodes with the force of his inner turmoil. The climactic pilgrimage into the stormy mountains with Vigo will lead to perdition for the unwitting romantic rivals who expire in the cold. In the end, Diotima stands by the ocean, alone with the recollections of Robert and Vigo.

If any logic sustains the narrative, it is the drive to tame, harness, and neutralize the inordinate power exercised by a woman. In a film introduced by male loss (the evocation of a fallen comrade) and in a narrative governed by Diotima's disruptive effect on two friends, we find an obsessive and recurring attempt to counter the stirring effect of a female image and body. The film begins with a death mask and ends with living death, Diotima languishing in sorrow and possessed by the thought of her deceased lovers. *The Holy Mountain* is a male fantasy, a dream about a woman whose sole occupation becomes dreaming about men. It is a film that confronts the fearful dynamics that ensue when men dream too ardently about a woman: Her image gives rise to powerful reactions and her gaze likewise has a remarkably arresting force. In this way, Diotima commands and distracts her male audiences, compelling them to react strongly. Robert sets out with Vigo on a suicidal climb, pushing his friend over a cliff when it becomes clear that the youth also loves the dancer. As Robert regains his senses, he grasps the cord on which Vigo's body

FIGURES 6.2 AND 6.3 Diotima, the dancer by the shore and her fantasy vision of an Alpine lover (Leni Riefenstahl and Luis Trenker in *Der heilige Berg/The Holy Mountain*, 1926).

FIGURE 6.4 Mourning overcomes Diotima; she retreats to the seaside and bemoans the deaths of the two mountaineers (Leni Riefenstahl in *The Holy Mountain*).

dangles, refusing to let go. The male bond persists in the stormy cold and the two freeze to death. The conclusion turns on Diotima in a ritualistic act of exorcism. Fanck transforms his female player from a woman whose agency has a special effect over the narrative to the special effect of a film, a zombie-like being characterized in the scenario's closing lines as "a dark, diminished countenance."[48]

<div align="center">VI.</div>

In numerous regards, mountain films reiterate scenes and images documented in Klaus Theweleit's well-known study of Freikorps subjectivity, *Männerphantasien*. Fanck's films, however, do not simply relegate women to the margins nor do they always succeed in reducing them to silence.

As a rule, *Bergfilme* render exterior nature and female bodies as spaces of exploration and sanctuary, mountains and women representing unpredictable and autonomous natural forces that attract and overwhelm. The panoramic arrest of sublime landscapes goes hand in hand with a desire to shape female presence and subdue its potential power. In this sense, both mountains and women are sites of a projective anxiety, a formative will, and an instrumental zeal, properties men revel in and at the same time fear, essences that arrest gazes and threaten lives, and elements that one tries to contain and control with the modern means at man's disposal—with mixed success.

Among all of Fanck's mountain films, no other title displays the coexistence of natural forces and modern technology as strikingly as *Avalanche*. Here, advanced tools permeate the text conspicuously, emphasizing a desire to measure and negotiate physical space with wind gauges, telescopes, radios, and airplanes, all of which play important roles in this narrative. The film has at its center the obligatory romantic triangle; Hella (played by Riefenstahl) comes between two comrades, a meteorologist and a musician, causing the former to despair and forsake the world when he learns that his friend also has fallen in love with her.

The female figure enters the film as a disembodied hand, which in a series of close-ups engages the massive machinery of an observatory. A cut to a fuller view shows the woman (only now can we specify gender) in a laboratory uniform gazing through a gigantic telescope. Later, she ascends to the weather station atop the Mont Blanc with her father, and we witness a scene in which two men wash dishes in the background while Hella peers through a microscope. She only cares about skiing and science, claims her father. "Oh well, girls nowadays. They're not good for anything." A subsequent passage suggests that there is a link between Hella's desiring gaze at the meteorologist and the catastrophic death of her father, as if her sexuality, somehow in harmony with the treacherous terrain, provokes the calamity. (The last thing the father sees is his smitten daughter walking with the meteorologist, a scene that causes him to look downward with a troubled countenance.) The narrative closes with a female hand in control of the situation, Hella lighting a fire while her admirer stands by paralyzed and incapacitated by the cold, a shot that reverses the film's initial image of male limbs warming themselves over a stove.

In *Avalanche,* a woman controls elements and instruments so conspicuously that the film prompted vehement critical demurs upon its release, impassioned protests that Hella's heroic rescue mission was utterly "improbable."[49] Precisely those factors—a woman masters the mountains in a storm and commands the narrative in its closing moments—render *Avalanche* not only an improbable film but also a symptomatic text. Hella is, as befits a fantastic entity, many things at once, a bundle of contradictory properties: modern scientist and athletic woman, sexless being and erotic projection, disembodied hand and nurturing presence. A figure introduced as an anonymous appendage, an individual who confounds fixed notions of gender, whose hands ultimately replace the male limbs that occupy the opening image, Hella represents the controlling interest of *Avalanche,* a film that suggests a connection between men's battle with external elements and their troubled relation to the opposite sex.[50]

VII.

In conceptualizing *The Blue Light,* Leni Riefenstahl wanted to create a *Bergfilm* in which a woman played a more prominent role than the mountains.[51] In so doing, she clearly recognized their paradigmatic equivalence in the generic economy. The result was, we recall, a cooperative production with the progressive Béla Balázs, who gave shape to the script and apparently played a considerable role in the direction.[52] Framed in a contemporary setting of tourism and automobiles, *The Blue Light* recounts a village tale for a modern audience, revealing the mechanisms behind the making of a myth and disclosing the psychosocial function of that text in the present. The story dramatizes the plundering of nature and the undoing of a woman, Junta (Riefenstahl starring in her directorial debut), stylizing the double violation in the form of a chronicle.

Much like Fanck's films, but even more emphatically, *The Blue Light* crosses borders and defies fixities. It involved a director who would become Hitler's premier hagiographer and a scriptwriter who was a respected leftist; it blends antimodern sentiment and a rational solution[53]; it combines romantic iconography, sophisticated technical innovation, and a generic framework. Riefenstahl's film mines the romantic legacy with the tools of

modernity, merging nature worship and instrumental reason, as well as a preindustrial world and the ways and means of the present.[54] The film renders a female outsider as a source of intense and dangerous fascination. A blue light (a quirk of nature caused by crystals illuminated by a full moon) issues from Junta's mountain sanctuary. The enchanting glow becomes virtually indistinguishable from her erotic attraction: Boys from the village, gripped by an uncontrollable urge, risk peril and find death in their attempts to penetrate the space that harbors the mysterious woman and the seductive beam. The film displays Junta as an (albeit unwitting) source of fatal temptation to the community's young males.

Junta's transformation into an icon comes in the film's concluding moments. A sublime property—both threatening and alluring—becomes an image and a commodity, a kitsch object hawked by children to tourists, a face framed by crystals which also adorns the cover of the popular village tale. Just as the townspeople mine her mountain retreat, they also recycle Junta, a metamorphosis that shapes disruptive forces—a fluke of nature and a strange woman—into more manageable forms. As Vigo, a painter from Vienna, stands over the expired Junta in the morning light, Riefenstahl's camera (in a matched dissolve) changes the once-vibrant character played by Riefenstahl into a stylized still image, the onscreen artist's gaze coalescing with that of the cinematic apparatus. A male look commanded by a female director processes Junta's countenance and body, transmuting the dead woman into a living legend.

The reconstitution of Junta in *The Blue Light* recalls that of Maria in Fritz Lang's *Metropolis* (Fritz Lang, 1927).[55] As Andreas Huyssen points out, the film demonstrates how woman can at once embody threatening nature and an out-of-control technology: The real Maria stirs the workers; the machine Maria runs amuck. In Patricia Mellencamp's account, *Metropolis* presents a frenzied series of projections. "There are actually four Marias," Mellencamp notes, machine, virgin, mother, and whore. "The crisis in the film is one of identifying the 'real' or *proper* Maria, of setting up the *proper* deployment of sexuality."[56] In *Metropolis*, woman becomes a special effect of a man-made desire machine, a site of attraction and a source of disturbance, the bearer of a compelling gaze and the bringer of intense confusion. Whether essentialized as maternal nature or projected as a destructive machine, Maria poses a threat. As the controlling

presence in the *Bergfilm* as well, woman exerts a force equivalent to both mountains and film. Like the former, she possesses for modern men an irresistible primal fascination, bearing powers that impassion onscreen beholders and lead them to self-surrender. Like the film medium itself, she exercises the captivating potential of an influential apparatus, acting as a medium of story and desire, indeed "der Ungeist der Handlung."

Let us, in conclusion, reconsider these three examples and ponder the generic economy of the mountain film. *The Holy Mountain* articulates a wish, namely that woman be recreated in the service of man. Diotima becomes a mourning machine, a "dark, diminished figure" devoid of any arresting potential or personal volition. *Avalanche* expresses the corresponding fear motivating that wish, the fear of emotional and erotic dissolution. The film ends with a woman's hand in control of the scene and the situation, an injured and frozen admirer looking on as Hella stands in and takes over. *The Blue Light* radicalizes the fantasy, enacting it not only in a filmic legend, but extending it beyond the realm of fiction, making the wish as it were come true. A woman stars in and directs her own fantasy of self-destruction, creating a film about the fateful sacrifice of a woman for the sake of a community, a martyr role cast in accordance with the painter's look that transmogrifies Junta into a mythical essence. In creating the film, Riefenstahl far exceeded her fictional calling as Diotima and Hella and became the consummate crafter of male fantasies, a person Hitler with some justification would later call the Third Reich's "ideal German woman." In *The Blue Light*, she is no longer just an actress who incarnates Fanck's distortions, but rather is a filmmaker who engenders, indeed enshrines them. With a gaze as intuitive and unconscious as it is radical, she fashions ineffably beautiful images of female abandon made to the measure of male desire.[57]

My comments on the *Bergfilm* figure within a larger research project of interest to me and a number of colleagues—i.e., an investigation of how Weimar Germany's complex interplay between modern and antimodern sensibilities found cinematic expression. In the mountain film, we confront a spirit of surrender and heroic resolve that, without a doubt, anticipates Nazi irrationalism. (Here Kracauer was correct—to a fault.) At the same time, it also reflects nonsynchronous energies active across the political and aesthetic spectrum in post–World War I Germany. This

exploration has shown how the genre forged a singular alliance between premodern yearning and advanced technology. Mountain films responded to German needs and gained the affections of mass audiences. It would seem that the *Bergfilm* became a popular genre both because of and despite its melodramatic contents. To ensure his films' increased accessibility, Fanck moved from pure documentaries to semifeatures. In the process, women came to serve as a narrative medium, the source of conflict and disturbance, in effect competing with the mountains for men's affections and attentions. To comprehend the mountain film, it is clear, we need to fathom the genre's inherently gendered constitution. Like other Weimar productions, but with more insistence, it enacts the male fantasies of a shattered and distraught postwar nation, casting women in a constantly shifting phantasmagoric role, making them at times a force of nature, at others a modern medium, and on occasion both. At any rate, they stand out—in the films themselves and in critical responses to the films—as a problematic force, the locus of ambivalent, contradictory, and quite volatile projections.

FIGURE 7.1 C. Hooper Trask, the Berlin correspondent for the *New York Times*, contemplated the lavish production costs for *Der Kongreß tanzt* (*The Congress Dances*, 1931), "an overwhelming figure to have spent on a film in post-war Germany, which is balancing so precipitously on the sharp edge of bankruptcy. All the more credit to the courage and enterprise of the Ufa in these dark and uncertain times."

TOO LOVELY TO BE TRUE

I.

The hallmarks of the silent era have without a doubt played a much more estimable role in historical accounts of German cinema than have the productions made after the coming of sound and the Nazi takeover. In most analyses, the films made in the Weimar Republic stand out above all by dint of the formal aplomb and intellectual appeal of "individually authored art films."[1] Commentators who share this influential persuasion applaud the masterpieces of Ernst Lubitsch, Fritz Lang, F. W. Murnau, and G. W. Pabst and focus on the mean streets, eerie spaces, and eccentric narratives of what Lotte Eisner calls "the haunted screen," from *Das Cabinet des Dr. Caligari* (*The Cabinet of Dr. Caligari*, Robert Wiene, 1920), *Nosferatu* (F. W. Murnau, 1922), *Dr. Mabuse, der Spieler* (*Dr. Mabuse, the Gambler*, Fritz Lang, 1922), and *Der letzte Mann* (*The Last Laugh*, F. W. Murnau, 1924) to *Metropolis* (Fritz Lang, 1927) and *Die Büchse der Pandora* (*Pandora's Box*, G. W. Pabst, 1928), along with other exemplars of the fantastic as well as street films, chamber room melodramas, and big city symphonies.[2] Despite its unquestionable status as a critical point of focus, this assessment has fostered, even if at times unwittingly, a partial and somewhat-occluded view.[3] A more inclusive approach would want to consider, along with the period's canonized

productions, its very substantial and, in numerous respects, significant body of genre films.

At first blush, most German sound features from the late twenties and early thirties seem to be decidedly out of sync with the harsh and harried *Zeitgeist*, a time of mass unemployment, economic instability, political unrest, and existential disquiet.[4] Indeed, the vast majority of genre films from the Weimar Republic's last years, especially the many musical comedies, would seem best characterized as *ungleichzeitig*, or out of keeping with the times.[5] In them, we behold performers who move with grace and ease, language that is perky and insouciant, and lavish set designs that bear few traces of grim realities. There is an intrepid vitality and an abundance of good cheer, even in the midst of crisis; despite imposing odds, the denizens of these fantasylands remain chipper and unflappable. Produced in a country that was dancing on a volcano, these films provide light fare for hard times. The situation may be hopeless, they suggest, but it is not desperate.[6]

In Weimar film musicals, which for the most part were operettas, bodies and spaces are constantly in motion; these symphonies of silliness celebrate transport and mobility. At the start of *Die Drei von der Tankstelle* (*Three from the Filling Station*, Wilhelm Thiele, 1930), a convertible hurtles down a country lane; the top is down and its male occupants are in the finest of fettles. Trees whiz by and the camera alternates between a whirring front wheel and a rear view from a side mirror. The entire scene unreels to the accompaniment of a spirited song ("Sunny day, lovely day/ Heart aflutter and the motor running!/Agreeable goal, agreeable start/ And a most pleasant journey") and a spunky score. *Quick* (Robert Siodmak, 1932) begins in an exclusive spa outfitted with state-of-the-art fitness machinery devised to make muscles taut and faces firm. The resort's fussy guests, fixated on the state of their health and pampered around the clock, devote their abundant leisure time to the pursuit of diversion. Echoing the dramatic prologues from Arnold Fanck's mountain films, *Die verliebte Firma* (*The Company's in Love*, Max Ophüls, 1932) commences with some dissolves over breathtaking panoramas. As the light musical treatment intimates, however, this first impression is illusory; after measuring the sublime immensity of the Alpine landscape, the camera narrows in on a singing romantic couple. This film about the

making of a film will quickly take leave of the authentic location and move to a studio setting.

These space-bending sound fantasies are intrepid time machines as well. *Das Flötenkonzert von Sanssouci* (*The Flute Concert of Sanssouci*, Gustav Ucicky, 1930) spirits us to Dresden in 1756, sampling conversations among a gathering of emissaries from countries conspiring against Prussia. The opening tracking shot lasts a full four minutes, granting us ample occasion to school our gaze in the play of signs and signals. Everything is coded here, we learn, even the musical accompaniment, so that seemingly innocuous phrases ("Isn't politics also a matter of not talking about politics?") assume political meanings. In *Der Kongreß tanzt* (*The Congress Dances*, Erik Charell, 1931), cannons mark the start of a new day at the 1814 Congress of Vienna. A voyeuristic camera sidles through a room full of people eagerly awaiting the latest developments. The most recent arrivals to the conference confirm that all of Europe is represented at the event; meanwhile, cannons continue to resound as nervous officials sneeze with equal loudness. From this antechamber, we move to Count von Metternich's bedside where, in a touch reminiscent of Ernst Lubitsch, world history takes place behind closed doors.[7] Over breakfast, the statesman monitors the vast proceedings via an elaborate network of minions and machines.

With great emphasis, these features implement the means of audiovisual reproduction, putting gramophones, radios, and projectors on conspicuous display. *Das Lied einer Nacht* (*One Night's Song*, Anatole Litvak, 1932) opens with the sound of a voice and the shadow of a microphone, which yield to the shadow of an announcer and then the shadow of a performer. A dissolve to a long tilt up radio towers is followed by another dissolve to an antenna on a building top and a pan across a window and into a living space. The mediated voice has, we see, found an audience, a dog sitting in front of a radio and listening to a loud male singer. The camera cuts seamlessly to a man with his mouth wide open—not a performer, but a patient at the dentist's office. There is an inordinate energy and irreverence in the subsequent cuts between places, faces, and spaces, as the film catapults from Vienna to Budapest to Bucharest; as a train travels through the night, we track the path of a telegram over the wires.

Einbrecher (*Murder for Sale*, Hanns Schwarz, 1930) takes us behind the scenes and offers a hands-on view of a technology that creates artificial worlds. The first shot provides a close-up of a singing torero, an animated figure redolent of a tale by E. T. A. Hoffmann, and opens up to a gathering of costumed cyborgs, stand-ins for the make-believe beings who inhabit the film we are about to see. A Walt Disneyesque *metteur en scène* directs the proceedings in a laboratory for mechanical puppets. Later in the film, a song reiterates the imaginary trappings of the world before us:

The dog looks alive,
The child speaks,
A world of simulations.
Everything moves in turns.
Inside her is only clockwork,
Not a heart.

II.

One might say, as Weimar contemporaries often did, that most early German sound endeavors were vapid and formulaic, indeed clockwork constructions without a heart.[8] Film studios certainly realized that this thought was on many critics' minds—and did not hesitate to acknowledge it. Toward the end of *Die Koffer des Herrn O. F.* (*The Suitcases of Mr. O. F.*, Alexis Granowsky, 1931), for instance, two executives from OTAG (Ostend Feature Film, Inc.) reflect on how their studio's new features might best respond to the strained economic climate. Their recipe for success is standardized light fare with only the most modest variations. The studio head gestures proudly to posters of coming attractions, featuring images of romantic pairs who will appear in future operettas: *Ich liebe, Du liebst, Er liebt, Wir lieben, Ihr liebt*—and, finally, to fill out this grand ensemble of six films, *Alle lieben*. And that is not all. There are also plans for similar productions with a martial aspect, as we see in a further profusion of posters: *Kasernenduft: Eine Tonfilm-Operette* (*The Aroma of the Barracks: A Sound Film Operetta*), *Kasernenzauber* (*The Magic of the Barracks*), *Es ist lustig zu marschieren* (*It's Fun to Go Marching*), and

Kasernenluft (*The Air of the Barracks*). In this economy, revue films coexist cozily with military reviews.[9] "A film with deeper meaning," maintains the studio boss, facing the camera in a close-up, "is of interest to no one. A film without deeper meaning is what a big city needs."

German features of the early sound era, outside of a few notable exceptions, have indeed been seen as lacking deeper meaning. Weimar cinema, by and large, is equated with the silent era before 1929; it has gone down in film history as a site of modernist endeavor that contributed substantially to international understanding of the medium's expressive potential and exercised an indelible influence on the very notion of what constitutes a film. Its chief significance for the scholars who established its critical reputation abides in its status as a "motor of modernity," as an entity that in crucial ways fueled Germany's belated and conflicted attempts to become a modern nation.[10] Features of the era at once enact and embody the tug and pull within this national body between the old and the new, between modern and antimodern initiatives. German films of the early thirties, apart from unquestioned masterpieces like Lang's *M* (1931) and *Das Testament des Dr. Mabuse* (*The Testament of Dr. Mabuse*, 1933), seemed in comparison devoid of substance and seriousness. If there is anything modern about early German sound films, it would seem to be their industrialized uniformity.

Even though comedies constituted a full one-third of the features produced during the Weimar era, they invariably take a back seat to German films of the fantastic, and they surely suffer when placed aside contemporary generic counterparts made in France and the United States. No German director of the twenties, beyond the young Lubitsch and, on occasion, Reinhold Schünzel and Ludwig Berger, receives particular recognition; discussions about German film comedies more often than not focus on performers.[11] Early German musical comedies do not hold up well when compared with works by René Clair, Lubitsch, or Rouben Mamoulian: *Three from the Filling Station* pales next to *Sous les Toits de Paris* (*Under the Roofs of Paris*, René Clair, 1930) and *The Congress Dances* is no *Love Parade* (Rouben Mamoulian, 1932). And the only German filmmaker who could rival Busby Berkeley's masses in motion would be Leni Riefenstahl. The popular early musical comedies, especially those produced by Ufa's Erich Pommer, frequently were chided as escapist and

negligible.[12] There were, to be sure, several realist films that addressed social circumstances and confronted unresolved political problems; *Kameradschaft* (1931) and *Westfront 1918* (1930) by G. W. Pabst and Slatan Dudow's *Kuhle Wampe* (1932) are often-noted exceptions to the rule. Josef von Sternberg's *Der blaue Engel* (*The Blue Angel*, 1930) had musical numbers, but no one would mistake it for a comedy. The much larger ensemble of films, it was—and often still is—said, sought to transform the gravity of reality into a kinder and gentler unreality. Lightweight fare (which did not necessarily have a light touch) was a preferred approach: operettas and revues, social comedies, romances, and farces with a folksy flair. "Again and again," Rudolf Arnheim writes about German film releases of 1931, "we note with dismay that we must flee into a void when we want to amuse ourselves."[13]

Three concerns have strongly inflected discussions of early German sound comedies. First, contemporary commentators met the coming of sound with suspicion, claiming, as did Arnheim, that it would mean the death of cinema as an art because its higher level of realism threatened to undermine "all the exceptional qualities of silent film that we had loved."[14] In a retrospective assessment, Siegfried Kracauer elaborated on how the presence of sound divested the image of its suggestive and evocative power. Verbal statements, he submitted, tend to articulate intentions, whereas camera shots apprehend the unintentional and the unspoken. Silent films probed "levels below the dimension of consciousness, and since the spoken word had not yet assumed control, unconventional or even subversive images were allowed to slip in. But when dialogue took over, unfathomable imagery withered and intentional meanings prevailed." He went on to note that both talkies and silent films contain ideological inscriptions, "although analysis of these attitudes is hampered rather than facilitated by the addition of spoken words."[15] Béla Balázs was sanguine that sound films might "teach us to analyse even chaotic noise with our ear and read the score of life's symphony"—in short, that they might train the human ear, just as silent films had trained the human eye.[16] Unfortunately, he later admitted, these great hopes would rarely find fulfillment in the sound era.[17]

A second complaint was that the sound comedies intensified film's powers of distraction. The Ufa musicals of the early sound era were seen,

in Arnheim's words, as film confections.[18] They appeal to "what is bad and stupid in man" and ensure "that dissatisfaction shall not burst into revolutionary action but shall fade away in dreams of a better world." These industrial commodities legitimate the status quo and stultify the possibility of collective resistance.[19] They fortify belief in the church and the power of capital; they also propagate the sanctity of marriage and the home.[20] According to Ernst Bloch, writing in 1929, distraction fuels emotion without creating momentum and "dams life back to nothing but youth, to inflated beginnings, so that the question concerning the Where to never arises."[21] Distraction is evasion, a deception "which is supposed to conceal the place and ground on which it occurs"; life becomes fully determined by the interests that govern the status quo: tedium by day, escape by night.[22] People come to regard their material limits and experiential lacks through the eyes of the powerful and big business. "In the evening, when lit, the dust of the day looks really colourful and alluring. This entices, but does not fulfil, does not create the desire for more genuine things, but for things that are always new."[23]

A third objection was even more emphatically political. The most prominent escapist sound comedies issued from Ufa, a studio owned by the media mogul Alfred Hugenberg and dominated, since his takeover in 1927, by his right-wing agenda. These productions colluded with nationalist and reactionary designs, increasingly so after Hugenberg, as chairman of the supervisory board, allowed his political predilections to determine the studio's direction. In 1930 the critic Hans Sahl spoke out against Hugenberg's upbeat panegyrics for the German military, his so-called *Zapfenstreiche*, saying that they agitated against reflection, transforming the sound film into "a German tragedy." Hugenberg, Sahl elaborated, "is fortunate in his control of a contingent of cinemas which permit him to add these films to the repertoire without drawing any attention."[24] The films that stirred the masses and provided emotional sustenance during the last years of Weimar, observes Klaus Kreimeier, were not leftist productions by Pabst or Brecht or Willi Münzenberg, but rather Ufa's melodramas, comedies, Prussia films, waltz fantasies, and barracks comedies. The progressives simply failed to understand collective dispositions and thus remained unable to satisfy the masses' inner cravings.[25]

Although sensitive to the objections of critics like Arnheim, Balázs, and Kracauer, recent commentators have suggested that we might approach the early sound films in less dismissive ways and regard them as integral parts of the Weimar legacy.[26] In reconsidering the significant exemplars of Ufa sound operettas made before the Nazi ascent to power, we in fact gain a sense of critical awareness and a decided self-consciousness; the films are very much sophisticated products of their times and not just regressive and, as such, symptomatic texts. If we put these works into dialogue with films of other genres, we encounter different answers to similar dilemmas, diverse strategies for dealing with times of crisis and the crises of the times. Seen together with other contemporary productions, these exercises enable us to comprehend the diversity of ways in which the Weimar Republic was both experienced and cinematically represented.[27] The seeming antagonisms of apparently nonsynchronous film artifacts, as Karsten Witte once observed, "can in fact produce historical insights."[28]

III.

In 1930, the German Reich was 1.7 billion Reichsmarks in debt, and four million people were unemployed. An article in the trade paper *Film-Kurier* in July 1931 related a question very much on the minds of Ufa studio executives: "What then would be more needed now than an offering of films that might lead audiences out of this spiritual vacuum and offer something that is both uplifting and distracting?"[29] *Three from the Filling Station*, produced by Erich Pommer, put this upbeat resolve into practice and became the most successful film of the 1930–1931 season.[30] A trio of friends (Willy Fritsch, Heinz Rühmann, and Oskar Karlweis) returns from a long vacation to find their servants gone and their belongings impounded. "Something very unpleasant happened during your absence," says their lawyer. An earthquake? they wonder. Or, maybe a change of government in Lippe-Detmold? This was after all a seismic time full of unpleasant surprises, particularly in Lippe-Detmold, where two years earlier the Nazis had won their first regional election. And in the state elections on September 14, a day before the film's premiere, the Nazis had

FIGURES 7.2 AND 7.3 The three "meshuganah musketeers" (Oskar Karlweis, Willy Fritsch, Heinz Rühmann) return home from a long vacation to bad news from their solicitor (Kurt Gerron) (*Die Drei von der Tankstelle/Three from the Filling Station*, 1930).

scored a decisive breakthrough. Asked if his wife perhaps might have had a blond child, the lawyer (played by a German Jew, Kurt Gerron) says no; things are "even worse than that: you're bankrupt."

The production registers the state of economic emergency and political turmoil, all the better to make light of it. Nonetheless, the rise of the Nazis and a tweak of Jewish anxiety do not go unacknowledged. The bankrupt trio remains unmoved by the challenge to their financial status; they bounce about in unison, cheerfully contemplating all the things they will have to do without, singing "Great God, we're bankrupt." Werner R. Heymann's five songs bring an undeniable vigor to the film, as does Franz Planer's intimate lighting (e.g., in the romantic duet, "Liebling, mein Herz lässt Dich grüssen"/"Darling, My Heart Sends Its Love to You"), fine touches that make up for Wilhelm Thiele's often clunky mise-en-scène (particularly his maladroit blocking and circus-ring staging) and the sometimes less than fluid editing. Hoping to recoup their losses, the three comrades sell their car and buy a filling station on a heavily trafficked road in the boonies. Sharing the chores of attendant, all three become enamored by Lilian (Lilian Harvey), a sprightly blonde in a shiny convertible, although only one of them (as casting policy dictated, her steady romantic partner Fritsch) will gain her favor.

Through it all, what the film speaks of as "the three meshuganah musketeers" never break a sweat; by no fault of their own, the sunny boys become executives in the Gas Station Corporation owned by Lilian's father. Even if reality intrudes in a brief documentary glimpse of the working day in a factory, this drab prospect is tempered by its protagonists' free-and-easy perspective: "We've seen work from the distance/And even from the distance it was not a pretty sight." As in many contemporary Ufa features, the pleasures of the male bond seem more compelling than the obligatory romantic union.[31] In the final moments, Willy (Fritsch) shakes hands with his friends and carries Lilian away from the scene. They pass through a curtain and suddenly stand before a spotlight. Looking into the camera, Lilian is astonished. There are people out there, she says, an audience! "Yes, indeed. A bunch of total strangers!" What are they doing there? What are they waiting for? Lilian quickly comes up with an answer: An operetta is not over until after the finale. To that end, the film offers a closing extravaganza in a protracted take that unites the entire cast of players.

FIGURES 7.4 AND 7.5 Willy (Willy Fritsch) and Lilian (Lilian Harvey) face the audience and the prospect of closure in the penultimate scene of *Three from the Filling Station*.

An altogether different "bunch of total strangers" occupies a shabby rooming house in Robert Siodmak's *Abschied* (*Farewell*, 1930); here, the impact of hard times becomes far more palpable and poignant. In this anti–Grand Hotel people live at close quarters; intrusions by strangers into private spheres and personal affairs are common occurrences. Everyone is at loose ends, albeit hopeful that things will get better. The film's key romantic couple sustains a candid conversation about their prospective monthly income, minutely calculating how, if all goes well, their savings will accrue over time and what that accumulated amount will mean for their future well-being. Siodmak's drama, which grants nary a glimpse of exterior spaces, presents a claustrophobic community of circumstance that negotiates dire straits. In the end, we see Brigitte Horney, who has just been left high and dry by her lover, sitting alone in a darkness of emotional devastation. This finale is anything but a celebration: "Everything in life is also like a song/Fading and vanishing, a farewell."

IV.

The haunting theme song of *Farewell* evokes the ephemeral and precarious nature of human endeavor: "How quickly we forget, what once was/ Nothing remains of everything that once was." The signature tune of *The Congress Dances* does something similar, albeit in a far more reassuring fashion: "Today all fairy tales become true/Today one thing is clear to me/That only happened once/That never happens again/That's too lovely/To be true." The catch phrase "Das gab's nur einmal" has now come to incarnate the nostalgic embrace of precious moments and past delights, a yearning for yesteryear's hit tunes or cinematic evergreens.[32] The past on view in this "superoperetta" (which cost a hefty 4 million Reichsmarks), directed by the master showman Erik Charell, is a simulacrum of Vienna, a site of court intrigue, of balls and waltzes, of sentimental schmaltz over Heuriger in Grinzing, and of Wiener Mädln and snappy marching cavaliers.[33] A love affair between the shop girl Christel (Harvey) and Czar Alexander (Fritsch) unfolds while the congress convenes. Hoping to distract Alexander from decisive deliberations, Metternich hires a seductive agent to waylay him; the czar in turn engages

the dimwitted Uralsky (also played by Fritsch) as a body double.[34] Christel and Alexander thus have time for assignations while the gathered nations plot Europe's future. Upon learning that Napoleon has returned to France, however, Alexander puts an end to the whirlwind affair and bids farewell.

Although the film was the uncontested box office hit of the season, it met with the extreme displeasure of influential critics. Kracauer deemed it "a senseless gathering of decorations"; in the name of amusement, the historical revue diverted attention from the true state of crisis and awakened "illusions and desires which can only serve the forces of reaction, and whip up a dust storm that totally blinds the audience."[35] Arnheim's assessment was every bit as harsh. It was a pity, he remarked, that members of the audience lacked the czar's power to deputize doubles: "I can think of people who would have liked to have sent stupid Uralsky to the film" in their place.[36] And yet, if *The Congress Dances* is an illusory concoction, it is one that makes no bones about its creation of illusions. Doubles stand in for characters in this fiction just as the film actors play their roles. The first view of Christel shows her responding to a foreigner's question: "Do you speak English?" No, she replies, which of course belies the contemporary spectator's better knowledge that the film star Harvey grew up in London. Metternich is a master surveiller, akin to Dr. Mabuse or Frederick the Great of *The Flute Concert of Sanssouci*, who at once monitors comings and goings as well as puts things in motion. In that way, his interventions enable the spectator's own sensory ubiquity; as a guiding hand, he also figures as an onscreen surrogate for the director. His panoptic point of view is primarily aural; from his bedside control center he requests to hear what is going on in a room, and we then see what he hears—and in this way both share and exceed his access to the flow of information.

The film's famous theme song exalts a lovely moment that has passed and will not return. This might be read as a celebration of nostalgia. If one considers the lines more carefully, it would seem to be a nostalgia for something that perhaps never really happened, for an experience that was "too lovely to be true"—much like the film we are watching, which glorifies cinema's powers of illusion and makes them transparent. Sights and sounds unreel in an unceasing flow of motion that seems real

FIGURE 7.6 Lilian Harvey as Christel in *The Congress Dances*: An infectious song about a magic moment accompanies a rousing coach ride through Vienna and into the countryside.

but is imaginary. Precisely at the moment when Harvey sings of things being "too lovely to be true," memorializing, in Karsten Witte's words, the "glorious promise of the *status quo ante*," costumed cable carriers enter the image.[37] The song describes this profusion of light and movement as "ein goldner Schein," which in German has a double meaning. This "golden gleam" renders things bright and brilliant, so much so in fact that it sometimes blinds us. In the film's rousing set piece, the song itself exerts a contagious appeal during its performance in and passage through a number of social spaces, from the city to the countryside, with a changing cast of classes singing the catchy lyrics and confirming the tune's irrepressible popularity. In the process, the film shows us the mediation of a self-conscious mass culture as well as revealing its illusory and false constitution, a dream machinery that openly acknowledges the spurious quality of its productions—"zu schön, um wahr zu sein."

As a fictional artifact that reveals its own sense of possibility and discloses its production of meaning, *The Congress Dances* was anything but unique. A number of Ufa operettas lay bare the cinematic apparatus and, in so doing, made it apparent just how self-consciously the studio's talented and sophisticated creators had crafted their productions. Ludwig Berger's *Ich bei Tag und Du bei Nacht* (*Day and Night*, 1932), in fact, unabashedly ironized Ufa operettas. In this regard, it was hardly an anomaly, for features that poked fun at film conventions, as Jörg Schweinitz argues, abounded during the Weimar era.[38] Nonetheless, for all his critical awareness, director Berger was surely unlike Brecht who espoused anti-illusionism in the name of political enlightenment. Indeed, Berger first gained notoriety as a filmmaker enamored of fairy tales, as his whimsical Cinderella adaptation, *Der verlorene Schuh* (*The Lost Shoe*, 1923), attests. He crafted escapist scenarios endowed with *Stimmung*, hoping to shed light on the "golden gleam" of Ufa's fantasy worlds and to provide a kind of enchantment in which spectators might find refuge without being blinded.

After his return to Germany from a disappointing three-year sojourn in Hollywood, Berger declined Ufa's offer to direct *The Congress Dances*. *Day and Night*, shot also in English and French, would become his masterpiece. Two denizens of Berlin share a bed in the same rooming house, but in shifts. Grete (Käthe von Nagy) works as a manicurist by day; Hans (Fritsch) waits on tables in an upscale nightclub. (If the disposition were reversed, quipped critic Willy Haas, "this would not be an operetta, but rather a moral tragedy.")[39] Grete and Hans meet by chance on the street, each mistaking the other for someone of a higher class station. The narrative's obvious destiny is the moment when the confusion of identities is resolved so that the two can sleep next to—rather than after—each other.

The narrative of *Day and Night* contrasts escapist fantasies with everyday pursuits and shows how they interact. Each morning on his return to his part-time lodgings, Hans walks past a cinema and talks to the projectionist Helmut. The film's opening sequence shows the start of *Dies alles ist Dein* (*All of This Is Yours!*), a Bombastik-Film production that outdoes any Ufa extravaganza (even *The Congress Dances*) in its excessive escapism

and opulent over-the-topness. Helmut is enthusiastic about the new release, quoting an approving critic on how this "real-life fairy tale" makes clear that "the golden moment" will one day come to all of us. Grete, likewise, repeatedly compares her everyday life to what she sees at the cinema and seems happiest when the two overlap so that things "are just like the movies." Hans is not smitten by screen fantasies and, suspicious of being taken in by anything or anyone, considers films to be hogwash (*Schwindel*). Negotiating between these poles of naive acceptance and cynical reason, Berger's feature presents a modern world in which the mass media is an integral part. We hear popular songs emanate from projectors and phonographs as well as radios, so incessantly that we readily understand a landlady's complaint that "hit tunes are spreading like the plague." In one's waking encounters, characters carry the movies with them. During an outing to Sanssouci, Hans and Grete manage to get locked in the music room of Frederick II. When they hear a flute being played, it is as if the ghost of the Great King were present, albeit in the form of a reprise from Ufa's Prussia film of several seasons back with Otto Gebühr, *The Flute Concert of Sanssouci*. While in the castle, the couple also sees Expressionist shadow plays straight out of Murnau or Lang. The reality of their world (and this film) reminds them (and us) of other films.

The reality that *Day and Night* represents, however, is also that of contemporary Berlin. Although the film was shot almost without exception in the Babelsberg studio, it provides a primer for the navigation of modern times and urban spaces. Characters dwell in part-time quarters that are anything but cozy or commodious. We see a glimpse of Hans's wallet, which is all but empty. Again and again we view price tags and hear characters talk about how much things cost and how one cannot afford them.[40] We encounter a swank bar from the perspective of a waiter who works there rather than that of its well-heeled patrons. Berger depicts the uneasy facts of everyday life that give rise to fantasies; he also shows various ways in which the producers of mass culture respond to and capitalize on collective dreams of a better world. The film legitimates the necessity for imaginary spaces that take people away from their vicissitudes and dissatisfactions.

Many Weimar films, both sound and silent, insistently and persistently interrogated the medium of cinema and disclosed the constructive capacities and abusive powers of a nascent mass culture. In the final shot

FIGURE 7.7 The final shot of *Ich bei Tag, Du bei Nacht* (*Day and Night*, 1932): The film fantasy ends. For the Weimar contemporary leaving the cinema, life goes on and reality continues.

of *The Cabinet of Dr. Caligari*, we quite literally see double and cannot determine whether the figure of authority is a benevolent doctor or a homicidal lunatic. Karl Grune's *Die Straße* (*The Street*, 1923) revels in the enticements of urban life in the form of a cinematic experience and at the same time demonstrates the perils of such seductive spectacles. Ironic epilogues leave us with all too happy endings in *The Last Laugh* and *Geheimnisse einer Seele* (*Secrets of a Soul*, G. W. Pabst, 1926). Lang's *M* exhibits how urban subjects apprehend increasingly abstract living spaces through visual and verbal mediations—which the film itself makes apparent are usually inconclusive and, as such, quite often unreliable. Ufa's early sound musicals, to varying degrees, represent self-conscious exercises in wishful thinking where a yearning for distraction coexists, not always amicably, with the reality principle.

Day and Night ends where it starts: at the movies. During the pyrotechnic finale of *Dies alles ist Dein*, the camera tracks down rows of delighted

viewers and fixes on a smiling Hans and Grete; they go in for a kiss as the lights come up and the audience rises to leave. We cut back to the screen and, while the curtains close, see *Ende* before the image darkens. If you are looking for succor, this Ufa comedy suggests, one can find it in cinema's illusions, but only for fleeting moments; for lasting happiness, one must look elsewhere. In these late-Weimar productions, fantasies of a better life gained fulfillment in the form of conciliatory reveries that clearly were marked as fictions and therefore not meant to be taken seriously. For all its regressive properties, observed Kracauer, distraction possesses a truth potential: It has the power to expose the world's true state of disarray and fragmentation rather than masking it.[41] These early sound comedies surely do not go quite that far in their pursuit of distraction; they do, however, mark the limits of make-believe and caution the spectator not to confuse cinematic illusions with social solutions.

FIGURE 8.1 In the rubble film, the shapes of war ruins often resemble Alpine landscapes (*Die Mörder sind unter uns/The Murderers Are Among Us*, 1946).

THE MANAGEMENT OF SHATTERED IDENTITY

I.

Shots of devastated German cities provide stirring vistas in postwar rubble films (*Trümmerfilme*). As low-angle compositions frame monuments of destruction against the vastness of cloudy skies, the shattered expanses of a depopulated metropolis assume the countenance of natural landscapes. Indeed, at times the jagged shards of broken buildings bear an uncanny resemblance to the craggy contours of Alpine peaks. It is therefore surprising that discussion of these often-studied works rarely has granted their most conspicuous shapes and spaces sustained or close attention.[1] To say that rubble plays a prominent role in the rubble film is both to state the obvious and yet to articulate an insight generally underacknowledged or overlooked by scholars. The *Trümmerfilm*, particularly the seminal exercise in this vein, Wolfgang Staudte's *The Murderers Are Among Us* (*Die Mörder sind unter uns*, 1946), also figures in a much larger history of rubble representation.

II.

The postwar rubble in Berlin had a different appearance than that in Frankfurt, Hamburg, or Dresden. Modern Berlin, notes Wolfgang Schivelbusch,

was less a conventional city than a city machine in which advanced technology did not simply work over old structures, but rather constituted the urban space's prime substance. Unlike other German cities, Berlin was in large part a product of the nineteenth and twentieth centuries; for that reason, steel skeletons undergirded much of its architecture. The capital's buildings (even its conventional edifices from the baroque to the Wilhelminian eras) were so massive that they better withstood bombing during World War II than those in other cities. The metropolis, reported Isaac Deutscher in September 1945, had been pulverized but not flattened.[2] Decimated Berlin maintained two visages: a vertical one in which towering ruins stretched into the sky and a horizontal one of vast open fields, the so-called steppes.[3] In *The Murders Are among Us*, it is the former that dominates.

Strictly speaking not a genre, the rubble film is rather a cycle of feature films produced in Germany between 1946 and 1949 that confronts postwar realities. Spanning a number of narrative formulas and employing a variety of styles, *Trümmerfilme* share a historical situation, a production context, and a political mission. With Germany's film industry out of commission, its studios demolished or seized, and many of its key figures compromised by their Nazi-era activities, the first movies after a year's hiatus (the so-called *Filmpause*) bore the mark of material shortages and artistic uncertainty. Shot largely on location with only restricted amounts of film stock, these films arose under the close control of the Allied occupiers, with different approaches at work in each of the four military zones.[4] Rubble films took stock of a shattered nation and registered a state of physical and psychological ruin.[5]

Exercises in the management of shattered identity, the first German features after World War II display an uneven blend of constructive initiatives and critical agendas. They try to envision a better future and work beyond (if not through) the experiences of the Third Reich, a past that, in crucial regards, refused to go away. Their new designs for living responded to the otherwise-grim outlooks of demoralized and homeless people. Regardless of the genre format, Germans usually appear as victims or rescuers, rarely as perpetrators.[6] Guilt belongs to the parties responsible for the misery of average German citizens and the desperate postwar situation. Although Hitler is referred to on occasion, his name is

never mentioned expressly in any of the rubble films. Despite his striking absence, the former leader's legacy is ever present. Exercises in moral rearmament for a population jaded by years of Nazi rule, these tales offer refresher courses in abiding verities and virtues. Above all, argues Gertrud Koch, the rubble film seeks to foster reconstruction by reinstilling a work ethic and reaffirming the importance of diligence, honesty, punctuality, moderation, and the belief that human beings should recognize and serve a higher power.[7]

Previous commentators as a rule link the *Trümmerfilm* to various period styles such as expressionism, neorealism, and on occasion film noir, suggesting formal affinities and historical relationships. The influence of expressionism marks a departure from the polish of Ufa productions under Nazi rule and a recourse to the venerable legacy of Weimar's "haunted screen"[8] with its lighting effects, animated objects, and eccentric angles, as well as its fixation on the mute world of objects and fascination with city streets. To be sure, one does find stylistic correspondences in select features from the late Hitler era, exemplars of aesthetic resistance, such as Helmut Käutner's *Romanze in Moll* (*Romance in a Minor Key*, 1943), *Große Freiheit Nr. 7* (*Great Freedom No. 7*, 1944), *Unter den Brücken* (*Under the Bridges*, 1945), and Peter Pewas's *Der verzauberte Tag* (*The Enchanted Day*, 1944), somber mood pieces atypical of the period in which disaffected individuals seek a better life outside of the community.[9] Neorealism would seem to add an international dimension to what we might otherwise think of as the cycle's German *Sonderweg*. There is a common penchant for location shooting (this is also the case for many early films noirs that probe the subterranean reaches and nocturnal haunts of urban spaces) as well as a shared emphasis on the facts of empirical existence and the importance of human solidarity. Both rubble films and neorealist productions suggest that a changed world demands new ways of seeing and different means of representation.

Contemporary debates repeatedly contrasted the *Trümmerfilm* with the *Traumfabrik*, pitting a cinema grounded in reality against a cinema of illusion. The designation *rubble film*, lamented Helmut Käutner, all too quickly became an epithet. This, he elaborated, was the sorry result of unwillingness among German audiences to accept films that probed the aporias of their history.[10] On January 4, 1947, an article appeared in *Der*

Spiegel with the title, "Voices from the Orchestra and the Balcony: People Don't Want to See Ruins." With such an abundance of grim prospects in daily life, why should depressing images also occupy the precious few spaces reserved for German art?[11] Postwar filmgoers eschewed rubble films and instead favored Hollywood features (both reprises and new releases) as well as evergreens from the Nazi era. In Rudolf Jugert's *Film ohne Titel* (*Film without a Title*, 1948), a scriptwriter describes the iconography of a rubble film ("Dusk. Ruins from below. Pan. A bar in the ruins.") as we see the obligatory askew angles, harsh lighting contrasts, and rundown spaces. The passage, based on Käutner's script, affords a self-conscious parody. By 1949, commentators declared that the age of the *Trümmerfilm* had passed. During the subsequent decade, rubble would all but vanish from the screens of German cinemas.

III.

Even though a host of documentaries made in East Germany right after 1945 had chronicled life amid the rubble,[12] Staudte's film was the first postwar German feature to do so. "Berlin, 1945," reads the opening image of *The Murderers Are Among Us*. "The city has capitulated." The narrative relates the homecoming of a broken man to a broken city. Hans Mertens, a shell-shocked former soldier, lacks the desire to resume work as a physician and get on with his life. How can a landscape of rubble become a site of *Heimat* for this depleted *Heimkehrer*? Mertens shares an apartment with Susanne Wallner, who has spent time in a concentration camp but has emerged with a fresh outlook. Unlike Mertens, she seems all but unburdened by her past experiences. In a series of flashbacks, the source of his malaise becomes initially audible and in the end fully visible. He cannot forget the brutal murder of innocent men, women, and children in Poland on Christmas Eve of 1942, an act of violence against which he protested but ultimately witnessed in silence. When he learns that the superior responsible for the massacre, Captain Brückner, is thriving as the prosperous owner of a factory, he reacts with rage and despair. The specter of the past, in the form of traumatic memories and the presence of a murderer, debilitates Mertens and prevents him from finding happiness

with Susanne. Only her last-minute intervention will prevent him from taking revenge on his former tormentor.[13]

Staudte's scenario stemmed from a wartime experience. An SS officer had called him a "communist pig" and threatened to kill him. What would happen, Staudte wondered after the war, if he were to meet the man now? Staudte circulated his script[14] among the cultural attachés of the four occupying powers. After rejections from officials in the British and American zones, Staudte finally found support from the Soviets. Even though he was not a communist, his unabashed hatred for the Nazis confirmed Russian antifascist resolve.[15] As a result, the first postwar German film would be made in the Soviet sector and bear the imprimatur of the Deutsche Film-Aktiengesellschaft (DEFA) studio. It premiered in Berlin on October 15, 1946, fourteen days after the convictions of twenty-two major war criminals in Nuremberg and a week before the resulting twelve executions were to be carried out.[16] More than six million people saw the film; it would go on to be screened in twenty-three countries,[17] which was unusual as most rubble films did not travel abroad and, when they did, they did not travel well.

Many German critics lauded the film as a path-breaking endeavor; one described it as a work that brought the viewer face to face with "German reality, our reality" and offered a tour "through our clouded psychic landscape."[18] Commentators also praised the film for its return to the legacy of Weimar cinema.[19] Friedl Behn-Grund, the cinematographer, received commendations for his stunning compositions and chiaroscuro lighting touches. Most reviewers granted that the film was a noteworthy effort even if they found reasons to fault it. According to Wolfdietrich Schnurre, the work failed to confront reality directly; instead, Staudte diverted attention from the truly miserable state of things with heavy-handed symbols. Nonetheless, the critic concluded, *Mörder* marked a bold beginning.[20]

Subsequent commentators, especially since the sixties, have faulted the *Trümmerfilm* for its fuzzy universalism and maudlin self-pity, its response to the question of German guilt with lame humanistic slogans and feeble assertions of good will. The majority of East and West German features from 1946 to 1951, submits Thomas Brandlmeier, are more successful in disclosing mental and spiritual residue than they are in probing German history.[21] This is not to say that these films fail to confront the past. A large

number of them in fact flash back to the years between 1939 and 1945. (With the exception of Staudte's *Rotation* [1949], however, films in this cycle do not revisit the prewar phase of the Third Reich.[22]) These acts of retrospection are very selective in their terms of remembrance; more often than not, they beg questions of responsibility and pay little attention to the true victims of German violence.[23] By and large, the rubble film is more concerned with moving forward than with looking back, with reconstructing the nation rather than reconsidering its past.

In crucial regards, the rhetoric of *Trümmerfilm* criticism anticipates that of W. G. Sebald's "Air War and Literature," particularly his objection that German authors aestheticized the aftermath of aerial attacks instead of carefully registering "the true state of material and moral ruin in which the country found itself."[24] The remnants of destruction from the closing years of the war, rather than being fathomed directly and palpably, filtered through the "half-consciousness or false consciousness" of writers primarily concerned with resuming their careers. Sebald celebrates exceptions to the rule like Hans Erich Nossack and Alexander Kluge, whose work focuses on the cataclysmic results of what he terms "the natural history of destruction." The latter notion is, without question, strangely at odds with Sebald's own call for a dispassionate chronicle of "real conditions."[25] For all his insistence on soberly attending to signs of violence, Sebald's "natural history of destruction" turns away from a national history of violence and fixes on a state of annihilation that appears to be the work of natural forces instead of human agents. This diversion of the gaze resembles what Sebald in another context castigates as "looking and looking away at the same time."[26] Such a shift of focus is, as we shall see, quite common in the rubble film.

IV.

One film produced right after the war scrutinized the rubble of Berlin at length and spared the viewer metaphorical contrivances. *Ein Tag im Juli* (*A Day in July*), a silent, fifty-minute documentary made in Kodak color during the summer of 1945, offers a symphony of a bleak city.[27] It was the work of U.S. Signal Corps personnel rather than a German crew.

Extended tracking shots capture ground-level panoramas of wasted residential buildings in front of which women clear away debris. A long take traverses the Kurfürstendamm, passing by the shells of former businesses and checking out pedestrians dressed up for an afternoon walk before stopping in front of a Café Kranzler that has seen far better days. We glimpse a clock in front of the Bahnof Zoo stuck at two minutes to twelve. Protracted aerial views, from a camera placed where Allied bombs once rested, reveal a former capital that resembles a phantom zone. The American plane soars over streets and buildings just as Hitler's aircraft had a decade earlier in its approach to Nuremberg at the start of *Triumph des Willens* (*Triumph of the Will*, 1935). The camera claims this landscape for the victors, reworking prominent German documentaries from the Weimar and Nazi eras and in the process updating German history.

The opening minutes of Billy Wilder's *A Foreign Affair* (1948) also mimic Hitler's descent from the clouds to the Nazi Party Congress. We even see a plane, like the Nazi leader's, cast a shadow over the city. The sequence takes stock of German destruction, reviewing a barren landscape while American politicians discuss the alternative futures of the Morgenthau and the Marshall Plan. "They ought to scrape it plumb clean, put in some grass, and move in a herd of longhorns," says one congressman. "I say build up their industries and get those smokestacks belching again," responds a colleague. At once looking back and looking ahead, Wilder, an Austrian-born emigrant and an American occupation officer, self-consciously mimics the celestial prologue of *Triumph des Willens*, replacing Riefenstahl's camera and Hitler's gaze with a regard that is in equal measure awestruck and constructive.[28]

Nazi *Kulturfilme* celebrated architectural grandeur and hailed Germany's cities of the future; the era's features very rarely included footage of war ruins. *Trümmerfilme* would frankly exhibit what wartime movies by and large had sought to conceal: the amount of destruction caused by Allied aerial attacks. Rolf Hansen's *Die grosse Liebe* (*The Great Love*, 1942) was unusual for a film of 1942 in that it acknowledged nocturnal air raids and showed life in bomb shelters. The protagonists of Käutner's musical, *Wir machen Musik* (*We're Making Music*, 1942), turn to viewers at the film's end and remind people to darken their windows. In Werner Klingler's *Die Deggenhardts* (1944), a family from northern Germany closes ranks

and stands steady as the war takes its toll on the home front. The final sequence contains elaborate images of destroyed buildings and churches in Lübeck after a particularly severe air raid in March 1942.

More typical of the time was Veit Harlan's *Opfergang* (*Ride of Sacrifice*, 1944), which begins with prospects of an intact and picturesque Hamburg, which stood in dramatic contrast to the shattered city in which the film was made and would be screened. Gerhard Huttula, an Ufa studio technician responsible for back projection, found his services increasingly in demand. If German filmmakers wanted to do a scene in a train compartment against an urban background, Huttula would be called upon to provide special effects in the form of "Rückprobilder" which might sustain the illusion of an unshattered world. As Hans-Christoph Blumenberg explains: "The more that war devastated Germany, the more Huttula's division became important for Ufa."[29]

In the final phase of the war, Joseph Goebbels commissioned an Ufa production on an immense scale, modeled after *Gone with the Wind* (Victor Fleming, 1939) and *Mrs. Miniver* (William Wyler, 1942). The only way to mobilize a shell-shocked populace, believed the minister at this desperate moment, was to bring people face to face with the harsh facts of reality. *Das Leben geht weiter* (*Life Goes On,* 1945) would celebrate the unbroken will of German families despite the horror and devastation of daily air attacks. From the fall of 1944 to the spring of 1945, the director Wolfgang Liebeneiner worked on what was to be a paean for total war. Although no footage remains, the existing storyboards offer vivid tableaus of vast destruction. The closing sequence of the script relates how "from these ruins, life will begin anew." We see burned tram cars, torn electricity cables, collapsed bridges, and a bombed-out train station. People clad in shredded and besmirched clothing walk down the street wearing goggles and gas masks. In this endeavor, Huttula was sent out to capture location footage of the immense damage. According to the cameraman Günther Anders, Liebeneiner would seek to hide the footage of Goebbels's grand rubble film so that after the war it might be transformed into an anti-Nazi production.

Many years later, Alexander Kluge and Peter Schamoni would make *Brutalität in Stein* (*Brutality in Stone,* 1961), a twelve-minute short that contrasts the decayed remnants of Nazi structures in the Nuremberg

Zeppelinfeld with the pomposity of Speer's edifices and the giganticism of Hitler's architectural fantasies.[30] The Nazi garbage pile of history provides a testimony in stone: The heroic style, monumental appeal, and large scale of depleted and unfinished structures bear witness to misguided grand illusions. This short documentary recollects shards and reflections of a collective dream, juxtaposing the fragments of today with the immodest designs of Nazi city planners, refashioning historical debris into a deconstructed museum of memories. Kluge's rubble film is a parody of a Nazi *Kulturfilm*; it begins with a shot from Kurt Rupli's *Das Wort aus Stein* (*The Word of Stone*, 1939) and concludes with images of building material, rocks, and ruin. These views reveal what is left of the fascist legacy and, in so doing, poignantly enact Theodor W. Adorno's project of dealing with memories of offense and catastrophe by working through them.

V.

Adorno's famous radio lecture of 1959, "Was bedeutet: Aufarbeitung der Vergangenheit?" ("What Does Coming to Terms with the Past Mean?"), reflected on Germany's still-unresolved relation to the legacy of National Socialism. Have German attempts at public enlightenment, he asked, truly succeeded in addressing a legacy of shame? Or has the insistence on revisiting history been met only with stubborn resistance?[31] The German survivors of World War II faced the formidable task of rebuilding their national community. As agents and symptoms of this reinvention of Germany, the rubble films remain historical artifacts, cinematic counterparts to the postwar era's philosophical "panoramas of cataclysm," particularly the influential interventions of Friedrich Meinecke and Karl Jaspers.[32] These cinematic scenarios, in keeping with popular sentiment, reaffirmed Meinecke's belief that fate had brought upon Germany a great catastrophe. They surely did not support Jaspers's conviction that Germans needed, with all due rigor and integrity, to acknowledge and atone for Nazi misdeeds.

German culture, maintained Meinecke, had emerged from the war fundamentally intact, despite "the monstrous experiences which fell to our lot in the twelve years of the Third Reich."[33] The central project

of postwar reconstruction would be to revitalize the venerable heritage of *Geist*, to restore culture and religion, and to create societies of Goethe venerators that might convey "the most vital evidences of the German spirit" (Meinecke, 120). Meinecke tells how a "frightful catastrophe" (Meinecke, 1) burst upon a noble nation. In Hitler, an "unholy man," "there lay something foreign to us Germans and very difficult to understand" (Meinecke, 58). Precisely because Hitler and the Nazis represented an "extraneous factor in the course of history" (Meinecke, 57), Germany still retained, in spite of what had happened, a sound culture that could not be held responsible for the misdeeds of a small circle of criminals. As in the rubble films, Meinecke's emphasis rests on the German vicissitudes that came in the wake of apocalyptic events. Here, too, we find a contrast between the many who have suffered and the guilty few who have caused the suffering. Indeed, Meinecke distinguishes between the healthy "we" and the murderous "they"—in other words, the murderers were among us.

Speaking from an altogether different perspective, Karl Jaspers declared that Germans could not simply banish the shadow of the past.[34] How, though, might a "pariah people" revive itself, particularly if all that Germans now have in common are negative features? How is a gathering of helpless and atomized individuals ever to become a community (Jaspers, 18)? People in distress, he noted, want to find hope and comfort, not to hear about the past and be burdened with guilt (Jaspers, 27). In his insistence that all Germans pose the question of their guilt and answer it forthrightly, Jaspers represented a rare voice. During the war, virtually everyone suffered losses of family and friends, Jaspers acknowledged, but how one lost them resulted in greatly different inner attitudes. Contrary to the Manichaeism of Meinecke, Jaspers saw substantial distinctions among those who had suffered, depending on the conditions of their suffering. Nonetheless, he posited a community of victims who shared a common situation and faced similar challenges. How is one to remake the world, and on what basis, when everything seems tainted and poisoned (Jaspers, 114)? There was a catastrophe (here, too, Jaspers's perspective is fundamentally at odds with that of Meinecke) and for it Germans bear the greatest responsibility. As individuals, he maintained, "we should not be so quick to feel innocent, should not pity ourselves as

victims of an evil fate, should not expect to be praised for suffering. We should question ourselves, should pitilessly analyze ourselves: where did I feel wrongly, think wrongly, act wrongly—we should, as far as possible, look for guilt within ourselves, not in things, nor in the others; we should not dodge into distress" (Jaspers, 114–115).

The *Trümmerfilme* issued from the same state of emergency that had produced Jaspers's call for ethical, moral, and political renewal. The vast body of rubble films, like their German audiences, chose to ignore Jaspers's proposals. The protagonists of these features do not assume responsibility for the past; instead, they view themselves as objects subject to higher powers. "We can't do anything," says a figure in Rolf Meyer's *Zugvögel* (*Migrating Birds*, 1947), "things simply happen to us." These films employ a jargon of authenticity that enlists an impersonal destiny as time's driving force and in so doing disavows the subjective factor in history. "I saw a few people," says the voice-over narrator of Käutner's *In jenen Tagen* (*In Those Days*, 1947). "The times were stronger than they were, but their humanity was stronger than the times." The temporal and geographical indeterminacy of titles (Gerhard Lamprecht's *Irgendwo in Berlin/Somewhere in Berlin*, 1946; Harald Braun's *Zwischen Gestern und Morgen/Between Yesterday and Tomorrow*, 1947; and Josef von Baky's *Und über uns der Himmel/And the Sky Above Us*, 1947) likewise corresponds to the cycle's larger retreat from the disturbing topographies of recent experience.[35] Meinecke's blend of fatalism and existentialism was the preferred response to the catastrophic state of things; Jaspers's call for critical self-reflection and exhaustive soul-searching remained most decidedly a minority opinion.

VI.

As reflections and symptoms of a spiritual wasteland, rubble films were anything but singular. The tangible presence of ruins dominated postwar urban life in Germany and also served as a frequent object of photographers and painters. There was, not surprisingly, a profusion of rubble photography by artists like August Sander, Henry Ries, Max Baur, Richard Peter, and Ewald Gnilka. And these images gave rise to

heated debate. Heinz Lüdecke's Marxist intervention of 1948 in the East German journal *Bildende Kunst*, for instance, considered how photography might represent ruins in an appropriate and a responsible way. Max Baur's "Schloßruine in Potsdam" ("Palace Ruins in Potsdam"), Lüdecke complained, turns heaps of ruins into a romantic vista. Leaves flutter in the wind and clouds billow in Baur's atmospheric panorama of a shattered palace: "Memento mori su specie aeternitatis." The tableau, anachronistic in its painterly grandeur, transmutes history into a fetish object by concentrating on fragments and not providing a sense of the larger whole, i.e., the Prussian militarism and German war that literally spawned this image. (These thoughts bring to mind Susan Sontag's larger concern about how "our very sense of situation is . . . articulated by the camera's interventions," which may well disarm our historical judgment.[36]) Like the film theorist Béla Balázs, Lüdecke stresses the importance of the "Einstellung," a word that at once connotes a frame, a mental attitude, and a worldview. The correct "Einstellung" is the appropriate fix on things; it is in equal measure a formal and a moral disposition. When images of what is ("Abbilder") yield to metaphorical semblances ("Sinnbilder"), we gain art but lose reality. A photographer needs to remain sober and find the proper relationship, both spatially and intellectually, to what stands before the camera.[37]

How might one best describe Staudte's "Einstellung" vis-à-vis the rubble of Berlin? A well-known image from the opening sequence of *The Murderers Are Among Us* comes to mind, a glimpse at a phantomlike facade framed by a cloudy sky (3:40).[38] This spellbinding take seems to represent what Sebald castigates as "the temptation to make the real horrors of the time disappear through the artifice of abstraction and metaphysical fraudulence."[39] Anyone who transforms the remnants of destruction into an aesthetic reverie lies, argues Lüdecke, because this rubble is a sign of violence that was caused by German aggression: "The consequences of the Second World War are neither idyllic nor romantic."[40] Similarly, Sebald rails against "the construction of aesthetic or pseudo-aesthetic effects from the ruins of an annihilated world." Like Lüdecke, he lauds approaches that are concrete and documentary rather than abstract and imaginary and that provide a sense of "the facts that stare straight at us in the language of those professionally involved in the horror."[41]

A subsequent image of a falling building maintains a compositional symmetry (25:02). The back of the edifice gives way, but the facade remains standing. Swirling dust imparts a *frisson* to the fractured structure, shrouding it in a haze that renders the background barely visible. "No stage decorator," to recall a reproach from Lüdecke's essay, "could have done it more effectively."[42] Staudte's camera, remarked the film critic Werner Fiedler, "creates stirringly beautiful landscapes of ruins." In the process, "incredible painterly effects come into view . . . A wall collapses—hopes fall to pieces. Clouds tower over the ruins—difficult memories darken a countenance. One stumbles, fumbles, and staggers between images and symbols."[43] A contemporary report described how Staudte had combed Berlin trying to discover a location with the most visually arresting ruins. Happening upon a devastated block that made an especially striking impression, he instructed laborers working there on a burst water pipe "not to wreck anything."[44] One image stands out in Henry Ries's collection of Berlin postwar photographs because of its, for the artist, uncharacteristically surreal look. The nocturnal view of rubble with contours and corridors of light in fact derives from Staudte's film set.[45]

Contemporary critics like Friedrich Luft attacked Staudte's images for their heavy-handed symbolism. The director, maintained Luft, should have spared viewers metaphors cloaked in shadows and been more concerned with capturing scenes of clarity and verisimiltude.[46] In this regard, it is striking that later commentators have not followed Luft and regarded the film's often-noted meeting of expressionism and neorealism as a potential conflict of interests, as a formal tension between the desire to probe the secrets of the soul and the wish to picture everyday life amid the ruins. André Bazin praised neorealism because it stripped away expressionism and eschewed montage, granting viewers "a sense of the ambiguity of reality." Although all cinema involves some level of artifice, neorealism—rather than imposing meaning—exercises a formal restraint that allows the world to retain its integrity and richness.[47] All things considered, Staudte's formal approach has little in common with neorealism. What the filmmaker reveals would seem to be more staged than found. Rather than redeeming reality, the rubble film stylizes and transfigures it.

Architectural discourses right after the war, according to Schivelbusch, elaborated how, in a reverse dialectic, the destruction of Berlin might give rise to new configurations that would bring the city and country together. Martin Wagner imagined that the former metropolis could become a homeland, a synthesis of *Stadt-Land-Kultur*, of modernity and nature.[48] The rubble of Berlin might be understood as a signifier of a vanquished modernity, except we would have to add that the modernity of the former asphalt city was brought down by the modernity of war technology. At first glance, it would appear that Staudte's film, in keeping with the backward movement of the natural history of destruction, retreats from modernity and recasts the ruins of the city machine as an atmospheric spectacle with the sublime grandeur of towering mountain peaks.

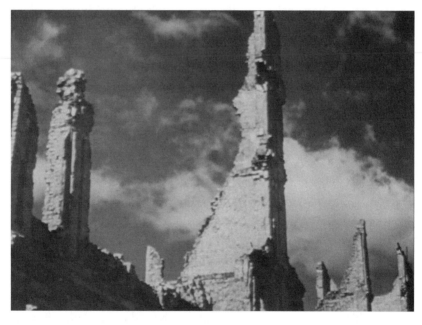

FIGURE 8.2 "In nearly every weekly newsreel we saw the mountains of rubble in places like Berlin and Hamburg, which for a long time I did not associate with the destruction wrought in the closing years of war, knowing nothing of it, but considered them a natural condition of all larger cities" (W. G. Sebald, *Vertigo*; image from *The Murderers Are Among Us*).

Staudte's *Trümmerbilder* contain more than a trace of baroque *vanitas* in their implied contrast between former greatness and present devastation; there is also something altogether romantic in their evocation of *Stimmung* and the uncanny. They are, as Peter Schjeldahl has said of paintings by Caspar David Friedrich, "shuddery pleasures, laced with something cold and weird."[49] No question, they are aestheticized, at times downright symbolic or allegorical. This does not mean, as Lüdecke might charge, that they remain incapable of making German history visible. The art historian Annie Bourneuf has shown compelling links between Friedrich's romantic landscapes and August Sander's postwar photographs of a vanquished Cologne. Consciously echoing Friedrich's *Rückenfigur*, Sander often aligns the gaze of the spectator, either overtly or by suggestion, with a vantage point that peers at the city from the top of a fractured edifice. The spatial position of an ethical watcher who looks out over the ruins of war corresponds to the temporal position of a witness or a judge. In their sharp, even hyperreal, focus on the details of destruction, Sander's cityscapes (like Friedrich's landscapes) present themselves as the function of a singular vision. In Bourneuf's estimation, they "draw attention to the seer and lead the viewer to align himself with this seer."[50]

The symmetries in Staudte's view of the shards of buildings described earlier are anything but arbitrary. They are a function of an aesthetic choice that also has determined the placement of the viewer: The director employs composition as well as editing to readjust and complicate how we see what we see. The image in question is preceded by a glimpse of a poster, an element that initially does not stand out in the busy long shot of a crowded waiting room. The camera will, with great emphasis, narrow in on the image and render it the key focus of compositional attention, framing it doubly, between the blasted out windows and human presences that appear on each side. The two figures, an old refugee and a crippled returned soldier, will recede and allow for an unobstructed view. The poster's vertical composition finally assumes center stage before seguing into a matched dissolve of the rubble ridges. This transition, although visually seamless, is aurally disjunctive. The clang of cymbals provides the sonic equivalent of an exclamation point. The rubble appears like a barren ridge of mountains; unpeopled and atmospheric; both foreground and background not separated by a middle space; the jagged shards of

edifices neatly framed in a medium long shot from a low angle. One shard assumes the center of the composition, and on each side, we see three smaller shards, in a symmetry reminiscent of Friedrich's work with its blend of the made and the found.

In gravitating toward the tourist poster of Nuremberg that bears the caption, "Das schöne Deutschland," the camera turns the viewer's focus to an artifact of *Heimat* discourse. As a reminder of the site of the Nazi party rallies and a recollection of shots from *Triumph of the Will*, it becomes an overdetermined ideological signifier. The camera dissolves from a tight view of this idealized vision of former glory to an image of an altogether different Germany, presenting a harsh history lesson and a causal relationship that are underscored by a percussive touch—as if to say that these lies led to these results. That the view of rubble has a distinct beauty of its own does not subtract from its disturbing quality; if anything, the majesty of the image heightens the grotesque irony of the contrast.

The subsequent course of German film history would, at least in the Federal Republic, dramatically reverse the sequence of these two images, in effect negating the emphatic critique inherent in the jarring clash between their before-and-after views. The *Trümmerfilm*'s panoramas of destruction with their spiritual void and material lack will yield to the *Heimatfilm*'s more soothing pastoral panoramas. The features of the Adenauer era will take leave of the rubble film's *Albträume* and embrace the *Alpenträume* of a *Schönes Deutschland*. Bleak prospects of a world without shelter will give way to a vast abundance of homeland films in the fifties with their intact communities, countryside havens, and flourishing cottage industries. Enacting the structured opposition between the terms *Zusammenbruch* and *Neubau* (collapse and reconstruction), homeland films will function as movie-made *Neubauten*, temporary domiciles, mass-produced and quickly created for displaced and disfranchised masses.[51]

VIII.

The opening shot of *The Murderers Are Among Us* presents an askew glimpse at an apparently inebriated Mertens walking down a path between mounds of refuse and mountains of ruins (1:20). In the foreground stands

a grave, behind which we see playing children—reminders of the wages of war coexisting with energetic signs of life. The compositional tension anticipates the film's dilemma: how is one to shape a future amidst this present and in the face of such a disastrous past? Mertens pauses for a second and turns around before entering *"Das moderne Cabaret,"* a sanctuary that promises *"Tanz Stimmung Humor,"* a deferral of present challenges and an escape from past horrors (2:10). The film's point of departure portrays a detour into a locus of alcoholic abandon, sexual indulgence, and honky-tonk music.

Already in the film's initial image, rubble assumes the double guise of a commanding physical presence and an objective correlative for a man who is an utter wreck. In this regard, rubble functions like the imposing mountains of the *Bergfilm* that, as Balázs points out, possess the distinct physiognomies of "living companions."[52] In *Der heilige Berg* (*The Holy Mountain,* 1926), the climber Robert witnesses his best friend being embraced by the woman of his dreams and reacts with shock and fury. An Alpine landscape blows up on the screen, an externalized reflection of his mental turmoil, a psychic eruption caused by the radical gap between an overpowering experience and the virtual breakdown of a human psyche that is unable to fathom this immensity. Rubble, likewise, becomes a character in its own right that is linked to a human drama and the narrative trajectory. A close-up of Mertens accompanies subjective sounds that replay his experiences of war and destruction. As the camera dissolves to an image of rats and ruins (45:34), Mertens's face and eyes spill over into the rubblescape. The camera tilts up from the rodents to the walking ruin who turns around and staggers drunkenly down the street. In this *Trümmerfilm*, rubble is more than just metaphoric or symbolic; it is often anthropomorphic.

Painfully dejected, completely uninvested, unable to love or work, plagued by disgust and nausea, Mertens enters the film as a textbook example of Freudian melancholy. The camera frequently shows him walking through the rubble, a realm of the abject in which he, viewing himself as a pariah, seems far more at ease than in his flat. At one point, the camera tilts up to reveal Mertens's disheveled silhouette and the ravaged building above him, as if the two shapes were parts of a whole (18:56). Mertens is a prodigal son who has come back to Germany, but he has not found a place to call home. "Did I say I felt comfortable here?" he snaps at Susanne.

"House, house!" he screams at his elderly neighbor Mondschein. "Cracks in the walls! Holes in the floor, the windows all boarded up, and the water dripping all the way down to the cellar." He is ruined because his mind is shattered; his traumatic experience in Poland has fundamentally altered his personality. His harrowing past will reappear in a series of flashbacks, memory fragments that the audience, drawing on its own collective experience, is called on to piece together.

The film's initial sequence also shows a second return. Susanne (the role that made Hildegard Knef famous) emerges from a train station, a ray of light amid a dark mass of distraught refugees and displaced persons (3:00). Released from a concentration camp, where she has spent the last three years of the war, she makes a beeline for her former residence, her makeup intact and her spirits undaunted. No sooner has she reoccupied her apartment than she goes to work clearing away the debris (22:13). For her, the past is not an issue; she is willing and able to leave it behind.[53] From the beginning, her movements and gaze are directed to what is before her. For Mertens, her flatmate, the past is a disease; it afflicts him like a merciless virus. Susanne seeks to comprehend his disaffection by piecing together the fragments of his disturbing memories.[54] She discovers the letter that establishes Mertens's link to Brückner and the wartime act of violence. When she chances on Mertens's journal, she realizes why he seeks revenge against his former superior officer. The facilitator of the memory work that will enable Mertens to confront and overcome the cause of his melancholy, she also intervenes and appeals to his ethical conscience. Mertens's shadow briefly merges with that of his former officer, and Mertens too almost becomes a murderer. Interrupting the attempt on Brückner's life, Susanne calls Mertens to order: "We have no right to pass sentence." His shadow recedes (78:55), and, now restored, he agrees with her, adding that "we have the obligation to call the guilty to justice, to demand atonement on behalf of millions of innocent people who were murdered."

IX.

The mission of the *Trümmerfilm* lay in clearing away the rubble, restoring human agency, and creating the conditions for a future community.

Toward that end and in a striking recast of the classical myth, Susanne plays a Eurydice who leads her Orpheus away from the realm of the dead and back to the world of the living.[55] (Egon Netenjakob aptly likens her to "an angel that returns unscathed from a KZ."[56]) In the film's opening sequence, she walks past a shattered statue of a mother and child, untainted and mute witnesses of war's violence (3:53). She will make posters redolent of Käthe Kollwitz's work that proclaim "Save the children!" Unlike Mertens, she will never again stand under the sway of the rubble during the course of the film. An angel of history in reverse, she has none of the awe and horror of her counterpart in Walter Benjamin's work because her gaze points in the opposite direction: Her aim is to escape a bad history and, in Staudte's narrative, no blast from the past will impede her progress. The eyes of this "woman in white" focus on the road ahead.[57]

An uneven and gendered division of labor governs the film's vision of German reconstruction: For the couple (and, by implication, a new civil society) to form itself, the broken man must look back to exorcise the images of horror that haunt and possess him. History becomes a male problem, and woman serves as the midwife who delivers man from its burden. Literally and figuratively a *Trümmerfrau*, Susanne clears away the rubble, both the bombing debris in the flat she shares with Mertens and the residue of the war in her lover's psyche. Mertens's working through the past certainly has little to do with what Jaspers or Adorno had in mind. The film makes visible what he cannot bear to see, but needs to see, if he is to restore himself, resume work as a physician, and become a husband and a father. At issue is a German war crime (the thirty-six men, fifty-four women, and thirty-one children shot in Poland on Christmas eve of 1942) as well as Mertens's self-understanding as a German citizen and a moral being. The deaths that he beholds are not his doing, but the act of violence torments him—particularly the feeling of shame that he was present while crimes were committed in the name of Germany. He is *not* one of the murderers; the distinction is anticipated in the title and essential to the film's project. Mertens looks at the past and reckons with the guilty party so that he might salvage a better self.

The telos of the narrative is for Susanne and Mertens to take leave of the past so that they might occupy a rubble-free future. This hopeful prospect is rehearsed in a night scene in which the couple walks through

a passage of ruins, the ridges of structures in the background carefully lit to provide the most striking impression (35:30). First viewed in long shot, the figures stroll toward the camera, providing both at the level of composition and perspective exact antipodes to the *Rückenfiguren* of August Sander's rubble photographs. Mertens and Susanne, having progressed to the foreground, look offscreen and up in the direction of the spectator. They step ever closer to the camera, until their bodies finally blot out the rubble and take over the frame (36:30).[58] As the characters extricate themselves from the ruins, Mertens articulates the hope of once again becoming a whole person who is capable of love. This dream of restoration, both of living spaces as well as human minds and bodies, is the rubble film's manifest destiny, a fantasy of an intact national corpus that will, of course, find its definitive incarnation in the *Heimatfilm*.

X.

The vast majority of postwar German feature productions, as commentators often have noted, rarely acknowledged the Holocaust. Only a small number of rubble films, in keeping with overarching Allied directives meant to foster cooperation and minimize resentment among an occupied populace, would speak of the Shoah or portray victims of the camps.[59] Rather than simply faulting German filmmakers for their many oversights and lapses in this regard, however, future scholars might want to consider more carefully, on a case-by-case basis, the significant role played by Allied occupiers in filtering and censoring the *Trümmerfilm*'s images of the Nazi past. Staudte's feature contains a sequence that, in the context of subsequent domestic productions during the next three decades (particularly in the Federal Republic of Germany), stands out as singular and bold. A stark image of silhouetted ruins against a cloudy sky fades to a newspaper headline seen in close-up at the frame's center: "2 Million People Gassed," and below, "Report from a Concentration Camp in Auschwitz" (49:58). The two shots confront the viewer with the inescapable facts of German history (both the site and the report of a crime) and at the same time inscribe the onscreen perspective of a perpetrator who is indifferent to the awful truth. The camera tilts up

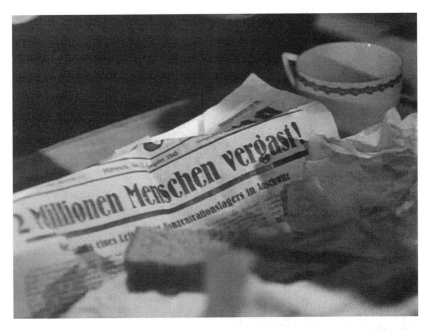

FIGURE 8.3 "2 Million People Gassed": an explicit acknowledgment of Nazi genocide (even if Jews are not mentioned, Auschwitz and concentration camps receive notice), a rarity in postwar German features (*The Murderers Are Among Us*).

to a medium frontal close-up of Brückner, who, in a take that lasts a full twenty seconds, eats his lunch with gusto, blissfully oblivious to the newspaper in front of him—which to him, as the composition reveals, is only sandwich wrapping. Brückner does not see the headline nor does he want to take notice of the rubble. He later will complain about its irritating ugliness, insisting that "the best way to get to know it is to ignore it." Like Mertens, Brückner is a *Heimkehrer*. But unlike Mertens, he feels at home precisely because neither physical nor psychic ruins have a place in his prosperous new existence.

Brückner embodies an unwillingness to mourn, which is not to say that he has no memories; he fondly recalls "the golden days of freedom in a grey uniform." Owner of a flourishing factory that recycles steel helmets into pots and pans, he anticipates the psychopathology of the economic wonder that never looks back but instead occupies itself, in the words of Alexander and Margarete Mitscherlich, with the

"expansion and modernization of our industrial potential, right down to the kitchen utensils."[60] He is, in the double sense of the word, shameless: He feels no shame and he has no shame. Confronted with his murders, he insists that he is innocent while the camera positions him behind bars and the loud music indicts him. He is condemned both visually and aurally while Mertens is exonerated. By working through his trauma and relinquishing his desire for revenge, Mertens comes to recognize himself as a victim and to disassociate himself from the perpetrator. For that reason, his final words can assume the moral high ground of a responsible citizen speaking in the name of those who have suffered unjustly. The closing procession of victims of the past consists of an old woman and two children, and two wounded German soldiers. There is no indication of Jews or any non-German victims, neither here nor in the closing vista of graves and crosses.

FIGURE 8.4 In a play of shadow redolent of expressionist chiaroscuro, Mertens (Ernst Wilhelm Borchert) reckons with the perpetrator Brückner (Arno Paulsen), all the better to disassociate himself from German war crimes (*The Murderers Are Among Us*).

Staudte's film was far less unsettling than Hanus Burger's *Die Todes-mühlen* (*Death Mills*, 1945), an Allied documentary that put German atrocities on view and circulated widely during the course of 1946, seeking to impress on people their nation's collective culpability.[61] The work had such a devastating and disturbing effect on German audiences that Americans officials withdrew it and refrained from further exercises in shock pedagogy. According to Aleida Assmann, these stark images made it impossible for Germans (even if they dismissed the film as Allied propaganda) to disavow or ignore the reality of the camps.[62] *The Death Mills* compiled and publicized incontrovertible evidence of violence and genocide committed under German auspices. Mandatory screenings of the film, Assmann argues, catalyzed a trauma among the nation's citizens—a function of their shame and not their guilt.[63] This trauma was less a response to murders committed by Germans than it was a reaction to the fact that the film had made unspeakable war crimes a matter of public record and in so doing had exposed and shamed the German nation.[64] "Our disgrace," remarks Thomas Mann, "stands in open view before the eyes of the world."[65] *The Murderers Are Among Us* acknowledges German war crimes, but unlike *The Death Mills*, it denies any collective German culpability for these crimes. Even the *Trümmerfilm*'s most acerbic revisitation of the Nazi experience, which Staudte's film arguably is, seems most noteworthy for the still-resonant way in which it delimits and reframes the question of German guilt by focusing on the effects of German suffering.

The Murderers Are Among Us resonates differently and strongly in light of Sebald's essay and the recent revival of interest in German wartime and postwar hardship. Seen in this light, the film is hardly dated; it remains, in fact, quite topical. It does not so much describe as reshape and stylize Germany's "state of material and moral ruin" (in Sebald's words) in the hope that it might be overcome. For that reason, the customary comparison with the verism of neorealism is in a crucial regard misleading. The first feature film made in postwar Germany beholds the physical destruction of German cities and repeatedly equates it with psychic devastation, suggesting how heavily the past weighed on some, although not all, citizens. Two sorts of ruin become intertwined, the rubble on the streets and the ruin in a returned soldier's mind, material damage and mental wreckage that have been caused by external forces.

Rubble, a signifier of destruction, assumes a mythic status within a vanquished nation's fantasy of reconstruction. Myths, as Roland Barthes tells us, may well naturalize. Sebald's "natural history of destruction" is a problematic notion precisely because it revives a long-standing German form of mythical thinking that defers to fate and destiny rather than the power of human agency. It remains, in Andreas Huyssen's acute formulation, "closely tied to metaphysics and to the apocalyptic philosophy of history so prominent in the German tradition and recoded in a variety of ways in the postwar period."[66] My endeavor has been to historicize the myths at work in rubble films, especially in their status as histories of destruction and compensatory scenarios whose rhetoric continues to exercise a pronounced influence on present discussions.

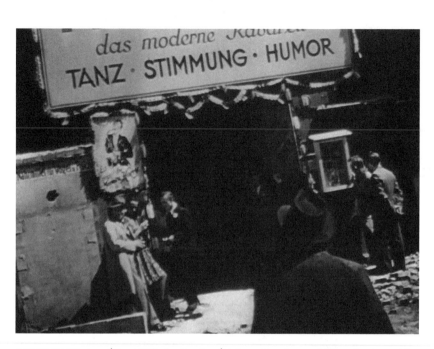

FIGURE 9.1 Mertens (Ernst Wilhelm Borchert) takes refuge from rubble and ruin, seeking diversion in "The Modern Cabaret" with its promises of dancing, good cheer, and humor. Postwar film features made in the Federal Republic of Germany would to a great extent follow this lead (*The Murderers Are Among Us*).

AFTER THE WAR, BEFORE THE WALL

I.

The first postwar German feature, Wolfgang Staudte's *Die Mörder sind unter uns* (*The Murderers Are Among Us*, 1946) beholds the ruins of a shattered city. Its opening shot fixes on a dazed man walking through a decimated landscape; in the foreground we see a grave, in the background playing children. The stark composition visualizes a temporal tension and enacts a historical dilemma: Given such a calamitous past, how is this man (and men like him) to get a grip and, unless he (and they) do so, how is Germany to have a future? The initial films made in a vanquished and now-divided nation, a phantom zone of disorientation and shell shock, address this challenge. As the shot continues, the returning soldier, plagued by harrowing recollections, turns a corner and walks into a nightclub that promises entertainment and distraction. In the end, *The Murderers Are Among Us* will leave this place behind as its hero confronts the past and faces present responsibilities. Future films made in what will become the Federal Republic of Germany (FRG) for the most part will not take their cue from Staudte. Rather, they will seek to elude troubles and banish traumatic memories.

II.

The rubble films (*Trümmerfilme*) of 1946 to 1949 would give way to a profusion of homeland films (*Heimatfilme*). The shift of perspective would take viewers from sites of devastation, both physical and psychic, to consoling prospects of verdant countrysides and intact village communities. "What we lack is joy," reads the credo to Curt Goetz's *Frauenarzt Dr. Prätorius* (*Dr. Prätorius*, 1949). "What we need is hope. What we really need is optimism. What we crave is good cheer. What we thirst for is love." West German films of the fifties provided such reassurances in abundance, sustaining a war-weary public that was hungry for affection and security. The most prominent genres, beyond the *Heimatfilm*, were problem films, melodramas, military comedies, historical costume epics, literary adaptations, musicals, and travelogues. The films of the Adenauer era (1949–1963) would offer sanctuary and diversion for the denizens of the newly constituted FRG.

III.

West German features of the fifties were, in many senses of the phrase, homeland movies. They were made for displaced persons who knew what it was like to be without a domicile, who sought shelter in an occupied and divided country. The citizens of the FRG were eager to return to a normal life, but they had no clear sense of what normalcy might mean in a nation that had never sustained a democracy and in an ideologically split world where atomic war often seemed both inevitable and imminent. The cinema of the Adenauer era played a crucial role in the restoration of Germany; it both accompanied and participated in the economic miracle. In the wake of quickly gained prosperity came increasing consumer opportunities as well as a flurry of fads and trends. Adenauer-era films document the modernization of an occupied country; they take us into households that increasingly sport American appliances; they record the impact of television and tourism; they display a new wave of motorization. These film fantasies offer important historical documents. They show us the power of wishes and the persistence

of illusions; they provide make-believe resolutions to serious conflicts. In that regard, these features provide a valuable chronicle of the puberty of a republic.[1]

<center>IV.</center>

Between 75 and 120 domestic features premiered annually during the fifties in the FRG, and well into the decade, they enjoyed great box-office success.[2] Nonetheless, the cinema of the Adenauer era has a lackluster reputation. Contemporary commentators, both at home and abroad, dismissed it as insular and provincial, derivative and predictable, anachronistic and trivial, ideologically bankrupt and socially irresponsible, either bland or saccharine.[3] There was no art cinema of note nor was there much experimental enterprise. Several directors had a certain flair and an undeniable talent (e.g., Staudte, Helmut Käutner, Kurt Hoffmann, Rolf Thiele, and the newcomer Bernhard Wicki), but none of them was deemed worthy of the appellation "auteur." Cineastes, both foreign and domestic, would not have thought of mentioning the best West German filmmakers in the same breath as Andrzej Wajda, Ingmar Bergman, Akira Kurosawa, Satyajit Ray, or Michelangelo Antonioni. This cinema did not travel well; in fact, it did not travel much at all. Made in the FRG for domestic consumption, it did not reach out to other cinemas (except Hollywood and, on occasion, France and Italy) and it did not it show much interest in international exchanges. It was the creation of a film economy dominated by Allied interests, a cottage industry of small and medium-size studios and of mainly undercapitalized independent producers. It stuck with the tried and true, recycling old films and formulas like nobody's business.

<center>V.</center>

Almost without exception, West German films of the fifties were the work of an older generation, of casts and crews who had served in studios administered by Goebbels's Ministry of Propaganda. In the cinema of the Adenauer era, the fathers lorded it over their sons and daughters, both

on- and offscreen. Even the juvenile delinquent films (modeled after American movies starring James Dean and Marlon Brando) with Horst Buchholz did not fully identify with their unruly protagonists. Georg Tressler's *Die Halbstarken* (*The Hooligans*, 1956) and Frank Wisbar's *Nasser Asphalt* (*Wet Asphalt*, 1958) showed how rebellion gives way to subjugation and how parental authority prevails in all dealings with young people. During the fifties, it was all but impossible for new talents to break into the film industry, and there would be a long wait before room for newcomers opened up. Those who had left Nazi Germany and gone to America, exiled directors such as Fritz Lang, Robert Siodmak, and Gerd Oswald, did not find a warm welcome upon their return. The so-called reemigrants were received as prodigal sons; they could not secure the power or trust that would have allowed them to help change the situation. In the minds of the directors who would create the New German Cinema, the cinema of the Adenauer era (like its mass culture in general) was politically suspect and artistically stagnant.

<p style="text-align:center">VI.</p>

At first glance, this cinema overwhelms the viewer with its excessive portions of silliness, whimsy, and sentimentality. (The word "kitsch" readily comes to mind.) Beneath what seems to be innocuous surfaces, however, often lurks something fragile or precarious. Pleasing facades repeatedly crack and reveal tableaus of panic, confusion, and disquiet. Characters try hard to be urbane and au courant and yet very often must recognize they are not up to speed or with it. Take, for instance, the unforgettable sequence in *Die Trapp-Familie in Amerika* (*The Trapp Family in*

FIGURE 9.2 (*top, opposite page*) Maria (Ruth Leuwerik) worries about the Trapp Family Singers' future in the New World. Seeking counsel about how to make it in America, she learns that the group lacks an essential ingredient if it is to be popular. At wit's end, she asks a store clerk whether he might have a book "about sex appeal, especially for concerts." "You don't really understand what sex appeal is?" he asks. "No," replies Maria, "I'm from Austria."

FIGURE 9.3 (*bottom, opposite page*) "She has it! That's sex appeal!" (*Die Trapp-Familie in Amerika/The Trapp Family in America*, 1958).

America, Wolfgang Liebeneiner, 1958) where Maria (Ruth Leuwerik) wonders what it means to have sex appeal and, fearing she does not have it, asks a Manhattan sophisticate where she might read up on it. The homeland film is not all lush forests and happy creatures. In *Grün ist die Heide* (*Green Is the Heather,* Hans Deppe, 1951), we partake of disfranchised refugees from the former eastern provinces hard-pressed to contain their resentment. In *Rosen blühen auf dem Heidegrab* (*Roses Bloom on the Grave in the Heather,* Hans Heinz König, 1952), we survey dark moors and lurid passions; here the *Heimat* becomes *unheimlich,* as shadowy and treacherous as the dread spaces of a film noir. On occasion, there are undeniable expressions of discontent about Allied occupation, but these feelings can be indulged only partially (see Robert A. Stemmle's *Toxi* [1952] or John Brahm's *Die goldene Pest* [*The Golden Plague,* 1954]). Many narratives revisit the sites and privileges of past glory with a stark feeling of loss, be it costume epics about eccentric kings and sweet princesses or nostalgic portraits of bourgeois family circles. In numerous retrofilms there abides a sense of shame and embarrassment about the Nazi past, but only a limited willingness to admit that the German populace at large shared culpability and, beyond that, an altogether systematic incapacity to take responsibility for and to sympathize with the true victims of German violence. These films bear out and attest to what Alexander and Margarete Mitscherlich called a nation's "inability to mourn."[4] As symptoms and products of their times, they provided protracted exercises in the negotiation of damaged identity.

VII.

It has been forty years since the Oberhausen Manifesto proclaimed the death of the old German film. Oberhausen's auteurist initiative, the anti-authoritarian impetus of 1968, and the programmatic resolve of the New German Cinema have played a predominant role in how commentators have approached the films of the Adenauer era. In fact, "Papas Kino" and its proponents had much more energy left than the Oberhausen activists imagined; and, indeed, West German features of the fifties, for all their detractors, have had a remarkable staying power. A renaissance of

Heimatfilme took place in the early eighties; soon thereafter, musicals (*Schlagerfilme*) with Peter Kraus and Corneilia Froboess resurfaced and comedies with the avuncular Heinz Erhardt gained a cult following. Late-night weekend television is unthinkable without Edgar Wallace movies, and screenings of the Sissi-trilogy with Romy Schneider are an integral part of the holiday season. During the mid-nineties, Bernd Eichinger remade a number of fifties classics with contemporary stars. Even today, some German filmmakers wonder how they might create a popular cinema and, as they do so, look back with envy at the Adenauer era. Others remain far less eager to let this sector of film history serve as a role model. Indeed, it comes to us today as a contested and controversial cinema. No matter what reservations we might have and what conclusions we might reach about these productions, if we want to comprehend the shape and substance of West German dreams during the early postwar years, we surely have no better resource.

III
FROM OBERHAUSEN
TO BITBURG

FIGURE 10.1 "Only the most feeble mind sees revolution solely in terms of devastation. We beg to differ: we see it as a massive act of construction." The voice of Adolf Hitler in *Brutalität in Stein* (*Brutality in Stone,* 1961).

10

REMEMBERING NOT TO FORGET

I.

In Nuremberg, an international convention of circus producers takes place. Later, Leni Peickert and a coworker go through the convention protocol and read it aloud: "I would like to see the person who after Auschwitz wants to try to prevent us from saying something we think needs to be said. A majority vote: the number with the rats won't be canceled. Applause! A break for refreshments." Speaking alone, Peickert continues: "Nothing at all can stop us, I would like to see the person who after Auschwitz wants to stop us from doing and saying what we think is right. Refreshments are passed around."[1]

II.

Brutalität in Stein (*Brutality in Stone*), a short documentary film made by Alexander Kluge and Peter Schamoni in 1960 and premiered a year later, represents one of Young German Film's earliest signs of life.[2] Made two years before the outspoken, indeed histrionic, Oberhausen Manifesto, it begins with a solemn declaration:

Every edifice left to us by history emanates the spirit of its creator and its age, even when it no longer stands in the service of its original

function. The forsaken edifices of the National Socialist Party, as testaments in stone, allow memories to come alive of that epoch which led to the most terrible catastrophe in German history.

I would like to scrutinize this statement from a double perspective. First, I wish to ponder the pre-Oberhausen setting and Young German Film's initial efforts, concentrating on a generation's evocation of the past and its confrontations with the cultural legacy of the Third Reich, with the systematic denigration of fantasy ware to tools of domination. Using *Brutality in Stone* as a point of reference, I want to rehearse the theoretical impulse and historical impetus behind Young German Film's desire to renew West German film and intellectual culture in the early sixties as well as to identify some of Kluge's chief discursive predilections.

Second, I wish to see what *Brutality in Stone* reveals today about the historical project that constituted Young German Film and, in subsequent years, determined the New German Cinema. In other words, I want to discern how this critical documentary on Nazi architecture, made in 1960, appears in light of recent debates about historical revisionism and the place of the Third Reich within the wider course of German history,[3] the heated controversy about the status of Nazi art and architecture within cultural institutions,[4] and discussions about the role New German filmmakers, including Kluge, have played in revisionist tendencies since the seventies. What does *Brutality in Stone* tell us about the past? What does it tell us about the present that examines the past? And what does this film, as a political intervention from the past that addresses a problematic cultural heritage, reveal about present-day issues and interests?

III.

1963, Nuremberg: a public screening of Leni Riefenstahl's *Das blaue Licht* (*The Blue Light*, 1932) in the Meistersingerhallen is a huge success. Carl Müller, prominent owner of the Studio für Filmkunst in Bremen, speaks of an overpowering experience: "Hundreds couldn't get in. . . . Rarely have I seen such an enthused audience. . . . How often I heard people say, 'What a film!'—'Why don't they make films like this anymore?'"[5]

On three occasions in the postwar period, German filmmakers declared their intention to create a new German film. Already in 1946, Hans Abich and Rolf Thiele issued a "Memorandum Regarding a New German Film" and established a studio in the English sector of Germany, the Filmaufbau Göttingen. Abich and Thiele wanted to make "films against the film of National Socialism," anti-Ufa productions with a constructive resolve. They soon found themselves, however, working with former representatives of the very cinema they sought to overcome. Indeed, their first project, *Liebe 47* (*Love 47*, 1949), an adaptation of Wolfgang Borchert's drama *Draussen vor der Tür* (*The Man Outside*, 1946), touted as its director the former Ufa production head, Wolfgang Liebeneiner.[6] There would be no decisive break and no novel impetus during the Adenauer era; even as late as 1957 about 70 percent of all West German feature films employed either a director or a scriptwriter who had worked in the Nazi period.[7] A second, less compromising initiative came more than a decade later with "DOC 59," a gathering of documentary filmmakers, cinematographers, composers, and the film critic Enno Patalas. The group sought closer connections with the international art film scene. They wished to merge documentation and fiction and to commingle authentic images and scripted narratives.[8] Despite its poignant awareness of West German film's drab state, the members of DOC 59 did not succeed in reviving an arid production landscape dominated by worn-out genre fare, mindless escapism, and paint-by-number production schemes, a national cinema without a distinct stylistic and critical will, all but devoid of experimentation, alternative resolve, and the voice of youth.[9] The dire situation, recognized almost universally, reached its acme when the government awarded no state prize for the best film of 1961, and Ufa finally met with financial collapse.[10] In this setting, a third attempt at renewal took shape, the "Oberhausen Manifesto" of February 1962, a document lamenting the bankrupt state of German film as an art and an industry. The statement announced, brashly and arrogantly, a collective's desire to "create the new German feature film."[11]

The twenty-six angry young men who signed the manifesto claimed to have "concrete intellectual, formal, and economic conceptions about the production of the new German film." By and large, this was not the case;

the manifesto provided a promise, but it did not articulate a program.[12] The group gained its identity above all from a shared sense of displeasure; from a common desire to combat the powers that controlled image production in West Germany; and from a wish to militate against an abuse of the medium that, in their assessment, had continued unabated since the Third Reich. In an essay of 1962 entitled "What Do the 'Oberhauseners' Want?" Kluge outlined the group's key objectives, namely to

1. free film from its intellectual isolation in the Federal Republic;
2. militate against the dictates of a strictly commercial orientation operative in the film industry today;
3. allow for conditions that make film aware of its public responsibility and, consequently, in keeping with this responsibility, to seek appropriate themes: Film should embrace social documentation, political questions, educational concerns, and filmic innovations, matters all but impossible under the conditions that have governed film production.[13]

Shortly after the Oberhausen festival, the signatories convened to discuss how they might bring about the intellectual transformation of German film and create institutional support systems.[14] A first goal involved founding a public subsidy mechanism that would fund the initial efforts of young filmmakers without commercial constraints. This came to fruition in 1964 with the Curatorium for Young German Film. Second, the Oberhauseners stressed the role of independent short films as a site of experimentation and sought to keep this endangered modality alive. Finally, the group called for an "intellectual center for film," where theory and practice might productively coexist. A laboratory for the new cinema, the Institute for Film Design in Ulm, which already was established in 1962, became "a place of higher learning directed against fascism."[15]

V.

October 1965, Oberhausen: Journalists, officials, and educators gather to view twenty previously banned films from the Third Reich and to discuss

the possibility of future public screenings.[16] Later, the distributor Atlas-Film releases Veit Harlan's *Kolberg* (1945) in a redacted version designed to defuse any pro-Nazi response by means of critical voice-overs and contrastive montages. The *Frankfurter Allgemeine Zeitung* calls the refurbished *Kolberg* "a convincing example of how film can be used to unmask and critically analyze film."[17] Atlas-Film executive Hanns Eckelkamp comes under fire nonetheless for what some observers perceive to be his opportunistic revival of the "brown screen."[18] Responding to an interviewer from *Der Spiegel*, Eckelkamp insists that he wants only to "bring anti-Nazi films into the cinemas, not Nazi films . . . It would be undemocratic to suppress these films. It is democratic when we put them in a new context and show them there."[19]

VI.

Remnants from the past as fragments, memories, and testimonies; texts from another epoch that speak to the present and disclose the innermost workings of another age: In this regard, the project of *Brutality in Stone* recalls that of Siegfried Kracauer's *From Caligari to Hitler*. In this work, Kracauer's symptomatic readings of Weimar films provide a secret history of collective inner dispositions, an analysis of prominent pictorial motifs, and "visible hieroglyphs" that disclose the "unseen dynamics of human relations."[20] Similar to Kracauer, Kluge and Schamoni refunctionalize historical motifs and forms so that, many years later, one might grasp their functional place in a larger *Zusammenhang*.[21] Likewise, we find a ragpicker's zeal in sifting through the garbage pile of history, sorting out and recovering discarded chunks of reality lest they be forsaken for all time. *Brutality in Stone* does not reconstruct the past, it reconfigures it, attempting to wrest memories of National Socialism from a public conformism that would deny their reality and materiality. It uses architecture, both actual buildings and planned structures, as artifacts of a collective dream of nightmarish proportions,[22] combating the forces that seek to suppress or mythologize recollection of the Third Reich. In this way, the film's impetus recalls Benjamin's "Theses on the Philosophy of History," especially in its disdain for those who would treat fascism as a catastrophic

entity vanquished by time rather than as a state of emergency that still weighs upon the present.[23]

In a lecture of 1959, "What Does Coming to Terms with the Past Mean?," Theodor W. Adorno confronted dispositions in the Adenauer era that seek to forget rather than to rethink the past, to deny collective German responsibility for World War II and the Holocaust, to relativize the significance (indeed, even the existence) of the death camps, to bicker over exact numbers (five, not six million Jews dead in the Holocaust), and to efface memory in a manner more conscious than unconscious. The result of these proclivities, claims Adorno, is mass repression that at best pays lip service to a national project of coming to grips with the past (*Vergangenheitsbewältigung*) through public demonstrations of philo-Semitism, screenings of *The Diary of Anne Frank* (George Stevens, 1959), and half-hearted reeducation programs, none of which ask difficult questions or probe painful consequences. For Adorno, the past needs to be worked through (*aufgearbeitet*) and to be reshaped into something new. The term *Aufarbeitung* blends psychoanalytical relentlessness and enlightened resolve; only in this way might the German subject even regain its lost maturity (the *Mündigkeit* extolled by Immanuel Kant) and reconstitute its political identity.

West German films of the fifties present few examples of critical endeavor, of a desire to comprehend the experience of the Third Reich in its harrowing reality. Paradigmatic instances of such coming to grips with the past are Helmut Käutner's *Des Teufels General* (*The Devil's General*, 1955), Kurt Hoffmann's *Wir Wunderkinder* (*Aren't We Wonderful?* 1958), and Bernhard Wicki's *Die Brücke* (*The Bridge*, 1959). With their humanistic rhetoric, the films console rather than interrogate, focusing

FIGURE 10.2 (*top, opposite page*) Runes in the ruins: "Films are particularly inclusive because their 'visible hieroglyphs' supplement the testimony of their stories proper" (Siegfried Kracauer; image from *Brutality in Stone*).

FIGURE 10.3 (*bottom, opposite page*) "Every edifice left to us by history emanates the spirit of its creator and its age, even when it no longer stands in the service of its original function. The forsaken edifices of the National Socialist Party, as testaments in stone, allow memories to come alive of that epoch which led to the most terrible catastrophe in German history" (*Brutality in Stone*).

on victims of circumstance (a jovial *Luftwaffe* general, a well-meaning *Bildungsbürger*, a group of young boys drafted into the army at the war's end), innocent parties held captive by situations they neither control nor fully fathom. These narratives display inexorable destinies; National Socialism is equated with unceasing fear and misery, especially for the average German citizen; the war wreaks violence on the unwitting and renders people orphans of history. Such films served to repress the past and to displace guilt and to obfuscate the undeniable; in the process, the true victims got cheated out of their remembrance.[24]

A number of difficult questions faced the Young German filmmakers: How to confront the repression of the past with a medium so utterly implicated in fostering public pacification? How to combat the status quo with an apparatus controlled by forces that liked things as they were, a world of reconstruction, economic miracle, and no experiments?[25] How to counter images of a past whose own images and imaginary dominated postwar attempts to imagine that past?

VII.

A key point of consensus among the Oberhausen group remained a preference for a mode of production in which the author might circumvent external pressures and maintain a high degree of control over the creative endeavor. Through energetic lobbying, Kluge and his colleagues set in motion public subsidy systems that would fund debut films and guarantee directors autonomy as long as they limited themselves to modest budgets.[26] Clearly, there was a marked difference between the West German *Autorenfilm* and the French *politique des auteurs*. As Kluge later points out, the fact that filmmakers craft personal works is one thing, that certain circles of filmmakers come together and embrace common goals regarding film politics is another. Film innovators protest for different reasons at different times, and even among peers the reasons will vary. Godard's initial protest, according to Kluge, was directed against culture in general and against the power of language in culture. Truffaut protested the misuse of language and education, and eschewed culture's abusive potential. The members of the Nouvelle Vague, nonetheless, protested against a "cinema of quality and

combatted a moribund cultural climate."[27] For all its diverse personalities and factions, the Oberhausen group spoke out, at least initially, not only against film in the service of the state and the status quo but also against a cinema that cultivated distraction and institutionalized amnesia, creating Valium for the masses and exercising a stranglehold over fantasy life.

Brutality in Stone stages a celluloid rebellion; its very shape ironically and critically mimics the *Kulturfilm*, a format that flourished during the Third Reich, the plotless short that accompanied almost every feature film. One cannot, in fact, understand Nazi cinema in terms of single films. Newsreels, shorts, and features shared the discursive labor. Although the main features, notes Hartmut Bitomsky, "might have shown revues and romances, the culture films took over responsibility for matters of *Weltanschauung*."[28] From the beginning of Young German Film, the short film functioned as an experimental vehicle. Bernhard Dörries and Edgar Reitz's *Schicksal einer Oper* (*Fate of an Opera House*, 1958), for instance,

FIGURE 10.4 Hitler contemplating Germania, his dream capital, a site of monumentality and megalomania (*Brutality in Stone*).

explored the war ruins of a Munich opera house.[29] The short film format would continue in the individual contributions of directors to omnibus films like *Deutschland im Herbst* (*Germany in Autumn*, 1978), *Der Kandidat* (*The Candidate*, 1980), and *Krieg und Frieden* (*War and Peace*, 1983), finding a later extension in Kluge's television spots for the television show *Die Stunde der Filmemacher* (*The Hour of the Filmmakers*). Kluge's first film would be a short, an anti-*Kulturfilm* as a form of anticulture, an act of subversion, analysis, and revenge.

VIII.

"All documentary films that are authentic," Kluge wrote in 1983, "document reality; all radical film experiments work at heart in a documentary fashion."[30] *Brutality in Stone* combines important and inextricably bound impetuses in Kluge's theory and praxis of film: documentation, authenticity, and experimentation. As *documentation*, it confronts voices and artifacts from the past with a retrospective revolt, seeking to represent historical reality as the fiction that it indeed is, pressing into service Hitler's claim that every great period "finds the final expression of its values in its buildings."[31] In a manner redolent of Alain Resnais's *Nuit et Brouillard* (*Night and Fog*, 1955), the film revisits an infamous site of barbarism, the Nuremberg Party Congress Grounds. The well-known site of Riefenstahl's *Triumph des Willens* (*Triumph of the Will*, 1935) in its present countenance is no longer the scene of mesmerizing spectacle, with massed ornamental groups of loyal followers; rather, it is a forsaken, vacant, seemingly lost space. The camera, in short fragments (the eleven-minute film contains more than two hundred single shots), provides still prospects of modernized neoclassicistic structures, registering severe angles, sharp planes, and an abiding penchant for the monumental and gigantic, edifices cast as, in Barbara Miller Lane's words, "symbols of the 'heroic scale of life' . . . intended to reflect the power of the dictator and his modern state over his subjects in the mass."[32] Architecture, observes Walter Benjamin, "has never been idle."[33] Nor is the camera idle here in its attention to aesthetic designs with a geometry of inhuman proportions. We see the space and structure of the massive Zeppelinfeld; stills of Hitler

at work on the empire's future capital, Germania, as well as simulations of that metropolis; sketches of other future edifices; models of utopian expanses; and the skeleton vestiges of an unfinished building, Albert Speer's Conventional Hall. Documentation, in Kluge's understanding, never takes sides and never claims to be objective or balanced.[34] It displays a heterogeneity of materials, multiple temporalities, and shifting fields of discourse. As a document, *Brutality in Stone* scrutinizes historical artifacts that created imaginary effects, facts that spawned fictions. The film thus reflects how the imaginary became real, seeking at the same time to fathom the construction of meaning by a state apparatus.

The quest for *authenticity*, submits Kluge, aims to activate those forces that enliven the spectator and that engage, challenge, and, on occasion, irritate audiences. The authentic text is a communicative entity, at once sober, concrete, and precise but also nomadic, willful, and at times extreme.[35] *Brutality in Stone* constitutes an eccentric work of archaeology, an exhumation in the vein of Gabi Teichert, the radical school teacher in Kluge's *Die Patriotin* (*The Patriot*, 1979). Its guiding impetus is a quest for *Zusammenhang*, the relationship of parts to wholes; of building blocks to entire structures; of shapes, forms, and surfaces to overall *Gestalten*; and of spectators to historical spectacles.

No doubt the voice we hear in *Brutality in Stone* lacks the subtlety and nuance of the capricious enunciators in other Kluge films, for example, the inexorable elephants in Kluge's *Artisten unter der Zirkuskuppel: ratlos* (*Artists under the Big Top: Perplexed*, 1968) or the talking knee in *The Patriot*. The sober declarations have no ludic élan; rather, they are terse, stark, and straightforward. An unreconciled intelligence guides this tour through a visual and aural museum of memories. We hear authentic voices: Hitler on various occasions, exultant Hitler Youth choirs, radio announcers, and cheering crowds from *Triumph of the Will*. We also partake of quotations: a gruesome verse from a Bund Deutscher Mädel songbook and a horrific passage from Rudolf Höβ's memoirs, in which the commander of Auschwitz describes the processing of human bodies in the camps, the factory-line slaughter of Jewish prisoners. The authentic concern of *Brutality in Stone* is with the past and with images of that past and their not fully understood or acknowledged place in present culture. A similar concern informs Jean-Marie Straub and Danièle Huillet's contemporaneous short,

Machorka-Muff (1963). In this film, an officer is called to postwar Bonn where he dedicates an Academy for Military Memories, a place where war veterans find government support for their revisionist enterprises. We witness the cornerstone of the edifice being laid and the accompanying ceremony, a striking enactment of official investment in the stylization and reconstruction of memory.[36] *Brutality in Stone* provides something similar, but it is more like a deconstructed museum of memories dedicated to gathering fragments and shards, collecting, evoking, and refunctionalizing its holdings so that we might better grasp the workings of the historically real, whose effects affect the present and are, in that way too, real.

An exception in an age of "no experiments," *Brutality in Stone* merges *experimentation*, intervention, and reinterpretation in an undertaking driven by an inexorable will not to forget. It contrasts, at times rather brazenly, aural and visual signifiers, juxtaposing the cities of the future with the merciless bombs of Allied air raids, confronting barren parade grounds with the jubilant sounds of the 1934 Nuremberg rally. The film's dominant strategies involve contrast, counterpoint, and parody. Its schematic and patterned editing rhythms underline and overstate the object of investigation, further forming the already hyperformed, exaggerating the regularity of spaces, shapes, and surfaces. The structures of the past are recycled and worked over (*umfunktioniert* and *aufgearbeitet*) so that they cease to serve their original function in two ways: They are at once no longer in use, but indeed are put to use in this film in another context, i.e., in the historical project of Young German Film and its attempts to renew German film history.

If realism has a motive, asserts Kluge, it "is never a confirmation of reality, but rather a protest."[37] The protest fueling this experiment blends radical imitation with a frontal onslaught, employing an aggressive montage that establishes relationships between seemingly unrelated elements. The camera moves solemnly in forward processions down expansive corridors as Höß describes the calmness of prisoners entering gas chambers, a combination that associates neoclassicistic promenades with Prussian thoroughness and thus links the shapes of edifices and the substance of political actions as emanations of a related ideological instrumentation. The opening shot literalizes the

dialectic of enlightenment and the antagonistic construction of National Socialism: We see a lake and a natural landscape behind it, over which the vast facade of a building will be superimposed, covering the trees and fields. Nature succumbs to monumental madness, to an instrumental will that shrouds itself in premodern garb, propagating blood and soil while transforming the world with the tools of modernity.[38] Kluge's first experiment offers an exercise in critical art history and outspoken archaeology, insisting that certain structures still bear heavily on the present. The subtitle of *Brutality in Stone, Die Ewigkeit von gestern* (*The Eternity of Yesterday*), will later replace the original title and find an ironic echo in Kluge's debut feature, of 1966, *Abschied von gestern* (*Yesterday Girl*).

IX.

Kluge will endure as the most prominent public defender of West German film, an individual whose belief in the power of cinema to redeem historical reality and to give voice to alternative energies continues to guide his work today—a cinema of *Eigensinn*, indeed.[39] And Peter Schamoni? He gained considerable attention for his feature debut, *Schonzeit für Füchse* (*No Shooting Time for Foxes*, 1966), a study of a young generation's passive aggression toward smug and unrepentant elders.[40] Two decades later, after commercial ventures in various generic veins, he went on to make biopics about romantic artists like *Frühlingssinfonie* (*Spring Symphony*, 1983) and *Caspar David Friedrich* (1986), films that in many regards resembled the confections eschewed by the Oberhausen activists.[41]

X.

1986, Cologne: In a series of public pronouncements, Peter Ludwig, a wealthy industrialist and an influential patron of the arts, castigates what he considers to be the narrow view (*Blickverengung*) that refuses to grant German art and sculpture from 1933 to 1945 a place in public institutions.[42] (He studiously avoids the phrase "Nazi art.") People have a right, he claims, to judge for themselves whether these controversy-ridden

works are barbaric. In any case, the operative taboos should be lifted and audiences should be granted a chance to see whether a distance of forty years might allow new approaches and different appreciations. The same person who purchased Pop Art two decades ago and had his portrait done by Andy Warhol now commissions the once-prominent Nazi artist Arno Breker to make busts of himself and his wife. It is a sign of the times, submits Ludwig: "Postmodern—what does that mean other than being traditional?"[43]

XI.

The initial project of Young German Film was a negative project, a critical mission, and a taking of revenge. The anti-*Kulturfilm* and the subsequent new feature films sought explicitly to recycle and supersede images from the past; to confront the facts, structures, and abuses of National Socialism; and to militate against collective misremembering and mass forgetting. If we jump ahead to the late seventies and early eighties, when New German filmmmakers had gained stature, self-assurance, and worldwide recognition, we glimpse a cinema invested in recreating national identity, a mission essentialized in Gabi Teichert's quest for a positive German history. "In the seventies," noted the artist Christo, "the Germans suddenly began to reinvent National Socialism. The Hitler period became an extraordinary creative resource for a whole generation of filmmakers and writers."[44]

When we look at the most celebrated New German Cinema revisitations of the Third Reich from the perspective of the so-called Historians' Debate (*Historikerstreit*), we cannot help but be taken aback. For we find more than passing traces of revisionist discourse in representative films, such as Hans Jürgen Syberberg's *Hitler—ein Film aus Deutschland* (*Our Hitler*, 1977), Helma Sanders-Brahms's *Deutschland, bleiche Mutter* (*Germany Pale Mother*, 1980), Rainer Werner Fassbinder's *Lili Marleen* (1980), and Edgar Reitz's *Heimat* (1984). These films rewrite history from the perspective of the present; as retro-scenarios, they transform history into myth, restaging the past in a way that exorcizes the shock of that experience and soothes the present.[45] Three characteristics stand out. First, a

fixation on Germany as a nation of victims and martyrs, and an attendant identification with innocent and impotent bystanders which undercuts the Holocaust and Jewish suffering. Second, the figuration of German history as woman—as an allegory of mourning (*Our Hitler*), as the central presence and source of continuity (*Heimat*), as a voice forced under duress into public service (*Lili Marleen*), or as a victim of violence and rape (*Germany, Pale Mother*). In this way, the nation becomes represented as a violated or a vulnerable female body, a stand-in and medium for a hapless Germany. And, finally, the reflection on the Nazi past as an unwitting reflection of that past: Saul Friedländer speaks of a "New Discourse" about National Socialism in which guilt gives way to fascination, shame to shamelessness, and awareness of wrongdoing to a (however unintentional) complicity with criminals.[46]

Unlike his colleague Edgar Reitz, Kluge does not wish to render German history within a master narrative that integrates the Third Reich into a wider course of time, relativizing its singularity, denying its extraordinary status, and resenting those who insist on its exceptional significance.[47] Kluge's first short confronts incontrovertible facts and places them within larger structures. Höß speaks candidly of the death camps' operations, leaving no doubt about questions of agency in the Holocaust. *Brutality in Stone* activates crucial memories. To be sure, this impetus also informs *The Patriot*; at times a curious inflection demonstrates how even Kluge, New German Cinema's most vigorous agent of historical memory, employs revisionist rhetoric.

The Patriot mourns and recollects "all of the Reich's dead,"[48] giving the deceased a voice, stressing that they are simply dead, but indeed they still are full of resolve and energy. The film's most persuasive spokesman is the talking knee of Corporal Wieland, a soldier "who wanted to live, but found himself in the wrong history" and perished in the Battle of Stalingrad. At one point the viewer is explicitly reminded that the Royal Air Force burned sixty thousand people during the World War II bombings of Dresden.[49] We also glimpse American aviators taking a cigarette break after, in the narrator's words, "dismantling Germany systematically for 18 hours." If we remember the dead and recall the monstrous, we behold a German history conspicuously unburdened of certain victims and certain remembrances. This is clear from the start of *The Patriot*, in

its opening quotation from Kurt Bernhardt's *Die letzte Kompagnie* (*The Last Company*, Kurt Bernhardt, 1930). We see a protracted traveling shot over dead Prussian soldiers, accompanied by the music Hanns Eisler composed for *Night and Fog*. According to Kluge's script, the scene "takes place either in the Seven Years' War or the Wars of Liberation, but now we see an anti-aircraft gun from 1943."[50] The strategy is disarming in that, as in President Reagan's visit to Bitburg in 1985, it collapses—at least by aural suggestion—Jewish concentration camp victims and German war dead, implying their common status. This is all the more disturbing for a film that makes no further mention of the Holocaust, a prolonged work of mourning that withholds even a single image of Jewish suffering, suggesting that we can talk of World War II without mentioning Auschwitz. In an odd way, *The Patriot* replicates what Friedländer speaks of as the New Discourse, wherein an "endless stream of words and images becomes an even more effective screen hiding the past."[51]

XII.

In his book *Bestandsaufnahme: Utopie Film* (*Taking Stock: The Utopian Film*, 1983), Kluge quotes (without citing a source) the following phrase: "The real becomes imaginary, and for that reason the imaginary is real."[52] This assessment surely applies to life in the age of electronic reproduction as well as to recent appropriations of the past in German discourse, retro-scenarios that transform history into the spectacle of myth, into fictions that take on the character of pseudo-fact.[53] To this day, Kluge remains acutely sensitive to those factors in contemporary society, which undermine historical memory and seek to perpetuate a constant state of diversion, a voracious present that engulfs and nullifies the past. These forces are considerable; they control fantasy production, determine the shape of cities, and dominate postmodernity in general, creating a situation in which the present forecloses future horizons and cuts off the past—or at least tries to. For all this, Kluge maintains (playing on William Faulkner's adage that the director reworks in *The Patriot*) that "the past isn't dead, it isn't even past."[54] We dare not misunderstand certain of Kluge's insights as Baudrillardian epiphanies. Kluge does not share the latter's vehement

pessimism nor his loss of faith in the resilient powers of the subject.[55] Kluge still supports the project of modernity, even in the face of postmodern challenges. He both mourns and protests the vitiation of certain forms of experience: the shattering of memory, the denigration of the past, the destruction of living spaces and public spheres, the decline of the cinema, and the stifling of human imagination by the new media.[56] Despite his keen awareness of "fatal strategies," Kluge refuses to succumb to fatalism and instead continues to articulate and practice strategies of resistance.[57]

XIII.

Cinema as a time machine: images out of time versus moments lost in time, films from the past against the power of the ever present.[58] A quote from the script to *Der Angriff der Gegenwart auf die übrige Zeit* (*The Blind Director*, 1985):

> PEOPLE ON SUNDAY. Reference to the film *People on Sunday*. A Sunday scene from the film *Kuhle Wampe*. Now it is fall 1984, 5 A.M. The time nears when the first waves of people will rush off to work. It is the day on which we go off daylight-savings time and reset our watches (that actually happened already in the night from Saturday to Sunday, but most people didn't notice it until Monday morning). The main thing is to forget what happened yesterday.[59]

It is essential, insists Kluge, to combat blithe takings of leave from yesterday, to remember not to forget.

FIGURE 11.1. "Macht kaputt, was Euch kaputt macht!" Bring down what brings you down: revolutionary insurgence in the final sequence of *Die Niklashauser Fart* (*The Niklashausen Journey*, 1970).

MANY WAYS TO FIGHT A BATTLE

I.

"A series of individual films," wrote Wolfgang Etten in his obituary for Rainer Werner Fassbinder and the New German Cinema, coalesced and "congealed as a 'corpus'" with a distinct mythology.[1] Fassbinder would function as the driving force that in fundamental regards set the pace and showed the way for the movement as a whole. "From his early social critique ... and the passage through German postwar history ... to the stupendous mannerism of *Querelle*," submits Andreas Kilb, "Fassbinder passed through each stage of German film's renaissance."[2] As a path-breaker and a pace-setter, he, more than anyone, even Werner Herzog, would assume a mythic status. The initials RWF are instantly recognizable; they immediately call to mind the master of subversive melodrama and the most significant epic filmmaker of the Federal Republic of Germany (FRG).[3]

The director's ongoing interventions in contemporary debates contributed seminally to discussions about such topics as the troubled historical relations between Germans and Jews, the fragility and precariousness of postwar democracy especially in the face of challenges by terrorists, and the psychopathology of the FRG from the Adenauer era through the Schmidt regime. This decidedly critical resolve assumed a plethora of formal shapes; Fassbinder wanted to fashion films that would question, unsettle, and

ultimately transform how people living in the FRG both thought and felt. Without fail and with justification, commentators have traced the director's oppositional initiatives to the sixties, to the rediscovery of Bertolt Brecht's epic theater (above all by Jean-Luc Godard) with its penchant for distantiation and refunctionalization, to the stark minimalism and bohemian flair of Andy Warhol and the restrained yet poignant realism of Jean-Marie Straub and the challenge that all of these eccentric approaches posed to cinematic convention, and to his desire to ignite scandal (invariably generating the description "enfant terrible"), all of which became readily apparent in his earliest endeavors in the theater and the cinema.

The filmmaker's predilection for acting out and causing displeasure emanated from a larger generational discontent among West Germans born after World War II. This Oedipal fury is essential to prevailing notions of New German Cinema in general and fundamental to the founding declaration of 1962, the famous Oberhausen Manifesto that laid to rest the cinema of the fathers and proclaimed that "The old film is dead."[4] The filmic effusions of angry young men and women, especially their critical confrontations with the Nazi past (with its mass violence and mass murder) and their fierce awareness of how that past had been both whitewashed and refurbished by their elders during the Adenauer era, become of a piece with the FRG's student movement (*Studentenbewegung*) and its vendetta against the powers that be. Filmmaking became a tool of political action; one consciously shot films in an attempt to strike back. "I don't throw bombs," Fassbinder was quoted as saying on the posters for *The Third Generation*, "I make films."[5] More than any of his peers, one might argue, Fassbinder embodied the hope, irritation, and disenchantment of his generation. Indeed, his work is perhaps the most exemplary instance of the post-1968 desire to challenge the status quo, to craft popular art with a critical inflection, and to defuse affirmative culture by infusing it with subversive content. He is, without a doubt, one of the most definitive and, as such, dominant presences of the seventies and, for this reason, someone we can study with a mind toward understanding a generational uprising and the various oppositional strategies and critical energies that sought to create an alternative cinema, especially in the FRG.

New German auteurs reacted against the abuse of film under Hitler and cinema's affirmative status as a stabilizing force and a vehicle

of political legitimation during the fifties, its collusion with the reactionary establishment and its deference to American capital. They intervened as well against a nation's all-too-eager willingness to forget the past and proceed with business as usual, to fall in with the dictates of Allied foreign policy, and to become a Cold War bastion. West German feature films from the late sixties and early seventies offered precious few images of the student movement's quite familiar iconography, the experiments in communal living and sexual liberation, the strategy sessions in smoky apartments and the mass meetings in university auditoriums, the street demonstrations with expressive transparencies and slogans chanted in chorus, and the bloody altercations with the police and testy responses from government officials. The political conflicts and public controversies of the late sixties rarely would find direct expression in the features of the so-called Young German Film. One looks in vain for a contemporary West German counterpart to Jean-Luc Godard's *La Chinoise* (1967), Lindsay Anderson's *If* (1968), Michelangelo Antonioni's *Zabriskie Point* (1970), or even Hollywood's *The Strawberry Statement* (Stuart Hagmann, 1970) and *Getting Straight* (Richard Rush, 1970). The opening sequence of Volker Schlöndorff's *Michael Kohlhaas* (1969) was exceptional in its topicality, in its direct linkage of student demonstrations from around the world (which we see in newsreel footage) with the grand refusal of Heinrich von Kleist's implacable protagonist.[6] If one seeks West German films that chronicled and represented the events of 1967 and 1968, one is best advised to view the shorts, essay films, and agitprop documentaries produced by Harun Farocki, Helke Sander, and other members of their cohort at the German Film and Television Academy Berlin (dffb).[7]

During the recent forty-year anniversary of 1968, media revisitations gave rise, especially on the European continent, to a vast profusion of articles, documentaries, and retrospectives. Amid much revisionism with more sober regards and measured assessments, there abided an unavoidable sense that one was dealing with a myth and that this myth, even as various commentators sought to neutralize or negate it, still exerted a strong influence. How might we bring together the myth of the enfant terrible, the young RWF, and the myth of 1968? How, I would like to inquire, did the director remember and represent the impetus of 1968 in films that issued

from a time when memories were fresh and myths were present but not fully formed? I would like to approach this question and reconsider two of Fassbinder's lesser known films, *Die Niklashauser Fart* (*The Niklashausen Journey*) and *Rio das Mortes*, features made within months of each other in 1970 that in quite dissimilar (and not always obvious) ways thematized and reflected on the experience of 1968. *The Niklashausen Journey* is both insistent, and at the same time provocatively ambiguous, in its representation of a failed mass rebellion incited by a youthful idealist. In its blend of radical slogans and conservative impulses, its nonsynchronicity of leftist politics and bourgeois conventions, *Rio das Mortes* demonstrates the unsettling influence of a different style and feeling that were in the air, making it clear that what was changing surely embraced but also transcended politics in its impact on one's sense of being in the world.

Both films remain to this day only partially apprehended, in decisive regards understudied, and, as a result, relegated to a secondary status. They have become buried within the inordinate profusion of activity in Fassbinder's early years, the sheer massiveness of his output between April 1969 and the end of 1970, during which time he completed ten feature films, two radio plays, two stage productions, and a television adaptation of *Das Kaffeehaus* (*The Coffee House*, 1970), as well as playing the lead role in Schlöndorff's adaptation of Bertolt Brecht's *Baal* (1970).[8] For most critics to date, Fassbinder's early works at best function as previews of coming attractions and as points of departure for assessments of the director's more significant subsequent output. Ultimately, it would be the revamped melodramas that arose after his often-elucidated exposure to the films of Douglas Sirk in the winter of 1970–1971 and the historical tapestries (especially *Berlin Alexanderplatz* of 1980 and *Die BRD-Trilogie/The BRD Trilogy*, 1979–1982) with their incisive studies of modern German sociopathology that would come to serve as the privileged sites of meaning and importance in Fassbinder's oeuvre. To be sure, the director in retrospect referred to his first features as naive and ephemeral, as throwaway films, "which one made in a certain situation in response to a certain matter and which one . . . could quickly leave behind."[9] For a variety of reasons, *The Niklashausen Journey* and *Rio das Mortes* have been left behind by film history. Let us revisit them and trace their approaches to 1968 and their respective negotiations of this mythic space.

II.

The Niklashausen Journey seems to be a work that lends itself to quick assessments and foregone conclusions; it resides in film history as the most conspicuous embodiment of Fassbinder's dismay regarding the failed project of the student movement. No other West German film of the time, argues Wilhelm Roth, dealt so directly with the experience of 1968.[10] Commentators consider it to be a reaction to the demise of the *Studentenbewegung*[11] as well as a recognition of the aporias inherent in the uprising's misguided continuation as a politics of terrorism. Beyond that, it has been seen within a wider "debate of the New German Cinema about the failure of the radical left, and the filmmakers' resolve not to make 'political' films."[12] Shot over twenty days in May 1970 for 550,000 West German marks(DM), at the time about $165,000, it premiered five months later on ARD, the FRG's first station. It then vanished from view until 2002, at which time the Taurusfilm-Munich in cooperation with the Fassbinder Foundation brought out a restored subtitled version on DVD.[13] This was Fassbinder's eighth feature and his first collaboration with WDR, a television station that would become a crucial (and, on several occasions, frustrating) site of operations during his career.[14] People did not like the film much nor did Fassbinder, claimed the producer Günter Rohrbach; it was in fact an unabashed catastrophe. Nonetheless, it still lingered in the director's mind many years later, so much so that he reportedly contemplated shooting some additional footage and recutting it.[15]

Commingling rural locations in contemporary Bavaria and period settings redolent of both the feudal Middle Ages and the Rococo era as well as modern Germany, the film tracks the journey of a young shepherd (played by Michael König), a preacher with a mission. Modeled on the fifteenth-century Franconian peasant leader, Michael Böhm,[16] the charismatic visionary seeks to overcome class injustice in the name of social equality; he calls for the end of the privileges of the clergy and the upper class as well as the systematic redistribution of wealth and property. His handlers, with even more radical intentions, urge him on. Böhm finds resonance among the impoverished masses and gains a substantial throng of followers. Ultimately his hoped-for cleansing of society comes to naught; his political designs alienate even well-meaning members of

the church and antagonize the hysterical Bishop of Wurzburg. In the final reckoning, the preacher's disciples are brutally slaughtered and Böhm is carried away by the bishop's soldiers (who appear as West German policemen and American military police), crucified in an auto junkyard, and burned at the stake to the accompaniment of a church choir.

The first two shots introduce the film's dynamic formal alternation of motion and stasis. We open onto a figure in a leather jacket seen in close-up from behind; the script identifies him as the black monk.[17] This camera setup often has served in German film history, from Robert Wiene's *Das Cabinet des Dr. Caligari* (*The Cabinet of Dr. Caligari*, 1920) and Fritz Lang's *Dr. Mabuse der Spieler* (*Dr. Mabuse, the Gambler*, 1922) onward, as a means to introduce power figures. It is Fassbinder himself, appearing in the inimitable tough-guy pose that he had assumed during his first appearances before the media as well as in the leading role of Bertolt Brecht's *Baal* in Volker Schlöndorff's television film (which had aired in January 1970). "Who needs the revolution?" he asks an interlocutor dressed exactly like the bounty hunter from Glauber Rocha's *Antonio das Mortes* (1969),[18] a film that enjoyed an iconic status among the West German student left, a hallmark of the Brazilian Cinema Novo, whose protracted use of spectacle and "Brecht-like blocks of ritualized action"[19] both expanded and exploded the language of cinema. The figure, explicitly referred to in the screenplay as Antonio, replies, "The people." Dietrich Lohmann's camera tracks left, then right, as the two figures, joined by a third cell member, Johanna (Hanna Schygulla), walk back and forth and reflect on the necessity for revolution and the proper role of the party. Despite the mix of period costumes (Fassbinder dons sunglasses, Schygulla a cocktail dress, while Antonio wears Third World peasant garb), everything is coordinated carefully (the precise spacing within the depth of field, the choreography of moving bodies, the rhythmic exchange of dialogue) in this protracted shot set in a bare and minimalistic brick-walled locus. Walking back and forth intriguingly enacts the play of possibility and, in this regard, resembles Fassbinder's contemporary antiteaterstaging of Goethe's *Iphigenie auf Tauris* (*Iphigenia in Tauris*), where characters, portraying "the open conflict of developed and developing stances,"[20] spoke more to the audience than to each other. These guerilla warriors muse about the mise-en-scène of revolution, realizing how theatrical effects might raise one's

interventions to a higher expressive power, an insight that will be central to the operations of the Red Army Faction and key to the ploys of the media-savvy terrorists in Fassbinder's *Die dritte Generation* (*The Third Generation*, 1979). Concluding with a repetition of the initial question and answer ("Who needs the revolution?"—"The people."), the opening tableau is both emphatic in the frontality of its assault and insistent in the terms of its political onslaught.

A cut moves the film outdoors to an extreme long shot from the bottom of a stairway at the top of which the preacher, who looks like a hippie,[21] addresses a circle of onlookers in front of a church, accompanying his sermon with the measured beating of a drum. The inspired speaker relates his vision of the Holy Maria and the message she has passed on. The religious sign becomes a political appeal: "The days of retribution," he announces, "have arrived." Unlike the first shot, the camera does not move, although as in the first shot, there is an unceasing expressive fluidity because the image in fact does change scale. Throughout the long take, a gentle zoom-in conveys us ever closer to the group at the top of the stairs, where those gathered sing a *Marienlied* ("Holy Mary, deliver us, Mother of God, so sweet") well known to religious pilgrims in Southern Germany. The image provides a colorful, even picturesque, tableau, a composition that is at once precise and ornate, framed by a gate and an arch, neatly symmetrical in its play of color and shadow and its positioning of figures across the frame, with gazes suggestively splayed over the visual field, all the while accompanied by the wind that blows in the trees.[22] The figures in the shot remain nearly static, the most vigorous movements being the preacher's drumming and the black monk's occasional exhalation of cigarette smoke. As the preacher ends with an appeal for a mass gathering in Niklashausen, the camera, with a sudden jerk, zooms back to the initial point of departure.

Dress, design, and decor from a number of periods coexist in the carnivalesque weave that is *The Niklashausen Journey*. As a collection of tableaus and a heteroglossia of historical voices, it is both a cinema of attractions and a station drama that depicts the march of a rebel on his rise to renown and his path to perdition. It is also an anthology of quotations from film history, wide-ranging, eclectic, and idiosyncratic. In its commemoration of the student movement, *The Niklashausen Journey*

revisits films that had fueled the political activists, working through the past in the form of various pasts, the privileged form of pastness being the cinema and its history. Often noted have been the formative importance of Godard's *Weekend* (1967; the multiple diegeses and the shared "structure of a picaresque journey through the countryside that ends in violence") and, as mentioned, that of *Antonio das Mortes* (both films, as Thomas Elsaesser points out, "mix declamatory rhetoric and readings from tracts with staged scenes").[23] The set pieces of Godard's *Sympathy for the Devil* (1968) come to mind as well, especially scenes of Black Panthers proclaiming their political objectives as well as backgrounds with piles of junked cars.

Essential to the extreme stylization of image and affect in *The Niklashausen Journey* (which many critics chided as tedious and pretentious) is the intense stasis of tableaus, so self-sufficient that they retard, and at times undermine, narrative continuity. Beyond that, the studied use of rich colors and the intricate choreography of gestures and gazes that catalyze a variety of emotions, are all impulses that figure strongly in the early work of Werner Schroeter, in which, as the director later acknowledged and as *The Niklashausen Journey* confirms, Fassbinder "made decisive discoveries."[24] The elaborate rituals, opulent palaces, and scenes of mass upheaval likewise bring to mind Hans W. Geißendörfer's vampire film *Jonathan* (1970), as do the depictions of a decadent court and a plundered rural landscape. The atmospheric and even painterly takes of country settings, so utterly rare in Fassbinder's work as a whole, lend a poignancy to the film's awareness of the harsh material conditions in these spaces. This coexistence of rustic beauty and bitter poverty, as well as the awareness of how political oppression weighed heavily on most people living in the German provinces, is seminal to the so-called antihomeland films made by West German directors at the time, particularly Schlöndorff's *Der plötzliche Reichtum der armen Leute von Kombach* (*The Sudden Wealth of the Poor People of Kombach*, 1971) and Reinhard Hauff's *Mathias Kneißl* (1971).[25]

The blend of past and present in the musical quotations is in keeping with the film as a whole. We hear various folk songs that praise the Virgin Mary (for instance, the *Marienlied*, "Meerstern, ich dich grüsse"); a peasant performs the *Bittgang*, "Earth, sing your song of joy loudly and strongly." Böhm delivers a rendition of "Bandiera rossa," a famous tune

from the Italian workers' movement that eulogizes the red flag. Written by Carlo Tuzzi in 1908, the song gained popularity among German Socialists and Communists in the twenties, and recirculated in postwar covers by the German rock stars Hannes Wader and Konstantin Wecker. The most striking and expressive music interlude in the film is a prolonged scene taken from a Munich concert by the experimental rock group, Amon Düül II, to which we will return.

Equally elaborate are the film's citations from German cultural history; its veritable *Zitatenschatz* ranges from passages out of Marx and Engels to a scene from Kleist's *Penthesilea* (performed by a trio of raging maenads, one of whom is Magdalena Montezuma, the crowning diva of Schroeter's features), and perhaps the most familiar tagline from Brecht's *The Three-Penny-Opera*. Indeed, at the end of the fourth shot, Fassbinder delivers the quotation with a knowing smirk, "Only he who lives in riches, lives in pleasure." The intertextual network also includes lines from the Colombian activist Camilo Torres and Eldridge Clever's *Soul on Ice*, as well as a lengthy newspaper reportage about the assassination of Fred Hampton, the founder of the Black Panthers, and the fellow soldier, Mark Clarke.

This chronicle of a failed revolution replays ways of speaking and showing, offering a compendium of gestures, voices, and initiatives. The rhetoric of the preacher and his followers provides a catechism in leftist politics and recalls the conceptual frameworks of West German student activists. For this reason, Elsaesser sees in the film Fassbinder's "most explicit look at both the rhetoric and the sentiment behind radical activism and ultra-left militancy."[26] Such claims, one recalls, were also common in contemporary reviews of the film. The free-handed appropriation of *Antonio das Mortes* as well as the film's ultimate martyrdom of a revolutionary leader surely were reflective of the student left's great fascination with Latin America and the legacy of Che Guevara. The Althusser student, Régis Debray, traveled to Cuba and other Latin American countries, collecting his experiences in a widely read book entitled *Revolution in the Revolution?*[27] Debray calls to mind the lessons that might be learned from Castro's revolution, how the Cuban Long March might function in other countries, and how it also might serve as a model for students in Europe, who would become urban guerillas and whose project it would be to continue Third World struggles against dictatorship and autocracy on the streets of the First

World and, with the use of subversive means and forms, to militate against state hegemony and pseudodemocracy.[28]

The Long March figures seminally in the final tableaus of *The Niklashausen Journey* and is central to any assessment of the film's politics. After the crucifixion of the preacher, a group of rebels carry on the struggle. An activist, speaking with a heavy foreign accent as his compatriots make Molotov cocktails behind him, insists that "there is only one way out of this situation and that is social world revolution, a world-wide civil war." Either we will live as human beings or "the world will be razed in our attempt to create a better life." Transforming a well-known slogan of the student movement into a terrorist punch line, he concludes, "Macht kaputt was Euch kaputt macht!" ("Bring down what brings you down!").[29] In the film's penultimate scene, the protesters-turned-terrorists confront the police in a prolonged gun battle that recalls the rooftop shootout at the conclusion of Lindsay Anderson's *If*. Fassbinder pulls out all the stops in what is unquestionably the feature's most dynamic sequence, a breathlessly sustained tracking shot that records the desperate onslaught and the pyrotechnic altercation, replete with running bodies, loud explosions, burning cars, and numerous casualties. Many died in the attack on a police station, Fassbinder, speaking in voice-over, reports in the film's final moments. The rebel leader, he reports, "did not yet realize that there are many ways to fight a battle." Three years later, other soldiers would return and, in a renewed invasion, almost all of them would die. And yet that is not the end, for the narrator continues. "But he and his comrades had learned from their mistakes" and retreated to the mountains. "Two years later," the voice-over concludes after a brief pause, "the revolution succeeded."

These closing signs seem to be clear. Or are they? Almost all previous commentators have in fact maintained that the film ends with the revolt's downfall.[30] Let us recall what has happened: Böhm is executed and his uprising fails; the remaining rebels in their desperation take recourse to more radical ploys, but their terrorist tactics have no success as we know from having witnessed in graphic detail the bloody demise of the insurrection at the hands of the police.[31] This is not, however, the film's parting shot. For the closing sentence would seem to leave open the possibility of a more upbeat and less lethal outcome.

In a conspicuous, perhaps even perverse, act of withholding, Fassbinder's voice-over verbalizes a hope without visualizing what this happier ending might look like. The final words allow at best a utopian prospect vested in the still-to-be-developed awareness "that there are many ways to fight a battle."

<div align="center">III.</div>

The conclusion of *Rio das Mortes* is far less downbeat and as a whole much lighter. Among Fassbinder's forty-some features, the film (shot in January 1970 and first shown that year at the Berlin Film Festival in July before its subsequent screening on West German television six months later) has received little attention; to this day it abides as one of Fassbinder's most rarely studied features. Elsaesser views it within the structural rubric of the director's early exercises in noir, with their "stark schematism" of narrative shape and character motivation, scripts in which "a male friendship, thwarted by a jealous woman, ends in deception and violent death."[32] Upon closer analysis, *Rio das Mortes* is not so readily or easily comparable to *Liebe ist kälter als der Tod* (*Love Is Colder Than Death*, 1969), *Götter der Pest* (*Gods of the Plague*, 1970), and *Der amerikanische Soldat* (*The American Soldier*, 1970). It surely is not a gangster film; its protagonists are more dreamers than schemers; its tone is far more playful; its atmosphere, despite a grey winter's cold, much less grim; and its outcome, as stated, anything but violent. For these reasons, it cannot be comfortably cubbyholed among Fassbinder's low-budget neo-noirs. The film remains something of an anomaly, not easily placed within the early productions or within the director's work as a whole. If anything, the bumbling male protagonist recalls the lackadaisical and feckless good-for-nothing played by Marquardt Bohm in Rudolf Thome's *Rote Sonne* (*Red Sun*, 1970) or the idle would-be hipster (Werner Enke) from May Spils's *Zur Sache, Schätzchen* (*Go for It, Baby*, 1968). *Rio das Mortes* has many comic touches and, one might even say, constitutes a Young German Film's *Dumb and Dumber* (Peter Farrelly, 1994); it is, in any event, a work on the margins, a lesser-known Fassbinder, but not a lesser Fassbinder.

Fassbinder related that the story idea came from Volker Schlöndorff, who generously agreed to let him use it; Janus Film provided 135,000 DM in a coproduction with antiteater-X-film. Shot over twenty days, the film reworked many of the routines that Fassbinder's troupe of players by then knew well, but otherwise, as the director later observed, the feature was not of particular importance, in general or for his development. Nonetheless, he was happy with the look of the film and in fact even retained a certain fondness for it. In retrospect, he considered it to be far more serious and well-crafted than it was thought to be at the time. (The producer called the script *verspielt*, i.e., whimsical.) He liked how the film presented "a very naive and simply told story in a naive and simple and cheerful or sad way, no matter how you want to look at it."[33] The plot, to be sure, is easily summarized. Two old school friends, Michel (who does home repair work) and Günther (a door-to-door travel agent) run into each other by chance in the Munich apartment of Michel's girlfriend, the student Hanna. Having rediscovered what they take to be an ancient map that shows the way to a treasure hidden near the Rio das Mortes, the two single-mindedly seek financial support for their planned expedition, which would be the fulfillment of a childhood dream.[34] After a number of false starts and dead ends, and to the dismay of Hanna, who has domestic designs on Michel, the pair surprisingly find a backer. The film concludes at the Munich airport where a distraught Hanna, seduced by Günther and abandoned by her lover, clutches a pistol and contemplates murder, but in the end desists, looking on as the two friends board a morning plane for South America.

Like the early films, arguably even more lavishly, *Rio das Mortes* abounds with borrowings and references. The choice of music is, as ever, distinctive in its eclecticism, a singular mix of high (including Albinoni's "Adagio in G Minor" and an aria from *Madame Butterfly*) and low (which evidences Fassbinder's wide-ranging knowledge of contemporary pop culture).[35] *Rio das Mortes* opens in Hanna's apartment; while she talks on the telephone with her mother,[36] the sounds of "Morning Song" from the album *One Nation Underground* by the American psychedelic folk group Pearls Before Swine, already audible during the credit sequence, continue. A glimpse at the album cover on the floor confirms that the music now issues from an onscreen source. Later Hanna and the two friends visit a

disco, which is decked out for Fasching in the most uninspired way. As Michel and Günther resume their deliberations about how to fund their expedition, Hanna (in a slinky red dress) dances with an unidentified character (played by Fassbinder) as Kenny Rogers's "Ruby, Don't Take Your Love to Town" emanates from the jukebox. A prolonged pan around the dance floor does not yield anything of particular interest; nothing much is going on, the place is staid and boring and hardly a haven of carnival revelry. The music changes to Elvis Presley's "Jailhouse Rock" and the camera follows Hanna and her partner as the room comes alive while they rock out with great abandon. The music over, Hanna smiles with pleasure and effuses, "That was really lovely."

Cross-references from films and books well known to contemporary audiences offer a unique glossary of the time's cultural preferences, be it the Pop Art color play of the credit sequence with its stark blue background redolent of Godard, the expressive use of a Buster Keaton poster (which hangs in Hanna's apartment) as a deadpan counterpoint to the comic action at various points in the narrative, the cameo role of Carla Aulala (known already from films by Hans Jürgen Syberberg and Werner Schroeter) and her homage to Marilyn Monroe (she sings, "I want to be loved by you and nobody else"), or Hanna's lengthy quotation from an account of Lana Turner's tawdry life history, including her many marriages and the famous stabbing of one husband by her daughter. The text comes from a Yaak Karsunke poem; Michel really likes it, even if Hanna wonders whether it would be appropriate for classroom use with fourteen-year-olds.[37]

Within the film's elaborate weave of texts and cross-references, two documents play an important role and, in each case, lead us back to seminal myths of 1968. The first is a textbook, which supplies a primer on child psychology and a guide for the reproduction of society. Hanna, a university student who is training to become a kindergarten teacher, scrutinizes *Das Kind zwischen 5 und 10*,[38] memorizing a passage regarding the socialization of children: "One must inculcate standards of achievement in a child early on and in that way help to make the adaptation to society as easy as possible." As she repeats the phrases, the viewer has time to mull over these thoughts and, in the process, to become a critical reader. When Hanna meets Katrin for lunch, the friend and classmate is trying to memorize the same words as if she were learning a foreign language.

Later a group of women, fellow students of pedagogy, gather in an auditorium of the Munich Hochschule für Pädagogik, walking in a circle before a chalkboard on which we see the phrase "USSA" (an abbreviation frequently used by a student left fond of linking American imperialism with Nazi violence) imposed over an erect penis that looks like a weapon. We hear the Gesell text again, repeated this time with sarcastic derision.[39] But the radical voice is not the sole sentiment; not all of the women in the group are leftists or feminists. Both Hanna and Katrin insist that they only want to get married and have children; one of their comrades (played by the ever-mesmerizing Magdalena Montezuma), staring into the camera, replies, "The oppression of women above all manifests itself in the behavior of women," which is the title of Hellmuth Costard's 1970 film.[40] In the tableau, Fassbinder reiterates the quite popular contemporary image of revolutionary women with an erotic aura (particularly in his direction of Ingrid Caven and Magdalena Montezuma).[41] At the same time, however, he makes it clear that this model is anything but universally accepted, even among university students, and, in the film as a whole, he positions his female protagonist as a plier of convention and conformity.

The second key document is the treasure map, an imaginary text that becomes a site of projection. The map not only catalyzes a quest; it seals a male bond. Michel forsakes Hanna and her desire for marriage in favor of adventure. The boyhood fantasy involves a faraway place and untold riches. Rio das Mortes, these seekers repeatedly claim, is in Peru, but even a brief look at a world atlas would make it clear that the river's location is in Brazil. Günther is so unburdened by a knowledge of history and geography that he does not know the difference between the Incas and the Mayas and is convinced that "inside a mountain somewhere in Peru" reside ancient Mayan temples. The pair's impressionistic sense of geography corresponds, as subsequent encounters bear out, to their less-than-certain grasp of basic

FIGURE 11.2 (*top, opposite page*) Student activists and the slogans and icons of 1968 (*Rio das Mortes*, 1970).

FIGURE 11.3 (*bottom, opposite page*) A reference, at once solemn and ironic, to the title of Hellmuth Costard's 1970 film, *Die Unterdrückung der Frau ist vor allem an dem Verhalten der Frauen selber zu erkennen* (Magdalena Montezuma in *Rio das Mortes*).

And anyway, what you say is pretty Utopian.

The repression of women can best
be recognized in women's own behavior.

economic factors and the most fundamental logistic questions. Their biggest problem is that their adventure requires venture capital.

Rio das Mortes is a film that constantly refers to money and the cost of things, whether it is Katrin's dress that she buys for 120 DM or the considerable discounts that Günther, a travel broker, promises for package tours. We witness an itemized reckoning for the tiling work done by Michel and his colleague for a middle-class client, the inventory of time spent, and the price per hour plus the cost of materials. We also watch a travel agent put together a painstaking inventory of the planned trip's cost, which, everything included, would come to about 34,440 DM. A protracted scene details the selling of Michel's sports car, his inept attempt at bartering, the close-up of the contract and the signature that signs at the bottom line, the cash (with bills carefully counted out) that exchanges hands, and a closing prospect of the car standing on the lot, bought for 2,200 DM and now priced at 3,600 DM. The quest for money will necessitate a series of negotiations, the first of which is with family members, meetings with Günther's mother (who writes a check whose amount is apparently modest) and Hanna's officious uncle (a no-nonsense businessman who has an intimate knowledge of economic conditions in Latin America, whose pointed questions about the pair's objectives, despite their amateurish attempts at market research that includes a visit to the Bavarian State Library and a call to the Peruvian Consulate, receive halting answers that do not inspire confidence). After family come friends. Katrin's significant other, Joachim, a graduate student in Latin American studies, describes with gusto the considerable opportunities for state funding of ventures like their own and urges Michel and Günther to try their luck with the German Research Society (*Deutsche Forschungsgesellschaft*), a federal body with offices in Munich. All you have to do, says Joachim, is to prove your qualifications. The subsequent appointment with a government representative (who speaks with pride of the agency's ongoing computerization), of course, turns out to be yet a further travesty, for the only one with qualifications is Joachim and he has not come with them. The larger part of the film's running time will involve such attempts by the two dreamers to secure the means for their screwball scheme. *Rio das Mortes*, one might say, presents an extended march through the institutions, albeit an ironic one, a set of

confrontations—in bourgeois interiors, business firms, and government agencies—with representatives of the reality principle.

Among the student left, maintains Wolfgang Kraushaar, prominent scholar of 1968 and the *Studentenbewegung,* money was held in suspicion as the instrument of capital; one of the very few ways in which it could be redeemed was when it was used to support revolutionary campaigns in the Third World, particularly in Latin America. In that regard, the benevolent leftist capitalist, usually a young heir to a family fortune, played an essential role in the era's mythology. Progressive millionaires acted as positive pendants to the greedy Uncle Scrooge, putting their riches in the service of good causes. These benefactors, argues Kraushaar, became important projection figures for a student left (itself invariably short of cash) skeptical about the power of capital.[42] In *Rio das Mortes,* the leftist myth of the good fairy who bankrolls Latin American causes receives an ironic, indeed hilarious, twist. Out for the evening in a bar and by chance speaking with an artist-acquaintance, the would-be treasure hunters learn of a rich woman who is fond of "giving money to people who are crazy enough. Theater people, painters, and the like." Just go up to her, the friend counsels them, and tell her that you are filmmakers. The woman in question takes a meeting and is impressed by the treasure map, which she calls "incredibly beautiful. Almost as if an artist had painted it." With little ado and great enthusiasm, she hands over a cashier's check for 30,000 DM. As farfetched and tongue in cheek as the scenario seems, it in fact reflects the director's own experience. While ferreting out backers for his first feature, Fassbinder had received a check for 20,000 DM from a similar good fairy, Hanna Axmann-Rezzori—the woman who appears in *Rio das Mortes* as Michel and Günther's patron.[43]

IV.

For young people living in West Germany, the year 1969, according to Dieter Kunzelmann, prominent activist and cofounder of the legendary Kommune 1, was one of "errors and confusions . . . Everything was in the process of dissolving, everyone was heading for the road . . . What a year of twists and turns, this 1969 . . . The only thing that remained clearly in view were one's lack of clarity and the attendant flights in search

of self-realization and the departures to new shores."[44] Both *The Niklashausen Journey* and *Rio das Mortes*, films that issued from this precise historical moment, were timely in their impetus; they displayed and replayed signs of the times, in the process reflecting on myths and their meanings in a time of flux. They attest, in quite different ways, to the path of a young generation in the wake of 1968 as it traversed both dangerous ground and unfamiliar terrain.

More specifically, the two early features chronicle the travails involved in the making of films and, as such, constitute significant film documents which, at crucial moments, become documentary films in their own right. In *The Niklashausen Journey*, two scenes do this with particular emphasis. As the camera shifts from a long shot of a rock quarry to a close-up of a guitarist, we quickly realize we are at a rock concert. Contemporary viewers would immediately recognize the group Amon Düül II and its lead player, Chris Karrer. The stylized and carefully composed tableaus that have defined the film to that point are no longer in evidence during this seven-minute sequence whose fluid and spontaneous cinema vérité recalls Richard Leacock. We partake of tight views of musicians and listeners, among whom figure the actors in the film (who are at the same time members of Fassbinder's team), having a good time, smoking marijuana, drinking Coca-Cola, sprawling on the ground, savoring the moment, and enjoying the scene in which there is little difference between spectacle and spectators. Later, the narrative yields to the film's site of construction and production of meaning. Hanna Schygulla, the actress rehearsing the role of Johanna, stands before a mirror and repeats dialogue about the function of property ownership within the natural order. The character who was the black monk now speaks as the director Fassbinder, correcting the actress and insisting that she get her lines right. As he reads the script with alternative emphases and insists on a different body language (the pose, he says, should be more humble), the auteur is irritable, impatient, and sullen. He stares at Schygulla with a fierce and intimidating intensity. The last line, he fumes, "has to be more aggressive, much, much more aggressive," complaining that "the pause was also far too long." Even more radically and directly than in Fassbinder's meta-film, *Warnung vor einer heiligen Nutte* (*Beware of the Holy Whore*, 1971), this passage bears

FIGURE 11.4 In an overtly Brechtian aside, Fassbinder steps out of character and speaks as the film's director to a female player (Hanna Schygulla in *The Niklashausen Journey*).

witness to the director's sometimes-autocratic relationship to his players and the studious shaping of his materials.

In what at first glance appears to be an unremarkable scene in *Rio das Mortes*, Michel, Günther, and Hanna leave the restaurant Tropic of Cancer and walk down the street. The two comrades continue talking about their quest for treasure, prompting Hanna's objection that the trip makes no sense because anything of importance surely will have been discovered already. No, replies Michel, "there are a lot of things, things that nobody has found yet." Undeterred, the partners talk about the tools they will need for their expedition. The mise-en-scène infuses the passage with an additional and suggestive point of reference. Hanna leans on the longhaired Michel and for a privileged moment the two replicate to a tee the famous cover motif from the album, *The Freewheelin' Bob Dylan* (1963), the iconic photograph of the singer strolling down a windswept lane in Greenwich Village with his girlfriend Suze Rotolo. Critic

Janet Maslin speaks of the image as "a photograph that inspired count-less young men to hunch their shoulders, look distant, and let the girl do the clinging."[45] Rotolo later would recall how the picture avoided the posed and polished quality of the era's record covers; it became "one of those cultural markers that influenced the look of album covers precisely because of its casual down-home spontaneity and sensibility . . . Who-ever was responsible for choosing that particular photograph . . . really had an eye for a new look."[46] In that way, Michel's insistence on things that have not yet been found rhymes with the mythic image with its new look that the tableau (given Hanna's conspicuous—and scripted—lean on Michel's shoulder) *consciously* seeks to replicate. Of course, by the time Fassbinder's film appeared, the "new look" on offer was not new at all; it was a well-known quotation. But as a quotation, it echoed a young German generation's larger recognition, a sense both of deficit and of challenge, that one needed to look beyond Germany if one was to find new ways of being. The quintessence of youth culture and coolness came from a faraway world, every bit as faraway as the Rio das Mortes with its promises of adventure.[47] In a similar regard, Michel and Günther's quest,[48] for all the bumbling that attends it and all the laughter that the pair's incapacity inspires, can at least on one level be taken seriously. For it also enacts, unrealistically but still not without veracity, the vicissi-tudes and challenges that dreamers, especially young German filmmak-ers, might have encountered in the FRG at the time.

The symbolic value of 1968, recent analysts of the era's mythology maintain, resides today more in its lasting aesthetic traces than in its failed political programs.[49] A signifier of coolness like the Dylan cover makes it clear how the mythology of the time abides especially as one of youth and a quest for new and more heightened ways of being in the world. In this light, Michel's response that there are "a lot of things, things that nobody has found yet" is both ironic and suggestive. In the context of the film's narrative, the sentence is yet a further instance of his cluelessness. Within the context of the post-1968 culture that produced and watched this film, however, the quest for the new that Michel espouses very much had to do with the era's larger concern about different ways of seeing as well as being seen. Any cultural transformation perforce would come only with new forms of representation, even if the institutional opponents of such new

FIGURE 11.5 A reenactment of the famous cover photograph from *The Freewheelin' Bob Dylan*: Michel (Michael König) with hunched shoulders and a distant look, a clinging Hanna (Hanna Schygulla). Fassbinder audaciously adds a third figure to the tableau, both triangulating desire and including a vestige of Allied occupation, Günther (Günther Kaufmann), presumably the son of an African-American soldier. While citing the iconic image, Fassbinder complicates the picture (*Rio das Mortes*).

expressions, as independent artists in West Germany knew well, maintained considerable power and control within the public sphere. Among all of the New German filmmakers, Fassbinder, more than anyone else, would take to heart Godard's eschewal of political films in favor of making films politically. He embraced the 1968ers' desire for renewal even if his work did not share their rhetoric. If there is a single lesson that he learned from the student movement it was that any substantial social change would necessitate a fundamental transformation in the ways that people think and feel. The incendiary and still-resonant body of films that he created would enact, in a multiplicity of ways, the wisdom of his voice-over narrator in *The Niklashausen Journey*, that "there are many ways to fight a battle."

FIGURE 12.1 (*top*) "I want to take a photo of you," says Alice (Yella Rottländer) to Philip Winter (Rüdiger Vogler). "So that you know what you look like" (*Alice in den Städten/Alice in the Cities,* 1974).

FIGURE 12.2 The child's snapshot commingles the countenances of the two travelers, anticipating their subsequent shared course in time.

HOW AMERICAN IS IT?

I.

One might even venture to say that the familiar is reassuring. We more or less know what to expect. What it will be like. It will be familiar. Which may be a great reason why we, every once in a while, wish to get away, to escape from the familiar, to visit some far-off place . . . because we are willing . . . no . . . because we are eager to stretch our imaginations and see something for the first time, something that is not entirely familiar. And so, if we are open-minded, we want to introduce to our existence something that is new, something that is different. . . . And then, in no time, we discover that the longer we stay in one place, the longer we sleep in unfamiliar beds, the longer we meet people from other countries, the more familiar it all becomes. How long can something remain unfamiliar? And, perhaps an even more important question is, does the unfamiliar activate and spark our curiosity and interest? Is it a call to us to explore and familiarize ourselves with the unknown?

—WALTER ABISH, *HOW GERMAN IS IT*[1]

Let us recall some privileged moments of American presence in New German films, examples of one culture's occupation of another: images of Yankees far away from home; Rainer Werner Fassbinder's American soldiers, for instance, getting drunk at a sausage stand, making a pass on a train; or like the debonair Mr. Bill, accepting Maria Braun's invitation to dance and teaching her to speak English. Or one thinks of Wim Wenders's American

friends, fictional and real, the displaced cowboy in Hamburg, Tom Ripley, and the dying maverick filmmaker Nicholas Ray. Images, too, of German minds channeling American dreams: Munich low-lifers trying to recreate tough-guy poses gleaned from gangster movies, those low-rent desperadoes in Fassbinder's early exercises in noir. "An American in my situation," reflects a troubled Hoffmann in the first shot of Reinhard Hauff's *Messer im Kopf* (*Knife in the Head*, 1978), "would probably shoot blindly out of the window." Prospects of Germans in Manhattan, matching scenes from above the Empire State Building some forty years apart: Tonio Feuersinger becomes an insignificant dot as he stands on the edifice in Luis Trenker's *Der verlorene Sohn* (*The Prodigal Son*, 1934). Stroszek, Scheitz, and Eva (in Werner Herzog's *Stroszek*, 1977) regard the New World from atop the same structure before they move on to Railroad Flats, Wisconsin. America also as the refuge for an emigrant film culture: Friedrich Munro (a thinly disguised stand-in for F. W. Murnau) steps over a remembrance to Fritz Lang on the Hollywood Avenue of Stars in Wenders's *Der Stand der Dinge* (*The State of Things*, 1982). And, not to forget, America as dangerous ground: Bavarians banished from their homeland and garbed in *Lederhosen* march to their demise on a Wild West street in Volker Vogeler's *Verflucht, dies Amerika* (*Yankee Dudler*, 1973). Presentiments, likewise, of America as a plague-bringer: A composition in Wenders's *Summer in the City* (1970) frames an Amoco gas station sign in Berlin so that we see "Amoc." Postcards and photographs from the United States as well: The poor people of Kombach (in Schlöndorff's antihomeland film of 1971, *Der plötzliche Reichtum der armen Leute von Kombach/The Sudden Wealth of the Poor People of Kombach*) partake of heartening accounts from friends who claim to have found fortune in Milwaukee. One gazes upon a panorama of Monument Valley in a scorched and divided Berlin during the airlift in Thomas Brasch's *Engel aus Eisen* (*Angels of Iron*, 1980). Scenes of a neon-lit Las Vegas float through the head of an emigrant-to-be on her way to the Munich airport in Uwe Brandner's *halbe-halbe* (*Fifty-Fifty*, 1978).

II.

America in the mind of German filmmakers, especially West German ones, constitutes a fantasy land, a daydream, a nightmare. This strong

foreign hold on postwar German imaginations has stimulated much discussion, speculation, and theorizing. Journalists and scholars alike have written at length about what one critic aptly terms "the familiar cross-cultural fantasy syndrome, that troubled love–hate relationship entertained by [Wim] Wenders and his peers with things American, expressed in the ubiquitously quoted quote, 'The Americans have colonized our unconscious.'" This approach, as Sheila Johnston goes on to say, is "particularly popular with Germanists generally well-versed in identifying *Amerikabilder* . . . in German literature."[2] The tendency in such commentaries has been to reduce a large complex of influence, borrowing, and interdependence, all of which is bound in networks of historical and sociopolitical determinants, down to simple variations on single themes. In this regard three explanatory models have prevailed.

1. *The American Friend as Enemy.* In this scenario, America poses a threat to a fragile Old World. Cultural imperialism is an object of focus— and criticism, especially for New German filmmakers who grew up under its influence. Although benevolent GIs would bring a shattered nation not only chewing gum, chocolate, and CARE packages but also a new cultural identity, Allied occupiers would later destroy this trust.[3] Americans would become increasingly ugly, ambassadors of materialism, diminishers of aura, and agents of potential doom. While emphasizing the virtual rejection of the powerful foreign culture and its diabolical hold on European imaginations, this disaffected view underplays the question of the continuing—and not always negative—fascination with and appropriation of things American by Young German directors, even after 1968 and the Vietnam war.[4]

2. *The Love–Hatred Syndrome.*[5] America also has meant mass culture and Hollywood, an entertainment industry that nurtured the imaginations of West German youth, providing identification figures for a fatherless society. American film has played the role of captivator and liberator, a dominant cinema whose patterns limit associations and reproduce the world in codified and ready-made schemes, a dynamic harshly taken to task in Max Horkheimer and Theodor W. Adorno's critique of the culture industry.[6] Film, however, also set imaginations free, presenting alternatives to the drab everyday of a country caught up in the difficult

and arduous business of reconstruction. American film—and American popular culture in general—filled a large gap in the fledgling democracy, serving as an ersatz homeland in the fifties, for young people and the future New German filmmakers.

American films came to West Germany as emanations of a mighty industry that exerted a hegemony over production, distribution, and exhibition, as well as circumscribing the making and partaking of images throughout the world. New German filmmakers, as Timothy Corrigan observes, are for this reason caught in a bind, victims of "a history that has been guided and nourished by the splendor of Hollywood and its images and a history that has been painfully aware of the lacks and deceptions at the center of those images."[7] In this regard, one might even go a step further: For so much of what one speaks of as American cinema came about as the work of emigrant and exiled German filmmakers. Hollywood in fact would be unthinkable without the contributions of the Weimar film culture that to a great extent and for various reasons relocated in Southern California during the twenties and thirties. A sense of debt and recognition to this film tradition therefore must become part of the calculation. When they consider American cinema, postwar Germans look on a simultaneous source of enchantment and disenchantment, a fascinating apparatus and a menacing behemoth. And one also considers traces of one's own displaced film history. Witness the often-discussed appropriation of Douglas Sirk by Fassbinder, who gained so much from the director's subversive reshaping of the melodrama in various Hollywood studios.[8] Or recall the lessons learned by Wenders, a permanent exile "at home on the road," as he considers Fritz Lang's course in time.[9] Think about the numerous Young German filmmakers like Fassbinder, Roland Klick, Rudolf Thome, and Klaus Lemke who during the late sixties cast their second-hand gangster fantasies in a noir mold.[10] Recall how Volker Schlöndorff, upon accepting the Oscar for *Die Blechtrommel* (*The Tin Drum*, 1979) in 1980, acknowledged his connection to this transplanted legacy expressly, taking the prize in the name of "all those worked here and whose tradition we want to pick up: Fritz Lang, Billy Wilder, Pabst, Murnau, Lubitsch."

3. *New German Cinema's Historical Amnesia.* Faced with a traumatic heritage of fascism and genocide, West Germans growing up in the

Adenauer era sought refuge in American popular culture. "The need to forget 20 years," observed Wenders, "created a hole and people tried to cover this . . . by assimilating American culture."[11] New German filmmakers, Raymond Durgnat insists, have for this reason wallowed "in a pit of historical amnesia."[12] Unable to come to terms with their parents' past and ill-equipped to confront the realities of the present, such an argument maintains, West German filmmakers seek refuge in foreign landscapes and other cultures, anything to take their minds off their own history. This approach, however, overlooks numerous German filmmakers that mediate subjective and historical factors, works one might call, borrowing a phrase from Walter Benjamin, "emergency brake films,"[13] works that explore the relation of individual histories to a more encompassing—and, for the most, unwritten and repressed—general history. New German Cinema is a decidedly national cinema, very much bound up in questions of identity and collective memory and concerned with the trauma of a still-unassimilated past that persists as a continuing source of tension and disquiet.

In West German cinema of various provenances, America often embodies a dream betrayed, a land of disenchantment and social inequity, a place where furious wheeling-and-dealing fuels vicious circles of materialism. In the examples to be discussed—Herzog's *Stroszek* (1977) and Wenders's *Alice in den Städten* (*Alice in the Cities*, 1974)—America appears not only as a deflowered garden and a sinister site of exploitation, but also and more significantly, it becomes a fantasy land that reflects and intensifies the preoccupations and conflicts of its visitors. The United States rarely assumes an exotic aspect in West German films. Rather, it becomes a testing ground, a foreign terrain travelers tread while exploring and reexamining themselves. In this way, American acts more as an idea than a reality, more a matter of objects, images, and fixations than real people and new experiences. It functions, in short, as an imaginary, a site where subjects come to understand themselves through a constant play and identification with reflections of themselves as others.

The motto from Abish's novel, a quote from Jean-Luc Godard, sums up these dynamics quite succinctly: "What is really at stake is one's image of oneself."[14] *How German Is It* (whose subtitle *Wie Deutsch Ist Es* articulates

the reflective dimension of this interaction) employs a strategy central to many West German evocations of America: minds ferment while abroad, but invariably "at the expense of the foreign culture."[15] German directors have made films set in America not so much "in order to 'understand' another culture"; rather, they use the signs of another country to establish an enriched relation to their own. Such a proclivity "reduces the landscape, everything . . . to a set of signs, of images and also introduces, not the interpretation itself, but the need for interpretation."[16]

<p style="text-align:center">III.</p>

Over the years, Werner Herzog has gained an immense following, especially in France, Great Britain, Italy, and North America, for his explorations of undiscovered places, bizarre terrains, and exotic venues. Surveyor of the extraordinary and advocate of the disfranchised, he enthralls audiences with his found objects and outlandish characters. America takes on a weird and unfamiliar countenance in *Stroszek*, a film Herzog made "to define my position about this country and its culture."[17] Americans, the director insists, "believe that they are normal, that they make sense, and that the *rest* of the world is exotic. They do not seem to understand that they are the *most* exotic people in the world right now."[18] Taking in milieux and inhabitants with bemused curiosity, the camera traverses the strange world of Railroad Flats with its empty streets, crowded truck stop, run-down gas station, and unsightly mobile homes. The locals' weekend outings involve searches for still-undiscovered victims of a mass murderer. People speak strange tongues, CB-radio jargon as well as the whirlwind phrases of auctioneers, a kind of speech in which incantation and wheeling-and-dealing merge surrealistically. A bank official hesitates when offered cash in payment for an outstanding bill, noting that "we usually only accept credit cards and checks." One later glimpses a reservation in South Carolina inhabited by Cherokees whose income derives from marketing mementoes from their culture to tourists.

These odd signifiers assume a place within a larger pattern of signification, a design typical of Herzog's fatalistic fantasies. To be sure, the camera's attentions to found objects in an out-of-kilter New World are not

just exercises in exoticism; in fact, their careful views of social conditions provide idiosyncratic field notes. Nonetheless, words uttered by Bruno shortly before his release from an Old World prison intimate the film's mythical trajectory: "It's like a circle." The circle is the informing structure in Herzog's cinema, an objective correlative to his dark romanticism. The circle stands for a trapped life without purpose, a human existence without meaningful progress; it signifies the eternal return of the same, motions that render people time-bound captives, subject to the whims of inscrutable higher powers. At best one can rebel against what seems to be the absurd and for a moment achieve a purified, ecstatic, and heightened sense of being. Ultimately, however, the typical Herzog protagonist is overcome by inexorable and inscrutable elements.

America appears in *Stroszek* not only as a place full of novel and goofy inhabitants but likewise reflects an intensified version of the tough world in Berlin, which Bruno and his fellow travelers flee. Before he leaves the mean streets of Kreuzberg, Bruno gains acute insight into how the world operates. His great hope—and the source of his ultimate tragedy—is that things might be different elsewhere. He escapes Berlin only to find the same dynamics at work in the United States. *Stroszek* contains a patterned series of repetitions that mirror Bruno's experiences at home and abroad. Brutal hoods who break down doors give way to slick bankers who politely knock and apologetically inform their tardy clients that they will have to auction off the house and the household. A comfortable and idiosyncratically arranged flat with a piano at its center becomes replaced by a mobile home in whose middle stands a television. Familiar and cherished belongings yield to objects packed in plastic and bought on installment. Migrant workers from Turkey living in a ghetto mirror a Native American working as a gas station mechanic and disfranchised Cherokees catering to tourists. The spontaneous mynah bird Beo, confiscated by U.S. Customs agents, finds New World counterparts among frozen turkeys and frenzied chickens. Life in the harsh confines of Kreuzberg left Bruno ravaged and battered. The fierce verticals of its gritty and narrow courtyards open up to the horizontal emptiness of the American Midwest, but nothing really changes. Bruno's trek to the United States becomes an extended *Moritat*, a grotesque ballad with a foregone tragic conclusion.

> I thought America would be different,
> and we could get rich quick.

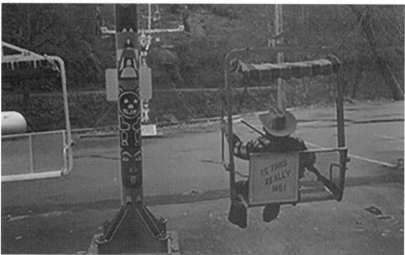

FIGURE 12.3 (*top*) The dark side of the American dream: Bruno (Bruno S.) and Eva (Eva Mattes), down and out in Railroad Flats, Wisconsin (*Stroszek*, 1977).

FIGURE 12.4 The last stop in Bruno's American odyssey, a journey that ends with an offscreen act of violence on a circling ski lift (*Stroszek*).

The film begins with a miniature portrait of a world trapped in a glass reflection. As the narrative takes its inevitable course, the reflection opens up to an absurd world, Herzog's dark romanticism at its darkest, where all hopes prove to be empty promises. In the first sequence, Bruno objects to a prison guard's perfunctory request that he, who has been in the institution for a long while and is surely well known, state his name. At the conclusion, he sits on a ski-lift chair on whose back we read, "Is this really me?" The closing shots show Bruno's final revolt against conditions that have fettered him from the film's start. He seeks to retain a distinct identity in a world that constantly threatens to engulf him. He rebels against the subtle—and for that reason more insidious—cruelty he comes across in person. Like many of Herzog's other heroes, he also strikes out against the sinister design of the world at large. "Things go around like in circles," he says to a prison warden early in the film. When Stroszek ultimately runs amuck, he mimics and thus mocks a world in which whirl is king. With rifle in hand, he leaves a stolen tow-truck in flames, the vehicle spinning driverless around a parking lot. He activates a coin-operated machine in which a dancing chicken gyrates on a spinning platter. Bruno himself goes around and around on a ski lift. We hear an offscreen gunshot, presumably the emigrant's final act of resistance. What kind of land is this that takes his precious Beo away from him, he wonders after landing in New York. The narrative as a whole provides an answer: The same country where one later glimpses caged chickens and rabbits, Native Americans on a reservation who are reduced to strangers in their own homeland, extensions among many others of a universal prison, and expressions of the fettered existence one encounters from the start to finish of *Stroszek*.

IV.

Throughout his career, Wim Wenders has remained a filmmaker who respects the integrity of the world, who denies the temptation to coerce characters, objects, and landscapes into ready-made forms, the patterns of recognition and narrative clichés of the dominant cinema.[19] He is an earnest bystander, a gentle gazer sensitive to the singularity and the vulnerability of the other. "There's a quotation I have pinned on my wall,"

he said in his famous conversation with Jan Dawson, "it's one of the few theoretical things about film-making that I can accept completely," going on to quote Béla Balázs's claim that the essence and possibility of film art is that everyone and everything looks like it is.[20] The line essentializes Wenders's cinema of impartial and careful regards. The same feeling inheres in his early writings as well, in his celebrations of the direct appeal of rock and roll or his deep veneration for the straightforwardness of classical American cinema and the westerns of John Ford.[21]

Philip Winter, the journalist traveling through the United States in *Alice in the Cities*, awakens from troubled dreams in the Skyway Motel somewhere on the eastern seaboard. With a start, he recognizes *Young Mr. Lincoln* (1939) on the television screen in front of him. Initially bemused, he becomes infuriated when a commercial interrupts his encounter with Ford's wondrous images. Winter is afflicted and disoriented; his lack of focus finds an expressive extension in the film's series of disconnected images, empty compositions, music that begins and ends abruptly, a camera whose random attentions parallel the imagistic desperation of Philip's persistent Polaroid shots. Something happens to you when you're on the road in America, he will apologize later to an editor as an excuse for not submitting his long-overdue travel narrative. America is a rich source of images, but his pictures do not capture his experience—in Wenders's terms, they do not show things as they are—nor do they tell a story. Speaking with an ex-girlfriend in Manhattan, the weary writer tries to explain away his malaise as a function of the foreign country. "From the moment," he says, "that you drive out of New York nothing changes, everything looks the same, so that you can't imagine anything else, so that you can't imagine any kind of change at all. I became a stranger to myself." America, he alleges, has made him lose all sense of sight and sound; his alienation, so it would seem, is a disease he contracted in the United States. But his none-too-convinced friend's response makes it clear that she has heard this all before: "You don't have to travel through America," she retorts, "for that to happen. One loses one's sight and hearing when one loses one's sense of life. And you lost that a long time ago." Philip's crisis, in other words, started at home.

Random stimuli overwhelm Philip as he travels on the East Coast. Information overload constantly interrupts and fragments his experience,

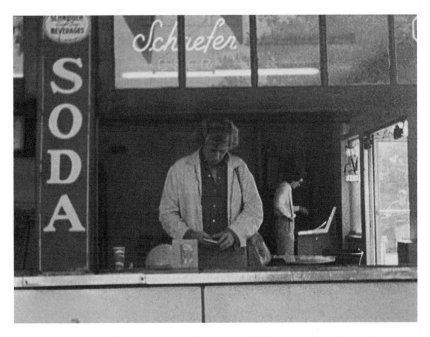

FIGURE 12.5 The matching positions and gestures of a director and his fictional surrogate: Philip (Rüdiger Vogler) shuffles through a stack of Polaroid photographs. In the background a hipster (Wim Wenders) stands at a window and contemplates a jukebox while we hear Count Five's "Psychotic Reaction" (*Alice in the Cities*).

exacerbating a wandering mind that feels it has no home base. Like other "road trilogy"[22] heroes, Philip initially thinks that observing the world will bring him closer to it. But his is a disinterested gaze, and it provides neither insight nor perspective. Impressions and memories remain empty as long as they lack a place and a purpose. America aggravates Philip's sense of insufficiency every bit as fiercely as Wilhelm's trip through the Federal Republic in *Falsche Bewegung* (*Wrong Move*, 1975) makes him aware of the distance between him and the world about which he wants to write.

Philip's unfocused gazing and imagistic impressionism give way to a regard for the other when Alice, a lost waif, enters the film. We first see her walking in circles around a revolving door. In joining her in that portal, Philip unwittingly walks into a narrative trajectory. Once the unlikely two companions return to Europe, a story takes shape, a search for a house on a photograph, the home of Alice's grandmother somewhere in the

Ruhr Valley. After they land in Holland, Alice takes a snapshot of Philip, "So that you at least know what you look like." The picture records not only his face but also the superimposed features of the picture-taker. Film becomes a record of communication, a medium that represents interaction between people, not just static frames and empty still lifes.[23] The ugly industrial landscapes in Germany, every bit as violated and compromised as the commercial strips and busy thoroughfares that sparked Philip's ire abroad, no longer weigh so heavily on him. Returning to Europe animates him and positions him within a trajectory that will lead him back to Munich, sitting in a train reading an obituary dedicated to John Ford. The simple directness of the American master may represent for Winter the lost world bemoaned in the article's title, "Verlorene Welt." Nonetheless, Philip has overcome his narcissistic listlessness and has gained a world of his own and now can look forward, at long last, to writing the story that eluded him abroad.

<p style="text-align:center">V.</p>

In each instance, America figures as a way station for travelers whose manifest destiny lies elsewhere. The United States plays the role of an imaginary, a set of possibilities one contemplates, a hall of mirrors one passes through while self-reflecting. Confused, inexperienced, and incomplete human subjects gain wisdom and insight in America; in Stroszek's case, his worst presentiments find confirmation. Wenders's hero puts his previous life into clearer perspective; Winter leaves the United States and becomes an ersatz father, finding the assurance to put his impressions into words and finish his article. Stroszek's act of rebellion mocks the fatal order that fetters him, an outburst that derides a world of vicious circles through its replication.

The entry into symbolic understanding in these itineraries necessitates that one take leave of America. Philip's journey will assume narrative proportions after he and Alice land in the Netherlands. To remain in America, given this cultural coding, means to linger on dangerous ground, to be trapped in a dead end, and to stand outside of one's own history. Witness the conclusions of Vadim Glowna's *Dies rigorose Leben* (*Nothing Left*

to Lose, 1983), Wenders's *The State of Things*, Werner Schroeter's *Willow Springs* (1973), or Vogeler's *Yankee Dudler*. Unlike other films about foreigners in the United States—e.g., Elia Kazan's *America, America* (1963) or Jan Troell's *The Emigrants* (1971)—one finds no recent West German examples more than peripherally concerned with assimilation and the shedding of national identity.

America functions as a site of projection, a place where unsure individuals see themselves in sharper focus, indeed a mirror image, a reflection against which one can better define oneself. This becomes strikingly manifest in the way West German films typically enact the passage between inland and America, as if the two countries were of a piece. The journey is usually a short one, a fluid movement between points. In Wenders's films, one disappears into an ethereal realm of clouds for a few seconds while characters gaze out of airplane windows or simply fall asleep. Traveling to America is like entering a dream. (How different this is from the excruciating and long boat passages in Kazan's and Troell's films.) In *Der amerikanische Freund* (*The American Friend*, 1978), Wenders moves back and forth between Manhattan and Hamburg via rapid cuts whose suddenness might easily lead one to mistake a New York cityscape for a Hamburg harbor. The final sequence of Walter Bockmayer and Rolf Bührmann's *Flammende Herzen* (*Flaming Hearts*, 1977) shows the protagonist Peter leaving for Kennedy Airport in a limousine. We see him several matched cuts later, without any indication that he has crossed the Atlantic Ocean, headed for his Bavarian home town on a local bus.[24]

In these scenarios, America figures as a crucial site in a larger process. These imaginary representations are not, to be sure, ahistorical givens, but rather they are the result of social mediations.[25] The evocation of the United States reflects developing images of self and homeland that demand careful and context-oriented attention. For Herzog, America is but one extreme example in a universe with a malevolent design. The United States looks like a large zoo in *Stroszek*, full of exotic creatures and strange caretakers, where people seem to be freer only because they move on long leashes. Herzog's vision of a fettered humanity, a modern-day Romantic fatalism, also has been played out in a host of settings: the Amazon Jungle, the Canary Islands, Biedermeier Germany, and Australia.

He reduces foreign landscapes to metaphors, using them as settings for his inexorable *misère-en-scène*.

Even if other West German filmmakers do not share Herzog's ahistorical pessimism, they do share a penchant for transforming foreign countries into a double for trouble at home. Although it functions as the dominant testing ground, America is not the only imaginary landscape to which New German directors take course. The coldness of Bavaria segues into the blue-and-white icebergs of Greenland in Herbert Achternbusch's *Servus Bayern* (*Bye-bye Bavaria*, 1977). The midlife crisis of a journalist erupts in a war-torn Beirut in Schlöndorff's *Die Fälschung* (*Circle of Deceit*, 1981). In something akin to a latter-day Expressionism, foreign terrains become intensified reflections of one's domestic situation. This works in reverse as well. Small-town America of the fifties in Douglas Sirk's *All That Heaven Allows* (1955) takes on the appearance of *Kleinbürger* Munich of the early seventies in Fassbinder's *Angst essen Seele auf* (*Ali: Fear Eats the Soul*, 1973). Hans W. Geißendörfer, in resituating Patricia Highsmith's *The Glass Cell* in Frankfurt (*Die gläserne Zelle*, 1978), transformed New York City into Manhattan am Main.

Wenders's constant and continuing recourse to America—most strikingly in *Paris, Texas* (1984)—figures within the larger quest of a postwar generation for a different history and a different experience, new sights and sounds, other expressions and styles. But America, as Wenders has come to realize in the course of time, is not simply a semiotic playground. If his early films celebrated the imaginary of American popular culture, subsequent work has dealt increasingly with the symbolic order constraining the production and circulation of images in the United States. *Hammett* (1982), *Der Stand der Dinge* (*The State of Things*, 1982), and *Reverse Angle* (1982) dramatize, and in their production history embody, the difficulty of making films based on strongly felt emotions and carefully observed details under present constellations. Why must one constantly tell the same stories and replicate the same patterns? "Stories only exist in stories," the director in *The State of Things* tells his cast, "whereas life goes by without the need to turn into story." Both as a reality and a reflection, America figures as the site of a film industry that lords over the world market with package deals, tie-ins, and formulaic schemes, sequels, prequels, and remakes, reruns of the same that are anathema to the free

flow of fantasy and personal filmmaking. The other-direction of images recalls a memory well engrained in the mind of any German filmmaker, the prospect of a national cinema monitored and ultimately administered by the state that once led many members of a film culture into exile. The evocation of Fritz Lang in *The State of Things* is, in this regard, a haunting moment and a poignant reminder. Specularity is no easy business when fantasy wares are controlled by speculators with political agendas. Filmmakers like Wenders sought to escape the denigration of personal filmmaking at home only to find, after an initial period of fascination, a similar dilemma abroad. The closer one looks, the more familiar the foreign experience becomes.

VI.

Let us reverse angles and gaze on American friends of the New German Cinema. One knows well the tale of how foreign admirers brought West German filmmakers recognition and acclaim denied them at home and how domestic observers started to take the new arrivals seriously in the wake of international regard.[26] The tendency, however, among American intellectuals who championed New German filmmakers was to dehistoricize this national cinema and to laud the deconstructed narratives, celebrate directorial eccentricity, and effuse about stylistic and formal singularity. One did so while virtually ignoring or vastly oversimplifying the body of experience that generated these images, a proclivity that led both to productive misreadings and curious confusions. An otherwise-insightful critic, for instance, identified "the sad-looking old gentleman" whose picture appears behind the beginning and end titles of *Lola* (1981) as Josef von Sternberg. For all of Fassbinder's deference to the American auteur—something borne out in the narrative's reliance on *Der blaue Engel* (*The Blue Angel*, 1930) and the film's expressively modulated lighting—the avuncular figure is clearly Konrad Adenauer.[27] It is odd that few enthusiasts of New German Cinema paused during its heyday to consider why they had invested so much interest and energy in this foreign body of films.

Just as America figured as a gap-filler for Young German filmmakers hungry for other experience, so too did New German Cinema provide

American filmgoers sustenance not so easily to be found at home. In strange ways, American audiences colonized West German fantasies, instrumentalizing the New German Cinema, making it the subject of numerous journalistic commentaries and scholarly examinations, employing it regularly in university course offerings, and featuring it as a mainstay in campus film series and art-house screenings. New German Cinema became a source of controversy and fascination at a time when individuals still reeled from post-Vietnam fallout. It continued to scintillate and galvanize audiences during the late–Cold War years with their ongoing political tension and constant presentiment of doom and destruction. In the nightmare visions of the New German Cinema, its gripping tales of angst and disaffection, foreign viewers partook of a fearful modernity and a worldwide disenchantment addressed at best only in America's most enterprising independent visions.

German nightmares served as the stuff of American redreaming. *Hitler—Ein Film aus Deutschland* (1977), in distributor Francis Ford Coppola's telling change of title, became *Our Hitler*. In the words of director Hans Jürgen Syberberg:

> Hitler was proud that no foreigner, not even a sympathetic or a vanquished one, would ever be able to say "Mein Führer." That would remain a privilege of the Germans for all time, like being a citizen of Rome during the age of glory. The Americans are now saying *Our Hitler*. And in talks about this Hitler, who now has become a film, this Hitler in a quite self-understood manner becomes "their Hitler." A German coming to America and knowing little or nothing about the strange change of the film's title, which only exists in America, will be surprised or even shocked to hear in discussions and dialogues an American suddenly speaking of this man as "his."[28]

Americans facing potential cataclysm seemed strangely drawn to German reenactments of the Third Reich, the Shoah, the devastation of a nation, and journeys into the most unsettling catastrophe in Western experience as well as explorations of its excruciating effects. This surely would help to explain the spate of American made-for-television films like *Holocaust* (Marvin J. Chomsky, 1978), *Playing for Time* (Daniel Mann, 1980), or *Inside the Third Reich* (Marvin J. Chomsky, 1982). One revisited

past horrors through foreign eyes from the position of contemporary subjects facing a bleak future.

In this cross-cultural exchange, a transatlantic give-and-take, foreign spectators gazed upon another culture's images to sharpen their own focus on themselves. Talking about American friends of the New German Cinema as well as New German filmmakers and their relation to America is like regarding viewers who in beholding the other simultaneously see self-reflections. This singular variation on Jacques Lacan's mirror stage produced the striking interaction exemplified in the snapshot Alice takes of Philip Winter, an image that merges both the person beheld and the beholder, as the little girl puts it, "So that you know what you look like."

I return to the questions posed by Walter Abish with which I began. Does the unfamiliar activate and spark curiosity and interest? In the case of the interaction under discussion, the answer is yes. The unfamiliar provides a distance enabling one to grasp the familiar so often overlooked in accustomed surroundings. Is it a call to explore and familiarize oneself with the unknown? Only to a degree: In the case of both West German filmmakers and their American friends, the seemingly unfamiliar helped above all to fathom the known and to find an alternative route of access to one's own identity and historical situation. Without a doubt, this dialogue between Americans and Germans produced a special relationship with very special terms, a meeting, to invoke two popular and overwrought paradigms, of the New Subjectivity and the New Narcissism, in which one revels in a foreign culture's images for selfish purposes. "What is really at stake," as Abish reminds us, "is one's image of oneself."

FIGURE 13.1 The citizens of Schabbach gather to commemorate the fallen German soldiers of World War I (*Heimat*, 1984).

13

THE USE AND ABUSE OF MEMORY

I.

From which authority does the president get briefed on World War II history?
a) *The Young Lions*; b) *Das Boot*; c) *Hogan's Heroes*.
Correct answer: b) *Das Boot*.

Das Boot, featuring a World War II U-boat commander nicknamed Der Alte who refuses to give the Heil Hitler salute, coats a Konrad Adenauer veneer of humanism on fascist soldiers and sailors. This film presents a reassuring image of wartime Germans that our administration believes to be accurate: most were conscripts drafted to carry out the hateful wishes of the Nazis.

—CARRIE RICKEY[1]

What happened in the past is too monstrous for us to be able to forget it or to domesticate it ridiculously with our Sunday speeches. If wounds would not always open up and bleed anew, as long as we live, how should we live with them? All honor to politicians who help in this direction with an honest heart.

—HANS JÜRGEN SYBERBERG[2]

On taking leave of Germany . . . and his teammates. His tour of duty was over. This was his final good-bye. He remembered all the good times, the joking and that special closeness that comes from sharing not only victory, but defeat.

As he shook hands with Willi, Rolf, Dieter and the others, he realized that they
had become brothers. And that was something he'd never forget.

—AT&T ADVERTISEMENT, *TIME*, MAY 27, 1985

"Reagan is emotional," an anonymous adviser said in recalling why the
President did not want to visit a concentration camp. He said, "Oh God,
I know about (the Holocaust), but do I have to see it?"

—GEORGE SKELTON[3]

This chapter offers an exercise in time travel. It tracks a text in a num-
ber of contexts, tracing German film history through various epochs and
traversing the larger field of German history as imagined in a series of
different spaces and settings. As such, it also constitutes an exercise in
intertextuality. This does not mean, however, an attempt to pinpoint bor-
rowings and influences nor just a study of recycling and citation. In what
might appear to be an eccentric itinerary, we will move from the Nazi
Party Congress of 1934 to postwar Germany; from there, we will look at
World War I veterans on the streets of Weimar Berlin; and, stepping back
in time a bit further, we will turn to a small town's tribute to those who
died during the Great War, before, in conclusion, revisiting a celebration
devoted to forty years of peace since 1945. The five stops will include
a documentary by Leni Riefenstahl, a short film by Jean-Marie Straub
and Danièle Huillet, sprawling epics by Rainer Werner Fassbinder and
Edgar Reitz, and the ABC News coverage of President Reagan's visit to
Bitburg. In each case, we will encounter a song, a performance, and a
spectacle. The song to which I am referring is "I Once Had a Comrade,"
a tune from the nineteenth century commonly used in German military
commemorations. I will consider five adaptations of the song and seek
to comprehend how each rendering imparts to it different meanings and,
in this way, provides five distinct reflections of and on history. These five
examples offer a minihistory of New German Film, starting with the fatal
past that spawned it, the initial critical resolve, subsequent subjective
approaches to the reclamation of history, later lapses into a less acute
sensibility, and, finally, the imposing and continuing challenges to those
seeking to capture memory and preserve a regard for the special terms of
German experience.

Any attempt to generalize about national cinema presupposes, as Philip Rosen observes, a distinct intertextuality to which one attributes a particular "historical weight," a shared nexus of meanings, generic formulas, and sociopolitical impulses and determinants, as well as a common cultural existence.[4] As I have argued elsewhere, the most crucial project of New German Cinema has been a forwarding of discourse in the face of official history, an endeavor that has involved a struggle against the dominant cinema in Germany and the Ufa legacy, a conscious resolve to challenge the mainstream media and their hold over the circulation of fantasy ware and information, and, finally, a continuing awareness of how American occupation has colonized and shaped West German dreams and representations.[5] The strength of New German Cinema derives from its variety and heterogeneity, the diverse ways in which its pliers engage the past and address the present. In this endeavor, these filmmakers have stimulated a regard for the powers of imagination, memory, and subjectivity, all of which function as potential sources of resistance against the mechanisms that limit human response, vitiate experience, and stifle the exchange of information and ideas.

As agents of historical memory, New German directors have traversed a wide spectrum of formal possibilities, ranging from Brechtian concepts of distantiation and epic realism to self-indulgent narratives that frame private obsessions against wider backdrops. One finds markedly documentary attempts at collecting forsaken bits and pieces lest they be consigned to the dustbin of history. Likewise, other filmmakers couch critical reclamations of history in the trappings of straightforward narratives in the hope of engaging larger audiences. From Straub and Huillet's minimalism to Alexander Kluge's discursive willfulness; from Fassbinder's reconstructions of the past, which display a profound awareness of their present significance to Syberberg's acts of cinematic mourning meant to exorcize trauma; or, Helma Sanders-Brahms's very personal account of shared moments with her mother during World War II. One could go on at length: Consider Herbert Achternbusch's attempt to atone for the deaths of six million Jews, Eberhard Fechner's images of German middle-class destinies over many decades, and Jutta Brückner's revisitations of the fifties and sixties, among many others. To be sure, we might mention some less convincing examples of the same impetus. And we dare not

forget a growing number of commercial filmmakers in West Germany eager to forego such critical and topical impulses for more accessible and popular generic models, people like Wolfgang Petersen as well as many young directors in the Federal Republic today.

The song that will be recycled in five different contexts bears the title, "Ich hatt' einen Kameraden" (The Good Comrade) and comes from 1809:

Ich hatt' einen Kameraden
Einen besseren findest du nit.
Die Trommel schlug zum Streite,
Er gieng an meiner Seite
In gleichem Schritt und Tritt.
Eine Kugel kam geflogen,
Gilt's mir oder gilt es dir?
Ihn hat es weggerissen,
Er liegt mir vor den Füssen,
Als wär's ein Stück von mir.
Will mir die Hand noch reichen,
Derweil ich eben lad'.
Kann dir die Hand nicht geben,
Bleib du im ew'gen Leben,
Mein guter Kamerad!

A literal English translation is as follows:

I had a comrade, you won't find a better one. The drum called us to battle, he walked at my side, in the same step and pace.
A bullet flew through the air, was it for you or was it for me? It tore him away, he lies at my feet, as if he were a part of me.
He tries to reach for my hand, just as I am reloading. I can't give you my hand, rest in all eternity, my good comrade!

To be sure, only two of the examples to be discussed employ the actual lyrics. Nonetheless, each enactment retains a sensitivity for the song's emotional connotations, lines that have taken on a powerful resonance in its many public performances over two centuries.

The first example, from Leni Riefenstahl's record of the 1934 Nazi Party Congress in Nuremberg, *Triumph des Willens* (*Triumph of the Will*, 1935), comes from the tenth of the film's twelve sequences. Staged in the Luitpold Arena, the Tribute to the War Dead's main participants are Adolf Hitler, Heinrich Himmler of the *Schutzstaffel* (SS), and Viktor Lutze of the *Sturmabteilung* (SA), plus an all-but-faceless throng of soldiers from both organizations. Although solemn homage is paid to those who fell on the fronts of World War I and the recently deceased President of the German Reich, Paul von Hindenburg, the sequence above all negotiates other casualties, namely the errant SA members Hitler purged on June 30, shortly before the Congress. Three figures marching down a wide lane, flanked by the faithful, laying wreaths at a monument for the war dead, star in a poignant act of mourning, ceremonial in tone, subdued in its choreography, and impressive in its grandiosity. The invocation of the song, "Ich hatt' einen Kameraden," which we hear from an onscreen source, is not only appropriate but also suggestive. The memory of dead comrades serves as a pretext for a radical makeover of history, an act of revision neatly folded into what appears to be a straightforward presentation.

Looking at this spectacle, the viewer gains the impression of witnessing finished events, fixed for all time, complete as they stand, self-enclosed and beyond question. The scene seems not to leave anything out and demands no additional information beyond what is visible. *Triumph of the Will* as a whole and this sequence in particular provide ready-made reality, a tableau arranged in such a way as to deny any challenges and to answer all questions, an approach that disguises a construction as the true state of affairs. Individual shots provide images of plenitude, yet remain uncluttered; the compositional rhythms are marked by geometrical precision and an impressive architecture. Every movement within these frames is controlled, whether it is the solemn procession of the leaders down the empty lane, the silent attention of the massed soldiers, or the carefully tracking camera taking measure of the procession from right to left. The shots, without exception, totalize, alternating between long-shot panoramas of the spectacle and closer, more emblematic shots of the *Reichsadler* and the swastika. Not for a second does anything appear uncertain or

unexpected. The scene offers a triumph of a mise-en-scène that is both highly stylized and devoid of frills.

For all of this imaginary persuasiveness, the film does not fully succeed in concealing its rhetorical bias, at least for viewers who resist its intended subject effect, people who refuse to become overwhelmed by this sequence of events. To be sure, not only National Socialists have succumbed to the film's allure; Riefenstahl's epic chronicle has found a vast community of cineastes eager to praise its stirring artistry.[6] The film represents an attempt to overcome a source of discord, to heal a glaring wound within the New Order. The emotional tenor of the evocation, the tribute to the war dead, positions Hitler and his minions as Germany's legitimate protectors who have intervened and replaced a moribund leadership that betrayed the front generation's interests by signing the Treaty of Versailles. Hitler also marches among the ranks of the living, members of a nation reformed and reshaped by National Socialism, which appears to be a compact and united movement. The scene demonstrates that Hitler continues to enjoy the trust and support of the SA, despite the bloody executions of Ernst Röhm and his followers.

Reclaiming the past to take command of the present, Hitler demanded crucial changes in the scope and shape of Riefenstahl's film. A lengthy prologue, assigned to Walter Ruttmann, was to have depicted the Nazi Party's long history of struggle. Hitler squelched this retrospective sequence in December 1934, recognizing that one could hardly review the party's development without acknowledging the importance of Röhm and the SA. The tribute to the war dead functioned as a crucial act of damage control in covering up a serious rift. It studiously replayed and painstakingly remade a quite-similar tribute from Riefenstahl's *Sieg des Glaubens* (*Victory of Faith*, 1933) in which Hitler had marched together with his comrade and friend Röhm in the same space at the 1933 Nazi Party Congress. A year later, Hitler and his deputies now abide as the administrators of their dead brothers' legacy. Beyond that, Hitler is seen as still enjoying the trust and loyalty of the storm troopers. In his address, Hitler talks of a "dark shadow" having spread over the movement, referring to the June massacre obliquely without once mentioning Röhm's name. This scene recasts an earlier film as it rewrites the past, blotting out the memory of a bloody purge with a carefully choreographed display of solidarity.

Images of plenitude that in fact reflect a circumscribed perspective, a revision of the past meant to legitimate the status quo, a mode of representation that aims to eradicate all discursive traces and create a fixed image of history, and a procession choreographed both to honor the war dead and to address the needs of the moment: Here we have *in nuce* the basics of the 1985 Bitburg commemoration.[7] The recoding of memory to update history and the whitewashing of the past to dress up the present likewise represent the abuse of the film medium painfully recollected and ardently eschewed by Young German filmmakers of a later generation. The systematic control of images and imagination in Nazi Germany remained an experience of seminal importance to the post-Oberhausen directors. In confronting a burdensome legacy, they reckoned with German history as well as German film history.

FIGURE 13.2 Adolf Hitler and Heinrich Himmler of the SS cast shadows on the SA leader, Viktor Lutze. The single image unwittingly reenacts what the Nazi spectacle as a whole endeavors to obscure, namely the bloody purge of the Storm Troopers in June 1934 (*Triumph des Willens/Triumph of the Will*, 1935).

III.

The use of "Ich hatt' einen Kameraden" in *Triumph of the Will* is far from just an obligatory accompaniment. Indeed, the song has suggestive dimensions, even if they remain implied, not emphasized, emotional effects of an imposing event. Riefenstahl seeks to unify the various elements at her disposal: composition, editing, sound, and movement. She wants a calculated response—and this is to be the result of careful orchestration and planning. It is to be affective and tangible and anything but intellectual, a response that sweeps the viewer into the onscreen movement, erasing the distance between spectator and spectacle. Without question, the strategy employed in Straub and Huillet's *Machorka-Muff* (1963) could not be more different.

The eighteen-minute short film caused much controversy when it circulated in private screenings at Oberhausen in 1963 after its rejection by the festival selection committee. Based on Heinrich Böll's pungent satire, "Hauptstädtisches Journal" ("Bonn Diary"), the elliptical narrative follows the movements of a reactivated officer summoned to the West German capital by the Ministry of Defense. Machorka-Muff receives a warm welcome, word that he has been made a general, and the approval of his plans by the West German parliament to establish an Academy for Military Memories. Böll's story appeared shortly before the national elections of 1956, in which the populace voted to rearm the Federal Republic. Straub was motivated by the memory of this event as well as its place within a larger history of militarism. *Machorka-Muff*, he elaborated, "is the story of a rape, the rape of a country on which an army has been imposed, a country which would have been happier without one. What does it mean to make films in Germany, or rather, to make films against that stupidity, depravity, and that mental laziness which, as Brecht remarked, are so characteristic of that country?"[8] *Machorka-Muff* depicts the abuse of memory and attempts to activate countermemories and employ them in a historical dialogue.

Making a film in Germany, at least for Straub and Huillet, means confronting the past abuses of image-makers in that country.[9] Its means systematically negating what movies have done as well as challenging the ways films tell stories and present history. As Straub is fond of saying, "Ninety percent of the films made are based on contempt for the people

who go to see them." Their alternative cinema implicates the spectator in the narrative process, not as an uncritical consumer within a captive audience, but rather as someone who has room to breathe and a chance to partake of and mull over the story, a narrative presented austerely and minimally, without titillating come-ons and dramatic pay-offs. *Machorka-Muff* barely manages to sustain the pretense of a fiction film; its amateur actors are stiff, the dialogue (in a Brechtian fashion) is spoken in monotone, the characters allow for no identification, and the camera cuts suddenly and at times even arbitrarily shifts spaces, undermining the viewer's sense of a comfortable and coherent perspective. Instead, the film offers a multiplicity of texts and a polyphony of voices in its aim to capture the complexities of a crucial historical moment.

The film quite literally explodes as Machorka-Muff relaxes at a café overlooking the Rhine. Earlier, in the film's second shot, he looked out onto the nighttime capital and mused: "There are vital forces waiting to be released." As he celebrates his success over coffee and peruses the day's newspapers, the film erupts into a series of articles and headlines from the conservative press, editorials in the *Deutsche Tagespost, Frankfurter Allgemeine Zeitung*, and *Die Welt*. The camera positions the viewer as a critical reader, focusing on key passages, directing attention to commentaries on the rearmament of West Germany, official and church apologias for the action. The sequence interrupts the film's already minimal narrative, providing a break in the story's progression, time to pause and reflect about what Straub termed "the rape of a nation" and its legitimators, factors very much still in evidence when he and Huillet made the film during the final phase of the Adenauer era.

As the general, garbed in his new uniform, dedicates the Academy for Military Memories, a place where future historical revisionists will find government support, the camera stresses Machorka-Muff's act of reading as both a process and a labor. The entire ceremony becomes a site of meaning construction: We see a band at work playing the obligatory anthem; we watch a mason carefully lay the cornerstone; we witness the dignitary's solemn tap on the structure. The tight shots present a close view of single activities orchestrated for a distinct purpose. The sequence draws attention to the fabricated character of the occasion, laying bare its operations in a double sense, both as a contrivance and a travesty.

One crucial image, a shot held for many seconds, essentializes the reflective and reflexive impetus of Straub and Huillet's countercinema. As the tune "Ich hatt' einen Kameraden" begins, the screen remains empty; it lingers quite literally as a *tabula rasa*, the empty space (*Leerstelle*) of reader-reception theory, a blank palette. This gap serves a number of functions. Just as the camera fixes on the general's uniform, studying its buttons and fabric in relation to the written speech in the soldier's hand, thereby connecting a certain role and a certain way of speaking, the empty shot also grants access to the grain of a text. We become able to see the music,[10] to comprehend its importance in this setting, and to think about the meaning of this song and the tradition that comes with it, a legacy that Straub and Huillet want to interrogate and undermine. The ground-laying sequence makes us privy to the enshrinement of forces seeking to sand off the rough edges of the past. At the same time, the choreography emphasizes that this event is a human labor and involves the spectator in the construction of meaning, providing the viewer space to see through the event as a historical fiction.

The tribute to the war dead in *Triumph of the Will* endeavored to whitewash history and eradicate "black shadows." *Machorka-Muff* seeks to resist similar endeavors many decades later. Instead of whitewashing history, however, it washes the image white, pausing for a moment to allow the viewer to grasp the fatal continuities at work here, the insidious "forces waiting to be released," and the remnants of a past still tangible in the film's Adenauer-era setting as well as Straub and Huillet's filmmaking present. *Machorka-Muff* was one of Young German Film's earliest signs of life; it remains to this day an exemplary work marked by a keen regard for history's unsettling lessons and cinema's expressive possibilities.

FIGURE 13.3 (*top, opposite page*) *Machorka-Muff* (1963) was the expression of what Jean-Marie Straub called his own "political rage—exactly this story of the European defence community, i.e., the fact that Germany had been rearmed—the story of a rape" (Erich Kuby as General Machorka-Muff).

FIGURE 13.4 (*bottom, opposite page*) A newspaper advertisement documents the discourse of West German militarization: "Any man who wants to be the master of his personal destiny and time acts voluntarily. Now that legislation regarding general conscription has taken effect, many young men are wondering when they are going to be drafted" (*Machorka-Muff*).

FREIWILLIG

kommt, wer Herr seiner Entschlüsse und seiner Zeit bleiben will. Da das Gesetz über die allgemeine Wehrpflicht in diesen Tagen in Kraft getreten ist, fragen sich viele junge Männer, wann sie wohl einberufen werden.

Fassbinder's *Berlin Alexanderplatz* (1980), with its dynamic blend of identification and distantiation, enlists the spectator as a witness in a clash between opposing discourses, a conflict between song texts and their meanings. The film stresses the private resonance of "Ich hatt' einen Kameraden," personalizing its lines and the memories they evoke for the singer as well as placing the performance in a wider context, presenting it onscreen before a hostile group at a table and a sympathetic friend, and at the same time making the offscreen viewer privy to additional perspectives. The altercation takes place in the second episode of the fifteen-and-a-third-hour film. Franz Biberkopf has just found employment as a hawker of the *Völkischer Beobachter* in a subway passage. Outfitted with a swastika armband, he speaks with a Jewish merchant about the meaning of his new occupation. He then confronts his former comrade Dreske and two other Communists with whom he used to associate before becoming disillusioned. The altercation continues in a bar, Franz's *Stammkneipe*, bringing the disagreement to a head between individuals convinced of their cause and a single person surrounded by a world of conflicting voices and cast by material necessity into a role that he, as an essentially apolitical person, neither endorses nor fully comprehends.

Sensitive to the heteroglossia of Alfred Döblin's epic novel of 1929, Fassbinder orchestrates his narrative to underline the place of his hero in a contradictory, confusing, and challenging world, a historical space bounded by different forces and influences, a conflict-ridden reality constantly in flux. Clearly a personal adaptation, Fassbinder's rendering foregrounds a man's attempt to navigate the streets of Berlin during the late twenties, to find his own voice within the city's polyphony, and to constitute himself as a subject despite the objective historical and social vicissitudes that challenge such an ambition. In another context I have discussed how the film likens modernity to a vast slaughterhouse, in this way rendering Biberkopf's life story as a violent tale in which he constantly finds himself threatened by external forces and seized by uncontrollable urges.[11] Reality and the modern world inscribe themselves on his body and leave distinct traces on his person. The sequence under discussion involves Franz in a tactical struggle; he employs a series of texts to defend

himself against the threat of physical violence. The viewer becomes doubly invested: like the kind bartender Max, sympathetically disposed and hopeful Franz will succeed, while at the same time being aware of German history's subsequent course and the retrospective implications of the scene's tensions.

Dreske and his comrades, in an attempt to provoke Franz, strike up the "International" and initiate a duel of discourses, challenging him to sing along. Hoping to defuse the situation, Franz promises a song and proceeds to tell a joke. The short tale about a sandwich that does not go down easily is presented while Franz himself continues to eat. Within the wider narrative, the anecdote suggests a body of experience not so easily assimilated, much like Franz's confrontation in the scene with his own past as a political progressive. He goes on to recite a poem written by a fellow inmate during his four-year sojourn in Tegel, a space to which the camera flashes back as Franz speaks. This text enumerates the vicissitudes of becoming a "male subject" in this world, stressing the power of a state patriarchy and vulnerable status of mortal bodies. (We recall that earlier Franz was asked by a Nazi war invalid whether he was "a German man.") Fassbinder, as is well known, framed the large novel above all as a love story between two men.[12] More important, he recast Döblin's epic in a way that drew attention to its historical energies, as an account of soldiers (like Biberkopf and Dreske) returned from the World War I battlefront, trying to make a home somewhere in the streets of the postwar city, seeking to understand where the front lies in a thousand-voiced reality. On crucial and repeated occasions we will see how male subjects do violence to each other—and, notably, to women. The story's chronology begins with the brutal beating of Franz's partner Ida; the discourse's end comes in the strangling of his lover Mieze. In the present sequence, Franz's poem provokes comment and criticism. The Communist Fritz objects that Franz should be more mindful of what the state does to him; memorizing a few lines of poetry is simply not sufficient.

Franz submits to the repeated call for a song and starts to sing, "Ich hatt' einen Kameraden," a performance that Fassbinder stages with great precision and care. He links the spectacle to an earlier scene, the moment where a confused and just-released Franz stood in a courtyard and sang "Die Wacht am Rhein" ("The Watch on the Rhine"), linking

two moments of crisis in which the ex-soldier takes recourse to familiar tunes and the body of experience they constitute. The period Franz spent in Tegel, four years, parallels the duration of World War I. The time behind bars and at the front was one of affective relationships with other men, male bonds with a strong emotional, indeed heterosocial, dimension. The song reflects on the power of these attachments just as Fassbinder's mise-en-scène accentuates the undeniable element of unrequited love in Franz's relationship to his former comrades, whose collective response resembles the jealousy of a jilted lover. In repeated cuts to the group at the other table and its hostile silence, Fassbinder stresses the volatile atmosphere, unmediated, for the moment at least, by Max's benevolent gaze. Franz's recitation is a private recollection linked both to a war experience as well as a previous moment of trouble. The relatively long takes show Franz singing almost to himself; he is framed in a way that doubles his image, suggesting a shadow of the past and how it haunts his present person. Tegel and World War I have left their marks on Franz and likewise relate to the reality Dreske and his chums want to change.

Escalating a volatile situation, Franz lets out all stops and taunts the group with the openly chauvinistic "Die Wacht am Rhein," almost provoking the fight he has so studiously sought to avoid. As the sequence reaches a conclusion, the music box in the bar (without apparent cause) starts playing the "Deutschlandslied," yet another instance in which a song reflects on the larger context of an embattled postwar republic, as well as reflects the filmmaker's desire to position the viewer as an active participant in this exploration of the past. Fassbinder does this, on one level, by constantly shifting between the private and the public, moving back and forth between personal destinies and historical determinants, always bearing in mind the retrospective advantage of the present-day spectator. On another level, he irritates the spectator

FIGURE 13.5 (*top, opposite page*) Dreske (Axel Bauer) and his comrades behold the offscreen Franz and are none too pleased by what they see and hear (*Berlin Alexanderplatz*, 1980).

FIGURE 13.6 (*bottom, opposite page*) His image refracted and shattered, Franz (Günter Lamprecht) digs into his memory and sings the famous tune about a fallen comrade.

by forcing an identification, at least in part, with a politically incorrect position, aligning our sympathies in the scene with a purveyor of the Nazi Party organ, creating a tension between our investment in the story and our knowledge of the subsequent course of the history from which it emanates. This is hard to swallow. Like the sandwich in Franz's anecdote, the scene does not go down easily; in fact, it keeps on coming up.

A central earmark of Fassbinder's strategy remains the manner in which he shows how texts provide points of identification and potential sources of conflict. History for the director is many-voiced. His stories invariably contain a multiplicity of embedded narratives, just as his films, repeatedly and insistently, focus on protagonists desperately seeking to forge their own story while facing the challenges of twentieth-century German modernity. In confronting that past's bloody spectacle, Fassbinder, in a style quite different from Straub and Huillet, sought to lay bare the foundations of German history, to provide a relationship to the past that presupposes the standpoint of the present and that involves both in a dialogical exchange.

V.

Despite their clearly divergent formal strategies and visual styles, both Straub and Huillet as well as Fassbinder act as facilitators, engaging the viewer in often-uncomfortable symposiums about the German past. In each case, the audience becomes privy to the construction of meaning, an activity fostered by Straub and Huillet's empty spaces for reflection and Fassbinder's dynamic notion of spectatorship, his inscription of multiple on- and offscreen viewers. *Machorka-Muff* and *Berlin Alexanderplatz* supply sites of entry outside of their fictional coordinates, utilizing points of reference that transcend the story spaces, independent loci beyond the story action and plot setting, meanings that are not fixed and determinate, but rather bound in a communicative relationship to the spectator and an economy with much larger stakes than just the interests of pleasure and illusion. Do we find an equally active notion of spectatorship and historical engagement when we turn to Edgar Reitz's *Heimat*, without a

doubt the most celebrated epic account of twentieth-century Germany to issue from the New German Cinema?

One's expectations, of course, are considerable. The film found inordinate resonance when it first aired on West German television during the fall of 1984, a warm reception both by viewing audiences and media critics,[13] as well as almost universal praise for its rendering of the German past as "a history of small people who live their lives in dignity, albeit without greatness,"[14] a reflection of a nation's evolution from the end of World War I to the early eighties from the perspective of a village in the Hunsrück region. The work came as the culmination of Reitz's own career, the crowning achievement of a director, who, since the late fifties and the beginnings of Young German Film, has seen himself as an agent of historical memory. His essay of 1979, "The Camera Is Not a Clock: Regarding My Experience Telling Stories from History," provides a programmatic articulation of this resolve. Film, says Reitz, "has much in common with our ability to remember. It provides not only the possibility to preserve images and events from the march of time, but also the possibility to merge the present and the past in a way that infuses the one with the other."[15]

Heimat militated against what Reitz decried as the international terrorism of American aesthetics, the forces that had coopted German history in the television series *Holocaust* (Marvin J. Chomsky, 1978).[16] Billed as a film "made in Germany," *Heimat* attempts to reclaim a past that in Reitz's appraisal had been unfairly appropriated by Hollywood. A mixture of oral history, an evocation of the haptic realities of the everyday in all their sensual concreteness, of Reitz's and scriptwriter Peter Steinbach's reworking of more than sixty years of German experience couched in images of a changing landscape, *Heimat* also relates the history of modern technologies, especially photography and radio, vehicles of sight and sound that are essential to cinema. The question remains, however, to what degree the film delivers on Reitz's retrospective promise.

In the first episode of *Heimat*, the erection of a war memorial is celebrated. The scene is set in 1922, three years since Paul Simon has returned from the front. In the midst of a ritual ceremony, the solemn remembrance of the soldiers who fell during World War I and the dedication of a monument in the town square, there is a disturbance. As the village

FIGURE 13.7 An unexpected demonstration of mourning interrupts Schabbach's remembrance of the war dead. Baker Böhnke remains disconsolate; sorrow is etched on his face, the symbolic marker of his loss is clutched in his hands (*Heimat*).

band plays "Ich hatt' einen Kameraden," an old man walks down the street with a small monument in his hand, weeping as he offers an idiosyncratic performance of the song, replacing "a bullet flew through the air" with "a bird," transforming the military anthem into a folk song. Paul Simon, who has escaped the fate of those being remembered, asks who this odd man is. It is the baker Böhnke, he is told; the man lost three sons in the war.

The personalization of the text contains elements reminiscent of Fassbinder. The performance links the song to the body; the past has imprinted itself on the baker, leaving him with a sorrow etched on his face and the symbolic expression of castration clutched in his hands, the miniature monument that stands for the parts of him lost in the war. The personal response stands at odds with the public demonstration, creating

a dissonance between the ritual act of remembrance and the painful fact of human suffering, a disparity of perception between an organic community and an estranged individual, an antinomy between the organizational structures of public life and the strong feelings of single persons. The critical perspective is introduced by the gaze of Paul, who throughout the sequence will look at the village with a growing discontent until he finally takes leave for America. The baker's intervention makes for a moment of discord, an act of resistance to the codified containment of emotion. He, like Paul, has to go "outside" Schabbach to cope with his sense of lack. A private slant on a public event; an audience engaged by an onscreen spectator; a figure who wears the past on his body like a uniform: in crucial regards, the scene bears resemblance to *Berlin Alexanderplatz*. Both films use the song as an expression of profound loss, which has a jarring effect on its audiences.

The earlier portion of the sequence before the baker's demonstration is also reminiscent of *Machorka-Muff*. We glimpse a construction site, a piece of stone in the middle of Schabbach looked upon by the ex-soldiers Paul and Glasich Karl. The scene foregrounds the dedication as a production and a labor, concentrating on the choreography and the mise-en-scène for the occasion with its elaborate unveiling mechanism involving the precisely timed coordination of a speaker, a schoolgirl chorus, and a local band. In cutting about the ceremony and tracking around the event, the camera fixes on different responses to the spectacle: the affirmative gesture of a priest, the spontaneous outburst of the young boy Hänschen Betz ("I'm here too," he proclaims loudly), the blank stares of various peasants, and the ironic comments of other onlookers. As in Straub and Huillet's film, Reitz's direction allows a certain distance from the goings-on marked by humor and analysis as well as insight into the contrived quality of the moment.

In witnessing the dynamics of the ceremony and the preparations for the event, the spectator feels an undeniable bit of suspense: Will the unveiling contraption really work? Reitz scripts the ceremony so that wider frameworks become manifest. The chauvinistic speech of an out-of-town speaker gives voice to larger energies at work in the postwar landscape and a spirit of revision eager to transform the defeat of World War I into a triumph of heroic German spirit, a pathos that looks forward to a

national revival and a new savior. Reference is made to the proliferation of such events, indeed to a veritable memorial industry with the same ceremonies and speeches. Throughout the sequence, Reitz shows how these sociohistorical forces resonate within Schabbach's populace. In this way, the microcosm of a small community reflects the macrocosm of a nation. The passage gains its critical power above all from Reitz's privileging of Paul's gaze, which is clearly marked as a minority view. The initial part of the ceremony will come to a close and at the same moment, as a sort of ritual catharsis, the downpour of rain will cease. The subsequent appearance of baker Böhnke indicates that energies and emotions remain that are not so easily cleansed and purged. It is essential that Paul relays our gaze to the old man, linking the perspectives of outsiders in a village of insiders.

Heimat chronicles the development of technologies devoted to seeing and hearing over six decades. Its voice-over narrator presents an ongoing commentary at the start of various episodes.[17] The film repeatedly leaps, at times with a seeming arbitrariness, from black and white to color in an endeavor to infuse an epic element. In its initial episode, *Heimat* aligns its narrative point of view with an individual ill at ease in the small village and critical of Schabbach's narrowness, a character who looks at the community with growing skepticism and disaffection. This marginal perspective, which works so effectively and essentially in the first episode, will be lost when Paul Simon sets off for America. Curiously, Reitz will forego such a critical gaze for the entire spectrum of German history from 1928 to 1955, not reinstating an outsider's perspective until episode nine, "Hermännchen."

The first episode also discloses the fate of another outsider living in a community of insiders, the difficulty encountered by Apollonia as a foreigner and her marginal status in the small town. She appears in a dialogue with Maria, the two speaking in a cellar as the arrangements for the public ceremony are being sorted out by the town's men. Apollonia, like her only defender, Paul, will depart from the narrative; she will never be heard from again. After the initial episodes, Schabbach assumes the proportions of a closed system, displaying an exclusionary propensity that will dominate most of *Heimat*. Made by a director chagrined by how American entrepreneurs had colonized the German past in *Holocaust*,

Heimat features many funerals and moments of mourning. Oddly and conspicuously, the film all but ignores the major calamity of twentieth-century German history, the Shoah. Odder yet, a film whose beginning is so assertive in its distanced perspective and so analytical in its presentation of the homeland, relinquishes these critical dimensions as it negotiates the Third Reich, precisely that juncture in German history at which dissenting points of view might prove to be most productive—and essential.

The sweeping epic, so enthralling and alluring in many ways, captures a wide spectrum of human experience, allowing much space for certain kinds of emotional demonstration and very little for others. The approach recalls the spirit of exorcism analyzed by Saul Friedländer in his critical essay on recent attempts to reflect on the trauma of the German past. Such acts of exorcism, as evidenced in a variety of films and novels, seek "to put the past back into bearable dimensions, superimpose it upon the known and respected progress of human behavior, put it in the identifiable course of things, into the unmysterious march of ordinary history, into the reassuring world of the rules that are the basis of our society—in short, into conformism and conformity."[18]

Heimat proved to be so successful in the Federal Republic because it recounted the most disturbing portion of German history in a way that disavowed burdensome aspects of that past, abandoning the critical framework of the film's initial episode, confronting the Third Reich and at the same time neutralizing and minimizing the experience of National Socialism while simultaneously binding the audience to the narrative by a compelling appeal to their emotions and powers of identification—and definitely not their critical faculties.

The film may have served as a comforting sanctuary for a nation's television audience and provided an opportunity for people, once again, to feel at home with a notion that, according to Reitz, has throughout modern German history suggested a "painful mixture of happiness and bitterness."[19] "What is being buried in *Heimat*," maintained Gertrud Koch, representing a decidedly minority view in the Federal Republic, "is not the 'simple truth' of the 'small people' that morality does not thrive on an empty stomach but the precarious consensus that one cannot speak of German history without thinking of Auschwitz."[20] After an impressive

start, *Heimat* lapses. Ultimately, it served, much as *Holocaust* had, to foster a collective exorcism, dramatizing in a stunning way the forgetfulness that can lie in remembering. In so doing, it anticipated the discourse of Bitburg.

VI.

On a cloudy day in May 1985, a public ceremony was held in Bitburg, a city near Trier in Rhineland-Palatinate not far from the Luxemburg border. Meant to commemorate the fortieth anniversary of the end of World War II, the spectacle was designed to be a media event. President Ronald Reagan's visit to the small Kolmeshöhe Cemetery stimulated a worldwide controversy about the German past and American investment in it, about the kinds of questions New German filmmakers so often had addressed over the past two decades. In the midst of many impassioned editorials, official equivocation, and strong pressure from the West German government to go forward with the planned agenda, commentators repeatedly focused on the graves of 49 Waffen-SS soldiers situated among the 1,887 war dead in the Bitburg cemetery. Concerned spokespersons wondered why, in an ostensible act of mourning for the war dead, so many other war dead were going unremembered, an objection that occasioned Reagan's infamous equation of the dead Nazi soldiers with concentration camp victims. As media experts carefully analyzed public response to Bitburg and reflected on its potential ramifications, they said very little about the actual event itself, especially its choreography and mise-en-scène.

The seemingly straightforward ceremony was intended to provide a moment of harmony,[21] to recall past events in a way that repressed sources of potential disturbance and contradiction. Even the otherwise so critically disposed liberal press took things at face value, claiming, as John Corry of the *New York Times*, that "the significance was not in what happened, but what it meant," going on to note in his review of the event that

> Bitburg came and went on television yesterday after dominating coverage of President Reagan's trip to Europe all week. On television, the visit to the German military cemetery was brief, wordless, and, from

the White House point of view, all that could be hoped: a solemn President simply placed a wreath against the base of a stone tower. There were few glimpses of demonstrators, and none at all, apparently, of SS graves.[22]

This account naturalizes a demonstration that was choreographed every bit as carefully as *Triumph of the Will*, a public spectacle designed to appear simple and self-evident, which nonetheless, upon more careful view, readily betrayed its spurious construction.

If Straub and Huillet and Reitz presented commemorations as both human designs and labors, matters bound in a larger nexus of determinations, the ABC News coverage of the visit moderated by the correspondent Peter Jennings, "President Reagan at Bitburg," gives the viewer the impression of being present while everything unfolds with a self-understood obviousness. We hear nothing about how Reagan's aide Michael Deaver had looked over the cemetery in advance, checking the shooting site for the most advantageous camera angles. No mention is made of the significant change in plans that came after public controversy had arisen. Originally, there were to have been numerous close-ups of the president, casting him in a star role Reagan no longer wanted to assume after the brouhaha.[23] That there is next to no onscreen audience but only principles is also a reflection of official choice, an exclusionary act that made the Bitburg cemetery a closed set and sought to eradicate all possible sources of spontaneity and opposition. The situation resembled a location shoot for a commercial production: The onscreen actors march down the lane pretending the camera is not present, taking part in a spectacle whose real audience is not there, just like a fiction film being recorded under controlled circumstances for future audiences.[24] Jennings expresses his thanks for pictures "provided by the combined resources of German television," neatly glossing over the fact that the images were the only ones screened on West German television and in fact constituted the *only* record of the event, the sole perspective allowed on the occasion by the institutional forces that staged and transmitted it.

The visual style remains deceptively simple and functional, in the main an extended long-shot pan to the left capturing Reagan, Chancellor

Kohl, American General Matthew Ridgway, and West German General Johannes Steinhoff as they walk along the north side and approach the memorial. A bit of zooming, some cuts that regroup the players, a close-up of a bugler: nothing seems obtrusive, everything seems self-evident. Peter Jennings correctly identifies the song that we hear, "Ich hatt' einen Kameraden," referring to the title in a heavily accented German.[25] It seems obvious, this song goes with this kind of ceremony, things could not be more self-understood. But given that we are dealing with an event so carefully stage-managed and orchestrated, one that left nothing to happenstance, a tableau meant as a symbolic demonstration of reconciliation between previously warring nations, it seems appropriate to consider deeper significance in this choreography of song, image, and movement.

Riefenstahl, as we have seen, instrumentalized "Ich hatt' einen Kameraden" as a simultaneous tribute to the war dead and the living soldiers, in the process glossing over the recent deaths of other comrades and the reasons for the purge of SA troops. The Bitburg ceremony similarly rewrites the past, casting the two heads of state and their generals as representatives of forces involved in a common cause and marching in unison. It is as if the spectacle were really celebrating the forty years of Cold War and anti-Communism that have united the United States and West Germany in a struggle against the Soviet Union.[26] Reagan's visit to the grave of Konrad Adenauer, the quintessential champion of the Cold War, earlier on the same day in this regard seems to be a logical extension of such an agenda.

It is crucial that no words are spoken during the Bitburg ceremony, that images enjoy a primacy of solemn persuasiveness. "Our duty today," Reagan would say at the Bitburg Airbase later that day, "is to mourn the human wreckage of totalitarianism, and today, in Bitburg cemetery, we commemorated the potential good and humanity that was consumed back then, forty years ago." Reagan's retrospective view of the Third Reich bears much in common with the popular historiography of the fifties, which sought to absolve Germans of war guilt by placing the blame on Hitler and his demonic leadership. "The war against one's totalitarian dictatorship," averred Reagan, "was not like other wars. The evil world of Nazism turned all values upside down.

Nevertheless, we can mourn the German war dead as human beings, crushed by a vicious ideology." Quite conversant with the language of exorcism, Reagan employs a discourse about evil and suffering that casts its portrayal of the past in the form of anecdotes and stories lifted from *Reader's Digest* and broaches the question of the Holocaust as an afterthought, a response to public outrage.

The official visit to Bitburg was marked by conspicuous absences: the lacking reference to the Jewish dead, the absence of onscreen protestors, the disavowal of those who died in the war against fascism elsewhere, and most particularly the denial of the SS graves. Not for a second does the television news camera situate them in relation to the spectacle, in effect disclaiming their actual existence by this act of visual exclusion. This is all the more glaring given that images of these graves had appeared in newspapers and magazines and had been repeatedly shown on television reports before the event. Image-hungry cameramen did not record the unsettling events that transpired soon after Reagan and Kohl left the cemetery. Two wreaths for the fallen comrades of the SS, hidden during the official ceremony, were placed next to the ones left at the memorial by the president and the chancellor. Some days later, on May 15, Martin Kalb published a story in the *International Herald Tribune* containing interviews with bystanders, the claim of a young man that Germans and Americans were getting along well until the Jews started making trouble, or the angry comment of an elderly woman that Reagan only stayed at the cemetery for eight minutes "because of the Jews." The Bitburg ceremony was a newsworthy event, but international television audiences were systematically denied the larger picture.

The media spectacle of May 1985 replicated a fatal past, both in its performance and its abuse of historical memory. It attempted, and clearly with mixed success, to eradicate all other possible interpretations, allowing only one perspective, suggesting that this vantage point constitutes the definitive version—even to the point of preposterousness. When watching the televised event, the viewer has two unavoidable questions: *where* are the SS graves and *why* do we not see them? At previous junctures in recent West German history, the country's filmmakers had gathered to reflect on important moments, forefronting continuities between past and present and offering significant alternative points of view, for instance

in *Deutschland im Herbst* (*Germany in Autumn,* 1978), *Der Kandidat* (*The Candidate,* 1980), and *Krieg und Frieden* (*War and Peace,* 1983). Jennings makes a poignant reference to the constant clicking of cameras as the four figures walk through the cemetery. Amid these photographers were no German filmmakers, for they would have been denied access to what was essentially a closed set. Beyond that, no one seems to have considered making a film about this event.[27] Even if filmmakers had, they would not have found increasingly cautious film subsidy committees and nervous television-editors ready to support their undertakings—much less commercial producers.[28] In 1985, a film like *Germany in Autumn* would have been impossible to make.

It is striking that *Heimat,* New German Cinema's most heralded representation of the past since Fassbinder's *BRD-Trilogie* (1979–1982), bears more than passing resemblance to the construction of Bitburg: a similar instance of exclusionary practice, a lack of outside points of view when they are most appropriate and necessary, a predilection for anecdotes and pathos in place of analysis and retrospection, and, above all, a normalization of the past that seeks to have a soothing effect on the present. "Some old wounds have been reopened," Reagan said in his speech at Bergen-Belsen, "and this I regret very much because this should be a time of healing." Hans Jürgen Syberberg, an individual who has gained notoriety for his passionate concern with Hitler and the forces projected into the figure, went so far as to champion Reagan's Bitburg performance in language reminiscent of Nazi rhetoric: "The picture of the lonely politician who believes himself to be in the right: how encouraging that would be for democracy, which so often degenerates into the exercise of minority opinions, its politicians to the mere executors of majority transactions."[29]

Bitburg, like crucial passages of *Heimat,* illustrates a forgetfulness in remembering. The dominant and influential history lesson has not come from reflexive and unreconciled sources like Straub and Huillet or Fassbinder; instead, as Carrie Rickey points out, we are presented with the popular mythology of Wolfgang Petersen's *Das Boot* (1981). We end with official history firmly enshrined and on public view, with few filmmakers willing or able to continue the critical endeavor that was once the hallmark of New German Cinema.[30] The present moment in the mid-eighties is not an encouraging one. With the atrophy of this critical

cinema comes the decline of alternative images from and about West Germany, different modes of representing an experience marked by fatal contours and continuing states of emergency. The present situation is for the most one of no experiments, a state of affairs summed up by General Machorka-Muff at the end of Staub and Huillet's short film: "Opposition—what's that?"

FIGURE 14.1 Cinema, insists Alexander Kluge, has abided as a mighty capacity in the human mind for centuries—and it will continue to exist long after film's passing (*Der Angriff der Gegenwart auf die übrige Zeit/The Blind Director*, 1985).

A CINEMA OF CITATION

I.

Behold the cover of Alexander Kluge's book, *Cinema Stories*,[1] and you find yourself eye to eye with a gorilla guarding a slumbering woman, an image you take to be a production still from *King Kong* (but you're wrong). The half-title page bears another unidentified photograph. Here a dashing man, with a nocturnal metropolis as his backdrop, embraces Catwoman (but no, it is not Halle Berry or Michelle Pfeiffer or Lee Meriwether). The table of contents lists thirty-nine tales, a mixed bag of titles ranging from the generic ("Cold Shower") to the convoluted ("How We Cameramen Became Patriots, Simply Because We Were Efficient"); from the decidedly straightforward ("The Final Film Screening in the Reich Chancellery") to the downright obscure ("The Plöger Delicatessen as the Replacement Target of a Demonstration"). Skimming the trim volume's 111 pages, you begin to realize that these entries are not so much stories as mélanges—texts comprising sketches, musings, dialogues, interior monologues, quotations, and other fragments of quite-differing consistency and emphasis.

Some of Kluge's cinema stories run a few lines, some several paragraphs; others are broken into sections and go on for many pages. Striking, amusing, on occasion bizarre and even grotesque, these whimsical snippets meander through film history, witty and wild, consistent only in their

proclivity for not staying put or on topic. The collection opens with an account of the Eldorado Cinema in Beirut, which steadfastly maintained its eclectic programming in the midst of civil war. From one entry to the next (and even within entries), we leapfrog through time and space: to an exclusive shopping avenue in Frankfurt am Main, the Lido in Venice, the streets of Baghdad, the West Berlin studio where Fritz Lang is shooting *Der Tiger von Eschnapur* (*The Tiger of Eschnapur*, 1959), the office of a DVD distributor in Lagos, a film festival in Tashkent. Along the way, we encounter Sergei Eisenstein, Joris Ivens, Federico Fellini, Erich von Stroheim, and Dziga Vertov's brother, partake of a conversation with Jean-Luc Godard about "blind love," and sit down for tea with Andrei Tarkovsky. A distinguished cast of philosophers, writers, artists, scholars, politicians, astronomers, and inventors holds forth on a heady assortment of topics. A professor muses about how subsequent ages might record and decipher light waves that left the Earth during the French Revolution. We return to cinema's various beginnings (Georges Méliès, the Lumières, Thomas Edison), regard the endeavors of a czarist propaganda cinematographer to film his opponents "in a partisan way," mull over the most effective techniques for the cinematic representation of dragons and dinosaurs and the reasons why spectators like to behold atrocities, hear of a film agent with Nazi sympathies who tries to smuggle German spirit into American productions, follow the destinies of both famous and lesser-known players (Harry Liedtke, an Ufa idol who takes years to build a career, is killed in seconds by Soviet troops; Olive Thomas, a rising star for David O. Selznick, comes to an early end in a Paris hotel room), and contemplate the impact of television as well as the future of cinema, which most definitely, come what may, will "emerge without a planner," i.e., "by mistake," "like so many good things."[2] The compendium's concluding take, "The Cosmos as Cinema," describes speculations "that the images of all previous ages stream past and through us," so that even scientists cannot predict what kinds of effects "the pictures of this totality" will have.[3]

Literal in its suggestiveness, the German-language title *Geschichten vom Kino* intimates the historical quality of cinema as well as of the feelings that animate and sustain it. (The double meaning of the German word *Geschichte* captures precisely the inextricable link between stories and human histories.) The principle of cinema, according to Kluge, is

something that moves us inwardly—not so much films themselves, but rather the emotions that generate films as well as those that film productions enact and catalyze.

Kluge's short stories, as his cinematic scenarios, have a studied and systematic (although the author would probably grimace at such a description) indeterminacy; this is, among other things, what distinguishes them from most narratives. He does not want to impose sense but rather to further the play of elementary immediacy so that the sensual impressions people have might come to life. Privileging *Sinnlichkeit* over *Sinn*, sensuality over making sense, Kluge implores his readers not to obsess about meanings. Any attempt to interpret every piece in his new book would be misguided. To want to understand it all, he would say, is at best a schoolmasterly resolve that forsakes the more fundamental experience of spontaneity and pleasure in favor of intellectual mastery.[4]

For the uninitiated, understanding it all is, in any event, out of the question. But, for people who have followed Kluge's work, this new publication is readily legible and in fact contains numerous reprises from the author's previous books and films. The seventy-six-year-old human dynamo has been remarkably visible and productive—frighteningly so, on a number of fronts—for half a century. Conversant in literature, film, television, music, opera, theater, art, history, politics, social theory, jurisprudence, and science, Kluge is at once a polymath of the old school as well as a modernist and an innovator. A student of history and religious music, he completed his law degree in 1956. His acquaintance with Theodor W. Adorno at the Institute for Social Research offered a crucial introduction to the work of the Frankfurt School; first-hand exposure to Fritz Lang's work in a West Berlin studio, where the old director suffered at the hands of producer Artur Brauner, also proved to be a valuable formative experience. Dismayed by what he saw (and remembering it later as he formulated alternative models of film production), Kluge spent much time in the studio's cantine writing short stories, which appeared in 1962 as *Lebensläufe* (*Case Histories*). Six further volumes, proffering thousands more pages of short fiction, would follow. At the same time, on a parallel track, Kluge pursued a rigorous program of cultural critique together with social theorist Oskar Negt, a collaboration that yielded *Öffentlichkeit und Erfahrung* (*Public Sphere and Experience*, 1972), *Geschichte und Eigensinn*

(*History and Obstinacy*, 1980), and a two-volume compendium of their collective endeavors titled *Der unterschätzte Mensch* (*The Undervalued Human Being*, 2001). Over the past four decades, Kluge has won virtually every distinguished literary award Germany has to offer, including the highly coveted Georg Büchner Prize in 2003.

In April 2007, Kluge also received a lifetime achievement award from the German Film Academy for his distinguished contributions as a filmmaker. Director (or codirector) of fourteen features and sixteen shorts between 1960 and 1986, Kluge was the preeminent proponent of the New German Cinema, whose founding moment was the publication of the Oberhausen Manifesto (an episode related at length in the German edition of *Cinema Stories*). Nimbly negotiating with government officials, Kluge successfully lobbied for an *Autorenkino*, or auteurs' cinema, sustained by unique public funding setups that allowed directors to be their own producers and freed them from the constraints of the commercial market. Along with directors Edgar Reitz and Detten Schleiermacher, he established, in 1964, West Germany's first film academy, the Ulm Institute for Film Design, a vanguard site for reflection and experimentation, which he oversaw until 1970. In subsequent years, he coauthored various pamphlets meant as interventions in the German film scene, most notably *Bestandsaufnahme: Utopie Film* (*Taking Stock: The Utopian Film*, 1983).

But no matter how prominent his role at home, Kluge's films received modest exposure in North America—even during the heyday of New German Cinema, from the seventies through its demise in the mid-eighties. The subject of innumerable international tributes and various academic symposia, Kluge was highly regarded, but outside of classroom showings in German studies departments (usually limited to the same two or three films), his work more often has been read about and cross-referenced than actually seen in the United States.[5] For this reason, the sixteen-disc comprehensive edition of Kluge's films from 1960 to 1986, which recently appeared in Germany, is a welcome event. Replete with English subtitles and a wealth of additional materials, it comes to us like a time capsule and a treasure trove.[6] The entire body of his film productions finally can be viewed and considered as a whole and, as is appropriate, placed in relation to his other endeavors.[7]

Like his stories, Kluge's feature films challenge customary patterns of recognition. German history provides a point of departure and a constant site of return for his endeavors; complex and conflicted, this history, maintains Kluge, does not readily lend itself to easy identification or transparent presentation. The bombing of his hometown, Halberstadt (80 percent of which was leveled by American and British planes on April 8, 1945), and the demise of the German Sixth Army at Stalingrad in February 1943 remain defining experiences in his films (and throughout his work), which must be thought of first and foremost as attempts to reflect truthfully the impossibly complicated and contested "reality" of postwar Germany—a task that could not be achieved, Kluge argued, by conventional means. Thus, he eschewed the spurious sutures of continuity editing and the seamlessly neat, easily accessible narrative packages that they produce. For all its intellectual resolve, his cinema is also loath to the dynamics of Eisenstein's montage. The Soviet master's collision of attractions leads the spectator, through an appeal to the senses and the emotions, to an inevitable dialectical conclusion, which is, in the end, just a more sophisticated sort of other-direction, and therefore, is anathema to Kluge.

Reality and realism are central terms in Kluge's aesthetic conception and are important for any understanding of his films. Neither a state of nature nor the way things are, reality is produced and not given; for that reason, it can be comprehended only in its constructedness and its connectedness, its *Zusammenhang*. Simply to document something, Kluge submits, is not realistic; reality does not exist without actions, fantasies, and wishes, which is to say, unless human senses and feelings are in motion. Feelings, to be sure, are anarchic and often unreliable; for that reason, one tries to harness them, often with success (sometimes, as in the case of National Socialism, with too much success), and enjoys all the more indulging their power in the form of films, operas, plays, and novels. Inclusiveness and generosity figure seminally in Kluge's suggestive and elusive choreographies of sights and sounds. They generate networks of meaning linked by interrelation rather than by flow or continuity, bringing together things that do not seem to belong together at all. This higher

realism aims to encourage responses that go beyond directorial design and authorial volition. Viewers should be free to pick and choose from a wealth of offerings so that films might arise in the head of the spectator—without question, Kluge's key concept and best-known catchphrase.

The German title of Kluge's first feature, *Abschied von gestern* (*Taking Leave of Yesterday*, 1966; released in the United States as *Yesterday Girl*), is programmatic: The narrative recounts episodes from the life of Anita G., a young Jewish refugee from the German Democratic Republic, who wends her way through an inhospitable West Germany, repeatedly confronting, in the words of Miriam Hansen, the "continuation of social practices and attitudes underneath [the nation's] official stance of having accomplished the break with the Nazi past."[8] In this sense, at least, the title is poignantly ironic. Nonetheless, the film's form and style marked a radical departure from popular German cinema of the Adenauer era. Influenced by Brechtian strategies of distantiation and what critic Richard Roud called Godard's "block-like tableau construction,"[9] Kluge employed a dialectical assemblage with surplus value rather than creating a coherent unity, interspersing Anita G.'s odyssey with fairy tales, dream sequences, paintings, photographs, drawings, intertitles, legal tractates, and documentary footage. The sound track merges his own laconic voice-overs, operatic and classical music, popular melodies from the thirties and forties, and sound montages not always in sync with the images. Even so, *Yesterday Girl* is one of Kluge's few commercially successful films. The German entry to the 1966 Venice International Film Festival, it won a special jury award.

Die Artisten in der Zirkuskuppel: ratlos (*Artists under the Big Top: Perplexed*, 1968), Kluge's second feature, provided an allegorical portrait of a cinema that dares to be different. Leni Peickert, who has inherited a circus from her deceased father, renounces tamed animals and domesticated meanings, wishing to offer novel attractions driven by love and respect for the richness of the real rather than by commercial calculation. Her creative aspirations, however, run up against economic challenges as well as practical realities; audiences neither understand what she is up to nor have any desire to partake of her whimsical experiments. In the end, she takes a job in television, hoping that a "politics of small steps" might allow her, over time, to realize her designs. A reflection on the gap between Young German Film's fondest fantasies and the stark reality of

FIGURE 14.2 The story of Anita G. (in *Abschied von gestern/Yesterday Girl*, 1966) is, in Kluge's words, "specifically related to the Federal Republic. Her story would be different if she were living in a different society. And it would be different if the Germans had a different history."

unreceptive audiences in the Federal Republic, both a critical taking of stock and a statement of hope, *Artists under the Big Top* anticipated the director's own subsequent move to television. Beginning in 1986, he would devote his energies exclusively to the small screen.

Kluge's early films dissolved boundaries between fiction and documentation, showing how fantasies and dreams collide with and yet help determine the shape of reality. His protagonists, full of energy and hope, have great ambitions but only limited logistical acumen; their uncertain courses of action are of a piece with narratives that ramble and take detours. The protagonist of *Gelegenheitsarbeit einer Sklavin* (*Part-Time Work of a Female Slave*, 1973), Roswitha Bronski, supports her family by performing illegal abortions. Increasingly sensitive to social problems and eager to become an activist, she experiences a tension between the

needs of the nuclear family and her emancipatory endeavors, not fully recognizing what the one has to do with the other. In his case studies of isolated individuals seeking purpose and connection, Kluge often frames his figures in close-up as they contemplate a problem or a crisis, his gentle voice-over commenting on and contextualizing their dilemma. Take, for instance, the opening of *Der starke Ferdinand* (*Strongman Ferdinand*, 1976). As the camera zooms in on a well-meaning but overzealous security expert whose thoughts revolve around states of emergency, we hear Kluge's reassuring voice intone, "There sits a man, Ferdinand Rieche, who works in the security business. He knows all there is to know, and can't comprehend that others don't." Ferdinand defines his life in terms of security zones, from his own person to his job to "everything in its entirety."

A high school teacher named Gabi Teichert and (rather bizarrely) the knee of Corporal Wieland, a soldier who fell in Stalingrad, guide us through the past in *Die Patriotin* (*The Patriot*, 1979), Kluge's definitive exploration of German history. Teichert regrets that the pedagogical materials available for advanced courses in German history are deficient ("It's hard to present a patriotic version of German history," she remarks), and she urges politicians (prominent Social Democratic officials filmed at a party convention) to create something better. The knee, part of what once was a leg, part of a body that belonged to an army and a nation, is also part of German history, a history that this voice and the film as a whole seek to recollect in the hope of revising and redeeming it. We must do away with the notion that the dead "are somehow dead," the knee insists. "We are in fact full of protest and energy." Merging shards of history in a variety of shapes and forms, *The Patriot* is an extended act of mourning and an encyclopedic memory of violence.

Deutschland im Herbst (*Germany in Autumn*, 1978) was the response of a filmmaker collective to the state of emergency that gripped the Federal Republic in the fall of 1977 as violence by the Red Army Faction escalated. The first of three cooperative projects initiated by Kluge (followed by a critical portrait of conservative politician Franz Josef Strauß, *Der Kandidat* [*The Candidate*, 1980], and an antiwar exercise, *Krieg und Frieden* [*War and Peace*, 1983]), it was an urgently felt intervention at a moment of danger, at a time when the actions of terrorists had led to harsh reactions by the government—a parlous situation in which

suspicion, witch-hunting, and denunciation proliferated and threatened West Germany's hard-won democracy, a state of siege that brought back memories of Adolf Hitler's Third Reich. Working together with Rainer Werner Fassbinder, Edgar Reitz, Volker Schlöndorff, and others, Kluge sought to record "images of our own country" that the media, blacked out and skittish during this crisis, refused to show, providing alternative information in the hope of restoring an endangered public sphere and putting a stop to the violence. This demonstration of group solidarity was perhaps New German Cinema's finest hour.

In his final three features, Kluge became even more thoroughgoing in his fragmentation of narrative and his penchant for heteroglossia. *Die Macht der Gefühle* (*The Power of Emotion*, 1983) continually interjects into its flow of images scenes from operas, and reflects on their inevitable tragic outcomes. An actor, fully aware of a drama's dire conclusion, always plays its first act with a sense of hope. "To have a way out," Kluge insists, is essential. "There must be a place for human happiness." Replacing plot logic with a horizontal string of associations, a collection of aphorisms, quotations, and dialogues, Kluge's philosophical essay on feelings and their hardships forwards a latter-day variation on Blochian hopefulness, a veritable smorgasbord of culinary pleasure, emotional nourishment, and food for thought. *Der Angriff der Gegenwart auf die übrige Zeit* (*The Attack of the Present Against the Rest of Time*, 1985; released in the United States as *The Blind Director*) ruminates on an all-consuming present that engulfs the past and threatens the future. "One could say: the principle of the present rages against the principle of hope and against all the illusions of the past," Kluge writes in the book that accompanied the film. "We live in a present which for the first time has the potential to become the power ruling over all other times."[10] *Vermischte Nachrichten* (*Miscellaneous News*, 1986) simulates a television news format. Perhaps its most disturbing pairing of images is a simple title—"Saturday, April 26, 1986, 10 P.M.," signaling the accident at a nuclear reactor in Chernobyl— followed immediately by an infant's curious gaze, the combination suggesting the presentiment of global catastrophe and the vulnerability of human life. *Miscellaneous News*, Kluge's last feature film to date, opened without advance word or publicity and went all but unnoticed by the press and the public.

Shortly thereafter, Kluge shifted his base of operations to German television, where he has worked ever since, presenting short films and interviews on such shows as *Die Stunde der Filmemacher* (*The Hour of the Filmmakers*), *10 vor 11* (*10 Before 11*), *News & Stories*, and *Prime Time/Spätausgabe* (*Prime Time: Late Edition*), continuing—in the hope of renewing—his long-standing dreams of cooperative cinema. His presence on commercial television is in his mind anything but an act of capitulation or accommodation. (Leni Peickert did not see it that way either.) Rather, as filmmaker Tom Tykwer said in a tribute, Kluge works within the culture industry all the better to resist it, providing reflection instead of anesthesia, surmise in place of certainty, and avid curiosity rather than smug assertion.[11] His playful short films and fascinating interviews, commingled with suggestive intertitles and illustrations, confirm that there is a place in a sea of crass commercialism for incongruous and unique islands. Kluge insists that one make necessary distinctions, even at the risk of being irritating or tedious, to assault the hackneyed and the conventional. In the process, he comes into conflict with the interests who rely on and make money off clichés. Contrary to the claims of his detractors, he has nothing against entertainment; he only asks that we distinguish between other-directed amusement and more spontaneous and meaningful forms of diversion. He is fond of saying that he moved *Autorenkino* from film to television, sustaining the project of New German Cinema in a different medium and, in the process, contributing to the future of cinema.

III.

With their dense weaves of disparate materials, Kluge's elaborate collages are undeniably imposing in their intertextuality. These wisps of experience shun linearity in the name of an unruly realism. They bring to mind what critic Raymond Bellour describes as "a cinema of . . . discourse, of critical intent, dissociation, thought, the apparatus, the brain," which assumes "the duty of speaking the states of the world," and, in Kluge's case, of registering the effects of German history.[12] Inordinately deferential to other visions and voices, Kluge's is a cinema of intellectual

communicability and, as such, one of citation. "He thought in the heads of others and in his head others thought as well," Bertolt Brecht (whom Kluge quotes approvingly) once said of a person he admired.[13] *Cinema Stories* plays with film history and reflects Kluge's predilections in this larger course of time. How precisely, though, does film history figure in his own film features? Do his references to other films reflect, as we see in *Cinema Stories*, a more embracing love of cinema's possibilities rather than a concrete love of actual films? Adorno liked to go to the movies; only the images on the screen put him off. Is Kluge, like his mentor, more an iconoclast than a cinephile?

Surely in his redemptive relationship to mass culture (despite his acute awareness of its regressive potential), Kluge does not share Adorno's dismissive determinism regarding industrialized amusement. (In this respect, he is much closer to Walter Benjamin.) Although the terse plot summaries in *Cinema Stories* at times recall the ironic pungence of Siegfried Kracauer's Weimar film notices (especially the exemplar of symptomatic criticism, "Film 1928"),[14] they spare us ideological insinuations. Godard's own cinema of citation offered, as Kluge has often pointed out, an essential point of orientation. Nonetheless, in crucial regards, Kluge's actual intertextual practice differs dramatically from that of his French role model. We find no clips from classic Hollywood films by Alfred Hitchcock or Howard Hawks, no affectionate glimpses at *The Lady from Shanghai* (Orson Welles, 1947) or *Duel in the Sun* (King Vidor, 1946); no fond recollections of westerns, film noirs, musicals with Gene Kelly and Doris Day, or screwball comedies; and no celebrations of star signs like Humphrey Bogart, Dean Martin, or John Wayne, much less of sex symbols such as Jennifer Jones or Elizabeth Taylor. Kluge's films pay no attention to Yankee fetish objects, to big cars, cigarettes, or pinball machines. And forget jazz, rhythm and blues, or rock 'n' roll—the music in Kluge's films is never cool or hip. Likewise, there are precious few of the insider jokes and cross-references that abound in films by Godard and his former *Cahiers du Cinéma* compatriots.

For all of Kluge's upbeat words about the diversity of New German Cinema, his own films do not seem to be in dialogue with the work of his peers. It would boggle the mind to imagine Kluge embracing Samuel Fuller, John Ford, or Nicholas Ray as ersatz fathers, as Wim Wenders has

done, or writing affectionate tributes to Douglas Sirk and Michael Curtiz and reflecting this fond regard in his features, as Fassbinder did. What Kluge and Wenders, along with Werner Herzog and Schlöndorff, do have in common is a great respect for Fritz Lang and F. W. Murnau. But Wenders's repeated nods to Japanese master Yasujiro Ozu find no equivalent in Kluge. Indeed, films from Asia, Africa, and Latin America seem altogether out of his purview. Beyond the Nouvelle Vague, French cinema does not appear at all in his work, nor do films, by and large, from most of Europe.

Of course, Hollywood is not altogether absent in Kluge's films. In *Yesterday Girl*, Anita G. walks by the Gangolf-Lichtspiele in Bonn, where a film with Tony Curtis, Jerry Lewis, and Thelma Ritter is playing. Although a title on the marquee does not come into view, it is apparently John Rich's *Boeing Boeing* (1965). On the run with suitcase in hand, Anita buys a ticket so that she might enjoy several hours' refuge from the cold streets. *Artists under the Big Top*'s Leni Peickert, working at a television station, looks at a monitor and scrutinizes the scene from *Where Eagles Dare* (Brian G. Hutton, 1968) in which Richard Burton masquerades as a Nazi officer. In passing, we glimpse a poster in *The Patriot* advertising the rerelease of *The Bridge on the River Kwai* (David Lean, 1957) during the holiday season in Frankfurt. In his short film for television, *Der Eiffelturm, King Kong und die weiße Frau* (*The Eiffel Tower, King Kong, and the White Woman*, 1989), Kluge transposes the face of the ape onto a shot of Bob Hope in a white tuxedo. By and large, Kluge's features show no sign of the Nouvelle Vague's Americanism or of the love–hate relationship with Hollywood so essential to the cinemas of Fassbinder and Wenders.

The features before *The Patriot* contain a limited range of references to other films. One finds clips from Nazi newsreels and, on occasion, narratives, Soviet hallmarks (*October*, Sergei Eisenstein, 1928), *Man with a Movie Camera* (Dziga Vertov, 1929), and *Chapayev* (Sergei and Georgi Vasilyev, 1934), and Joris Ivens's *Rain* (1929). *Der große Verhau* (*The Big Mess*, 1970) and *Strongman Ferdinand* (by far the most formally conventional film in Kluge's corpus) do not in fact include a single citation. Subsequent productions make a much more concerted use of German film history, especially Weimar classics (both sound and silent, from *Sumurun* [Ernst Lubitsch, 1920] and *Die Nibelungen/The Nibelungen* [Fritz Lang,

1924] to *Die wunderbare Lüge der Nina Petrovna/The Wonderful Lies of Nina Petrovna* [Hanns Schwarz, 1929], *Menschen am Sonntag/People on Sunday* [Robert Siodmak et al., 1930], *Die letzte Kompagnie/The Last Company* [Kurt Bernhardt, 1930], *Kuhle Wampe* [Slatan Dudow, 1932], and *Ein blonder Traum/A Blonde Dream* [Paul Martin, 1932]) and overtly political films from the Third Reich directed by Karl Ritter and Veit Harlan. On occasion, Kluge also revisits early cinema, whether the Oskar Meßter short *Der dressierte indische Elephant* (*The Trained Indian Elephant,*1897), which is quoted at length in *The Patriot,* or the German documentary about the Lumières's invention of the film camera, in *The Blind Director.*[15] More often than not, Kluge embeds his films of choice within dense and suggestive constellations. The opening sequence of *Artists under the Big Top,* for instance, couples documentary footage from the 1939 Day of German Art with an Italian-language rendering of the Beatles's "Yesterday," creating an ironic contrast between Nazi art's grand illusions, with its bombastic merger of aesthetics and politics, and a popular tune, diminished and defamiliarized in its reproduction as a foreign knockoff.

The texts that Kluge selects rarely are identified (not even in the published scripts that accompany many of his films in book form) and, on occasion, even willfully misrepresented. The clips frequently (but not always) undergo an obtrusive working over; they are twisted and tinted, matted and fragmented, manipulated into shapes that make them at times resemble found materials and undermine any aura that they might have once possessed. The first ten minutes of *The Power of Emotion* utilize snippets from Fritz Lang's *Kriemhilds Rache* (*Kriemhild's Revenge,* 1924), Karl Ritter's *Stukas* (1941), and Gustav Ucicky's *Morgenrot* (*Dawn,* 1933), films commonly considered either fascist or protofascist. In Kracauer's assessment, *Kriemhild's Revenge* was part of a nationalistic epic meant to renew the patriotic spirit of a disenfranchised country. *Dawn,* likewise, elevated "war to the rank of an unquestionable institution." The heroic speech cited from *Stukas* ("Yet gladly will I sacrifice myself for the fatherland, bleed my heart's blood for the fatherland!") celebrates soldierly obeisance to a collective death wish. Kluge does not single out these films as bad objects and castigate the hollowness of their ideological appeal; he takes their affect and pathos seriously and trusts that subsequent history

has enabled us to understand and assess their meanings. There is a retrospective irony that comes through, in the lethal outcome of these films and in the lethal outcome of the histories from which they issued and in which they circulated. One might be tempted to call what Kluge does here postmodern; he takes films out of context and inserts them into designs of his own making. It would be more accurate, however, to say that he disassembles and decontextualizes these disparate pieces before going on to reassemble and rehistoricize them.

Kluge bears little resemblance to the classic cinephile, who ferrets out indeterminate meanings in highly coded films, who scans (especially Hollywood) features for moments that stand out and take on their own stirring and independent existence.[16] His citations from other films are not epiphanic evocations (e.g., Jean-Paul Belmondo in Godard's *À Bout de Souffle* [*Breathless*, 1959] twitching his lip like Humphrey Bogart), but rather pieces in larger constructions, fragments inserted within the *Zusammenhang* of his own discourses. To what degree Kluge's own films lend themselves to cinephilic appropriation is another question. One might point to his many nature interludes and stirring cityscapes. But these seem self-consciously idyllic (and prospects that initially appear to be beautiful often overstay their welcome and quickly become kitschy) or intentionally evocative and, as such, too obvious for a cinephile's personalized and highly selective poaching. Kluge's cinema of citation privileges *Zusammenhang* and not auratic moments; what is important above all is that sights and sounds interrelate and resonate as thought images (*Denkbilder*).

IV.

There is an undeniable disparity—already apparent in *Artists under the Big Top*—between Kluge's utopian conception of cinema and his work's meager appeal for most spectators. He may well have fancied his films to be collections of materials so richly diverse as to offer something for everybody, but even sophisticated and indulgent audiences have often found them confusing, less likely to stimulate and intrigue viewers than to make them feel they were downright stupid or somehow missing the

point. During the seventies and eighties, Alexander Horwath recollects, many cinephiles became disenamored of what they considered to be a "cinema of film theory," which lent itself best to academic appreciations rather than enthralling experiences in the dark.[17] Long-standing admirers, filmmakers clearly in Kluge's debt, also have wondered how his ostensible nondeterminacy and theoretical munificence actually translates into actual praxis.[18] In his trains of thought, they submit, he remains the conductor; his commentaries control the way we see and what we hear; his voice, for all its nuance and irony, just about always seems to have the last word.

Kluge's notion of emancipated feelings, argues feminist filmmaker Jutta Brückner, remains undifferentiated and disembodied, abstract and ahistorical, inattentive to gender and difference.[19] Feminist critics like B. Ruby Rich complain about the way in which Kluge's voice speaks for his female protagonists and reduces them to the status of puppets.[20] Still other commentators, myself included, have wondered about the conspicuous absence of the Holocaust in Kluge's elaborate historical panoramas.[21] Gabi Teichert, Kluge's voice-over claims, is "interested in all of the German Reich's dead," but *The Patriot*, much less any of his other features, does not show a single image of the Shoah or directly acknowledge the effects of wartime genocide. Watching the film now in the context of recent discussions about German suffering can be even more disconcerting, given the many scenes stressing the disastrous and harrowing effects of Allied bombing on the German population.[22]

These concerns resonate within larger discussions that have helped to problematize, refine, and historicize our notions of auteur cinema. Self-reflexive cinema was once held to be the mark of a higher and exalted consciousness. Commentators have long since come to realize that the self that reflects is surely not above criticism. For all its alternative impetus, the New German *Autorenkino* to a great degree remained a site of male fantasy (as the interventions of directors like Helke Sander have attempted to make clear).[23] And the pliers of German retro films, eager to rewrite the nation's history while renewing its film history, ultimately would create narratives of German victimization and vicissitude with a revisionist quality, as Anton Kaes argues in his book *From Hitler to Heimat: The Return of History as Film* (1989).[24] Despite the continuing

relevance of these objections, Kluge's films as a whole have stood the test of time. They have gained new meanings in light of recent celebrations of 1968 and its legacy, the revived attention to terrorism in Germany and the Red Army Faction, recent debates within film studies about early cinema and its relationship to modernity, and, of course, the concern about what the end of cinema will mean for the world at large.

As someone who ceased making features decades ago, Kluge realizes that we live in a time of shifting medial paradigms; film as we have known it for more than a century may soon cease to exist. Nonetheless, he is not one to speak of cinema's impending death or to let the presentiment of its demise serve as, in film critic Nicole Brenez's words, "a grand melancholy theme" in the production of new films, as it has for so many of his peers.[25] He does not share Godard's bleak persuasion that the redemptive power of the film medium has been vanquished and superseded by Hollywood's spurious harmonies and television's industrialized falsehoods.[26] Indeed, he insists that his work for television figures in—and as—the future of cinema. With fondness and animation, he extols early film's primitive diversity and consciously seeks to replicate its resistant energies in his own recent productions. Prenarrative cinema with its minute-long films is robust, he enthuses; it furthers the joy of curiosity and astonishment that comes with our ability to love, enlivening viewers without deceiving them. These films are so compelling because they do what they do without needing to know why, confirming that there is such a thing as a filmic unconscious. At the German Film Academy awards ceremony in spring 2007, Tykwer lauded the director's one-minute films (which introduce many of the features in the Edition Filmmuseum DVD collection) and their recourse to the impetus of early cinema.

In *The Blind Director*, a cranky filmmaker (modeled after Fritz Lang) is losing his sight. "I hate images," the self-styled iconoclast snaps at a journalist. In the final sequence, we gain access to what goes on in this disaffected artist's mind. "Inside he was full of images," says the voice-over.[27] A publicity still of actress Louise Brooks (looking to the right) appears next to a circle with a tinted excerpt from the Lumières's *L'Arrivée d'un train en gare de La Ciotat* (*The Arrival of a Train at the Station*, 1895). We cut to a garish poster depicting the country couple from Murnau's *Sunrise* (1927) kissing in the midst of a big city intersection; to the right, we see

FIGURES 14.3 AND 14.4 In the inner light of his personal mindscreen, the blind director (Armin Mueller-Stahl) imagines films that he has been unable to make. And he also recalls F. W. Murnau's *Sunrise* and the Lumière Brothers's *L'Arrivée d'un train en gare de La Ciotat* (in *The Blind Director*).

the circular matte of the train, but the locomotive now moves in reverse away from the station. Kluge's second-to-last film concludes by going back to the past, celebrating early cinema's arrival, suggesting that the future of film might well rest in the not fully realized promise of its beginnings. By taking leave of cinema as it is now, Kluge searches for its future, recalling the great hope of its mythic founding text and literally rewinding the image. Indeed, his concept of film's possibility harks back to the utopian potential of what Tom Gunning has called "the cinema of attractions."[28]

Indefatigably productive as a writer, philosopher, media entrepreneur, and public intellectual, Kluge believes that films need not exist for there to be cinema. After all, cinema arose centuries before there were films, as "the spontaneous workings of the imaginative faculty," "raw material of associations" for which "the invention of the film strip, projector, and screen only provided a technological response."[29] In Kluge's assessment—a point recapitulated in *Cinema Stories*, which combines the principle of hope and the power of stubborn resistance—cinema has abided as a capacity in the human mind for thousands of years, and it will continue to exist long after film's passing. Ever one to nuance his insights, the director goes on, "It could well be that, following its rebirth, cinema will adopt a form that we won't immediately recognize," and he punctuates the thought with a quotation from Michelangelo:

I'm not dead
I'm merely changing places
I am still with you
In dreams you'll see my traces.[30]

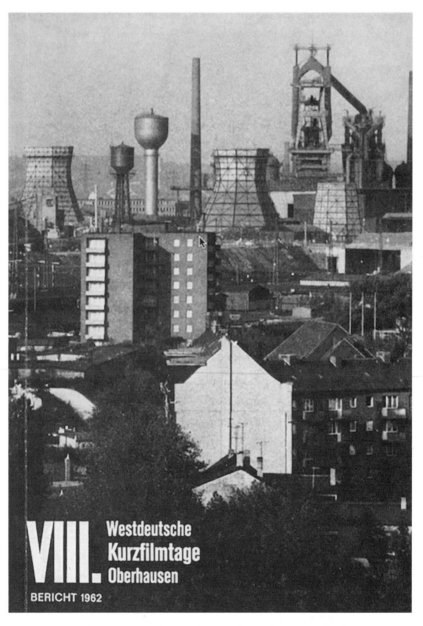

VIII. Westdeutsche Kurzfilmtage Oberhausen

BERICHT 1962

FIGURE 15.1 In February 1962 at the West German Short Film Days in Oberhausen, twenty-six angry young men announced their ambitious plans to renew a national cinema: "Since the end of the war the German film industry has never been in such a precarious state. Which is to say it has never been so ready for an intellectual and artistic new beginning of German film" (Enno Patalas).

15

THE DECLARATION OF INDEPENDENTS

I.

A handful of words in large type filled a page of the West German journal *Filmstudio*'s spring 1962 number. The editors' telegraphic message—devoid of punctuation and eccentric in its line breaks—proclaimed:

> Papas cinema
> is dead mani
> festo of the yo
> ung 1962 ho
> pe or
> disaster[1]

By the time that issue of *Filmstudio* appeared, the manifesto in question had become well known (and, in many quadrants, notorious) among observers of the film scene in the Federal Republic of Germany (FRG), who were fiercely divided in their reaction to the dramatic intervention of twenty-six brash, young, and aspiring filmmakers at a press conference held on February 28, 1962, during the Oberhausen Short Film Festival. In an expression of Oedipal outrage, these earnest young men—and it is indicative of the times that they *were* all men—assailed what they deemed to be a spiritually arid and intellectually bankrupt national cinema, announcing their

intention to bring to it creative redemption and intellectual renewal. Blending a harsh critique with a constructive resolve, the succinct statement—its concision itself a blunt instrument—announced "the collapse of the conventional German film," reiterating the news of its demise in the emphatic closing, which declared that "The old film is dead" and expressed reason for hope: "We believe in the new one."[2] Both a devastating prognosis and a program for renewal, the document demanded a departure from the past and sketched a design for the future. To be sure, this promise of a fresh start bore a curious resemblance to the wishful thinking of *Stunde Null* (or "zero hour") rhetoric that had circulated in Germany directly after World War II, with its tacit belief that one might start from scratch.

This fabled document, now hallowed as the Oberhausen Manifesto, provided the founding myth for what would become the Young German Film and, about a decade later, the New German Cinema. Against formidable odds, the manifesto precipitated radical changes in the way films

FIGURE 15.2 The ironic evocation of the *Heimatfilm* in the opening shot of Oberhausen activist Walter Krüttner's short film *Es muß ein Stück vom Hitler sein* (*It Must Be a Piece of Hitler*, 1963), an acerbic reflection on Obersalzberg and postwar Führer worship.

in West Germany were funded and made, and it profoundly changed the equation with respect to the question of who would make them, with an immediacy, a vehemence, and a pertinacity that is truly astonishing. (One need only compare the efficacy of Oberhausen to that of the "First Statement of the New American Cinema Group," also issued in 1962, to confirm this.)[3] And if only a very few of the filmmakers who endorsed the statement ultimately would achieve some measure of international renown, the manifesto undeniably forced the opening that made possible the extraordinary creative outpourings—of the likes of Werner Schroeter, Volker Schlöndorff, Rainer Werner Fassbinder, Wim Wenders, and Werner Herzog—that put German film at the forefront of international cinema during the seventies and eighties. As we reflect on the document, we would do well to recall the energies that spawned this now legendary pronouncement and gave it such potency. At the same time, we should be alert to the more ambivalent (and less remarked) aspect of this remarkable legacy.

II.

The signatories' vendetta against the "conventional German film" of their day was at once a response to established interests as well as to historical aporias. To decry the "conventional," above all, was to disdain the legacy of Ufa, Germany's principal—and, in equal measure, renowned and infamous—film studio, and to applaud its postwar dismantling and the demise of everything that it had stood for, especially the well-made German film, with its staid tradition of quality, a tradition that had dutifully and diligently served the National Socialist order. The young filmmakers rejected the cinema of their fathers (and grandfathers), particularly its cultural perspectives and its cozy relations with established interests and reactionary politics. But within the Oberhausen signatories' virulent negativity inhered an equally ardent positivity, the conviction that members of a younger generation might improve the state of affairs if only they dared stand up and seize the moment. "Since the end of the war the German film industry has never been in such a precarious state," the sympathetic film critic and activist Enno Patalas observed, typifying a

FIGURES 15.3 AND 15.4 The young Alexander Kluge, spokesperson for the Oberhausen signatories and advocate of a national cinema more finely attuned to West German realities.

prevalent attitude of the times. "Which is to say it has never been so ready for an intellectual and artistic new beginning of German film."[4]

The Oberhausen activists included twenty directors, only three of whom (Ferdinand Khittl, Hansjürgen Pohland, and Herbert Vesely) had yet completed a feature. More modest formats, they argued, even if driven by necessity, had provided their generation an arena in which to experiment and take risks, and in this way foster a new language of cinema. Short films by young German cineastes such as Alexander Kluge and Edgar Reitz, the manifesto proclaimed (without naming names), had made a splash at international festivals. And these works had generated enthusiasm among foreign journalists and had once again brought attention to German cinema as a site of vanguard endeavor for the first time since the Weimar Republic. This awareness of the value of international prestige was prescient in its recognition (now taken for granted) of how powerful a bargaining chip praise from abroad could be. In subsequent years, the New German filmmakers would become masters in the triangulation of desire, using their festival successes and art-house triumphs abroad as a means to legitimate their endeavors at home and to secure funding for future productions. Beyond that, the manifesto asserted, this new cinematic language (the nature and very existence of which, it should be noted, is asserted without further elaboration), forged in the crucible of the short film, must now transform the feature-length film. For this to happen, dramatic change would need to take place in West Germany. Artists would have to be freed from outmoded conventions, commercial pressures, and external interventions. With great (and, given their relative lack of experience, not altogether justified) certainty, the group asserted that it had "concrete intellectual, formal, and economic ideas" about the kinds of films they would make and how they would go about making them. Likewise, the signatories acknowledged their willingness to bear financial burdens.

Surely an overdetermined document, the Oberhausen Manifesto looked back in anger and gazed forward with critical zeal and professional ambition. As a historical reckoning, it reiterated well-known and longstanding concerns about the state of West German film culture, which was in such dire condition that the government had not deemed any feature worthy of a Federal Film Prize in 1961. Journalists and critics

in the FRG, throughout the fifties, had made their dismay regarding the quality of domestic features abundantly clear and repeatedly had called for a renewal of the nation's cinema. Take the January 1958 issue of the FRG's most significant film journal, *Filmkritik*, which enumerated the New Year's wishes of the editorial board that there be "no new films by [Wolfgang] Liebeneiner, [Rolf] Hansen, [Gustav] Ucicky, Braun (Harald as well as Alfred), [Horst] Hächler, [Kurt] Maetzig, and, of course, [Veit] Harlan" (all of whom, save Hächler and Maetzig, had played prominent roles during the Nazi era and remained quite active after the war) as well as "no new films about wise doctors and trusting patients, jovial estate owners and pious peasants, war heroes, invaders from outer space and other stand-ins for Bolsheviks, Russian subhumans (in films from the West) and American subhumans (in films from the East), hooligans and Marcelinos, drug addicts, hat thieves, and other eccentrics."[5]

In his polemical analysis with the caustic title *Der deutsche Film kann gar nicht besser sein* (*German Film Cannot Be Better*, 1961), the Munich-based critic and film historian Joe Hembus summarized a nation's dismay about its dismal film culture.[6] The country's productions lacked an international presence, he complained; its films did not circulate widely, and its best-known directors (Helmut Käutner, Wolfgang Staudte, Kurt Hoffmann, and Rolf Thiele) enjoyed little recognition abroad and lacked compelling authorial signatures. One looked in vain for noteworthy stylistic inflections or memorable productions, for films that reckoned with the past or confronted the present in convincing ways, for endeavors that took formal risks or provided alternative initiatives. The features of the era, insisted Hembus, were impersonal and insipid, star-driven and genre-bound. Almost without exception, he lamented, West German film of the fifties was the work of casts and crews who had served in studios administered by Joseph Goebbels's Ministry of Propaganda. The French Nouvelle Vague offered a valuable foreign model of a reinvigorated national cinema and a viable solution to the West German misère; here, effused Hembus, "a group of young people with something to say chose film as their medium and secured access to opportunities to say what they had to say."[7]

The Oberhausen signatories demanded a change of course—and the moment was right. West German film was—in this regard there seemed to be little disagreement—a national embarrassment. The crisis of "Papa's

FIGURE 15.5 Signs of life from a Young German Film in the state of becoming: group photo with signatures.

cinema" coincided with the bitter end of Konrad Adenauer's administration and the so-called *Spiegel* affair of 1962, a public scandal that ultimately led to the aging chancellor's resignation. Although there had been several attempts to foster renewal in the West German film scene, none of these previous endeavors (e.g., the "Memorandum Regarding a New German Film" of 1946 or the formation of DOC 59,[8] a collective of documentarians, cinematographers, composers, and critics) had gained traction.

The drafters of the manifesto gathered on a January evening in a backroom of the Chinese restaurant Hongkong on Munich's Tengstrasse. The critical impetus of Alexander Kluge, the key spokesperson for the group as well as a writer and a lawyer of some reputation, very much influenced the shape of the plan for a radical transformation. The envisioned film culture was to take its place within a more inclusive and dynamic public sphere. It would reflect the thoughts and energies of a younger Germany, a generation that had been doubly disfranchised, both as producers and spectators. Its proponents would initiate dialogue with representatives of the other arts (e.g., members of the Bauhaus and the literary association Gruppe 47 as well as exponents of avant-garde music and modernist art) so that film in the FRG might be freed from its intellectual isolation. Cinema, argued Kluge, should foster a more

encompassing and expansive sense of reality and become a site of alternative expression; it must dare to be different and militate against conservative forces. Any creative renewal, the Oberhauseners realized, would necessitate dramatic changes in material arrangements so that economic criteria would no longer stand as the sole measure of quality and success.[9]

The proclamation of the manifesto occasioned much critical comment. As one might expect, established members of the film industry and the conservative press ridiculed the young men for their audacity, linking their inflated rhetoric to that of the great liar of lore, Baron Münchhausen, and calling them *"Obermünchhausener."* Nevertheless, despite substantial opposition, the initiative served as a valuable catalyst with significant and lasting results, including, but not limited to, the founding of film academies in Ulm, West Berlin, and Munich, and the formation, in February 1965, of a government funding agency, the Board of Curators of the Young German Film, which served as the impetus for the large network of federal and regional agencies subsequently created to subsidize film production in Germany. The manifesto, furthermore, triggered an impressive wave of features. In 1966, Ulrich Schamoni's *Es* (*It*) and Schlöndorff's *Der junge Törleß* (*Young Törless*) premiered at the Cannes Film Festival, where the latter received the International Critics' Prize. A few months later, Peter Schamoni's *Schonzeit für Füchse* (*No Shooting Time for Foxes*) garnered a Silver Bear at the Berlinale. And that fall Kluge's *Abschied von gestern* (*Yesterday Girl*) was awarded a Silver Lion at the Venice Film Festival. All but the first of these films had received support from the Board of Curators. Critics from a host of countries celebrated what quickly became known as Young German Film. In time, auteurs from West Germany, their careers made possible by the cultural opening forged at Oberhausen, would gain a substantial profile as pliers of the New German Cinema, arguably the most significant national film movement of the seventies.

III.

As a founding myth for a cinema of auteurs that attained international prominence, the Oberhausen document provided an impressive point of departure. As a collective enterprise, the manifesto marked a significant

juncture at which a number of creative and ambitious filmmakers came together and, despite many differences, spoke out in the name of a utopian vision. Given the historical moment, their outspokenness was understandable and, in light of their marginal status, necessary. Looking back at this foundational text with the distance a half-century affords, we now can see not only the very real achievements of Oberhausen but also the sometimes-problematic consequences of the heroic narrative it gave rise to—the oversights and exclusions, the denial and distortion such mythomania invariably entails—and therefore also the need to reconsider the historical record and retell the tale.

The heroic narrative, for instance, conveniently overlooks the fact that the Oberhausen activists occasioned criticism not just from the established film industry but also from fellow independent filmmakers. The signatories were vigorously attacked by Rudolf Thome, Roland Klick, and Klaus Lemke, for example, as well as by Jean-Marie Straub and Danièle Huillet—directors loosely referred to at the time as the "Munich School," whose dissatisfaction with the Oberhauseners ranged from political objections to reservations about discursive strategies and aesthetic directions.[10] And indeed, even the Oberhausen collective was never an uncontested and united front, a delicious irony given that this gathering of filmmakers, most of whom operated out of Munich, presumed to speak for German film as a whole.

But perhaps the greatest distortion perpetuated by the Oberhausen myth lay in followers' unthinking acceptance of the manifesto's implicit claim that no sign of life could be detected anywhere in German film beyond the fledgling efforts of the signatories themselves. This was to ignore, willfully so, the nascent alternative cinema that in fact existed in in the FRG in the fifties. (Take the significant avant-garde endeavors of Ottomar Domnick, a filmmaker whose work is ripe for rediscovery.) Neither does the manifesto make any mention of film production in the German Democratic Republic; as was common at the time, the Oberhauseners spoke of German film as if the FRG were the only Germany, presuming in that the Adenauer administration's *Allvertretungsanspruch*. In that regard, their manifesto, for all its progressive intent, remained a Cold War document. Its conspicuous lack of female voices likewise reflected the era's patriarchal proclivities.

Finally, the Oberhausen Manifesto and the New German Cinema, very much in accordance with the ideological critiques of Siegfried Kracauer and Theodor W. Adorno, shared a marked displeasure for films that simply affirmed the status quo. As purveyors of distraction and products of a wannabe culture industry, the Adenauer era's popular cinema had no progressive advocates. Moreover, as symptoms of a society ostensibly beset by collective amnesia, this fantasy ware—in keeping with Alexander and Margarete Mitscherlich's influential thesis about repressed guilt in postwar West German culture at large[11]—took flight from the past and failed to confront and work through its collective investment in a problematic heritage of authoritarianism and violence. Oberhausen's auteurist initiative, the antiauthoritarian impetus of 1968, and the reformative designs of the New German Cinema have played a strong, indeed predominant, role in how commentators have approached the FRG's films of the fifties and early sixties.

Over the past few years, film scholars and cineastes have begun to revisit and reevaluate Adenauer-era productions and, in so doing, to challenge the central premise of the Oberhausen Manifesto. The master narrative, in which a limpid "Papas Kino" simply shriveled up and faded away in response to the young Turks's uprising, has come to seem decidedly contrived, for this mainstream cinema proved to be far more vital than its young adversaries made it out to be. Rainer Werner Fassbinder (whose death in 1982 marked another key juncture in postwar German film history) was not the only one of his peers to find a productive working relationship with representatives of the older generation. He also was not the sole New German filmmaker to look back at the Adenauer era and its mass culture with both a fond and critical regard and to acknowledge certain of his immediate precursors' importance with respect to his own output. Several retrospectives in 2012 (e.g., at the Zeughaus Kino in Berlin) sought to demonstrate that the film culture denounced wholesale by the Oberhauseners was perhaps not so dead after all.

IV.

As was evident already in its first bloom, the cinema of authors that we can trace back to Oberhausen was proud, arrogant, and willful, both

self-important and self-indulgent. Its practitioners viewed their convocation as a gathering of Davids waging war against an army of Goliaths. Without question, this German template exercised a strong influence on subsequent attempts in the United States to conceptualize an independent cinema—from the countercultural ambitions of the renegades behind *Easy Rider* (Dennis Hopper, 1969) to the anti-Hollywood aesthetic of Jim Jarmusch and Amos Poe in the eighties to the delusional messianism and breathtaking self-regard of today's *auteurs maudits*, such as Gregg Araki, Vincent Gallo, and Harmony Korine. New German Film constituted a proto-independent cinema long before there was a Sundance Institute or an Independent Film Channel. Its members, both colleagues and competitors for pieces of a never large subsidy pie, were "indies" *avant la lettre* who defied integration into the dominant cinema and whose very strength and identity rested in their difference from and resistance to the mainstream. The Oberhausen signatories revolted against codified ways of seeing and sought to redefine film and to reinvent the cinema; they privileged alternative images (*Gegenbilder*) and more expansive and complicated understandings of reality, perspectives that were at once unvarnished and outlandish. Difficult and demanding, the New German *Autorenfilm* would perhaps be taken as seriously as it was abroad precisely because it was so vehemently disliked at home, rendering it an eccentric cultural ambassador that spoke for the nation often by speaking (and acting out) against it. It was vulnerable yet fierce, precarious yet nonetheless firm in its conviction, and uncompromising in its insistence that films did not always have to be popular or pleasing to justify their existence.

It stands to reason that representatives of the so-called Berlin School, a countercinema that since the turn of the millennium has gained wide regard as a German new wave, have played a prominent public role in recent remembrances of Oberhausen. Young directors like Christian Petzold, Christoph Hochhäusler, Angela Schanelec, and Thomas Arslan share an aesthetics of a poignant patience and a desire to make the conditions of modern existence visible. Quite adamantly, the adherents of the Berlin School assail the disregard for reality of many recent German features, especially Nazi-Stasi retro films like *Der Untergang* (*Downfall*, Oliver Hirschbiegel, 2004) and *Das Leben der Anderen* (*The Lives of Others*, Florian Henckel von Donnersmarck, 2006). Berlin School

productions have reanimated international enthusiasm for a nation's film culture that had become insignificant and all but invisible since the mid-eighties, after the death of Fassbinder and, with him, the demise of an *Autorenkino*. The Berlin School has revived and updated the critical and creative resolve articulated a half-century ago by a group of young activists, confirming that the incentive of Oberhausen has not diminished in its urgency—and ongoing importance.

IV
POSTWALL PROSPECTS

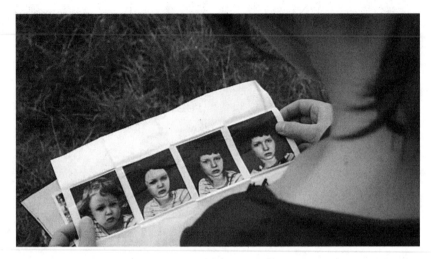

FIGURE 16.1 Nina (Julia Hummer) looks at computer-generated images of a phantom self and an imaginary destiny only to reject the possibilities and connections these photos of a person who resembles herself might entail (*Gespenster/Ghosts*, 2005).

AN ARCHAEOLOGY OF THE BERLIN SCHOOL

I.

The filmmakers commonly associated with the Berlin School, despite undeniable differences of style and sensibility, share certain predilections, among which are an aesthetics of reduction and restraint, a penchant for image-focused rather than plot-driven constructions, a veristic resolve marked by an investment in the here and now, and a desire to negotiate the quotidian spaces as well as the less-charted reaches of contemporary Germany and Europe, loci in which transit sites quite often transmute into twilight zones. Theirs is a cinema of observation, not fabrication, more monstrative than narrative, a praxis that respects the weight of images and recognizes the substantial ethical responsibility of a medium that traffics in facsimiles of the real. This cinema of nonintervention is marked by Siegfried Kracauer's initiative to redeem physical reality. Like that of the late Kracauer, its understanding of realism is keenly reflexive and highly self-conscious.[1] For the exponents of the Berlin School, reality is produced, not given, shaped by the forces of nature, to be sure, but above all determined by the historical impact of human agency.

In characterizations of the impulses that gave rise to this newer German cinema, certain filmmakers are regularly credited as essential precursors: Marco Abel mentions Robert Bresson, Michelangelo Antonioni, Michael

Haneke, the Dardenne Brothers, Maurice Pialat, Jean Eustache, and Philippe Garrel.[2] To this inventory Georg Seeßlen adds John Ford, Jean-Luc Godard, and John Cassavetes.[3] One might also include Frederick Wiseman (particularly his trust in the viewer's power of judgment), James Benning (especially his acute sensitivity to both natural and built landscapes), and Apichatpong Weerasethakul (his stirring blend of hyperrealism and comic absurdism). It also would make sense to consider the conspicuous impact of photographers like Walker Evans, Robert Frank, or the early Larry Clark as well as painters like Gerhard Richter and Edward Hopper.

For all its cosmopolitan sophistication, intellectual curiosity, and informed awareness of film history and contemporary world cinema, the Berlin School came about in Germany under specific conditions and at a certain time. Even if they surely did not fully define the movement's ultimate shape, four domestic determinants figured as crucial formative impulses.

II.

The Munich periodical Filmkritik (1957–1984): Without question, *Filmkritik* remains to this day the most significant periodical film publication to have come from the Federal Republic of Germany (FRG). It was, recalled Christian Petzold, "the best journal that I ever read."[4] What Olaf Möller terms the "*Filmkritik*-style" was shared both by film critics like Peter Nau, Manfred Blank, and Helmut Färber (all of whom also taught film history at the dffb, i.e., the Berlin Film and Television Academy) and filmmakers such as Hartmut Bitomsky and Harun Farocki (who attended the dffb and later assumed prominent functions there) as well as Wim Wenders, Rudolf Thome, and Gerhard Theuring (directors who also wrote film criticism). "You wrote when you weren't filming," argues Möller, "you filmed when you weren't writing; writing and filming ultimately became a continuous stream in the flow of life." After a reconstitution of *Filmkritik*'s editorial board in the early seventies, the prose in this journal privileged observation and description over analysis and evaluation. Single sequences from a film, as Möller elaborates, often

28. Jahrgang, Heft 9-10/1984, Nr. 333-334 · ISSN 0015-1572 · B 2846 E · 15 DM

Filmkritik

KLASSENVERHÄLTNISSE

von Danièle Huillet und Jean-Marie Straub

nach Franz Kafkas Amerika-Roman

DER VERSCHOLLENE

FIGURE 16.2 The cover of *Filmkritik*'s final number, an issue devoted to Jean-Marie Straub and Danièle Huillet's Kafka adaptation, *Klassenverhältnisse* (*Class Relations*, 1984). The directors privileged by this journal, claims Olaf Möller, rejected "the classical bourgeois notion of the functionality of art, in which everything is ultimately resolved and assigned its meaningful place."

were "described for pages on end, very carefully, with each scrupulously weighed up against its implications, its resonance, its role in the logic and the poetry of the sentence and the text."[5] The director whom the editors of this journal most highly revered was himself a master of description and observation, namely Jean-Marie Straub, a filmmaker who has no ideological ax to grind and does not impose a vision on the viewer, whose images are precise and whose style is unadorned. As a journal, *Filmkritik* provided a model for the Berlin School's house organ, *Revolver*. Like *Filmkritik*, *Revolver* would serve as a site for spirited cinephilia, a forum for talented young artists and critics to write about films that they appreciate and, in the journal's inimitable interviews, to talk at length with filmmakers whom they consider to be kindred spirits.

III.

A tradition of realistic endeavor: This spans postwar German cinema and film theory from the poetic realism of Helmut Käutner's *Unter den Brücken* (*Under the Bridges*, 1945), a film particularly cherished by Christian Petzold (who extols its virtues at length in the recent homage to German film history, *Auge in Auge* [*Eye to Eye*, Michael Althen and Hans Helmut Prinzler, 2008]), to Jürgen Böttcher's *Jahrgang 45* (*Born in '45*, 1966) and Roland Klick's *Bübchen* (1968), both of which were screened in a *Revolver*-sponsored series curated by Christoph Hochhäusler in Paris during the spring of 2011. It includes the effusions of German sensibilism with their poetic empiricism. Take, for instance, Wenders's *Summer in the City* of 1970 and the anti-Oberhausen Munich School of the late sixties, especially the minimalism of Rudolf Thome's early features such as *Rote Sonne* (*Red Sun*, 1970), a film that Wenders praised for its "ability to display for ninety minutes without any sense of urgency nothing more than surface appearances."[6] In addition, one might add the *cinéma pur* of Straub and Danièle Huillet as well the gritty urban sketches of the young Klaus Lemke.

A common emphasis in these different initiatives finds expression in Siegfried Kracauer's *Theory of Film: The Redemption of Physical Reality* (1960), which represents a master text in any approach to the Berlin School. What we need to do, claims Kracauer, is to regain touch with

reality, to look at it more closely, and to experience it more fully and concretely. Herein lies film's revelatory potential. What he desires is that we partake of and, at the same time, see through and truly apprehend a reality in which everything has become abstract, functional, and determinate, and in which meaning is obvious and transparent. We need to restore to objects and the world their presence and poignance. Film's ultimate mission is to see and experience things in their concreteness.[7]

Proponents of the Berlin School eschew the disregard for reality (*Realitätsferne*) in most features made in Germany today. Few productions, Petzold insists, reveal what today's Federal Republic really looks like and impart a more profound sense of what it feels like to reside in postmillennial Europe. Germans fancy that they live in cities, says Petzold, but they really live in *Schlafstädte*, dreary places with "those same shops, always Schlecker, Eiscafé San Marco, a french-fry stand, three or four hairdressers, a specialty store for electronics."[8]

Berlin School scenarios negotiate displaced places and historical voids; they emphasize sites off the beaten track (at times literally off the map), rarely traversed sectors of the country and the continent. Cameras insistently fix on people in motion and offer the viewer an acute experience of physis; reality, seen in this way, encompasses the province of physical things and human bodies, the empirical world apprehended in its diversity and complexity rather than corseted within generic constraints and subordinated to the imperatives of narrative trajectories. These images allow viewers to probe the changed (and ever-changing) terms of contemporary experience and to take sensual measure of the contradictions of supermodernity, be it in the existential spaces of the new bourgeoisie, the opaque workings and often-brutal consequences of global capitalism, or the dramatically transformed appearances of the buildings and streets that contemporary citizens of Europe inhabit. The dreamscapes explored here often turn out to be nightmarish topographies. Indeed, in the spectral images and dystopian prospects of this haunting cinema abides a reality that is doubly disturbing. These films show how *what is* is a function of *what was* as well as offering presentiments (or, on very rare occasion, a hope) of *what might be*. In this uncertain (and, for that reason, dynamic) mix of dread prospects and occasional (albeit subdued) glimmers of hope abides a unique realism whose equal measures of curiosity and critique alternate between the acerbic and the redemptive.

The legacy of the dffb: This impetus embraces the film academy's teachers as well as its students and their common culture of cinephilia (which included regular group screenings of a quite-eclectic variety of films and carries on, as noted, in the pages of *Revolver*). One can clearly see the impact of the "technological lyricism" (Christoph Hochhäusler's phrase) of films by Harun Farocki and Hartmut Bitomsky[9] (with whom Thomas Arslan, Angela Schanelec, and Christian Petzold studied) in the continuities between Bitomsky's *Der VW Komplex* (*The VW Complex*, 1990) and Petzold's *Wolfsburg* (2003) or, even more directly, in the direct impact of Farocki's *Nicht ohne Risiko* (*Nothing Ventured*, 2004) on Petzold's *Yella* (2007), endeavors that behold the eerie shapes of postindustrial modernity and the alienating aspects of commercial spaces.[10] Petzold readily acknowledges how he learned from Farocki the art of making images that dissect the uncanny workings of modern capitalism.

Another lesson that Petzold learned from Farocki has to do with the importance of body language. In German film, argues Petzold (and, in the process, he also brings to mind the insights of Michael Klier's astute critique of acting in the New German Cinema, *Gesten und Gesichter* (*Gestures and Faces*, 2002), there has always been too much "facial expression, eyebrow play, and theatrical language." Petzold elaborates about how while working on his final film at the dffb, *Pilotinnen* (*Pilots*, 1995), his mentor Farocki was making *Der Ausdruck der Hände* (*The Expression of Hands*, 1997). As a result, Petzold found himself very interested in the creative capacity of human hands, becoming sensitive to how much physicality is lost in most German films, where the dialogue and actor's visage dominate so strongly that they efface the rest of human body. German actors do not need to visit New York for lessons in method acting, Farocki quipped; rather, they should go to Switzerland and have their face muscles surgically severed.[11] Olaf Möller calls Farocki's films "Gespensterbilder," i.e., "images of things that are not visible and yet are nonetheless present," an appellation that also applies to Petzold's haunted cinema (especially his so-called Ghost Trilogy).[12] One might in fact say that the Berlin School as a whole does not put its faith in the self-evident immediacy of images,

FIGURE 16.3 Hands, maintains Harun Farocki, "often seem to reveal something that the face seeks to hide. . . Pathologists look closely at hands, not at faces, when they try to gauge the age of a person. The hands are not as capable of lying as the face; they present the truth in a more direct fashion" (*Der Ausdruck der Hände/The Expression of Hands*, 1997).

but rather it lets things become visible above all in the spaces between images; in that way, films take on shape and meaning in the process of being viewed.

V.

Subterranean currents in West German film culture of the eighties and early nineties: Within a subterranean history of German cinema abides a prehistory of the Berlin School, works that cling to reality, that eschew film conventions and the politics of identification, that explore reality's lesser-known quadrants, and that present characters whose lives are sketchy— or in the case of Alfred Behrens's *Berliner Stadtbahnbilder* (*Images from the Berlin S-Bahn*, 1982) and Michael Klier's *Der Riese* (*The Giant*, 1983), show us no characters at all—instead offering features that meander through streets and cities.

In the German prehistory of the Berlin School (which involves a much more elaborate chronicle and, for that reason, surely warrants more detailed study), one film is of particular significance. In a 2005 interview, Petzold described the lasting impression that *Der Riese* had made on him and his fellow dffb students. *Der Riese* consists of surveillance camera footage shot in various West German cities over the course of three years: streets, traffic intersections, airports, banks, department stores, villas, and doctors' offices. The images include ambient sound as well as the musical accompaniment of Aram Khachaturian, Sergei Rachmaninoff, and Richard Wagner. It is called *Der Riese*, elaborates Petzold, because the cameras "gaze at the world from on high and because the Giant is large and looks on people from above. At the same time the Giant is a little dumb."[13] These camera eyes are ubiquitous and unrelenting; they stare unceasingly and keep painstaking tabs on current events. And yet, for all their omnipresence, they are undiscerning and indiscriminant. Marked by "distance, abstraction, and a certain placid ambiguity,"[14] these mechanical recorders do not make choices or provide emphases; rather, while taking in everything, they sort out nothing. Klier discerns an uncanny dimension in the workings of the Giant's affectless eyes; surveillance images, he claims, "have the effect of documents about another planet, horrible scenes like those from a science fiction nightmare." At a certain juncture, the banality and ordinariness of these silent witnesses become fantastic, even "obscene in a way, because they attack people and rob them of their dignity."[15] For this reason, one might say that *Der Riese* shows cinema's potential endpoint. Indeed, one might call this composition about German urban centers a symphony of surveilled cities.

Despite the dystopic dimensions ascribed by Klier and Petzold to surveillance cameras, they do not remain only objects of critique and dystopia. Observation, which is an act of faith for the Berlin School, is an essential part of surveillance; according to Marta Gili, observation, like surveillance, involves "a certain detached alertness, the act of carefully watching, listening, and registering events and their context without intervening in them."[16] Throughout Berlin School features, surveillance functions as an undeniably suggestive point of reference. Repeatedly these films inscribe or mimic surveillance cameras and, in so doing, let the ambiguity and undecidabilty of surveillance serve a critical and constructive purpose, for instance in:

FIGURE 16.4 "Klier calls *Der Riese* 'einen Film.' I think that's a way of flagging the work's ambition—but successful as it is as cinema, it's also pure video, one of the very few examples which works equally well both as installation and as tape. Blandly and brilliantly totalitarian, it announces a routine fact of postmodern times, hailing "der video-camera über alles" (J. Hoberman).

- *Gespenster* (*Ghosts*, Christian Petzold, 2005): Surveillance footage documents two female shoplifters as they exit from W & M in the Potsdamer Platz arcades; a few minutes later, we hear how a troubled mother has repeatedly watched a surveillance video of a man abducting her daughter; this harrowing image will reappear as a mindscreen, an extension of the mourning mother's memory, a locus of traumatic loss in which the daughter is dragged offscreen and vanishes from sight.
- *Schläfer* (*Sleeper*, Benjamin Heisenberg, 2005): The film's opening shots have the feel and texture of surveillance camera footage; a discussion between two characters about observation is captured from a perspective that itself both resembles—and operates like—a surveillance camera.
- *Dreileben* (2011): The trilogy is in fact framed by surveillance camera images. *Eine Minute Dunkel* (*One Minute of Darkness*), Hochhäusler's

contribution and the film's final feature, refers to a missing slice of surveillance camera footage. And, to heighten the enigma and add a twist of irony, the film ends with a further moment of elision. We see a surveillance camera's record of a decidedly climactic moment, but the film freezes and, in a touch that consciously plays on the film's title, fades into darkness before we can ascertain what has actually happened.

Shorts and features made at the dffb figure in this prehistory as well, films like Christoph Willems's *Der Mann aus dem Osten* (*The Man from the East*, 1990), Wolfgang Schmidt's *Navy Cut* (1993), and especially Michael Freerix's *Chronik des Regens* (*Chronicle of Rain*, 1991), films from what Rainer Knepperges terms "the lost generation of the fin de siècle."[17] One cannot help but note the many ways in which particularly Freerix's feature anticipates the Berlin School. The film is shot in West Berlin just before the fall of 1989 and follows a slacker though the city as he savors his last day of *flânerie* and freedom before he starts a new job. A protracted opening sequence offers a long take of the protagonist in an apartment eating breakfast and then clearing away things and doing the dishes, utterly unburdened by any sense of urgency. The scene unfolds in full duration; during its course, we will hear a scream in the distance and watch the unharried hero walk to the window and ask for quiet before he, ever undeterred, resumes his kitchen chores. Clearly, the extended passage sets a tone and establishes a tempo; the scenario attends to all those everyday things that other films consider to be insignificant and, for that reason, spare us.

One might be tempted to compare *Chronicle of Rain* to Jim Jarmusch's classical exercise in hanging out and shirking responsibility, *Stranger Than Paradise* (1984), but that would be misleading. There is no pretense of coolness in Freerix's portrait about idlers and the old age of youth; the characters are decidedly unhip and the images have a markedly improvisatory, unadorned, and at times even unattractive quality. The editing is not always seamless; the image often jumps from one space or conversation to another without the customary continuities of scale or of temporal and spatial relations. Foregrounding the film's lacking points of orientation, Harun Farocki, in a cameo appearance, plays a distraught city stroller who asks the hapless protagonist for directions.

FIGURE 16.5 Making light of its own meandering trajectory, *Chronik des Regens* (*Chronicle of Rain*, 1991) features Harun Farocki in a cameo role as a distraught city stroller who asks the hapless protagonist (Mario Mentrup) for directions.

VI.

Especially after his breakthrough narrative feature, *Überall ist es besser wo wir nicht sind* (*The Grass Is Greener*, 1989), Klier often was grouped with well-regarded rising filmmakers, such as Jan Schütte (*Drachenfutter/Dragon Chow*, 1987) and Uwe Schrader (*Kanakerbraut/White Trash* [1984] and *Sierra Leone* [1987]), touted as a critical miniaturist, or positioned as an exponent of a so-called New German Realism. Despite occasional festival successes and critical laudations, the films of these and other directors from the late eighties and early nineties, which in conspicuous regards figure as precursors of the Berlin School, never registered as strongly as the products of the New German Cinema. No overarching oppositional mission arose with which one could associate the work of these filmmakers and grant them a common identity that might have afforded them stronger resonance and higher visibility. As a consequence, these productions became orphan films, marginalized and without a *Zusammenhang*,

forsaken and forgotten because they lacked a compelling sense of belonging to something larger.

For all the confusions and misapprehensions it has engendered, the term Berlin School has served quite effectively as a point of reference, a site of coherence, and (despite the many differences between the individual directors) a common cause, as well as a source of product recognition, an appellation that enables quite disparate films to accrue meaning within significant creative and constructive constellations. Indeed, so compelling is this paradigm that it also affords us the retrospective means to redeem otherwise-obscured sectors of German film history or what I have termed a subterranean history of German cinema.

FIGURE 17.1 Surveillance camera images give way to a moment of darkness, the function of a technical failure that leaves behind a mystery and catalyzes a quest (*Dreileben*, 2011). The :33 is one of many instances in the trilogy involving play with the number three.

THE SURVEILLANCE CAMERA'S QUARRY

I.

"The world changes," Ilya Ehrenburg once remarked, "when you stare straight at it."[1] And so it follows that when a surveillance camera fixes on its quarry, it transforms what it sees. In Christoph Hochhäusler's *Eine Minute Dunkel* (*One Minute of Darkness*, 2011), such a camera breaks down while a murder is in progress and the resulting technical glitch produces a moment of darkness. The film chronicles the quest to understand what has happened during the blackout—quite literally to fill in the blank.[2]

The nearly four-and-a-half hours of *Dreileben* (2011) are in fact framed by surveillance cameras. The title of Hochhäusler's contribution, which is the trilogy's final feature, refers to a missing slice of surveillance footage in a film that demonstrates how a camera's stare at the world does not ensure that one sees (much less apprehends or understands) reality. *One Minute of Darkness* resolves the enigma of the missing shot only to conclude with a further moment of darkness. In the film's last seconds, we glimpse a surveillance camera's record of a decidedly climactic moment, but the image freezes and, in a formal gesture that ironically reiterates the film's title, fades into black before we can confirm that what looks to be another act of violence, indeed another murder, actually has transpired. Here again, left with a void, we must fill in the blank. And we are left to our own means for the film is now over.

The following considers the crucial function of inscribed surveillance cameras in Hochhäusler's film as well as their framing role in the *Dreileben* project as a whole. Along the way, I want to make some more general observations about the use and meaning of surveillance footage within the endeavors of the so-called Berlin School.

II.

Let me begin with what might seem to be a straightforward question: Is *Dreileben* one film or three? Put differently, how might one best characterize the relation between the trilogy's separate contributions? Are they complements or counterparts, variations on a theme or distinct exercises? Is this an ensemble, or are the different pieces at odds or perhaps even in competition with each other? This seemingly straightforward question is not so simple after all, and, for that reason, I will return to it. But let me say a few initial words about the pertinence of threesomes for the architecture of *Dreileben*.

The three films by three directors were made possible through a cooperation of three television stations: BR, WDR, and ARD. Part one shows us a romance; part two an investigation; and part three a manhunt. Or, in Christiane Peitz's summary assessment, Christian Petzold's contribution "situates the action and charges it with tension," Dominik Graf's segment "condenses it to a social study of a small town," while Hochhäusler's conclusion "moves into the brushwood of the past."[3] Each film privileges a circumscribed perspective (a young hospital attendant, a police psychologist from out of town, and a man on the run and the ailing police chief who is hot on his trail). A foreigner plays a central role in each segment, and each of them has missing parents. In all three films, a repressed element surfaces, and it does so with a vengeance, particularly in the final segment. Each contribution, furthermore, foregrounds a threesome and accentuates the role of triangulated desire. Oh, and yes, the name of the Chief Physician at the clinic is Dreier.

What, we might ask, links this trilogy to noteworthy recent ensemble films? Its structure is in fact quite similar to that of *The Red Riding Trilogy* (2009), three freestanding but nonetheless interlinked films by

different directors about acts of violence. One also thinks of Lucas Belvaux's *La Trilogie* (*The Trilogy*, 2002), three films that replay situations from discrete perspectives and employ distinct genre formats while maintaining a uniform visual style. And, of course, there is no getting around a mention of Krzysztof Kieslowski's *Trois Couleurs* (*Three Colors*, 1993–1994) or his *Dekalog* (*Decalogue*, 1989–1990). Likewise, the blend of hospital and forest quickly brings to mind David Lynch's multipart *Twin Peaks* (1990–1991) as well as Lars von Trier's *Riget* (*The Kingdom*, 1994).

III.

One Minute of Darkness opens with images of velocity, shots from vehicles onto passing landscapes that appear in a blur. We travel so rapidly that we cannot focus our gaze and, for that reason, we enter a terrain with little orientation and on uncertain footing. This foray into the woods of Thuringia could not be more at odds with the compensatory itinerary heralded in a recent study commissioned by the Bundesministerium für Bildung und Forschung: "Many people go to the woods in search of some breathing space. They feel free in the forest and gain the impression that their senses, which atrophy in their everyday lives, are reactivated there."[4] The sylvan space becomes, in this official understanding, a respite from the everyday, indeed "the negation of modern society."[5] The forest, Wilhelm Heinrich Riehl wrote in 1884, "allows us *Culturmenschen* to enjoy the dream of a personal freedom untouched by police surveillance. Yes, even the most settled being can run, jump, and climb there according to one's heart's desires."[6]

In Hochhäusler's forest one finds neither escape nor recreation; it appears as an *unheimliche Heimat,* a site of witch hunts from the Middle Ages to the Cold War, a surreal province of *Stimmung* that evokes oneiric images of medieval King Barbarossa's slumber and Richard Wagner's *Rheingold*. *One Minute of Darkness* figures within a larger German return to the forest, something marked by the recent exhibit at the Deutsches Historisches Museum in Berlin, "Die Deutschen und ihr Wald," as well as by many recent films from the Federal Republic of Germany that not only inscribe a forest setting but also dynamically retreat to the woods, such as

FIGURE 17.2 The Thuringian Forest, a haunted space that appears in *Dreileben* (and particularly in *Eine Minute Dunkel/One Minute of Darkness*) as an *unheimliche Heimat.*

Ulrich Köhler's *Montag kommen die Fenster* (*Windows on Monday*, 2006), Hans Weingartner's *Die Summe meiner einzelnen Teile* (*Hut in the Woods*, 2011), Hans-Christian Schmid's *Was bleibt* (*Home for the Weekend*, 2012), Tim Fehlbaum's *Hell* (2011), Julian Pölsler's *Die Wand* (*The Wall*, 2012), Sebastian Fritzsch's *Endzeit* (*End of Time*, 2013), or the final sequence of Benjamin Heisenberg's *Der Räuber* (*The Robber*, 2010). Hochhäusler transforms the Thuringian Woods and the small town it surrounds into the scene of multiple crimes. His film probes a site of historical memory, traversing dangerous ground where strange things exist and bad things happen.[7]

Hochhäusler's feature dwells on the irrational far more strongly than those of his two colleagues; in his contribution, the homeland assumes a much more harrowing and threatening aspect. The man on the run, Molesch, is by turns whimsical and afflicted, exposed to the elements, haunted by inner demons, and hounded by armed police troops and barking German shepherds. Reinhold Vorschneider's camera captures odd critters and bizarre encounters; the close up of swarming ants, for instance, recalls the subterranean monstrosities from the opening sequence of David Lynch's *Blue Velvet* (1985). As you watch the film, observes Nino

Klinger, one thinks of Terrence Malick's *Badlands* (1973) or Charles Laughton's *The Night of the Hunter* (1955).[8] The film's episodes, in Leo Goldsmith's appraisal, "weave back and forth between observational character study, surreal schizoid fever-dream, and straight-up whodunit."[9] *One Minute of Darkness* is a pursuit narrative featuring an escaped man, a policeman's investigation, and the spectacle of a logistic enterprise.

IV.

Thus far, I have sketched the architecture of *Dreileben* and said some preliminary words about Hochhäusler's negotiation of space. I want to return now to my key concern, namely the inscription of the surveillance camera as a frame for the trilogy and its crucial functions, both for Hochhäusler's film and within the entire undertaking.

The opening moments of Petzold's contribution, *Etwas Besseres als den Tod* (*Beats Being Dead*) shows the medical assistant Johannes sitting in front of surveillance camera images. Four views of a hospital appear on his

FIGURE 17.3 The initial surveillance images of *Etwas Besseres als den Tod* (*Beats Being Dead*) anticipate the challenge posed by *Dreileben* as a whole: How are we to put together what seem to be isolated images recorded by an inert camera and make sense of what they show us?

computer screen and, at first, seem to provide quite disparate prospects. Within a few minutes, however, we begin to make sense of what initially seem to be the random and unrelated perspectives of the four cameras. Empty and isolated frames (of a car waiting, of people who will be leaving, of tickets, and of an evening's engagement) become mapped and narratively bound; this happens because we, as viewers, put the pieces together. This initial exercise anticipates the challenge posed by the film as a whole to make sense of its puzzle—and puzzling construction.

Surveillance cameras record without intention or design; they are in this way directionless. Their random archive acquires use value as one tries to transcribe what has been captured into meaning, i.e., to transform it into audiovisual evidence. Conceptual artists often have employed surveillance cameras precisely because of their placidity, lack of affect, and ambiguity. These images do not speak until people speak for them, putting them together and discerning what they might mean.

Michael Klier's *Der Riese* (*The Giant*, 1983), a compilation of surveillance camera footage captured in various German big cities, had a seminal impact on Petzold and his fellow filmmakers-to-be at the dffb. Employing a strategy of patience rather than sensationalism, Klier apprehended moments in which the everyday assumes a fantastic and horrific aspect. Early prenarrative cinema, in quite striking ways, also employed the camera as a recording device, as an agent of surveillance, which documented quotidian occurrences in real time: trains arriving at stations, workers leaving a factory, babies eating their breakfast, or the leaves of trees swaying in the breeze.

V.

Beats Being Dead will return at several junctures to Johannes's monitor and its four surveillance camera images. In his last look at his computer screen, the hospital attendant will fix on the top right view as he tries to locate his Bosnian lover Ana, a chambermaid in a local hotel. He has just been interrupted by Dreier, who is overjoyed to tell his young charge (and prospective son-in-law) that Johannes is free to move to Berlin with his daughter Sarah, both sealing Johannes's social

status as well as his professional future as a doctor. An inspection of the screen, as Johannes searches for Ana, shows us an empty surveillance image, which momentarily, but significantly, marks a salubrious turn of events for him: things, after all, would be much easier if Ana, a repeated source of distraction and interruption, were out of the picture. One might even ascribe the prospect to a social climber's wishful thinking.

Hochhäusler's film features an investigator's quest to solve the mystery of the missing surveillance footage. We watch the policeman Kreil study the footage in question on a television monitor; it bears the date July 14, 2005, along with precise time codes. We alternate between views of all four cameras and more circumscribed takes of single images. As the inscribed time code registers 18:22:24, we see Molesch on the bottom right near the shed, which we know is the site of a young woman's murder. Molesch walks toward it. There is no human presence in the other three images. At 18:22:32, the image on the bottom right starts to blur and goes white before fading into darkness. The time code says 18:22:33. (The three has been doubled in another instance of the numerical play that abounds in *Dreileben*.) The camera lingers for several seconds on this moment of darkness. On the monitor—and, most conspicuously, over the empty frame—we can make out Kreil's reflection. The policeman will ponder the image, indeed he will stare at it, and his intense regard will change how he (and ultimately *we*) see things. Kreil considers additional evidence and reconsiders the working (and decidedly faulty) conclusion of previous investigators; his act of analysis, a function of empathy coupled with additional research and closer analysis, yields a different conclusion. Molesch, it turns out, is not the murderer; the police have been chasing the wrong man.

But no sooner has Kreil solved the puzzle than the film, in an act of reversal, introduces another instance of visual shutdown, which, once again, leaves us in the dark. The falsely accused Molesch, now distraught and unraveled, is seen in the early morning counting women who are walking down the street. One, two, three . . . seven is Ana, and that is the fatal number. Clutching a large kitchen knife, Molesch sets out after her. We suddenly (and surprisingly) cut to a surveillance camera view of her without any indication of who, if anyone, might be

watching it. We return to a normal shot, a close-up of Molesch seen from behind with Ana indistinctly present in the deeper background as he tracks her; we cut in to his hand and his very big knife. Then the image returns to the surveillance footage (but only one screen of four is in view). Ana runs, Molesch pursues her; it is a long shot and unreels in slow motion until Ana exits offscreen left. She reenters the frame and runs up the stairs; a very minimal ambient music is audible. She stops and turns around to pick up her purse. We cut to another view of her running up the hill, purse in hand; it is still surveillance footage. She leaves the shot. Molesch enters the frame on the right—and is altogether chilling. We cut to what will be the final shot: it is dated September 14, 2010, the time code says 07:44:26. Molesch approaches Ana, who faces him and moves backward; he raises his arm to stab her, at which moment the image goes black. A second minute of darkness. And then the closing credits.

Much could be said about this final tableau. At the very least, it demonstrates how Molesch's haunted past and submerged trauma, a function of a troubled childhood very much inflected by the German Democratic

FIGURE 17.4 Molesch (Stefan Kurt) bludgeons Ana (Luna Mijovic); the brutal act of violence is the product of a troubled past and a childhood trauma very much inflected by the fraught history of the GDR (*Beats Being Dead*).

Republic's difficult history, literally erupts in a murderous act of violence, which constitutes an overdetermined return of the repressed. But the scene, in fact, is also a reprise; we recall it from the end of Petzold's *Beats Being Dead!* There, in a sequence straight out of a slasher movie accompanied by music redolent of Bernard Herrmann, we saw Molesch approach Ana with murderous intent and heard Ana scream before the film cut to Johannes, who had been sleeping in a car driven by Sarah, his fiancée, en route to Berlin. We cannot help but wonder whether Johannes has been dreaming all of this, all the more because he awakes with a start, as if Ana's cry had roused him. He changes seats with Sarah; while he drives down a country road, we hear a reprise of Julie London's "Cry Me a River," the song that he had so painstakingly and movingly translated for Ana earlier in the film. Johannes slows down. "I am happy," says Sarah. The car goes even slower; Sarah looks over as it comes to a halt. "Johannes?" she exclaims as the haunting tune continues. Sarah gets out of the car, we see an open door, hear once again the call "Johannes?" as the music plays on, and the image goes dark before the credits, a moment of darkness that, seen retrospectively, anticipates the title of Hochhäusler's feature as well as the trilogy's ending. Positioned as the film's final cue, the scene of Ana's murder becomes legible as an act of wish fulfillment; the slaughter allows her double exclusion, as a foreigner and an interloper, and it also ensures that nothing stands in the way of the ascent of a would-be member of the new German bourgeoisie. The scene's stunning reprise in the trilogy's final moments as surveillance footage marks it as a memory from a larger archive of repressed experience that constitutes (and haunts) the film as a whole.

The quarry created by surveillance apparatus needs to be processed if it is to gain meaning, which is what critical viewers of *Dreileben* produce as they sift through the trilogy as a whole, reviewing this profusion of sights and sounds, sorting it out and transforming it into audiovisual evidence. To rescan surveillance footage, the viewer must proceed like a detective, like Kreil in *A Minute of Darkness*, for only the reconstructive mind can assemble the discrete pieces and determine what they actually show—and, quite crucially, what they do not. In that regard the surveillance camera, which constitutes a radical cinema of attractions, provides the raw material for *Denkbilder*, i.e., thought-images that result from the

transformation of seemingly random signifiers into markers of time and signs with significance. Such thought-images are very much the point in the Berlin School's endeavor to make films that reveal the blind spots and rough edges of contemporary German reality. Hochhäusler's film becomes a reflection on the relation between the directness of the surveillance camera and the impact of editing, and on the strange things that can happen when cameras stare at things and people try to put images together.

VI.

One of the key points of discussion in the e-mail correspondence between Petzold, Graf, and Hochhäusler that gave rise to *Dreileben* was the great regret that most German films remain isolated and freestanding, existing only for themselves and not in relation to other films or contexts, in that way not figuring in a constellation or within a *Zusammenhang*. This concern leads me back to my initial question about whether *Dreileben* is one film or three films. My answer would be, and, there is no great surprise here, that it is both. As a trilogy, the project surely attests to the diversity and richness of postmillennial German cinema. Moreover, the film's multiple and multiplied narratives and perspectives give rise to what Leo Goldsmith has termed a "strange dialectical calculus."[10] A trio of filmmakers, three quite different sensibilities, managed to commingle and constellate their complex designs. In this way, single films, made with modest means on tight schedules with varying emphases, came together and were raised to a higher and evocative power as an ensemble. *Dreileben*, as Dennis Lim puts it, "conjures not just three lives but worlds of possibility."[11] This multiple-voiced film might be understood as a manifesto for a German film of the future, one that at once accentuates and yet strengthens the distinctiveness of its participants, one that blends theoretical reflection and practical execution, and one that provides an awareness of international film history and a concern about the state of contemporary German cinema. "In a way," remarked Hochhäusler in an interview, "the auteur film is the inability to do anything other than your own thing. And yet after the film is over you recognize that your own

thing has larger collective dimensions than you might have thought."[12] Out of strong variances of opinion and fundamental disagreements arose a production that at once retains conspicuous marks of differing approaches and nevertheless gives voice to German filmmakers who remain able to say *I* in the context of a *we*, a we that became a three and yielded the remarkable film that is *Dreileben*.

FIGURE 18.1 The book, confirms the former Stasi agent in the concluding scene of *Das Leben der Anderen* (*The Lives of Others*, 2006), "is for me."

HERITAGES AND HISTORIES

I.

The Lives of Others. Imagine that you were hearing this title for the first time and that you knew nothing about Florian Henckel von Donnersmarck or his Oscar-winning film of 2006, *Das Leben der Anderen.* You might well think that the phrase referred to an ethnographic inquiry, an account of a foreign culture, in keeping with film titles like *In the Land of the Headhunters/In the Land of the War Canoes* (Edward S. Curtis, 1914), *Trance and Dance in Bali* (Gregory Bateson and Margaret Mead, 1952), or *The Last of the Cuiva* (Brian Moser, 1987). The ethnographer, we read in a classical textbook about the composition of field notes, "writes down in regular, systematic ways what she observes and learns while participating in the daily rounds of the lives of others."[1]

Of course, if one has seen the film, such an association will seem far less compelling. But even if that is the case, the four words have a suggestive richness. As in the title of Wolfgang Staudte's exemplary Deutsche Film-Aktiengesellschaft (DEFA) feature of 1946, *Die Mörder sind unter uns* (*The Murderers Are Among Us*), the phrase intimates a tension, an implied difference between a "we" and a "they." Staudte's title, however, for all its vividness, is far less ambiguous in its marked, even Manicheistic, antinomy between others in our midst who are unlike us, perpetrators who

must be identified and taken to task for their war crimes. The others of von Donnersmarck's film, one surmises, might be the objects of Stasi violence; they also might refer to an even larger body of others, namely a Communist state and its culture of surveillance, East German society at large, and a defunct republic overcome by history. "The film is called *The Lives of Others*," said Joachim Gauck, founder of the New Forum and the first Federal Commissioner for the Stasi Archives. "For me it could just as easily be called *The Other Life*, the one that we left behind us after we finally got rid of the GDR (German Democratic Republic)."[2]

In one regard, then, the initial association might not be altogether off the mark given the title's reference to otherness, be it the lives of others or what Gauck calls the other life. Indeed, this film manifests two essential attributes of many so-called ethnographic narratives. It represents a foreign culture through the prism of a more dominant one and articulates that foreign culture's history from a position of power that claims for itself semantic sovereignty. James Clifford's essay "On Ethnographic Allegory" in fact proves quite helpful in comprehending the perspectival alignment of *The Lives of Others*. Ethnography, argues Clifford, often posits its object as something that is disappearing; what is perceived to be a culture's insufficient discursive capacity and its potential dissolution supply a rhetorical justification for a representational practice that he terms "salvage" ethnography. The other will disintegrate and be lost for all time unless it is saved (i.e., salvaged) in the form of an ethnographic record. The recorder is an interpreter as well as a "custodian of an essence, [an] unimpeachable witness to an authenticity."[3] *The Lives of Others* is a salvage text that enacts a redemptive Western allegory, a tale of consensus for a unified Germany.

II.

The Lives of Others is certainly one of the most visible and successful European features of the new millennium. Let us briefly ponder its postwall place. Contemporary German cinema, speaking broadly and quite schematically, is internationally visible today in two configurations: (1) in a profusion of popular "retro films" that have become increasingly plentiful since the late nineties, and (2) in the work of the Berlin School, which

has recently gained notoriety among festival audiences and cineastes and now enjoys the status of a German new wave. And between these two possibilities there exists a dynamic and dialectical relationship. The first transforms the key German traumas of the twentieth century into the equivalent of historical theme parks; the latter is a cinema of space and place that seeks, with phenomenological insistence, to remap Germany within the new European order. One revisits the past, the other reflects on and reconnoiters the topographies of the present. The conciliatory scenarios of so-called New German historical films, of which *The Lives of Others* is without question the most significant example, have boomed dramatically over the last decade. These narratives spirit us back to Hitler's evil empire and the horrors of the Holocaust, and, more recently, to the Stasi state of fear and loathing. From *Aimée & Jaguar* (Max Färberböck, 1999), *Rosenstraße* (Margarethe von Trotta, 2003), *Der Untergang* (*Downfall*, Oliver Hirschbiegel, 2004), *Napola—Elite für den Führer* (*Before the Fall*, Dennis Gansel, 2004), *Der neunte Tag* (*The Ninth Day*, Volker Schlöndorff, 2004), and *Sophie Scholl—Die letzten Tage* (*Sophie Scholl*, Marc Rothemund, 2005) to *Das Drama von Dresden* (*The Drama of Dresden*, Sebastian Dehnhardt, 2005), *Der letzte Zug* (*The Last Train*, Joseph Vilsmaier/Dana Vávrová, 2006), *Anonyma—Eine Frau in Berlin* (*A Woman in Berlin*, Max Färberböck, 2008), *Nordwand* (*North Face*, Philipp Stölzl, 2008), *John Rabe* (Florian Gallenberger, 2009), *Habermann* (Juraj Herz, 2010), and *Unter Bauern* (*Saviors in the Night*, Ludi Boeken, 2009), recent German films have channeled the nation's historical reservoir and created a tsunami of retrospective readings (of which there have been repeated surges since 1945), an updated variation on an impetus that Anton Kaes once described as "the return of history as film."[4]

For New German Cinema of the seventies and early eighties, as is well known, that return came in the form of looks backward, looks that were both analytical and critical. Current retro films, in contrast, provide conciliatory narratives that seem chiefly driven by a desire to heal the wounds of the past and thereby seal them and to transform bad history into agreeable fantasies that allow for a sense of closure. "Celluloid memory," in the words of Lutz Koepnick, "reawakens the dead and redeems historical injustice from today's standpoint." In this way, this new series of German retro films "present historical epochs from the perspective of

post-memory."[5] These celluloid memories, many of them driven by great ambitions and sustained by substantial budgets, consciously appeal to mass audiences and seek to create communities of consensus. Particularly when they are successful, these popular narratives assume political proportions.

Elsewhere I have sketched the impact of the genre cinema that followed the overdetermined demise of New German Cinema in the mid-eighties. I used the phrase "New German Cinema of Consensus" and this notion has fostered far more discussion than I might have imagined a dozen years ago when I wrote what I thought would be an uncontroversial contribution to a collection entitled *Cinema and Nation*.[6] The appellation, I took care in saying, *did not* apply to all of the films made in Germany since the death of Fassbinder and the onset of a government-endorsed witch hunt on critical filmmakers, which was accompanied by radical changes in film subsidy policies, a fierce backlash against the *Autorenkino*, and the advent of a new cinematic populism. Not for an instant did I forget other forces at work in this nation's film culture, indeed offbeat voices and unreconciled visions, films with a historical ground, a postnational sensibility, a multicultural awareness, and a topical impetus, whose recalcitrant, if underacknowledged, presence I emphasized in the essay's closing passage. The problem is that these edgy films were at the time hard to see, cast to the margins or all but invisible, and for these reasons, they remain to this day largely forgotten. The phrase "Cinema of Consensus" referred to a gathering of films and filmmakers that had dominated media accounts and industry campaigns meant to bolster the film industry's public profile in Germany and abroad during the Kohl era, which is to say the cinema that had been most popular and therefore most conspicuous and, in that way, most symptomatic of a dominant discourse that presumed to speak as a we when it in fact mirrored only the film industry's powers that be.

Likewise, I was not assailing genre cinema in general nor was I insinuating, as if I were the spawn of Max Horkheimer and Theodor W. Adorno, that films seeking to be popular only can be seen as affirmative and regressive. (After all, we no longer live in the seventies and have ceased to worship at the altar of Screen Studies and venerate apparatus theory's deterministic orthodoxies as if they were unquestionable articles of faith.) I surely was not claiming that New German filmmakers, even if many of

them sought to foster an alternative culture and create an oppositional
public sphere, were altogether unsmitten by and unbeholden to genre. As
a film historian who at least tries to get things right, how could I? Think
of the significance of melodrama for Rainer Werner Fassbinder, Wer-
ner Schroeter, Christian Rischert, Robert Van Ackeren, Margarethe von
Trotta, and Helma Sanders-Brahms; of road movies for Wim Wenders,
Adolf Winkelmann, and Hans Noever; of film noir for Rudolf Thome,
Roland Klick, and Klaus Lemke; of the street film for Uwe Brandner,
the crime film for Hans W. Geißendörfer, and the *polit-thriller* for Volker
Schlöndorff; of antihomeland films like *Jagdszenen aus Niederbayern*
(*Hunting Scenes from Bavaria*, Peter Fleischmann, 1969), *Jaid—der ein-
same Jäger* (*Jaid—the Lonely Hunter*, Volker Vogeler, 1971), and *Mathias
Kneißl* (Reinhard Hauff, 1971); of the signature retro films from *Die BRD-
Trilogie* (*The BRD Trilogy*, Rainer Werner Fassbinder, 1979–1982) to
Heimat (Edgar Reitz, 1984); of the innumerable literature adaptations,
from *Nicht versöhnt* (*Not Reconciled*, Jean-Marie Straub and Danièle Huil-
let, 1965) and *Der junge Törleß* (*Young Törless*, Volker Schlöndorff, 1966)
to the abundance of adaptations during the mid-seventies; and, yes, let us
not forget the movement's many comedies, from Young German Film's
Kuckucksjahre (*The Cuckoo Years*, George Moorse, 1967), *Wilder Reiter
GmbH* (*Wild Rider Ltd*, Franz-Josef Spieker, 1967), *Quartett im Bett*
(*Quartet in Bed*, Ulrich Schamoni, 1968), *Engelchen* (*Angel Baby*, Marran
Gosov, 1968), and *Zur Sache Schätzchen* (*Go for It, Baby*, May Spils, 1968)
to New German Cinema's *Die Reise nach Wien* (*The Journey to Vienna*,
Edgar Reitz, 1973), *Lina Braake* (Bernhard Sinkel, 1975), and *Der starke
Ferdinand* (*Strongman Ferdinand*, Alexander Kluge, 1976), much less
the zany misadventures of Rosa von Praunheim's and Lothar Lambert's
wacky personages or the desperate screwball antics of Herbert Achtern-
busch's errant husbands.

What the Cinema of Consensus above all lacked were critical voices
and incisive visions, especially in the relationship comedies (*Beziehungs-
kisten*) from Doris Dörrie's *Männer* (*Men*, 1985) to Sönke Wortmann's
Der bewegte Mann (*Maybe . . . Maybe Not*, 1994), as well as in the crude
and lewd proletarian farces (*Prollkomödien*) like *Ballermann 6* (Gernot
Roll and Tom Gerhardt, 1997), *Werner—Das muß kesseln!!!* (*Werner—
Eat My Dust!!!*, Udo Beissel and Michael Schaack, 1996) or *Kleines*

Arschloch (*The Little Bastard*, Michael Schaack and Veit Vollmer, 1997). In the appraisal of Georg Seeßlen, we find on the one hand "lust, love, and social climbing somehow brought into balance, the residue of bohemian indulgences comically overcome, a retreat into the private sphere, liberality confirmed beyond a doubt by the presence of token homosexuals; on the other hand, we find the image of a proletarian body that refuses to grow up, for which the world consists only of eating, drinking, and tele-tubbery."[7] What especially dismayed me about the Cinema of Consensus, and its unremarkable portraits of yuppies and slobs, was the way in which this cycle of comic populism functioned in a more general turn against personal and critical filmmaking and within the wider framework of a political regime wrestling, as never before and not very well (especially after the opening of the wall), with questions of diversity and difference. During the Kohl era, there was a provincialization of German film culture as a whole; in the years 1985–1995 German cinema all but disappeared from the programs of major festivals and the catalogues of foreign film distributors.

III.

Since my thoughts on the New German Cinema of Consensus appeared in 2000, certain structures and constellations have become more apparent; it is now much easier to discern a larger picture; to recognize contours, counterpoints, and fault lines; and to see how the Cinema of Consensus continues and indeed has found its most prominent extension in the new profusion of retrofilms, which commonly is spoken of as German heritage cinema. We do not have to labor unduly to make that connection; filmmakers like Joseph Vilsmaier and Florian Henckel von Donnersmarck as well as producers like Bernd Eichinger and Günter Rohrbach have repeatedly invoked and defended the consensus paradigm. They certainly know what they are doing when they appropriate the past and seek to transform it into a lucrative commodity. We should be mindful, as Randall Halle's recent book helps us to be, of the international marketing of historical films, a crucial pursuit within the German film industry's concerted efforts to optimize the exchange value of national properties

as transnational commodities.[8] Buena Vista, for instance, is essential in our understanding of the success of von Donnersmarck's film as is the calculated implementation of tie-ins and extensions in Eichinger's historical features. There is something strategic (perhaps even mercenary) about the commercial exploitation of German wartime suffering and postwar victimization in a plethora of films made during the past decade for German television. And it has become a truism that only German films about Nazis (and now members of the Stasi) ever get nominated for Academy Awards.

Rohrbach's essay "Das Schmollen der Autisten" ("The Pouting of Autists") provided a trenchant apologia for a Cinema of Consensus; one might go so far as to call it a programmatic intervention. Let us recall the setting: Several weeks before the 2007 Berlin Film Festival, Rohrbach, the well-known producer and President of the German Film Academy, published a polemic in *Der Spiegel*. In it, he lashed out at Germany's movie critics, who have, he charged, little regard or respect for most filmmakers and the film-going public. Instead, they champion an esoteric art cinema that appeals to their precious cinephilic sensibilities.[9] For this reason, Rohrbach, employing a medical disorder as an epithet and an insult, called these commentators autistic and went on to chide them for their hostile relation to the German film industry and their inattentiveness to the responses of their readers. Vain and self-serving, these pundits are ever ready to attack productions that harbor great ambitions and seek to please large audiences—in short, would-be consensus films. Why, wondered Rohrbach, was a film like Tom Tykwer's *Das Parfüm* (*Perfume: The Story of a Murderer*, 2006) that attracted millions of viewers panned with such malice and harshness? What, other than poor judgment and bad will, stood behind the fierce backlash against *The Lives of Others*, a box-office success blithely castigated in the press as a "cinema of consensus"? The film's technical competence and deference to cinematic convention, after all, are hardly marks of formal incapacity and surely not just signs of commercial opportunism. Works that connect with a large and diverse spectatorship are anything but easy to make; indeed, fumed the furious producer, consensus films are daunting undertakings and do not deserve to be treated with automatic scorn and kneejerk dismissiveness.[10]

Shortly after Rohrbach's invective, von Donnersmarck weighed in. Speaking in a *Spiegel* article published on February 12, he regretted that *The Lives of Others* had not found as strong a resonance as he had hoped for or envisioned. His film, he insisted, "doesn't have enough of a consensus yet! The consensus I strive for is a film that everyone likes, one no one can criticize."[11] Months before he had assailed critics who had faulted the film precisely because it harbored such ambitions. How can one attack a film, he raged, that

> appeals to almost everyone, and thus to very different people!... Those who repeat this verdict presumably want Germany to be lumbered with the kind of mediocrity that has induced so many "consensus people," from William Weiller [*sic*] to Wolfgang Petersen, to flee the country! If "consensus film" is supposed to mean the same as "trivial" or even "bad film," then I want to make a lot more bad and trivial films in my career.

"I wish," he concluded, "that *The Lives of Others* was much more of a consensus film."[12]

It is striking how in the director's account "almost everyone" and "very different people" come together while watching his film in an act of affective *Gleichschaltung*, a mighty moment of sublation in which diversity succumbs to the higher power of consensus. And it is striking as well how he equates the quite different destinies of William Wyler, a Jewish emigrant (born in Alsace and educated in France) who came to the United States in the twenties and established himself as a filmmaker, becoming in effect an exile only after the rise of Hitler, and Wolfgang Petersen, a successful young director who happily moved to Hollywood in 1987 (and, contrary to von Donnersmarck's insinuation, did not leave West Germany because the New German Cinema refused to have him). Both individuals, insists von Donnersmarck, had "to flee the country" because Germany was dangerous ground for popular filmmakers; his claim, in each instance, suggests that he is not unduly burdened by a knowledge of film history.

In accordance with the director's designs, *The Lives of Others* functioned as a vehicle of consensus on various levels. Emulating the successful patterns of reception from Steven Spielberg's *Schindler's List*

(1993), von Donnersmarck's historical film became a privileged object of public education and national identity formation; the wider regard that came with this exposure served as an effective means of generating political spin. Culture Minister Bernd Neumann arranged an exclusive showing for the German Bundestag prior to the film's official premiere. Legitimating its value as a historical memory, he urged that it be screened in German schools. A substantial study guide produced by the Bundeszentrale für politische Bildung (Federal Bureau for Political Education) ensured that the film would serve as a seminal text in future study of the GDR and the Stasi. Prominent former dissidents such as Wolf Biermann likewise, despite some misgivings, attested to the film's veracity and granted their seal of approval, claiming "The political sound is authentic."[13] After the film won an array of Bavarian film prizes early in 2007, a public podium discussion with von Donnersmarck was scheduled. The director asked that the positively disposed critic Rainer Gansera be present, but not Claus Loeser, who had panned the film. The filmmaker's participation, it became clear, had as a condition the elimination of any contrary voices. Public discourse about the film, in this way, became inextricably bound to its advertising value, which is a larger problem for film critics who wish to remain independent and indeed critical.[14]

IV.

Von Donnersmarck's production provides a paradigmatic example of what scholars describe as a distinct genre, the German heritage film. "A genre's history," Steve Neale reminds us, "is as much the history of the term as it is of the films to which the term has been applied; it is as much a history of the consequently shifting boundaries of a corpus of texts as it is of the texts themselves. The institutionalization of any generic term is a key aspect of [its] social existence."[15] If we are to continue to employ the term in the context of German cinema, we would do well to give its conceptual and historical implications some further and more careful thought. Four critical concerns come to mind about this often-used concept's pertinence within an understanding of postmillennial German film

culture and suggest some ways in which we might refine our use of the term in this specific national setting.

1. *The question of appropriation, which is also one of translation.* How well does the notion of heritage cinema translate, which is to ask, how well does it apply in the German context? One recalls that the notion is taken from discussions initiated by British film scholars about features made in the United Kingdom and, later, France (e.g., Andrew Higson, Richard Dyer, and Ginette Vincendeau).[16] The question is one of naming, i.e., of formulating a term that accurately accounts for the distinctive qualities of recent German historical features. The appeal to heritage cinema has quite often (but not always) deployed national history positively, recalling the former glory of the British Empire and putting treasured traces of the imperial past on display and employing them as cultural capital. The term "German heritage cinema," if we follow recent scholarly exchanges (e.g., the influential contributions of Lutz Koepnick), almost without exception refers to historical films that look back at "bad" history, especially the Nazi epoch. This heritage, as the history of Academy Awards granted to postwar German films confirms, seems to be what travels best and has the greatest allure for foreign audiences. To be sure, the so-called Stasi era has come to gain equal power as a sign of a bad German past that can be transformed into successful movies. In the words of Timothy Garton Ash, "Nazi, Stasi: Germany's festering half rhyme."[17]

It is instructive to consider other possible appellations. In 2003, Katja Nicodemus likened the attractions of recent history films to exhibits in a nostalgia shop (*Nostalgiebude*):

German cinema has become a site of yearning and memory in which we search for lost times and lost paradises, in which we hallow childhood dreams and conciliatory fantasies. . . . As it fetishizes signs of the past, this new German haven of curios provides something for everyone, from tales of Nazi-era resistance [*Rosenstraße*] to the Spree forest pickle dreams of the ever-present GDR [*Good Bye, Lenin!*, Wolfgang Becker, 2003] from the soccer myths of postwar Germans

[*Das Wunder von Bern/The Miracle of Bern*, Sönke Wortmann, 2003]
to the hedonistic grand refusals of the 1980s [*Herr Lehmann*, Leander
Haußmann, 2003].[18]

Cristina Nord, writing in 2008, speaks of a "new German naiveté." History
films like *The Lives of Others*, she argues, make a great to-do about their
authenticity, without for a second acknowledging that their putative
authenticity is in fact a construction and, as such, an illusion. Would-be
postideological films produced by Bernd Eichinger and Günter Rohrbach
spare the viewer reflective distance in the name of a seductive and spuri-
ous reproduction of the way things were.[19]

2. *The limited range of reference.* Nicodemus's comments about a new
cinema of nostalgia make another problem strikingly transparent. To
this date, with a few notable exceptions, Anglo-American discussions
of heritage cinema fixate narrowly on films that deal with a small sector
of the German past and diminish the larger and more diverse German
sense of history (*Geschichtsgefühl*) that has surfaced in the nation's fantasy
production since the mid-nineties.[20] Looking at the striking recurrence
of titles and directors in recent scholarly discussions, one might very well
believe that the Nazi-Stasi eras are the sole domains of contemporary
German filmic retrospection. Postmillennial German cinema, in fact,
has probed a decidedly wide range of pastness and recognized the
contemporary resonance of a number of different heritages, for instance
in the following:

- Biopics from a variety of epochs, including *Der Einstein des Sex* (*The
 Einstein of Sex: Life and Work of Dr. M. Hirschfeld*, Rosa von Praunheim,
 1999), *Klemperer—Ein Leben in Deutschland* (*Klemperer—A Life in
 Germany*, Kai Wessel and Andreas Kleinert, 1999), *Marlene* (Joseph
 Vilsmaier, 2000), *Abschied—Brechts letzter Sommer* (*The Farewell*, Jan
 Schütte, 2000), *Der Verleger* (on Axel Springer, *The Publisher*, Bernd
 Böhlich, 2001), *Schiller* (*The Young Schiller*, Martin Weinhart, 2005),
 Mein Leben—Marcel Reich-Ranicki (*My Life*, Dror Zahavi, 2009), *Romy*
 (Torsten C. Fischer, 2009), and *Goethe!* (*Young Goethe in Love*, Philipp
 Stölzl, 2010);

- The postwar years and the Adenauer era, especially *Das Wunder von Bern* but also *Marmor, Stein & Eisen* (*Marble, Stone and Iron*, Hansjörg Thurn, 2000), *Solino* (Fatih Akin, 2002), and *Die Entdeckung der Currywurst* (*The Invention of the Curried Sausage*, Ulla Wagner, 2008), as well as a plethora of recent television movies about the destinies of German refugees after World War II and the ARD miniseries *Unsere fünfziger Jahre* (*Our 1950s*, Thomas Kufus, 2005);
- 1968 and its afterlife in the guise of the Red Army Faction, including *Die 68er Story* (*The Story of the 68ers*, Wolfgang Ettlich, 1999), *Die innere Sicherheit* (*The State I Am In*, Christian Petzold, 2000), *Die Stille nach dem Schuß* (*The Legend of Rita*, Volker Schlöndorff, 2000), *Das Phantom* (*The Phantom*, Dennis Gansel, 2000), *Was tun wenn's brennt?* (*What To Do in Case of Fire*, Gregor Schnitzler, 2001), *Black Box BRD* (*Black Box Germany*, Andres Veiel, 2001), *Baader* (Christopher Roth, 2002), *Starbuck Holger Meins* (Gerd Conradt, 2002), *The Raspberry Reich* (Bruce LaBruce, 2004), *Das wilde Leben* (*Eight Miles High*, Achim Bornhak, 2007), *Der Baader Meinhof Komplex* (*The Baader Meinhof Complex*, Uli Edel, 2008), *Dutschke* (Stefan Krohmer, 2009), *Die Anwälte* (*The Lawyers—A German Story*, Birgit Schulz, 2009), *Wer wenn nicht wir?* (*If Not Us, Who?*, Andres Veiel, 2011);
- The eighties and the Kohl era, including *23* (Hans-Christian Schmid, 1998), *England!* (Achim von Borries, 2000), *Happiness Is a Warm Gun* (Thomas Imbach, 2001), *Das Jahr der ersten Küsse* (*The Year of the First Kiss*, Kai Wessel, 2002), *Liegen lernen* (*Learning to Lie*, Hendrik Handloegten, 2003), *Die Ritterinnen* (*Gallant Girls*, Barbara Teufel, 2003), *Herr Lehmann*, and *Am Tag als Bobby Ewing starb* (*On the Day Bobby Ewing Died*, Lars Jessen, 2005); and
- Films about the GDR, before and after unification, Rip Van Winkle narratives with characters who sleep through history such as *Good Bye, Lenin!* and *Berlin Is in Germany* (Hannes Stöhr, 2001), along with the Brussig adaptations *Sonnenallee* (*Sun Alley*, Leander Haußmann, 1999), *Helden wie wir* (*Heroes Like Us*, Sebastian Peterson, 1999), and *NVA* (Leander Haußmann, 2005), but also *Bis zum Horizont und weiter* (*To the Horizon and Beyond*, Peter Kahane, 1999), *Wege in die Nacht* (*Paths in the Night*, Andreas Kleinert, 1999), *Deutschlandspiel* (*The Germany Game*, Hans-Christoph Blumenberg, 2000), *Die Unberührbare* (*No*

Place to Go, Oskar Roehler, 2000), *Wie Feuer und Flamme* (*Never Mind the Wall*, Connie Walther, 2001), *Der Tunnel* (*The Tunnel*, Roland Suso Richter, 2001), *Führer Ex* (Winfried Bonengel, 2002), *Der Aufstand* (*The Uprising*, Hans-Christoph Blumenberg, 2003), *Kleinruppin Forever* (Carsten Fiebeler, 2004), *Der rote Kakadu* (*The Red Cockatoo*, Dominik Graf, 2006), and, of course, *The Lives of Others*.[21]

3. *The term heritage's rich (and, in current discussions among film scholars, vastly unprobed) connotations for students of German culture.* The history of this idea in the twentieth century readily lends itself to alternative ways in which one might employ the term heritage, particularly if we take into account the *Erbschaft* (heritage) debates that reach back to Georg Lukács's reflections on an appropriate and progressive classical-realist canon to exchanges in the history of the GDR regarding which elements in the bourgeois heritage might be salvageable for a socialist society. "Every nation throughout the stormy path of its history," notes Anna Seghers, "drags along with it, from generation to generation, what we call its heritage. Hungry for freedom it appropriates from its cultural past whatever is needed to sustain us."[22] Particularly illuminating is Ernst Bloch's *Erbschaft dieser Zeit* (*Heritage of Our Times*, 1935) and his concept of nonsimultaneity, with its sensitivity for thoughts out of season.[23] Bloch demonstrates how nonsynchronous elements (which the Nazis appropriated and successfully exploited) represented legitimate desires and might in fact have proved useful in the creation of an anticapitalist heritage. In short, he talks about how one might salvage things that conventional wisdom consider to be illegitimate properties and make them viable and workable. In Anson Rabinbach's assessment, Bloch makes us mindful of "treasures discovered in the rubble—the lost heritage of the time."[24]

4. *The legacy of German film history as a heritage in its own right.* Within the circumscribed focus of current German heritage cinema discussion, crucial heritages, the bearers of significant experience and the objects of considerable public interest, have become obscured and overlooked—take, for instance, the legacy of the GDR (especially its history as represented in its film history) as well as the continuing appeal and, for many commentators, the problematic heritage of Ufa, whose

codes and conventions and whose notion of the well-made film, for example, von Donnersmarck to a large degree relies on and replicates. *The Lives of Others* is, quite literally, a heritage film: It inscribes heritage in its narrative and, as a cultural artifact, enacts the construction of a humanistic heritage. In so doing, it puts on display the illusory quality of such a construction; its popular reception also attests to the seductive power of such illusions.

<div align="center">V.</div>

In the course of time, *The Lives of Others* has, as the film's international success confirms, become for memories of the GDR what *Schindler's List* now represents for recollections of the Holocaust: a master text. Both films offer rescue narratives in which an insider (a Nazi party member, a Stasi surveillance officer) goes native and becomes a guardian angel; each depicts the transformation of a calculating collaborator into a *guter Mensch* (good person) capable of empathy. *The Lives of Others* does not want to engender discomfort nor to generate controversy. It wants to please, and, as its director repeatedly has attested, it wants to please everyone. Von Donnersmarck celebrates an art that both defies and overcomes politics and in that way harmonizes.[25] His parable fosters a heritage of the good man in which Beethoven's music can be imagined to possess anti-Communist potential: If Lenin had listened to the Appassionata, it is suggested, there would have been no revolution and, by implication, no GDR and no Stasi and no divided Germany. In the curriculum of words and music that constitutes the Stasi operative Wiesler's re-education, Brecht is de-Ossified; the Socialist activist figures solely as a lyrical poet, not a Communist or the proponent of a critical theater. The many references to *der gute Mensch* conspicuously recall Brecht's *Der gute Mensch von Sezuan* (*The Good Person of Szechwan*, 1943), all the better, it would seem, to disavow this dialectical play about the necessity of tactical behavior for the sake of material survival. *The Lives of Others* is in fact just the opposite of Brecht's critical parable, which leaves its audience disappointed and consternated; as the curtain closes, all questions remain open.

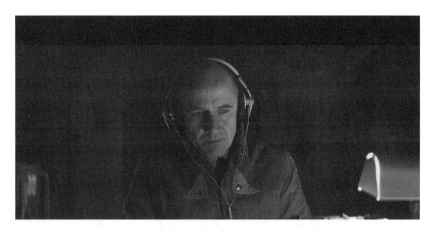

FIGURE 18.2 Wiesler (Ulrich Mühe), the surveillance expert, whose privileged modality is aural. The postwall spectator is empowered by the film, enabled also to see what the agent can only hear (*The Lives of Others*).

A distinct structure of retrospection, claims Clifford, governs many ethnographic portraits; they search for fundamentally desirable human traits. In this endeavor, as stated, the recorder and interpreter of fragile custom serves as a custodian of an essence.[26] In von Donnersmarck's postwall allegory, the state servant comes to identify with a dissident; the spectator in turn comes to identify with the renegade agent as he turns against bad politics.[27] The narrative portrays an aesthetic education that reforms a Stasi agent and creates a larger community in which perpetrators and victims come together and, to quote Schiller's "An die Freude" ("Ode to Joy"), "alle Menschen werden Brüder" ("All men become brothers"). This community is sanctified by a book whose catalyst is the oppositional director Lerska and whose patron saint is the Stasi operative; it seals the male bond that is made possible by Christa Maria's act of sacrifice (*Opfergang*), a suicide that serves as a self-punishment for the actress's collaborationist activities. The book replicates, indeed essentializes, the impetus of the film as a vehicle of redemption; it celebrates a triumph of good will in dark times and circulates in a reunited Germany. Wiesler says the book is "für mich." As a stand-in for the film as a whole, it also is for us.

This salvage narrative allows us access to the presence of pastness. The camera grants the viewer an augmented perspective in the same way that

the film as a whole offers a sense that what we are seeing is authentic. In that regard, the spectator becomes a fellow surveiller who enjoys a more exclusive entry to the film world's sights and sounds; we see the lives of the others from a position that is far more omniscient than that of the low-tech Stasi. Minister Hempf's claim that observers like he and Grubitz, a high-ranking Stasi officer, "see more" is of course cynical but also doubly ironic. He utters these words while, unbeknownst to this Socialist Unity Party of Germany (SED) official (who himself will become an object of surveillance), he is the object of Wiesler's gaze. And, to be sure, during the operation, the Stasi's key tool will be hidden microphones, not cameras. As Wiesler listens to the others, his sonic perspective also becomes visible, which means that the viewer can see what the eavesdropper cannot. The implied audience's perspective exceeds that of the unsophisticated East German security apparatus; the contemporary spectator enjoys a privileged relation to the spectacle, a perceptual and technological sovereignty granted by the filmmaker.[28] The film is "for us," the empowered denizens of a contemporary post–Cold War world.

In this would-be ethnographic enterprise, von Donnersmarck views himself, as statements made in innumerable interviews confirm, as an agent of authenticity and of historical memory.[29] He shot on original locations, employed contemporary phonographs and typewriters, period furniture, decor, music, and color.[30] He aimed to capture "the inner truth of the GDR" and spare German viewers "yet another folkloristic orgy with historical costumes." As this last quote makes clear, von Donnersmarck explicitly sought to distance his film from the *Ostalgie* wave and did so by billing his feature as the more accurate and serious portrayal of life in the GDR.[31]

Many film critics praised the film for this very reason. Paul Cantor, apparently not at all modest in his reliance on the movie's press kit, argues that until *The Lives of Others*, we had only upbeat exercises in *Ostalgie*: "No German film had attempted to portray the brutal nature of the communist regime in East Germany." It is as if Sibylle Schönemann's *Verriegelte Zeit* (*Locked-up Time* 1990), Roland Gräf"s *Der Tangospieler* (*The Tango Player*, 1991), and Thomas Heise's chilling *Barluschke—Psychogramm eines Spions* (*Barluschke—Portrait of a Spy*, 1997) had never been made—much less Alexander Zahn's low-budget production from 1992, *Die Wahrheit über die Stasi* (*The Truth about the Stasi*). The film, Cantor continues, justifiably was

hailed "for its willingness to confront what many Germans seemed content to let slip down the memory hole of history." The feature "seems destined to stand with *1984* as one of the most chilling evocations of the nightmare of twentieth-century totalitarianism."[32] Cantor's rhetoric emphatically recapitulates and reaffirms the director's resolve: For von Donnersmarck made a film about the GDR as if it were, as far as cinema goes, *terra incognita*, as if DEFA had (almost) never existed, as if he and his production were the privileged and primary bringers of this culture into expression, and as if no one before him had really tried, much less succeeded, in such a historical reckoning. In this way, he overlooks or marginalizes previous endeavors, all the better to erase and supersede them.[33]

Von Donnersmarck's film and the Schlöndorff-DEFA controversy of 2008 are of a piece, insofar as they both, in one case directly, in the other indirectly, respond to the heritage of the GDR and the legacy of DEFA. "I got rid of the name DEFA," boasted Schlöndorff, the former Babelsberg studio head in an interview with the regional newspaper *MAZ*. "DEFA films were just terrible. They were shown in Paris, where I studied, but only in the cinema run by the Communist party."[34] The off-the-cuff (and off-the-wall) remark caused widespread anger and chagrin. An open letter signed by one hundred and twenty prominent German directors and actors was published a few days later; the statement provided an inventory of DEFA's venerable legacy: ten thousand films in various genres, ten features that are considered by specialists to be among the one hundred most important German films of all times, not to forget the significant body of children's films as well as DEFA's continuing resonance, including, for example, the 2005 Museum of Modern Art retrospective of twenty-one features. Schlöndorf's rant was all the more curious given that nothing specific had occasioned it.

When one contemplates the history of DEFA, many heritages come to mind. These heritages are, in this context, pertinent and worthy of more careful consideration and, to use Bloch's term, significant in their nonsynchronicity:

- The legacy of antifascist cinema, films that provide lessons in how one might conceptualize an antifascist aesthetic.
- The *Kaninchenfilme* (Rabbit Films) of 1965/1966, ten productions, noteworthy signs of new critical and artistic life, banned by the Eleventh

Plenum of the SED Central Committee, which were rediscovered and screened after unification.

- The *Wendeflicks*, features and documentaries made in the GDR between 1988 and 1994, the last films from East Germany with their vivid, ironic, and poignant portraits of the disintegration of a nation and the recasting of a populace.
- The essential heritage of documentarism, for example, Thomas Plenert's patiently attentive camera, Helke Misselwitz's portrait of GDR women (*Winter, adé* [*After Winter Comes Spring*, 1988]), Jürgen Böttcher's train-yard images (*Rangierer* [*Shunters*, 1984]) and postwall vistas (*Die Mauer* [*The Wall*, 1991]), and Winfried and Barbara Junge's epic *Lebensläufe* (*Résumés*, 1981) along with Volker Koepp's poignant portraits of working-class destinies in Wittstock. In addition to the plethora of politically correct (*linientreu*) productions, DEFA also sustained a venerable legacy of critical realism.

VI.

This discussion began with an invocation of a film title's ethnographic connotations and went on to consider von Donnersmarck's signature feature as a self-conscious consensus production that, in the name of authenticity and verisimilitude, displays tableaus from the GDR as a heritage for our times. To create consensus, it crafts comforting and conciliatory images from out of time, postideological prospects that in fact reintroduce well-known Cold War panoramas that claim to be the way things were, scenes from an imagined past marked by an emotional suasion that eschews reflective distance. This is but one way of looking at the lives of others and only one sort of heritage cinema. Let us in closing consider other perspectives to be found in a different kind of heritage cinema.

Jürgen Böttcher's *Jahrgang 45* (*Born in '45*) was banned in 1965 before its completion and did not come into full view until 1990. About an hour into the film, we see West German visitors from a tour bus

gawking at young East Berliners who sun themselves on the steps of the French Cathedral on the Gendarmenmarkt; the tourists stare with a lurid intensity as if the strange beings before them, actors in a film about East Germany who are portraying citizens of the GDR, were creatures in a zoo or the denizens of an exotic village. But Böttcher's idlers are not just the objects of the gaze; they also return it—as does the film as a whole. Böttcher's feature both records importunate Western cameras and demonstrates that the others on view have lives that transcend intrusive and patronizing perspectives that would cast them in the role of abject others.

Born in '45, like the *Kaninchenfilme* as a corpus, brought to the screen nonsynchronous energies, an everyday East German reality at odds with and at times even divorced from the SED's party priorities. The film patiently measures the living spaces of Prenzlauer Berg and the conditions of existence for young people who reside in a state of dismay, uneasiness, and anticipation. It is a portrait of dreamers and, as a film, both an exploration of a grand refusal to live according to official expectations as well an expression of alternative perspectives and hopes for a different experience. Enacting Bloch's notion of redemption, Böttcher offers a transcendence that is freed from the constraints of otherworldliness. "We need not be afraid," argues Bloch, "of taking note and of distinguishing the hunger for happiness and freedom, the images of freedom for human beings deprived of their rights, images which are contained in these dreams."[35] Böttcher's film is extraordinary in the way it restores the essential meaning of utopia as an immanent force and provides a waking dream of the possible.

This example supplies a necessary counterpoint to von Donnersmarck's film and represents a different cinema with a quite divergent approach to the lives of others. *Born in '45* abides today as a remnant from a cinema that might have been, insisting, with keen and unflinching nonsynchronicity, on an unpopular and untimely view of a society. Böttcher's chronicle of young rebels attests to an unreconciled and unconsensual heritage within a much larger and, in so many regards, still-uncharted subterranean history of German cinema. As a film from the past, it enacts aspirations that had a real existence as visions of possibility

FIGURES 18.3 - 18.6 West German tourists look at East German youth sunning themselves on the Gendarmenmarkt; it is as if the visitors were beholding creatures in a zoo. The three young men, however, refuse to let themselves be reduced to mere objects and gaze back with scorn and defiance (*Jahrgang 45/Born in '45*).

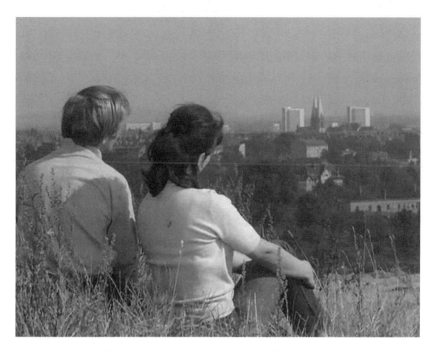

FIGURE 18.7 Al (Rolf Römer) and Li (Monika Hildebrand) peer into the distance and contemplate inhabiting a place one might truly call home: a hopeful vision of a better world from the lives of others (*Born in '45*).

despite the formidable powers and challenges that militated against their existence. As a heritage film, *Born in '45* offers a concrete historical record that commingles critique with hopefulness and affords us an altogether different ethnography, a decidedly different manner in which we might envision the lives of others in the GDR and other lives that might have and could have been.

FIGURE 19.1 Veit Harlan's eyes avert the camera and make the viewer ponder what was on his mind. This enigmatic shot provides the opening take for *Harlan: Im Schatten von Jud Süß* (*Harlan: In the Shadow of Jew Süss*, 2008).

LIFE IN THE SHADOWS

Felix Moeller's gripping new documentary opens onto a photograph of Veit Harlan. Nazi Germany's most venerated director gazes upward, his regard slightly eluding the eye of the camera so that one wonders where he was looking and what he was thinking. The question of his allegiance and his motivation, and the consequences of both, will occupy the viewer for the next ninety-seven minutes. This formidable auteur, for all his stylistic distinctiveness, primarily would become remembered for one film. "After World War II," says the voice-over narrator as the camera moves in for a tighter view, "he was tried twice for crimes against humanity because of his anti-Semitic film, *Jud Süß*." The title, *Harlan—Im Schatten von Jud Süß* (*Harlan—In the Shadow of Jew Süss*, 2008), consciously evokes the filmmaker's memoirs of 1964, *Im Schatten meiner Filme* (*In the Shadow of My Films*).[1] No question, Harlan's infamous feature of 1940, along with Fritz Hippler's *Der Ewige Jude* (*The Eternal Jew*, 1940), abides as the most nefarious hate film produced in Nazi Germany; as such, it has cast long and lasting shadows. Moeller's documentary probes the history of this film and the course of a career as well as the enduring effect they have had on the people closest to the filmmaker. As an attempt to work through a difficult past, by turns disturbing and edifying, Moeller's chronicle provides a reception history in the form of a family drama with an international cast and a multigenerational scope.

An accomplished film historian, Moeller is the author of *Der Filmminister* (1998), an authoritative study about Joseph Goebbels's management of the German film industry during the Nazi era.[2] Drawing on the administrator's voluminous diaries and archival sources, the book offers an intriguing account of the propaganda minister's preferences and policies as well as his day-to-day activities and his irritations, concerns, and interventions. Among Moeller's previous films is a portrait of the young Hildegard Knef, *Knef—Die frühen Jahre* (*Knef—The Early Years*, 2005), which chronicles the star's rise to prominence and makes no bones about her unabashed acts of opportunism and accommodation. And he directed *Die Verhoevens* (2003), another history of a family, an upbeat and affectionate tale of three generations of filmmakers, the patriarch Paul Verhoeven, his son Michael (director of *Das schreckliche Mädchen/The Nasty Girl*, 1989), and his grandson Simon, also a director, as well as the actress Senta Berger. To be sure, Moeller has an interesting family history of his own; he is the son of Margarethe von Trotta in whose films he has appeared and for whom he has functioned as a historical consultant.

Early on, Moeller also served as a researcher for Ray Müller's *Die Macht der Bilder* (*The Wonderful Horrible Life of Leni Riefenstahl*, 1993), a portrait of Nazi cinema's other most prominent personality, Leni Riefenstahl. Without question, Riefenstahl and Harlan have much in common. Artists in whose work politics and aesthetics commingled, they stand out as the most celebrated and highly decorated filmmakers of the Third Reich. Riefenstahl's *Triumph des Willens* (*Triumph of the Will*, 1935) sold Hitler to the German people; *Olympia* (1938) sold Nazi Germany to the world. Harlan's *Jew Süss* provided a plebiscite for the Holocaust; *Kolberg* (1945) furthered a last-ditch attempt to win a lost war by cinematic means. Subsequently, the two figures would become the most visible and volatile remnants of Nazi cinema, objects of press polemics, hate campaigns, and legal proceedings. Harlan, as Moeller's film attests, would find his way back into production with greater ease than his female colleague. He would, in fact, complete ten features in the fifties, melodramas like *Hanna Amon* (1950) and *Ich werde Dich auf Händen tragen* (*I'll Carry You on My Hands*, 1958), the spy movie *Verrat an Deutschland* (*Germany Betrayed*, 1955), and the antihomosexual feature, *Anders als Du und Ich* (*Bewildered Youth*, 1957). The directors left behind self-serving memoirs that present them

as the victims of malevolent forces; in both narratives, Minister Goebbels assumes a key role as a demonic figure (Harlan repeatedly describes him as the devil incarnate) that pressured them to work against their will and, in so doing, compromised and ruined them for all time. To the end of their lives, both artists would remain ever defensive and stubbornly unrepentant, insistent that they were innocent of the charges leveled against them for their Nazi-era endeavors, mournful in their belief that they had suffered—and, long after the demise of Hitler, continued to face—grave injustice. "I sustained hours and months of torment under Goebbels," writes Harlan in the final passage of his memoirs, "and afterwards, in a variety of ways, throughout the postwar era."[3]

How does Moeller's directorial essay compare with Müller's? What is most compelling about the latter's biography is his keen focus on how Riefenstahl wishes to be seen, how he scrutinizes, with painstaking intensity, the idealized self-image of a passionate and naive artist who is interested only in her work and oblivious to the world around her. "We're in the presence of a legend with many faces," announce the film's first spoken words. Müller's camera surveys a tabletop covered with stills of the dancer, actress, director, and photographer and watches Riefenstahl sort through them. Who is the real person behind all the pictures and stories?, we ask ourselves, much as we puzzle over the different Charles Foster Kanes on view in Orson Welles's classic feature of 1941. The scene shows us an auteur handling images of herself and makes it clear that she is a consummate editor, someone whose life story has undergone constant revision for decades, a celebrity who was a legend in her own time as well as a legend in her own mind—and someone who insists that this legend be of her own making, a triumph of *her* will. Müller shows Riefenstahl for what she thinks she is and in the process draws attention to the contrived quality of this self-portrait. The German title of the film, *Die Macht der Bilder*, foregrounds the battle over the power to make sense of a filmmaker's audiovisual legacy and the history to which it belongs, as well as the power of the images Riefenstahl made and the desire to retain that power long after the relations of power have changed. In this showdown meant to determine who is to control what we see, Müller seeks to recast Riefenstahl's images and the stories that attend them, to reposition them in other contexts and grant them different meanings beyond her preferred scenarios.

In its emphasis on Harlan's extended family, Moeller's approach is surely more dialogical.[4] Is it, however, less dialectical and, as such, less compelling? Although he often is audible as he asks questions, Moeller, unlike Müller, never comes into view. Commentators in fact have criticized his understated presence, claiming that the film is evenhanded to a fault and, as such, without a clear perspective. But is this really the case? As one might expect of an accomplished film historian, Moeller most certainly has done his homework. He benefits substantially from an exhibition devoted to Harlan's *Jew Süss*, which took place in the Stuttgart Haus der Geschichte and served as a key location for Moeller's documentary. (An extensive catalogue accompanied the event.)[5] He marshals a plethora of evidence, period paraphernalia (including a pass granting Harlan privileged access to the rear entrance of the Ministry of Propaganda), private correspondence, stills, two-sheets, press reviews, newspaper clippings, home movies, television documentaries, Nazi newsreels, and, above all, clips from Harlan's films, which, aside from *Jew Süss* and *Kolberg*, have remained virtually unseen outside of Germany. These materials present a public record; they also provide points of reference that illustrate, nuance, and on occasion complicate the candid interviews with thirteen subjects, members of Harlan's extended family, his children, nephew, stepdaughter, and grandchildren, along with the film archivist Stefan Drößler, who offers incisive analysis about the shape, appeal, and meaning of Harlan's cinema.

The generous use of clips from *Jew Süss* deserves comment. To this day the film is held under lock and key in Germany; it can be shown only under special circumstances in which an approved specialist provides a critical introduction and leads a discussion after the screening. Nonetheless, it is commercially available as a DVD in the United States and accessible on the Internet. The very fact that contemporary German audiences cannot view the film in the cinema or on television suggests that their government still considers it to be a civic danger and the populace to be politically immature. So the clips from the original, at least for a German viewership, possess the status of sights and sounds unfit for public consumption. Oskar Roehler's recent biopic about the star of Harlan's feature, Ferdinand Marian, *Jew Süß—Film ohne Gewissen* (*Jew Süss: Rise and Fall*, 2010), studiously (and, at times, with a lurid tastelessness) simulates

scenes from the movie, consciously trading on the intense curiosity that attends the long-denied wish to partake of this forbidden fruit.

What motivated Harlan, whose first wife was Jewish and who prided himself on his philo-Semitism, to make *Jew Süss* and cast his third spouse, Kristina Söderbaum, in a leading role? How did his children, as members of a family and public citizens, respond to the knowledge that their father was charged with crimes against humanity? How do his grandchildren cope with the shame still attached to the family name? Rather than pursuing a fixed line of argument, Moeller offers a variety of perspectives, approaches, and tones without aligning the film with any single participant. It is a chorus with much dissonance and counterpoint. At times variances of opinion among family members assume melodramatic contours. Kristian Harlan cannot understand why his brother Thomas has attacked his father in public so fiercely and even dared to profit from such activities. Nor can their stepsister, Maria Körber, who wonders why Thomas is so implacably bitter. And we see how Thomas's Oedipal rage about the misdeeds of his father has shaped his identity and catalyzed his political engagement as a filmmaker, writer, and public intellectual; how his passionate activism, with its unrelenting desire to undo his elder's sins, has made for the undoing of the son who, his health precarious, resides in a Alpine sanatorium. Another son, Caspar, militates against nuclear reactors in an attempt to join the resistance against future "crimes against humanity."

No German film has so stunningly dramatized the rigors, complications, and aporias of what Theodor W. Adorno spoke of in a famous radio address of 1959 as "working through the past."[6] The Nazi experience with its legacy of destruction, violence, and murder, Adorno claimed, remained unprocessed by a West German populace eager to move forward and disinclined to look back. Instead of an active confrontation with the psychic and affective energies that people had invested in Hitler and his regime, the citizens of a new republic under Allied occupation shunned public enlightenment and maintained a defensive posture of resolute disavowal and willful forgetting. Precisely because of his vehement resistance, Harlan became one of the most polarizing figures of the fifties, someone whose response mirrored, indeed acted out, collective dispositions that most Germans were loath to acknowledge in their own persons. For that reason, one could all the more revile the filmmaker's repeated claims that

FIGURE 19.2 (*top*) Nele Harlan, granddaughter of Veit Harlan (*Harlan: In the Shadow of Jew Süss*). "Especially interesting to me was what kind of impression the third generation had of their grandfather. If there would be no interest left for this period where the immediate family was concerned, how could one expect any interest from the younger population in general?" (Felix Moeller).

FIGURE 19.3 Alice Harlan, daughter of Thomas Harlan, confronts an infamous film and its memories of violence: "For years in history class at school here in France, I suffered terribly from a vague sense of shame. It's only now that I can talk about it more openly" (*Harlan: In the Shadow of Jew Süss*).

because he had worked under duress, he bore no personal responsibility. Unlike the patriarch, none of Harlan's offspring claims to be a victim or indulges in self-pity; each of them, to varying degrees, feels an undeniable sense of concern and responsibility. In depicting different ways of dealing with shame and guilt, the film itself enacts the impetus that Adorno called for: a "coming to terms with the past in the sense of aiming for enlightenment," which, the philosopher submits, entails a "turn toward the subject," i.e., an awareness of one's own place and role in history.[7]

The memory of Veit Harlan's guilt abides and the family is obliged to live with it. "It's almost something positive," one of his granddaughters says in closing, "like a reminder to bear all this in mind." Working through the past, Moeller suggests, is an ongoing process that knows no closure. In the film's final minutes, we return to the Stuttgart exhibit and watch Harlan's progeny as they view the feature and mull over what it means both to and for them. The strength of Moeller's film lies in its attempt to fathom the shadows of a past that refuse to fade away. If we witness images from *Jew Süss*, Moeller insists that we do so through a perspective that is both historical and embodied, with the awareness of its infamous reputation and through the eyes of family members who, like it or not, must forever live with this film and deal with the legacy of shame and the large burden that go with it.

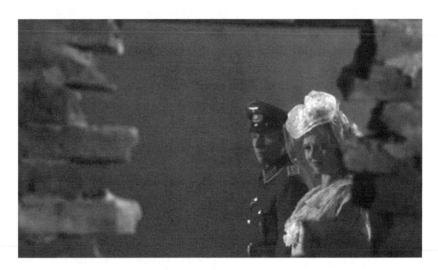

FIGURE 20.1 The unforgettable opening tableau from Rainer Werner Fassbinder's *Die Ehe der Maria Braun* (*The Marriage of Maria Braun*, 1979; Klaus Löwitsch and Hanna Schygulla): An image of Hitler vanishes after an explosion; through the resultant hole in the wall we glimpse a "Blitzehe," a whirlwind wartime wedding.

TWO TRIPS TO THE BERLINALE

1998: No More Explosions

I.

How well I remember the sights and sounds of my first Berlin Film festival. It's three in the afternoon on February 20, 1979, at the opening press screening in a jam-packed Zoo-Palast. I'm sitting in one of the front rows. The lights go down, the curtain opens, the Berlinale brass fanfare resounds. And the festive setting suddenly yields to a much less stable site of aperture and eruption. Before me is an image of Hitler and then a loud explosion. Within seconds, and with the most minimal of means, a single shot creates a tableau with an expressive shape and an epic scope. The shattered public icon and political image frame a private drama, literally circumscribing and determining the marriage of Hermann and Maria Braun, a union consummated almost a decade later by another explosion, a disaster accompanied by a procession of negative snapshots of other chancellors, West Germany's postwar leaders. The initial scene from *Die Ehe der Maria Braun* (*The Marriage of Maria Braun*, 1979), one could not help but notice, is attended by the conspicuous crying of an unseen infant. This is, if anything, an expressive marker, the cameo presence of the director who was born in 1945, an intimation that the story of his parents'

generation and the puberty of the republic also coincides with his own coming into the world.

It was the heyday of New German Cinema and these were mind-boggling times and galvanizing films. "The Germans," announced an article in *Time*, "are now producing the most original films outside America."[1] (For many of us at the time, these films were the most original and provocative ones being produced anywhere.) American friends, like myself, of what we came to speak of as the NGC clamored for the scintillating productions of these angry young men and women. On the next morning, I had my first live encounter with the enfant terrible Fassbinder. He appeared at the press center wearing his well-known black leather jacket, a grey Homburg, and an unbuttoned shirt, unkempt and disheveled, speaking in tones that alternated between buoyant, ironic, and caustic. Shouldn't there have been a happy end?, someone asked him. But the film has a very happy end, Fassbinder replied with a smirk, it couldn't be happier.

Among the more than forty German films I saw during the festival's twelve days, I also recall Hellmuth Costard's *Der kleine Godard an das Kuratorium junger deutscher Film* (*The Little Godard to the Curatorium Young German Film*, 1978), which I viewed in the Forum, a film in which Jean-Luc Godard asks, "Is it possible to make films in Germany today? Are Germans capable of producing viable images?" So many films provided positive responses to this question, interventions inflected by a sense of negativity, works that commented on and enacted the vicissitudes of fantasy production and at the same time demonstrated the uncompromised volition of a self-consciously minor (and proud of it) cinema. In the same year, filmmakers would update the Oberhausen Manifesto in a declaration signed in Hamburg, complaining about the radical decline of short, experimental, and documentary filmmaking in West Germany.[2] "The strength of German film," claim the signatories, "is its variety." This national cinema was interesting for me because it was so vulnerable and yet so scrappy, precarious and nonetheless outlandish, uncompromisingly insistent that films did not always have to be popular or pleasing to gain an audience's attention.

My first visit to the Berlinale provided a close-up view of a cinema that refused to let the past rest and to allow people in the present to proceed

with business as usual. Everywhere I looked I saw a concern with repressed experience and the power of unmastered feelings. During those days, I vividly remember an outing to the Akademie der Künste; it was high noon on Friday, February 23. In the offing was a showdown with the American television series, *Holocaust* (Marvin J. Chomsky, 1978), which had just aired on German third channels and was the talk of the nation. Hans Jürgen Syberberg stood before a packed auditorium and asked people to forget everything they knew about German history, to divest themselves of all expectations and prejudices. *Hitler—ein Film aus Deutschland* (*Our Hitler*, 1977), he announced, requires a spectator with an open mind. The introduction did not go over well. Nor did the four parts of his seven-hour work of mourning. The postscreening discussion was heated and unfriendly, all the more since Syberberg seemed to relish politically incorrect locutions: "One simply and honestly has to work through all the possible associations of the phrase 'Hitler in Germany.' It's a terrible truth, but if we don't do this, we're lying to ourselves." The director found few supporters and seemed quite happy that this was the case; indeed, his downright aggressive responses to detractors and assailants suggested that he took great pleasure in being disliked.

Here, in any event, were narratives and film essays that revisited German history and in the process consciously endeavored to renew German film history. What intrigued me was the rich diversity of this national cinema, whose identity was grounded in difference and variety, whose foremost impetus was taking exception to the rule and, in the spirit of Walter Benjamin,[3] recognizing the dire state of emergency in which one lives and pulling the emergency brake in the speeding express train of time: so many attempts to eschew the tried-and-true and to challenge the status quo, to confront the shape of the present, and to remap the homeland; so much sympathy for outsiders, for alternative perspectives, and for marginalized destinies.

II.

The Berlinale would come to occupy a central place in my annual calendar, remaining to this day essential for my own emotional and intellectual ecology. New German films in the meanwhile have ceased

to play so prominent a role in my yearly visits to this event. In the competition program, it often has become the site of debacles, so-called *Schlachtfeste*. (I particularly remember the press's brutal ravaging of Jeanine Meerapfel's *The Lovers* [*Die Verliebten*] in 1987.) Each year, I try to figure out the optimal balance between inclination and duty, to negotiate between the cineaste's yearnings and the specialist's obligations. In initial encounters, curiosity and anticipation drew me to the Minilux and later to the Filmbühne am Steinplatz for the Neue Deutsche Reihe. Now I am less eager to scurry from Wittenbergplatz to the Urania, to climb the stairs and enter the sterile extension school screening room where recent German productions unreel. One thing has not changed, however. The ever-affable and upbeat Heinz Badewitz is still there, introducing filmmakers, establishing contacts, doing his best to maintain a supportive environment.

Two decades since my first Berlinale, I attend the event with decidedly different expectations. New German film, as ever, alternates between fulsome self-confidence and somber stock-taking. But no longer do its representatives eschew the popular or avoid the mainstream. On the contrary: At no price do directors want to come off as esoteric or elite and to appear as provocateurs who seek to discomfit or irritate an audience. The films of Rainer Kaufmann, Doris Dörrie, Sönke Wortmann, Katja von Garnier, Joseph Vilsmaier, Helmut Dietl, and Detlev Buck seek a new German consensus. The creators of this cinema do not dream or speak out. They are professionals who take pride in their craft, who replace the *Autorenfilm*'s yen for style with a mainstream cinema's styling. Quite reasonably, they want to please, which means appealing to wide audiences. On occasion, but not terribly often, they have succeeded. Their films at best possess a domestic allure; despite the best efforts of the Export-Union and the Goethe-Institut, they have by and large not fared well abroad. German films have all but vanished from American art houses over the past decade, since *Heimat* (Edgar Reitz, 1984), *Männer* (*Men*, Doris Dörrie, 1985), *Der Himmel über Berlin* (*Wings of Desire*, Wim Wenders, 1987), and *Das schreckliche Mädchen* (*The Nasty Girl*, Michael Verhoeven, 1989).

Recent visits to the Berlinale have found me more inclined to spend my days and nights in the Astor Film theater on the corner of

Kurfürstendamm and Fasanenstraße, watching the elaborate and exciting historical programs organized by the Stiftung Deutsche Kinemathek, retrospectives devoted to Babelsberg and the Cold War, to the film years 1939 and 1945, to the productions of Erich Pommer and the work of Robert Siodmak and G. W. Pabst. If I initially could not help but feel that watching old films was a guilty pleasure when it meant the neglect of current productions, I have come in many years to regard the Retro offerings as the Berlinale's main attraction. I sometimes pity my colleagues from the Goethe-Institut as they hunker down in the Urania, duty-bound as ambassadors of German culture to take in the entirety of each year's Neue Deutsche Reihe.[4] On days in 1998, for example, that produced pronounced fits of fanny-twitching and little cinematic reverie after encounters with such titles as *Widows* (Sherry Hormann, 1997), *Hunger* (Dana Vávrová, 1996), and *Bandits* (Katja von Garnier, 1997), I have been prone to share these sentiments. But even in the sparest of years, I have always come across a half-dozen German films that have intrigued and engaged me, have lingered in my mind and enriched my life, and have made me want to keep coming back for more. In 1998, for instance, a year that was a disaster for German films in the Competition,[5] I nevertheless recall stirring encounters with Andreas Dresen's *Raus aus der Haut* (*Despite Himself*), Thomas Heise's *Barluschke*, Peter Lichtefeld's *Zugvögel* (*Trains'n'Roses*), and Tom Tykwer's *Winterschläfer* (*Winter Sleepers*). Alongside the New German Cinema of Consensus, there abides a minor New German Cinema in the work of Michael Klier, Andres Veiel, Fred Kelemen, Jan Schütte, both Lars and Wolfgang Becker, Elfi Mikesch, Uwe Schrader, Volker Koepp, Helke Misselwitz, Christoph Schlingensief, Romuald Karmakar, and Philip Gröning, among others. And of Tom Tykwer and Dominik Graf who make exhilarating films that play with contingency, deadly smart exercises in genre-bending in which nothing is preordained and anything can happen.

When I watch German films at the Berlinale as we enter the new millennium, I do so with an unbroken hopefulness, even if it comes with a more sober regard, the product of a long epoch that has given rise to only a handful of explosions and surprises. Nonetheless, New German film has not altogether lost its potential for incendiary and illuminating perspectives.

2013: School's Out

I.

A film festival is a unique kind of heterotopia, a marketplace that challenges visitors to transform profusion and plenty into a coherent program. Faced with four hundred films screened over ten days, accredited guests at the 2013 Berlinale had to decide which sectors of the spectacle they would inhabit, in essence, to determine which festival of many possible ones they would create and, having done so, inhabit. One chose from features, documentaries, and short films in the main sections, the Competition, Forum, Panorama, and Perspektive Deutsches Kino as well as sundry special screenings. For visitors with historical agendas, there was also a retrospective, "The Weimar Touch," dedicated to the legacy of classical German cinema. Festival-pass holders (which come in a variety of colors allowing differing levels of access) eager to remain abreast of current German feature and documentary production could view the forty-four offerings in the program "German Cinema—Lola@Berlinale," closed screenings of the titles under consideration for the year's German Film Academy Prizes. The 2013 Berlinale had barely begun before it was being declared a washout. Various commentators, who would be proven dead wrong, complained that the competition program was thin, the entries lightweight. As in years past, but with higher levels of impatience and displeasure, domestic journalists (a notice by Tobias Kniebe of the *Süddeutsche Zeitung* set a snarky tone[6]) compared festival director Dieter Kosslick unfavorably with the Venice Film Festival's Alberto Barbera and Cannes's Gilles Jacob, faulting the Berlinale's competition program for its content-oriented populism, politically driven selection policy, desperate pursuit of stars and Hollywood presences, and lack of formal daring and cinephilic allure.[7] In these notices, with their obligatory dismissiveness, a key point of reference was the lack of German films in the competition lineup.

In this regard, the fare *was* thin, but a quick sampling of the entries in the rich programs of the Forum, Panorama, and particularly the Perspektive Deutsches Kino would have necessitated second thoughts and occasioned far less jaded assessments. Only two German features found their

FIGURE 20.2 Thomas Arslan's *Gold* received little mercy from German film critics at the 2013 Berlinale. "Anyone who associates gold with fever is dead wrong in this case. This *Gold* is cold to the heart" (Ekkehard Knörer).

way into the main competition, Thomas Arslan's *Gold* and Pia Marais's *Layla Fourie*. The latter was in fact an international coproduction, a *polit-thriller* shot in Johannesburg and set in the fallout and paranoia of a post-apartheid nation. For Marais, a South African national who has lived in Berlin and made two German features, the film marked a homecoming; nonetheless, few observers viewed the endeavor as a German entry.

As the festival unfolded, the sorry state of German cinema—once again, like clockwork—became a favored topic of discussion. Similar laments had surfaced at last year's festival. Doris Dörrie, the partisan of feel-good movies and an ever-reliable purveyor of new age harmonies, had distinguished in interviews between esoteric films made for museums and festivals and features that actually please the people who go to the movies.[8] This self-advertisement takes us back to her screwball comedy *Männer* (*Men*), whose appearance in 1985 was seen by many commentators as a panacea, an antidote to what both critics and politicians decried as a decrepit New German Cinema that reduced its audiences to hunger artists. As director Dominik Graf would elaborate in a polemic written shortly before last year's German Film Awards, the schematic alternative seems to be love-less films about emptiness made in an empty way (mainly by directors trained in the nation's film academies) and films that celebrate mindless-ness in a mindless manner; in other words, either a stern art-house cinema

of relevance and authenticity or a would-be popular genre cinema that, in a mercenary and desperate way, caters to the lowest common denominator.[9]

For all their formal precision and sophistication, Berlin School films by the likes of Arslan, Christian Petzold, Angela Schanelec, Maren Ade, and Christoph Hochhäusler (among others), argued Graf, on the whole made "an irritatingly monotone impression. Too much art, too much good intention?" What German cinema needs, he submitted, was more spontaneity, immediacy, and, yes, bad taste. Many online cinephiles for this very reason venerate the excesses and outré effusions of directors like Alfred Vohrer, Eckhart Schmidt, Klaus Lemke, and Will Tremper.[10] At the 2013 festival, a particularly fierce attack on the Berlin School in the online journal *Artechock* ignited further reflection on the relationship between a cinema of authors and a popular film culture. Dietrich Brüggemann, the director of several noteworthy features as well as a frequent writer for the (now-defunct) film journal *Schnitt*, felt no need to conceal his dismay about the state of things. Why is there such an unbridgeable gap, he asked, between German films that are "deadly serious and incredibly heavy" and ones that "simply wreak of pure mindlessness?"[11] The opposition is strong, and it is also false. Three works screened at the Berlinale, in quite different ways and with quite divergent consequences, made this apparent.

II.

The first of these three films, and the sole identifiably German film in the competition, Arslan's *Gold*, was ravaged. "Welcome to a world of tortuous boredom and intense pain," cracks Brüggemann.[12] The production follows a motley collection of German migrants, their bodies and fortunes at risk, as they traverse the Canadian wilderness on their way to the prospect of gold in Alaska. Although some of the obligatory trappings of the western (a crooked guide, bounty hunters, broken wagon wheels, frontier villages) are on display, the film for the most spares us dramatic climaxes save an attempted lynching, the grisly amputation of a leg, and the obligatory showdown on an empty street. The images that most vividly linger in mind are mounted figures seen from behind riding through never-ending forests, occasionally encountering a dazed wanderer or an

impassive Native American. (There are no wild animals, although we do see a bear trap.) *Gold*'s sparseness was for its assailants unendurable, but for its few defenders mesmerizing in its oneiric intensity.

No other competition film at the 2013 Berlinale received such scorn and abuse from the critics. The press screening was a virtual squirmfest and concluded with boos and hisses. Above all, the film became a target for critical dismay about the Berlin School in general. Nina Hoss does horseback, quipped its detractors; here, argued critics, we find an exemplary instance of everything that is misbegotten and unbearable about a cinema that taxes its audiences and denies viewers all those things that make films riveting and enjoyable. Stilted dialogue, lack of warmth and affect, systematic undernarration, and unbroken earnestness that gives rise to inadvertent risibility; here, in nuce, were all the negative attributes of the Berlin School that Graf spoke about several years ago in his now-famous e-mail exchange with Christian Petzold and Christoph Hochhäusler.[13]

And yet, there was something disingenuous, even perverse, about this overreaction. Among the titles generally left unmentioned in unfavorable comparisons of *Gold* with other westerns were Monte Hellman's *Ride in the Whirlwind* (1965) and *The Shooting* (1966).[14] Ever since the legendary retrospective of his work at the 1998 Munich Film Festival, Hellman has enjoyed a cult status in Germany. And his so-called antiwesterns, with their existentialistic minimalism, lack of motivation, and Kafkaesque absurdism, enjoy high esteem among the nation's cineastes. (A DVD of the two films was released recently in Germany.) Seen through the prism of Hellman's endeavors, Arslan's undertaking, with its endless panoramas and phantasmagoric feverishness, its unpopulated landscapes and flat characters, is an evocative exercise in plot abstinence and an emptiness so radical that it gives rise to an alluring indeterminacy. Why, however, do German critics praise these very same attributes in *The Shooting*, even in Jim Jarmusch's *Dead Man* (1995), and yet deride them in *Gold*?

III.

The second film that enacted the spurious dichotomy between the deadly boring and the blithely insipid was Sandra Prechtel's Panorama entry,

Roland Klick—The Heart Is a Hungry Hunter (2013). The documentary opens onto a frenetic Mario Adorf somewhere in a barren desert, running down the tracks after a departing train. Few people attending the film's Cine-Star premiere could have identified the source of this clip, Klick's legendary sort-of-western *Deadlock* (1970). The tableau is not only galvanizing in its sweaty physicality (precisely the kind of role for which the swarthy and heavy-set Adorf would become famous) but also suggestive in the way the scene anticipates Klick's own destiny. Here was a filmmaker who issued from the Munich scene in the sixties, made some well-regarded features about losers and lowlifes (beyond *Deadlock*, his key titles are *Jimmy Orpheus* [1966], *Supermarkt* [1974], and *White Star* [1983]), all the while refusing to align himself with the New German Cinema. A self-styled auteur who revered Hollywood professionals, he would himself never make the leap to the mainstream. (The kiss of death for his career hopes would come when Bernd Eichinger fired him as the director of the blockbuster-to-be *Wir Kinder vom Bahnhof Zoo* [*Christiane F.*, 1981].) Klick indeed also would miss the train; the great promise of his early work would remain unfulfilled.

To consider Klick is to contemplate a subterranean history of German cinema and to remember the lesser-known second Oberhausen

FIGURE 20.3 A grizzled Mario Adorf in Roland Klick's stunning end game of a western, *Deadlock* (1970).

Declaration of 1965 signed by, among others, Peter Nestler, Rudolf Thome, Klaus Lemke, and Jean-Marie Straub. This motley collective, despite its diversity of approaches and personalities, castigated a German film that fetishized a circumscribed mode of realism that, with a know-it-all-ish progressive politics and socially critical schoolmasterliness, sanded off the rough edges of reality. The Young German Film of Alexander Kluge and the initial Oberhausen signatories, they insisted, surely did not have a monopoly on the medium's creative and expressive potential.[15]

Klick did not make films, he made cinema. And the calling of his cinema was to be sensual, not to make sense. His galvanizing work (three shorts and eight features made between 1962 and 1988) is hot, not cold; it knows nothing of New German Cinema's distantiation and self-reflection. His signature style, in the appraisal of Rudolf Worschech (coeditor of the prominent monthly journal *epd Film*), blends "exactness of observation, occasionally disjunctive editing, a disdain for the extraneous, the portrayal of characters through their actions and not their words, an emphasis on the physical and on action."[16] *Jimmy Orpheus* and *Supermarkt* have no sociopolitical ax to grind. In these films, action means enactment, audiovisual immediacy and not intellectual elaboration. Politics enters into the mix for Klick insofar as cinema functions in the public sphere and interacts with audiences of diverse sensibilities. A director must communicate with spectators—not preach to them or put them off. Klick's critique of the New German Cinema's "esoteric demeanor" parallels to a tee Graf's displeasure with films that fit "into the art-house drawer."[17]

This body of recalcitrant work cannot be written off as generic fare any more than can Graf's, as the resounding success of the latter's recent career retrospective at the 2013 Rotterdam Film Festival illustrated. And Graf's collaboration with Petzold and Hochhäusler—the very Berlin School directors with whom he famously had corresponded about the deficiencies of their cinema—on the three-part film, *Dreileben* (2011), confirms how fatuous the dichotomy between auteurist and popular initiatives can be. A multivoiced film screened at the Berlinale in 2011, *Dreileben* might be understood as a manifesto for a German film of the future that at once accentuates and yet augments the distinctiveness of its participants while blending an awareness of international film history and a concern about the state of contemporary German cinema. Moreover, *Dreileben* shows

how authorial inscriptions and generic conventions might interact in diverse and enthralling ways.

Likewise, the cinema of Roland Klick demonstrates persuasively how the emptiness of Antonioni's landscapes could coexist with the down-and-dirty expanses of the film noir and the thriller. The director's disdain for easy psychologizing; his desire to show and not tell; his relentless resolve to probe and manipulate convention and, in that way, to challenge and engage the viewer, are emphases he shares in common with Graf—but also with exponents of the Berlin School. Klick's legacy should prod us to rethink German film history and find a place for a significant cinema that coexisted with and yet stood apart from Young German Film and its extension, New German Cinema. Graf, both in his films and his always-engaging critical essays,[18] has expanded our awareness of what is artful about popular cinema and of the degree to which auteur cinema relies on generic design. For those familiar with André Bazin's seminal essay, "On the *Politique des Auteurs*" (1957), this mutual exclusivism will seem like yesterday's news.[19]

IV.

A third film at the 2013 Berlinale that complicated the alleged antinomy between artful and entertaining domestic offerings, Jan Ole Gerster's *Oh Boy* (2012), a début feature and a dffb diploma film, was screened (only once) in the "German Section." It already had received elaborate festival exposure (including two showings at the American Film Institute Fest in November 2012) and had a successful theatrical run; it also appeared at the Museum of Modern Art in April 2013. *Oh Boy* tracks young Niko Fischer (played by rising star Tom Schilling), a good-for-nothing—unemployed, feckless, pensive—as he meanders through Berlin in search of a cup of coffee. As the cash-poor flâneur walks about in Prenzlauer Berg and Mitte, we partake of spaces and haunts familiar to young denizens of the metropolis: the bohemian sanctuary St. Oberholz and the American eatery White Trash Fast Food; the (recently closed) Kunsthaus Tacheles; the subway stop Eberswalderstraβe; and a gentrified café with a Swabian waitress who is by turns solicitous and sadistic. These sites commingle

FIGURE 20.4 (*top*) The feckless Niko (Tom Schilling) and his good-for-nothing friend Matze (Marc Hosemann) hanging out in the Prenzlauer Berg eatery, White Trash Fast Food (*Oh Boy*, 2012).

FIGURE 20.5 The protagonist of *Oh Boy* at the end of a twenty-four-hour-long and citywide search for a cup of coffee: "I found it appealing to have a character who does nothing, who is very passive and still, but is wide awake and noticing things, and I thought it would be interesting to send him on a road trip without really leaving Berlin" (Jan Ole Gerster).

with a cast of Berlin originals in a wacky city symphony; even if the film spares us the local dialect, the idioms and inflections retain their inimitability. Critics are fond of likening *Oh Boy* to Woody Allen's *Manhattan* (1979), reserving special praise for Philipp Kirsamer's crisp black-and-white cinematography and a moody jazz score redolent of early Nouvelle Vague productions, dubbing it German mumblecore as well as linking it to the zaniness of Werner Enke in May Spils's paean to hanging out and shirking responsibility, *Zur Sache, Schätzchen* (*Go for It, Baby*, 1968), and positioning it within a series of recent German "Generation 30" films like Hanna Doose's *Staub auf unseren Herzen* (*Dust on Our Hearts*), Constanze Knoche's *Die Besucher* (*The Visitors*), and Brüggemann's 3 *Zimmer/Küche/Bad* (*Move*; all 2012).

The gloomy and overcast urban expanses assume a whimsical and enchanted aspect; the film takes time—indeed, it has a remarkable lack of urgency, very much in keeping with its main character's lack of volition. Like its protagonist, the film seems to know quite well what it does not want to be. We see Niko visit the set of an American Nazi retro film, an apparent knockoff of Quentin Tarantino's *Inglourious Basterds* (2009) in which a German officer falls in love with a Jew. This, we are told, "is based on a true event," which only emphasizes the speciousness of the spectacle. At another point, a self-important theater director refers with snarling disdain to the "*Berliner Sonderschule*" and this dismissive appraisal marks a crucial point of reference. The German appellation *Sonderschule* commonly refers to a school for students with special needs, including the disabled. Unlike Brüggemann writing about the Berlin School, though, Gerster sees no need to be snarky; it is important that the phrase is uttered by an angry and resentful artist in the midst of a hissy fit.

In fact, *Oh Boy* recalls a significant (but rarely mentioned and all but unseen) precursor of the Berlin School, Michael Freerix's *Chronik des Regens* (*Chronicle of Rain*, 1991), a dffb diploma film that was shot in West Berlin just before the wall went down. The city has the look of a sleepy haven full of cafes and parks in which an idle protagonist malingers with friends on the day before he plans to begin working for real, reading newspapers, talking on public telephones, drinking endless cups of coffee (a pleasure denied Niko until the last minute of *Oh Boy*), walking along rivers, and hiking through forests. This film is not in a rush; it savors *temps*

mort and takes time seriously, attending to everyday things that most films cast off as insignificant.

Film critic Lukas Foerster noted several years ago that *Chronicle of Rain* poignantly displays what the Berlin School has lost as it has become more formally refined and art-house compatible, namely "the utter originality of a filmic style that does not kowtow to the whims of the culture industry and the tastemaking agendas of feuilleton pages, but rather insists on aesthetic idiosyncrasy and a complex, subversive relationship to contemporary history."[20] Even if I find Foerster's verdict to be a shade harsh, I share his enthusiasm about *Chronicle of Rain* and cannot help but note how its minimalism, modesty, and spontaneity reverberate in *Oh Boy*. In bringing new life and energy to German cinema, yet another stunning diploma film from the dffb intimates what a *Berliner Sonderschule* might look like.

ACKNOWLEDGMENTS

In making sense of films, film historians consider the situations from which audio-visual artifacts issue and the contexts in which they resonate, tracking the many functions and different meanings that works come to assume, in so doing constantly shuffling between the frameworks of various pasts and the perspectives of the present moment. Over time, one's relationship to films changes and develops for a variety of reasons; for me, such changes are in great part the result of the conversations, exchanges, and, at times, disagreements with colleagues, friends, and students. Indeed, a very large cast figured as coproducers in the making of this book. I surely cannot express well-deserved thanks here to everyone who helped me along the way, but I would at least like to acknowledge those individuals whose support and assistance were particularly crucial.

During the three decades that the contributions in this volume span, I regularly shared thoughts with my friend and trusted collaborator Anton Kaes, relishing and relying on our invariably long, inimitably freewheeling, and always invigorating Sunday afternoon telephone calls regarding a myriad of topics. More than anyone, Tony has opened up my intellectual regard and expanded my scholarly frame of reference. My conversations with Hans Helmut Prinzler, so often in his Charlottenburg apartments, regularly made me mindful of books that I should know and films that I needed to see. The late Karsten Witte was a constant source of invigoration

and encouragment; almost twenty years since his death, I continue to realize how great my intellectual debt is to him. Through Karsten I also came to know Gertrud Koch, Miriam Hansen, Heide Schlüpmann, and Wolfram Schütte, each of whom I came to respect and all of whom I will always associate primarily with Frankfurt and Critical Theory and, in matters of film, critical criticism. Jan Christopher Horak, who knows more about German exile cinema than anyone else on the globe, can without fail be counted on for unexpected references and helpful suggestions. I also am thankful to Lothar Just for gaining me access to the Munich film scene and sharing his insider's knowledge about the complex workings of the German film industry.

Since 1985, Tony and I have conducted the German Film Institute more than a dozen times, most recently at Dartmouth College and the University of Michigan. These week-long summer events, especially since the turn of the century, have brought together groups of scholars to watch and talk about both well-known and lesser-seen German features, shorts, and documentaries. The intensive programs of screenings and discussions have stimulated my own thoughts immeasurably and I am thankful to my GFI colleagues, many of whom have become good friends, whose insights and energies have made these events so memorable and enlivening.

My colleagues at *New German Critique*, especially David Bathrick, Andreas Huyssen, and Anson Rabinbach (otherwise known to fellow members on the editorial board as the "Undead") have set imposing standards of critical rigor and sustained significant discussions since the early 1970s. The journal has served as a seminal site for explorations of film and mass culture and I have taken great pleasure in participating in and on occasion helping to guide these endeavors.

Institutional support at the University of California, Irvine and later Harvard University, both in the form of sabbatical time off and research funding, has been essential in providing the wherewithal for long stays abroad and sustained periods at home to organize my thoughts and put them to paper. I owe a very substantial thank you to Jennifer Crewe at Columbia University Press, who waited for this manuscript far longer than either of us might have wished, and who was both extremely gracious and inordinately responsive when at long last it finally materialized in her inbox. Kate Schell at CUP has likewise been ever cordial, reliable, and

proactive during the production process. Lisa Fluor generously agreed to help with the copyediting of the manuscript and assumed responsibility for the index. Her eagle eye for infelicities as well as her unfailingly sharp attention to matters of form and style are greatly admired and deeply appreciated.

Finally, I am grateful to Gerd Gemünden and Johannes von Moltke for the equal measures of sensitivity and critique in their responses to an initial version of the manuscript. Their careful comments and incisive suggestions proved to be invaluable in helping me determine the final shape of this book.

NOTES

Introduction: History Lessons and Courses in Time

1. Siegfried Kracauer, "Über die Aufgabe des Filmkritikers," in *Werke, Band 6.3, Kleine Schriften zum Film 1932–1961*, ed. Inka Mülder-Bach (Frankfurt am Main: Suhrkamp, 2004), 63.

2. Karsten Witte, *Lachende Erben, Toller Tag. Filmkomödie im Dritten Reich* (Berlin: Vorwerk 8, 1995), 257.

3. See Theodor W. Adorno, "The Curious Realist: On Siegfried Kracauer," trans. Shierry Weber Nicolsen, *New German Critique* 54 (Fall 1991): 159–177.

4. See Rudolf Arnheim, "Melancholy Unshaped," *Journal of Aesthetics and Art Criticism* 21, no. 3 (Spring 1963): 291–297.

5. See Karsten Witte, "The Indivisible Legacy of Nazi Cinema," trans. Eric Rentschler, *New German Critique* 74 (Spring–Summer 1998): 23–30.

6. Klaus Kreimeier, *Die Ufa-Story. Geschichte eines Filmkonzerns* (Munich: Hanser, 1992).

7. Karsten Witte, "Too Beautiful to Be True: Lilian Harvey," trans. Eric Rentschler, *New German Critique* 74 (Spring–Summer 1998): 38.

8. Siegfried Kracauer, "Kunst und Dekoration," *Frankfurter Zeitung*, October 13, 1931.

9. See esp. Alexander Kluge and Oskar Negt, *Geschichte und Eigensinn* (Frankfurt am Main: Zweitausendeins, 1981).

10. Such a critical reexamination of German cinema during this epoch is the impetus behind my book in progress, *The Cinema of Consensus: Zeitgeist Scenarios in the Kohl Era, 1982–1998*.

11. Siegfried Kracauer, "The Little Shopgirls Go to the Movies," in *The Mass Ornament: Weimar Essays*, ed. Thomas Y. Levin (Cambridge: Harvard University Press, 1995), 303.

12. See Tom Tykwer's eloquent and astute tribute to Kluge, "Der Testpilot der Kinematographie: Laudation auf Alexander Kluge," *Frankfurter Allgemeine Zeitung*, April 25, 2008.

1: How a Social Critic Became a Formative Theorist

This essay first appeared in *Arnheim for Film and Media Studies*, ed. Scott Higgins (New York: Routledge, 2010), 51–68. It is reprinted here with the kind permission of the Taylor and Francis Group.

1. Arnheim's exemplary contribution to film theory appeared as *Film als Kunst* (Berlin: Rowohlt, 1932); a full English translation, which Arnheim considered to be unsatisfactory, appeared a year later as *Film*, trans. L. M. Sieveking and Ian F. D. Morrow (London: Faber & Faber, 1933).

2. Siegfried Kracauer, *Theory of Film: The Redemption of Physical Reality* (Oxford: Oxford University Press, 1960).

3. See Dudley Andrew, *The Major Film Theories: An Introduction* (Oxford: Oxford University Press, 1976; Princeton: Princeton University Press, 1997).

4. Kracauer, *The Mass Ornament: Weimar Essays*, ed. and trans. Thomas Y. Levin (Cambridge: Harvard University Press, 1995).

5. Roland Barthes, *Mythologies* (Paris: Éditions du Seuil, 1957).

6. Rudolf Arnheim, *Film Essays and Criticism*, trans. Brenda Benthien (Madison: University of Wisconsin Press, 1997). Further references to this text will appear parenthetically in the text as *FEC* with page numbers. Aside from the addition of two articles, the collection follows the West German edition of 1977, *Kritiken und Aufsätze zum Film*, ed. Helmut H. Diederichs (Munich: Hanser, 1977). Arnheim explicitly commends Diederichs for having tracked down these journalistic notices; he [Diederichs] "besieged archives, procured copies, and culled the forgotten and obscure from all over the world, particularly in German, but also in English and some Italian" (*FEC*, 7).

7. Sabine Hake's study of Arnheim's Weimar film criticism and theory poses a marked exception and a decidedly more contextually acute perspective. I share her focus on the social dimension of Arnheim's early criticism and appreciate her carefully researched analysis of "his contribution to the cultural and political debates of the late twenties." See Sabine Hake, *The Cinema's Third Machine: Writing on Film in Germany 1907–1933* (Lincoln: University of Nebraska Press, 1993), 271. Although I concur that these early writings enact "the tension between

aesthetic, psychological, and social categories of evaluation," I do not believe however that they fully "resolve" them (Hake, 271) in a way that will yield "the unity of a work in which formalist tendencies exist side by side with an acute awareness of the functioning of mass entertainment" (290). Hake's attempt to reconstruct Arnheim's work on film as a "unity" is contradicted by her own thoughtful discussion of how, in later reediting *Film als Kunst*, Arnheim "eliminated all traces of a political consciousness and deleted numerous contemporaneous references" (290). As I will argue, it might well be more accurate to say that Arnheim *obscured* (rather than *resolved*) the tensions posed by the social and historical incentives of his early writings. Likewise, very substantial evidence speaks against Hake's generalization that the young Arnheim lacked interest in "sociological questions" and, for that reason, subordinated "everything . . . to the filmic text" (275). Nor did the exuberant and fun-loving young gadabout altogether disregard pleasure (279).

8. Long before Arnheim became a professor of Visual and Environmental Studies at Harvard in the 1960s, Lewis Jacobs chided the "ivory tower" approach of *Film as Art* in a review of 1934 that appeared in the journal *Experimental Cinema*. Cited in Hake, 283, who elsewhere speaks of Arnheim's "rigidity in aesthetic matters" (282).

9. Dirk Grathoff, "Rudolf Arnheim at the *Weltbühne*," in *Rudolf Arnheim: Revealing Vision*, ed. Kent Kleinman and Leslie Van Duzer (Ann Arbor: University of Michigan Press, 1997), 21.

10. For profiles of the journal and its contributors, see *Die Weltbühne. Zur Tradition und Kontinuität demokratischer Publizistik*, ed. Stefanie Oswalt (St. Ingbert: Röhrig, 2003).

11. Hans Reinmann, "Vorwort," in Rudolf Arnheim, *Stimme von der Galerie* (Berlin: Benary, 1928), ii–iii.

12. "Introduction," *FEC*, 3.

13. "Introduction," *FEC*, 5.

14. Peter Sloterdijk, *Critique of Cynical Reason*, trans. Michael Eldred (Minneapolis: University of Minnesota Press, 1987), 389.

15. Ibid., 410.

16. Ibid., 501.

17. Ibid., 509.

18. Béla Balázs, for instance, articulates this position in *Isskustvo Kino* (1945). See the English translation, *Theory of the Film*, trans. Edith Bone (New York: Dover, 1970), 17: "Thus the question of educating the public to a better, more critical appreciation of the films is a question of the mental health of the nation." For a survey of film criticism in the Weimar Republic, see Heinz B. Heller, "Massenkultur und ästhetische Urteilskraft. Zur Geschichte und Funktion der deutschen Filmkritik vor 1933," in *Die Macht der Filmkritik. Positionen und Kontroversen*, ed. Norbert Grob and Karl Prümm (Munich: edition text + kritik, 1990), 25–44.

19. Heller, 28.

20. Kracauer, "Über die Aufgabe des Filmkritikers," in *Werke, Band 6.3, Kleine Schriften zum Film 1932–1961*, ed. Inka Mülder-Bach (Frankfurt am Main: Suhrkamp, 2004), 61.

21. Kracauer, "Über die Aufgabe des Filmkritikers," 63.

22. David Bordwell, *Making Meaning: Inference and Rhetoric in the Interpretation of Cinema* (Cambridge: Harvard University Press, 1989), 71–104.

23. Theodor W. Adorno, "The Curious Realist: On Siegfried Kracauer," trans. Shierry Weber Nicolsen, *New German Critique* 54 (Fall 1991): 167.

24. Adorno, "Siegfried Kracauer ist tot," *Frankfurter Allgemeine Zeitung*, 1 December 1966.

25. Arnheim, "Vorwort zur deutschen Neuausgabe," in *Film als Kunst* (Frankfurt am Main: Suhrkamp, 2002), 10.

26. Karl Prümm, "Epiphanie der Form: Rudolf Arnheims *Film als Kunst* im Kontext der zwanziger Jahre," in Rudolf Arnheim, *Film als Kunst* (Frankfurt am Main: Suhrkamp, 2002), 276.

27. Likewise, in a discussion of *Kuhle Wampe*, Arnheim praises the film's uninhibited use of natural ambient sound, claiming it "could reserve many sound technicians' superstitious prejudices." He goes on to laud the sparse and expressive use of dialogue and the creative implementation of sound in Hanns Eisler's songs and musical score (*FEC*, 94).

28. Cf. *Theory of Film*, 304: "The small random moments which concern things common to you and me and the rest of mankind can indeed be said to constitute the dimension of everyday life, this matrix of all other modes of reality. It is a very substantial dimension."

29. Arnheim, "Vorwort zur deutschen Neuausgabe," 12.

30. See Arnheim's review of *Theory of Film*, "Melancholy Unshaped," *Journal of Aesthetics and Art Criticism* 21, no. 3 (Spring 1963): 291–297.

31. Manny Farber, "White Elephant Art vs. Termite Art," in *Negative Space: Manny Farber at the Movies* (New York: Praeger, 1971), 139–140.

32. Farber, *Negative Space*, 135.

33. Balázs, *Theory of the Film*, 21: "The fact that the art of the film is not yet fully developed offers an unprecedented opportunity for aestheticists to study the laws governing the evolution of an art in the making." Critics and scholars of silent cinema, Balázs elaborates, "were offered the opportunity of watching a new art being born before their eyes."

34. Cf. Kracauer, "Die verfilmten *Weber*" [1927], in *Werke, Band 6.1*, 350–351. Kracauer's review pays careful attention to the film's form, the way in which individual parts serve to suggest something larger, the use of contrast and repetition in the editing, the construction of space, and the creative lessons that the director Friedrich Zelnik has learned from Eisenstein and

Pudovkin. It is a good film, claims Kracauer, but it does not compare well to its Soviet prototypes because it is anachronistic. *The Weavers* restages a conflict from a transitional era that every worker in the audience knows has been "overcome by social policy and unions." For that reason, "it does not serve a revolutionary function, but rather demonstrates how remarkably times have changed" (351).

35. In her screenplay for Fritz Lang's *Frau im Mond* (*Woman in the Moon*, 1929), Thea von Harbou "imagines that big business people or scientists are like Ludendorff imagines the freemasons and the Jews. The 'five richest people in the world' are sitting around a table like the wise men of Zion" (*FEC*, 153).

36. Kracauer's comments on the book appeared both in the literary supplement of the *Frankfurter Zeitung* on 10 January 1932 and in the January 1933 issue of *Neue Rundschau*. The notices are quite similar; references are taken from the first one, "Neue Filmliteratur," reprinted in Kracauer, *Werke, Band 6.3*, 15–19.

37. "Neue Filmliteratur," 18.

38. See *Film als Kunst*, esp. 159–223 and 325–328.

39. See the section on aesthetic and sociological film criticism in Helmut H. Diederichs, *Anfänge deutscher Filmkritik* (Stuttgart: Fischer, 1986), 24–35.

40. See Heller, 28.

41. Kracauer, *From Caligari to Hitler: A Psychological History of the German Film* (Princeton: Princeton University Press, 1947), 5: "The films of a nation reflect its mentality in a more direct way than other artistic media. . . . Films are never the product of an individual."

42. Hake, *The Cinema's Third Machine*, 290.

43. For an intriguing discussion of Arnheim's approach to cinematic standardization and stereotyping, see Jörg Schweinitz, *Film und Stereotyp. Eine Herausforderung für das Kino und die Filmtheorie* (Berlin: Akademie, 2006), 178–196.

44. Karsten Witte, "Von der Diskurskonkurrenz zum Diskussionskonsens," in *Die Macht der Filmkritik. Positionen und Kontroversen*, ed. Norbert Grob and Karl Prümm (Munich: edition text + kritik, 1990), 160.

45. Sloterdijk, *Critique of Cynical Reason*, 501.

46. Gertrud Koch, "Rudolf Arnheim: The Materialist of Aesthetic Illusion," *New German Critique* 51 (Fall 1990): 164.

47. Andrew, *The Major Film Theories*, 27.

48. Hake, 282.

49. "Introduction," *Film as Art* (1957), 4.

50. Ibid., 7.

51. Miriam Hansen, "Introduction," *Theory of Film*, xiii.

52. "So-called Freedom [1932]," *FEC*, 98.

53. *Film als Kunst* (1932), p. 330. Quoted as translated in *Film* (1933), 296.

This essay first appeared as "Kracauer, Spectatorship, and the Seventies," in *Culture in the Anteroom: The Legacies of Siegfried Kracauer*, ed. Gerd Gemünden and Johannes von Moltke (Ann Arbor: University of Michigan Press, 2012), 61–75. It is reprinted here with the kind permission of the University of Michigan Press.

1. Michael Rutschky, *Erfahrungshunger. Ein Essay über die siebziger Jahre* (Frankfurt am Main: Fischer, 1982). The initial edition of the book appeared in 1980 and was published in Cologne by Kiepenheuer und Witsch.

2. The book, in fact, was seen as either out of time or behind the times or simply out of keeping with the times. Surely none of its early reviewers took time to consider it, as Miriam Hansen later would, within wider intertextual constellations of its historical moment. It might be productive, Hansen argues, to think of the volume "as contemporaneous with the magazine *Film Culture* and developments in independent film production and distribution; with existentialism in philosophy and life-style, minimalism in art and music; with Susan Sontag's essay 'Against Interpretation,' Miles Davis's *Kind of Blue*, Lawrence Ferlinghetti's *A Coney Island of the Mind*, and movies such as *Shadows* and *The Hustler*." See Hansen's provocative introduction to the most recent edition of *Theory of Film* (Princeton: Princeton University Press, 1997), ix. A notable exception to the otherwise-lackluster initial reception granted to *Theory of Film* is Rudolf Arnheim's appreciative review, "Melancholy Unshaped," reprinted in Rudolf Arnheim, *Toward a Psychology of Art* (Berkeley: University of California Press, 1966), 181–191. Arnheim goes so far as to characterize the study as "probably the most intelligent book ever written on the subject of the film" (181).

3. For two useful surveys of West German film criticism of the postwar era, see Ulrich von Thüna, "Filmzeitschriften der fünfziger Jahre," in *Zwischen Gestern und Morgen. Westdeutscher Nachkriegsfilm 1946–1962*, ed. Hans-Peter Reichmann and Rudolf Worschech (Frankfurt am Main: Deutsches Filmmuseum, 1989), 248–262; and Joachim Paech, "Filmwissenschaft, Filmtheorie und Filmkritik in Westdeutschland 1960–1980. Das alte (Klage-)Lied," in *Abschied von Gestern. Bundesdeutscher Film der sechziger und siebziger Jahre*, ed. Hans-Peter Reichmann and Rudolf Worschech (Frankfurt am Main: Deutsches Filmmuseum, 1991), 212–223. The situation was altogether different in France where film theory entertained a long-standing and fruitful interaction with avant-garde production, where film discourse resonated within an elaborate network of cineclubs and maintained an integral presence in intellectual life and cultural activity.

4. See Walter Schmieding's scathing assessment in *Kunst oder Kasse. Der Ärger mit dem deutschen Film* (Hamburg: Rütten & Loening, 1961), 16: "There is no department of film studies in [West] Germany, no scholarly literature, no

scholarly research, no academy where young directors, cinematographers, script-writers, and dramaturgs might study." See also Helmut Färber, "Diskussion: Zum Selbstverständnis der *Filmkritik*," *Filmkritik* 11, no. 4 (April 1967): 228. According to Färber, there is no theoretical basis for film criticism in West Germany. Universities occasionally may offer film courses, but no serious research on film comes from academic quarters. Notable exceptions to the rule included Walter Hagemann and the Münster Institut für Publizistik; the Deutsche Gesellschaft der Filmwissenschaft, established in 1953, and its periodical, *Beiträge zur Film-forschung*. Noteworthy as well was the Hamburger Gesellschaft für Filmkunde and its annual publication, *Hamburger Filmgespräche*.

5. The essay appeared with Karsten Witte's insightful "Introduction to Siegfried Kracauer's 'The Mass Ornament,'" trans. Barbara Correll and Jack Zipes, *New German Critique* 5 (Spring 1975): 59–66.

6. Any informed assessment of Kracauer, Inka Mülder-Bach argued in the mid-1980s, requires a familiarity with his *Feuilletons* of the 1920s and 1930s. See her important monograph, *Siegfried Kracauer—Grenzgänger zwischen Theorie und Literatur. Seine frühen Schriften 1913–1933* (Stuttgart: Metzler, 1985), 16.

7. Siegfried Kracauer, *From Caligari to Hitler: A Psychological History of German Film* (Princeton: Princeton University Press, 1947).

8. See Thomas Elsaesser, "The New Film History," *Sight and Sound* 55, no. 4 (Autumn 1986): 246–251.

9. Barry Salt, "From Caligari to Who?" *Sight and Sound* 48, no. 2 (Spring 1979): 122. For an equally disparaging, indeed unabashedly hostile assessment of the book, see Martin Sopocy, "Re-examining Kracauer's *From Caligari to Hitler*," *Griffithiana* 40–42 (October 1991): 61–73.

10. See Philip Rosen, "History, Textuality, Nation: Kracauer, Burch, and Some Problems in the Study of National Cinemas," *Iris* 2, no. 2 (1984): 69–84; Patrice Petro, "From Lukács to Kracauer and Beyond: Social Film Histories and the German Cinema," *Cinema Journal* 22, no. 3 (1983): 47–67; and Thomas Elsaesser, "Film History and Visual Pleasure: Weimar Cinema," in *Cinema Histories, Cinema Practices*, ed. Patricia Mellencamp and Philip Rosen (Frederick, MD: University Publications of America, 1984), 47–84. For an updated recon-sideration, see Thomas Elsaesser, "Weimar Cinema, Mobile Selves, and Anxious Males: Kracauer and Eisner Revisited," in *Expressionist Film—New Perspectives*, ed. Dietrich Scheunemann (Rochester, NY: Camden House, 2003), 33–71.

11. Elsaesser, "Film History and Visual Pleasure," 59.

12. See Pauline Kael, "Is There a Cure for Film Criticism? Or: Some Unhappy Thoughts on Siegfried Kracauer's *Nature* [sic] *of Film*," *Sight and Sound* 31, no. 2 (Spring 1962): 56–64; reprinted in Pauline Kael, *I Lost It at the Movies: Film Writings 1954–1965* (New York: Boyars, 2002), 269–292; Peter Harcourt, "What Indeed, Is Cinema?" *Cinema Journal* 6, no. 1 (Fall 1968): 22–28; Richard

Corliss, "The Limitations of Kracauer's Reality," *Cinema Journal* 10, no. 1 (Fall 1970): 15–22; Andrew Tudor, "Aesthetics of Realism: Bazin and Kracauer," in *Theories of Film* (New York: Viking, 1973), 77–115; Dudley Andrew, "Siegfried Kracauer," in *The Major Film Theories* (Oxford: Oxford University Press, 1976), 106–133; Noël Carroll, "Kracauer's *Theory of Film*," in *Defining Cinema*, ed. Peter Lehmann (New Brunswick: Rutgers University Press, 1997), 111–131; and Malcolm Turvey, *Doubting Vision: Film and the Revelationist Tradition* (Oxford: Oxford University Press, 2008), esp. 41–48.

13. Kael, with her inimitable irreverence, includes Kracauer "in the great, lunatic tradition." See "Is There a Cure for Film Criticism?" 271.

14. Tudor, *Theories of Film*, 79

15. Carroll, "Kracauer's *Theory of Film*," 111.

16. Kael, "Is There a Cure for Film Criticism?" 272.

17. "Briefly stated," Kracauer wrote in a programmatic essay of 1932, "the film critic of note is conceivable only as a social critic. His mission is to unveil the social images and ideologies hidden in mainstream films and through this unveiling to undermine the influence of the films themselves wherever possible." See Siegfried Kracauer, "Über die Aufgabe des Filmkritikers," in *Kleine Schriften zum Film 1932–1961*, vol. 6.3 of *Werke*, ed. Inka Mülder-Bach (Frankfurt am Main: Suhrkamp, 2004), 63.

18. See *film* 56, no. 3 (March 1956): 155. All translations from German, unless otherwise noted, are the author's.

19. Enno Patalas and Wilfried Berghahn, "Gibt es eine linke Kritik?" *Filmkritik* 5, no. 3 (March 1961): 134.

20. Enno Patalas, "Plädoyer für eine ästhetische Linke: Zum Selbstverständnis der *Filmkritik* II," *Filmkritik* 10, no. 7 (July 1966): 407.

21. Helmut Färber, "Diskussion: Zum Selbstverständnis der *Filmkritik*," *Filmkritik* 11, no. 4 (April 1967): 228.

22. Frieda Grafe, "Doktor Caligari gegen Doktor Kracauer," *Filmkritik* 14, no. 5 (May 1970): 242–244. The author of *From Caligari to Hitler* claims Grafe was, like the fictional Dr. Caligari, "a victim of books" (244).

23. At the Oberhausen Festival of 1969, members of *Filmkritik*'s political wing (i.e., the contributors Ulrich Gregor, Klaus Hellwig, Peter Jansen, Theodor Kotulla, Martin Ripkens, Hans Stempel, and Heinz Ungureit) announced their collective resignation from the journal. For detailed and useful accounts of this rift, see Claudia Lenssen, "Der Streit um die politische und ästhetische Linke in der Zeitschrift *Filmkritik*," in *Die Macht der Filmkritik. Positionen und Kontroversen*, ed. Norbert Grob and Karl Prümm (Munich: edition text + kritik, 1990), 63–78; and Irmbert Schenk, "'Politische Linke' versus 'Ästhetische Linke'. Zum Richtungsstreit der Zeitschrift *Filmkritik* in den 60er Jahren," in *Filmkritik. Bestandsaufnahmen und Perspektiven*, ed. Irmbert Schenk (Marburg: Schüren, 1998), 43–73.

24. Sontag's "On Interpretation" appeared in German as "Gegen Interpretation," in the German collection of Sontag's writings, *Kunst und Antikunst. 24 literarische Analysen* (Frankfurt am Main: Fischer, 1964). Many West German film critics felt encouraged by Sontag's essay to become subjective and aphoristic, descriptive rather than prescriptive. See Ulrich Kurowski, "Sieben einzelne Gedanken zu einem Film," *Kirche und Film* 23, no. 1 (January 1970): 3–4.

25. Karsten Witte, "'Die Augen wollen sich nicht zu jeder Zeit schliessen': Die Zeitschrift *Filmkritik* und Junger Deutscher Film 1960–1970," *Medium* 15, no. 11–12 (November–December 1985): 93.

26. See Siegfried Schober, "Kino statt Kritik?" *Filmkritik* 14, no. 1 (January 1970): "Cinema and no more film criticism, a mere compilation of experiences and feelings, no longer any critical reflection and resistance, that's what we have seem to have come to, and if we replace criticism with cinema, we now, almost without exception, partake of the images of politics rather than the reality of politics, seldom what is concrete and specific about politics and increasingly the larger and, as such, vague picture" (3). It should be noted, to be sure, that angry letters to the editor as well as a decline in readership confirmed that numerous readers were not happy with *Filmkritik's* new direction. See Thomas Brandlmeier, "Filmtheorie und Kinokultur. Zeitgeschichte und filmtheoretische Debatten," in *Kino-Fronten. 20 Jahre '68 und das Kino*, ed. Werner Petermann and Ralph Thoms (Munich: Trickster, 1988), 54.

27. Urs Jenny, for instance, lamented that the revered sociological critic of *From Caligari to Hitler* had become the dogmatic—and reactionary—author of *Theory of Film*. See his review, "Gottsched im Kino," *Film* 3, no. 6 (June 1965): 6. Clearly, Jenny's likening of Kracauer to the pedantic eighteenth-century adherent of aesthetic strictures was not meant as a complement.

28. The West German edition of *Theory of Film* appeared as *Theorie des Films. Die Errettung der äußeren Wirklichkeit* (Frankfurt am Main: Suhrkamp, 1964). The book initially was to be published by Rowohlt, but a disagreement between Kracauer and the press put an end to these plans.

29. *Das Ornament der Masse: Essays* (Frankfurt am Main: Suhrkamp, 1963).

30. Helmut Lethen, "Sichtbarkeit: Kracauers Liebeslehre," in *Siegfried Kracauer. Neue Interpretationen*, ed. Michael Kessler and Thomas Y. Levin (Tübingen: Stauffenberg, 1990), 197.

31. Hansen, introduction to *Theory of Film*, x.

32. Wim Wenders, "Vom Traum zum Trauma. Der fürchterliche Western *Spiel mir das Lied vom Tod*," *Filmkritik* 13, no. 11 (November 1969): 649. Wenders's film reviews have been collected and translated into English. See *Emotion Pictures: Reflections on the Cinema*, trans. Sean Whiteside and Michael Hofmann (Boston: Faber and Faber, 1989).

33. Wenders, "Van Morrison," *Filmkritik* 14, no. 6 (June 1970): 292.

34. Wenders, "*Kelek*," *Filmkritik* 13, no. 2 (February 1969): 113.

35. Klaus Kremeier, "Zeit der Flaneure: Der junge deutsche Film und seine Propheten," *Film* 6, no. 6 (June 1968): 2.

36. Heinz Ungureit, "Kann die Filmkritik noch parieren?" *Kirche und Film* 22, no. 5 (May 1969): 3. One finds a number of similar interventions against *Filmkritik*'s aesthetic turn in the Frankfurt journal, *Filmstudio*, many of whose contributors had frequented the lectures of Horkheimer and Adorno.

37. Rutschky, 187.

38. See the section in Rutschky's book entitled "Allegorese des Kinos," 167–193.

39. *Theory of Film*, 167–169. The German title of von Hofmannsthal's essay is "Ersatz für die Träume."

40. Ibid., 168.

41. Ibid., 169. This formulation bears much in common with a sentiment voiced by the Bavarian director, Herbert Achternbusch, arguably the most radical and willful subjectivist among West German auteurs of the 1970s: "I don't want to think at the cinema. I want to see. I scoff at a kind of cinema that won't let me rediscover my own feelings. I demand a sense of justice back from cinema. To keep myself going cinema was always important to me. Too much has been lost in my dreams." See Herbert Achternbusch, *Die Stunde des Todes* (Frankfurt am Main: Suhrkamp, 1975), 10.

42. *Theory of Film*, 165.

43. Rutschky, 189.

44. Olaf Möller, "Passage along the Shadow-Line: Farocki and Others— Approaching a Certain *Filmkritik* Style," trans. Roger Hillman and Timothy Mathieson, *Senses of Cinema* 21 (July–August 2002).

45. Ibid.

46. *Filme* (1980–1982) was published in Berlin and coedited by Antje Goldau, Norbert Grob, Norbert Jochum, and Jochen Brunow; its run lasted thirteen issues.

47. Frank Arnold, "Bekenntnis zur 'offenen Form des Schreibens.' Gespräch mit Norbert Grob und Norbert Jochum über Filme, *Filme* und Filmkritik," *Film-Korrespondenz* 27, no. 2 (February 10, 1981): 21.

48. Ibid., 21–22.

49. Claudius Seidl, *Tempo*, March 1989. Quoted in Karsten Witte, "Von der Diskurskonkurrenz zum Diskurskonsens," in *Die Macht der Filmkritik. Positionen und Kontroversen*, ed. Norbert Grob and Karl Prümm (Munich: edition text + kritik, 1990), 165.

50. Ibid., 164.

51. Joe Hembus, *Der deutsche Film kann gar nicht besser sein: Ein Pamphlet von gestern. Eine Abrechnung von heute* (Munich: Rogner & Bernhard, 1981), 176.

52. Cf. Theodor W. Adorno, *The Jargon of Authenticity*, trans. Knut Tarnowski and Frederic Will (London: Routledge, 2003).

53. Vivian Carol Sobchack, *Carnal Thoughts: Embodiment and Moving Image Culture* (Berkeley: University of California Press, 2004), 55.

54. See Helmut Lethen, "Sichtbarkeit: Kracauers Liebeslehre," in *Siegfried Kracauer. Neue Interpretationen*, ed. Michael Kessler and Thomas Y. Levin (Tübingen: Stauffenberg, 1990), 195–228; Heide Schlüpmann, *Ein Detektiv des Kinos. Studien zu Siegfried Kracauers Filmtheorie* (Frankfurt am Main: Stroemfeld, 1998); Christian Keathley, *Cinephilia and History or The Wind in the Trees* (Bloomington: Indiana University Press, 2006), esp. 112–132; and Miriam Hansen, "Introduction" to *Theory of Film: The Redemption of Physical Reality,* (Princeton: Princeton University Press, 1997), vii–xlv, and "'With Skin and Hair': Kracauer's *Theory of Film*, Marseille 1940," *Critical Inquiry* 19, no. 3 (Spring 1993): 437–469. See as well the thoughtful discussions of Kracauer's *Theory of Film* in Hermann Kappelhoff, *Realismus. Das Kino und die Politik des Ästhetischen* (Berlin: Vorwerk 8, 2008), and Drehli Robnik, "Leben als Loch im Medium: Die Vermittlung des Films durch Siegfried Kracauer," *kolik.film* 2 (2004).

3: The Passenger and the Critical Critic

This essay was first published as "Karsten Witte: The Passenger and the Critical Critic," *New German Critique* 74 (Spring/Summer 1998): 15–22. It appears here with the kind permission of Duke University Press.

1. Karsten Witte, *Der Passagier—Das Passagere. Gedanken über Filmarbeit* (Badenweiler: Oase, 1988), 47.

2. He very much liked Harry Alan Potamkin's description of G. W. Pabst as a director who "indulges in extraterritoriality," describing it in his own words as "a location where the laws of familiar terrains no longer apply." See "China and Yet Not China: *Shanghai Drama* (1938)," in *The Films of G. W. Pabst*, ed. Eric Rentschler (New Brunswick: Rutgers University Press, 1988), 168.

3. The photograph, apparently unposed and caught by a camera unseen by Witte, appears in *Time Out Berlin: The Definitive Guide to Unified Berlin* (London: Penguin, 1993), 101.

4. Recounted by Claudia Lenssen in "Karsten Witte (1944–1995)," *black box* 94 (December 1995): 5.

5. Karsten Witte, "Von der Diskurskonkurrenz zum Diskurskonsens," in *Die Macht der Filmkritik. Positionen und Kontroversen*, ed. Norbert Grob and Karl Prümm (Munich: edition text + kritik, 1990), 161.

6. Witte's engaged and personable presence as an interlocutor comes through poignantly in an interview with his grandmother about her visits to the cinema. [NOTE: articles in this journal as well as its title appear in lower case.] "'meine

ureigene leidenschaft': gespräch mit elsbeth ries, meiner großmutter," *frauen und film* 17 (September 1978): 24–35. Witte was the first male writer to publish in this journal. The same number also includes his review of Nagisa Oshima's *In the Realm of the Senses* (1976) and the transcript of a discussion with Gertrud Koch about the film: "kino als reich der sinne: gespräch zwischen gertrud koch und karsten witte" (39–48).

7. Witte, "Von der Diskurskonkurrenz zum Diskurskonsens," 156.

8. *Im Kino: Texte vom Sehen und Hören* (Frankfurt am Main: Fischer, 1985), 12. On the same page, he quotes a passage from Georg Forster to describe critical endeavor: "There is perhaps no work that drains one's energies more than this unceasing seeing and hearing with its mixture of attention and expectation." Elsewhere he cites Joachim Schumacher's credo: "To partake of the world beyond the ego with an attention to what is out there which also involves a form of politeness to things, is a capacity that one needs to learn." See Witte, "Ästhetische Opposition: Käutners Filme im Faschismus," *Sammlung* 2 (1979): 123.

9. Ibid., 155.

10. He was the editor of a significant collection of film theoretical texts, *Theorie des Kinos: Ideologiekritik der Traumfabrik* (Frankfurt am Main: Suhrkamp, 1972).

11. Witte, "Von der Diskurskonkurrenz zum Diskurskonsens," 160.

12. Witte, "Ende gut, alles gut. Eine Nachbemerkung," in *Lachende Erben, Toller Tag. Filmkomödie im Dritten Reich* (Berlin: Vorwerk 8, 1995), 257.

13. See "Thesen zum Verhältnis von Filmkritik und Produktion," in *Seminar: Filmkritik. Protokolle einer Veranstaltung der Arbeitsgemeinschaft der Filmjournalisten in Frankfurt am Main 1978*, ed. Gertrud Koch and Karsten Witte (Frankfurt am Main: Arbeitsgemeinschaft der Filmjournalisten, 1978), 85–93.

14. Claudius Seidl, "Müssen Kritiker kritisch sein?" in *Die Macht der Filmkritik. Positionen und Kontroversen*, ed. Norbert Grob and Karl Prümm (Munich: edition text + kritik, 1990), 178, 179.

15. "Diskussion zu den Referaten von G. Koch und Karsten Witte," in *Seminar: Filmkritik*, 94.

16. Seidl's review addressed the retrospective at the 1989 Berlin Film Festival devoted to "Europe 1939." The notice appeared on February 18, 1989 in the *Süddeutsche Zeitung*.

17. See Witte's article, "Wie Filmgeschichte schreiben?" *epd Kirche und Film* 34, no. 12 (December 1981): 12–13.

18. Witte, "Wie Filmgeschichte schreiben?" 12.

19. Witte estimated that he had seen and studied half of the era's feature film productions.

20. "The Indivisible Legacy of Nazi Cinema," trans. Eric Rentschler, *New German Critique* 74 (Spring/Summer 1998): 30.

4: The Limits of Aesthetic Resistance

A slightly longer version of this essay originally appeared as "Douglas Sirk Revisited: The Limits and Possibilities of Artistic Agency," *New German Critique* 95 (Spring/Summer 2005): 149–161. It is reprinted here with the kind permission of Duke University Press.

1. Upon his arrival in the New World, Detlef Sierck changed his name to Douglas Sirk. When discussing his German works of the 1930s, I will refer to the director as Sierck.

2. Speaking with two West German interviewers in 1973, Sirk said: "A story nearly always leaves you a chance to express something beyond plot or literary values. . . . In pictures, the place of language has to be taken by the camera—and by cutting. You have to write with the camera." Cited in Heinz-Gerd Rasner and Reinhard Wulf, "Begegnung mit Douglas Sirk (1973)," in *Douglas Sirk. Imitation of Life: Ein Gespräch mit Jon Halliday*, ed. Hans-Michael Bock and Michael Töteberg (Frankfurt am Main: Verlag der Autoren, 1997), 215.

3. The information related to Halliday by Sirk about his upbringing and his alleged Danish heritage was, in fact, apocryphal. See the entry, "Detlef Sierck/Douglas Sirk," in *CineGraph*, installment 8 (Munich: edition text + kritik, 1987), B1.

4. Reprinted in *The Films in My Life*, trans. Leonard Mayhew (New York: Simon & Schuster, 1978), 149.

5. Reprinted in *Godard on Godard*, trans. and ed. Tom Milne (New York: Viking, 1972), 136.

6. See the account of the Sirk reception in France and Great Britain in the first chapter of Barbara Klinger's *Melodrama and Meaning: History, Culture, and the Films of Douglas Sirk* (Bloomington: Indiana University Press, 1994).

7. These discussions involved a trans-Atlantic exchange described by Laura Mulvey as a two-way movement: European intellectuals embraced the products of American popular culture, which were then received back into their homeland and negotiated into academia through another exchange of cultural fantasy, the arrival in the United States of European-grown ideas. See "Americanitis: European Intellectuals and Hollywood Melodrama," reprinted in *Fetishism and Curiosity* (Bloomington: Indiana University Press, 1996), 21.

8. William James Horrigan, "An Analysis of the Construction of an Author: The Example of Douglas Sirk," diss. Northwestern University 1980, 31. One suspects, quipped German critic Wolfram Schütte, "that wise old Sirk (who holds the interviews) is a lot more clever than his deferent young interlocutors." See Schütte's scathing polemic, "Fünf ärgerliche Thesen und eine Frage,"

epd Kirche und Film 27, no. 2 (February 1974): 6. It is well-known that prior to his interview with Halliday, Sirk had read Andrew Sarris's auteurist primer (which includes a laudatory entry on Sirk), *The American Cinema: Directors and Directions 1929–1968* (New York: Dutton, 1968) as well as the first edition of Peter Wollen's *Signs and Meaning in the Cinema* (Bloomington: Indiana University Press, 1969).

9. Horrigan, 37.

10. Horrigan, 35.

11. Klinger, 34.

12. Cf. the conversation between Fritz Göttler and Frieda Grafe, "Imitation is Life: Conversation zu Douglas Sirk," *24* [Munich] 12 (Winter/Spring 1997): 21. We have to think of Sirk, argues Göttler, not just as a melodramatist, but as a genre director, someone who made film noirs, war epics, and Cold War cloak-and-dagger productions. If Sirk refers to Shakespeare in his interviews, he does not do so to raise himself above cinema and evoke elite culture. Rather, claims Göttler, he aligns himself with Shakespeare as a pragmatist and a popular artist aware of the general public. One needs to consider Sirk as someone who recognized how genres worked and respected his audience's expectations. If he infused literature and irony into genre cinema, it was not simply because he believed these elements would ennoble it.

13. Klinger, xvi. .

14. Klinger, 9.

15. Jon Halliday, "Notes on Sirk's German Films," in *Douglas Sirk*, ed. Laura Mulvey and Jon Halliday (Edinburgh: Edinburgh Film Festival, 1972), 20–21.

16. Horrigan, 130–131.

17. -k., "*Schlussakkord,*" *Film-Kurier*, July 25, 1936.

18. For a more general account of Sirk's status in Nazi Germany, see my *The Ministry of Illusion: Nazi Cinema and Its Afterlife* (Cambridge: Harvard University Press, 1996), esp. 129–135.

19. See Prinzler's unpublished manuscript, "The Nobody: The Reception of Douglas Sirk's Films in the Federal Republic of Germany during the Fifties."

20. Typically, critics panned Sirk's films without even mentioning the director's name. There is, however, one striking formulation redolent of subsequent auteurist appreciations in the closing passage of an otherwise-unsigned negative notice on *Written on the Wind*: "The cold glowing colors, the stylized takes, the reserved performances, the super luxurious sets and costumes, all impart to the piece a cold splendor whose cool undertone almost neutralizes the kitsch of the story" (*Filmkritik* 1, no. 6 [June 1957]: 90).

21. Heinz-Gerd Rasner and Reinhard Wulf, "Begegnung mit Douglas Sirk (1973)," reprinted in *Douglas Sirk. Imitation of Life: Ein Gespräch mit Jon Halliday*, 211.

22. The *Filmkritik* interview came in the wake of a Munich Sirk-retrospective in 1972 and accompanied a twenty-five-film tribute in the Munich Film Museum. ARD would air five Sirk films in November 1973; on the 28th of the month, Süd 3 screened Wolfgang Limmer's Sirk-documentary.

23. Contrary to accepted opinion, it was not Fassbinder alone who transformed the nobody Sirk into a somebody in the Federal Republic. Cineastes in Cologne and Munich reconsidered his films with great interest already in the late sixties. The Cinemathek Köln sponsored a series devoted to Sirk's Hollywood melodramas in 1969 and published an elaborate documentation. This event was followed late in the year by a comprehensive work retrospective. See Sebastian Feldmann, "Leserbrief," *epd Film* 3, no. 10 (October 1986): 14.

24. It appeared in the February 1971 issue of *Film und Fernsehen*. For an English translation, see "Imitation of Life: On the Films of Douglas Sirk," in Rainer Werner Fassbinder, *The Anarchy of Imagination*, ed. Michael Töteberg and Leo Lensing (Baltimore: Johns Hopkins University Press, 1992), 77–89.

25. Fassbinder, "Imitation of Life," 78.

26. Fassbinder, "Imitation of Life," 84.

27. See Schilling's comments in "Tradition im Kino 15.10.78," *Filmforum* (December 1978): 61.

28. Walter Bockmayer, "Hommage à Douglas Sirk: Schande für uns und Ehre zu wenig," *Filmforum* (November 1978): 8.

29. "Fünf ärgerliche Thesen und eine Frage," *epd Kirche und Film* 27, no. 2 (February 1974): 6. Schütte particularly has in mind the recent shift in editorial policy of *Filmkritik*.

30. Peter W. Jansen, "Wo Utopie vor die Hunde geht," *epd Kirche und Film* 27, no. 2 (February 1974): 7.

31. Jansen, 7.

32. Jansen, 8.

33. Gertrud Koch, "From Detlef Sierck to Douglas Sirk," trans. Gerd Gemünden, *Film Criticism* 23, no. 2–3 (Winter/Spring 1999): 16.

34. Koch, 25.

35. Linda Schulte-Sasse, "Douglas Sirk's *Schlußakkord* and the Question of Aesthetic Resistance," *Germanic Review* 73, no. 1 (Winter 1998): 5.

36. Schulte-Sasse, 6.

37. See Schulte-Sasse's characterization of "a regime and film apparatus whose own totalizing effect is so well documented" (6).

38. Notes on Sirk and Melodrama," *Movie* 25 (1977–1978): 53.

39. See particularly Witte's essay, "Ästhetische Opposition? Käutners Filme im Faschismus," *Sammlung: Jahrbuch für antifaschistische Literatur und Kunst* 4 (1980): 110–123.

40. "The Indivisible Legacy of Nazi Cinema," trans. Eric Rentschler, *New German Critique* 74 (Spring/Summer 1998): 30.

This essay first appeared as "Springtime for Ufa," *Quarterly Review of Film & Video* 15, no. 2 (Spring 1994): 75–87.

1. *Schauprozeße* (Munich: Piper, 1990), 15.

2. Wolfgang Jacobsen, "Babelsberg, Terra Incognita: Ortsbestimmung," in *Babelsberg. Ein Filmstudio 1912–1992* (Berlin: Stiftung Deutsche Kinemathek/ Argon, 1992), 7.

3. See Anja Henningsmeyer, "Interview mit Ufa-Ausstellungsleiter Dr. Rainer Rother," *zitty*, November 26, 1992, 227. Rother, chief director of the exhibit, spoke of a desire "to create a situation which quotes the reality of the studios without seeking to imitate it. The main idea is to bring the viewer into ever new artificial worlds which do not remain intact, but are shattered and destroyed, in essence a direct confrontation with the dream world."

4. *Die Berliner Zeitung,* for instance, ran a series of unabashedly nostaglic pieces under the title, "Das gab's nur einmal—die deutsche Traumfabrik im Spiegel persönlicher Erinnerungen" (That Happened Only Once—The German Dream Factory in the Mirror of Personal Memories). Sample installments bore headlines like, "No One Had Such Glowing Blue Eyes As He Did" (on Hans Albers), or "They [Ufa films] Were Meant to Further German Spirit," the Third Reich recollections of a former Ufa extra.

5. For a provocative showdown between 'critical critics' and their 'Neue Wilden' opponents, see the collection of essays, *Die Macht der Filmkritik. Positionen und Kontroversen,* ed. Norbert Grob and Karl Prümm (Munich: edition text + kritik, 1990).

6. Cf. Harun Farocki's review of the publication that accompanied the WDR series, "Ein Detektiv in der Ideologiefabrik: Klaus Kreimeier untersucht deutsche Spielfilme," *Frankfurter Rundschau,* June 16, 1972.

7. Klaus Kreimeier, *Kino und Filmindustrie in der BRD: Ideologieproduktion und Klassenwirklichkeit nach 1945* (Kronberg Ts.: Scriptor, 1973), 21.

8. Kreimeier lives as a self-employed writer, the author of career studies of Joris Ivens, Andrej Wajda, Rosa von Praunheim, Andrej Tarkovsky, Akiro Kurosawa, and Wim Wenders. He also writes regular editorials about television and media culture. Recent essays along these lines have appeared as *Notizen im Zwielicht: Fernsehalltag und Bildschirmwirklichkeit* (Hannover: Schüren, 1992).

9. Siegfried Kracauer, *From Caligari to Hitler: A Psychological History of the German Film* (Princeton: Princeton University Press, 1947), 47. For a fundamental criticism of Kracauer's methodology, see Klaus Kreimeier, *Die Ufa-Story. Geschichte eines Filmkonzerns* (Munich: Hanser, 1992), 66.

All subsequent quotations from this book will be cited by page number in the body of the text.

10. Kracauer, "Kalikowelt: Die Ufa-Stadt zu Neubabelsberg," *Frankfurter Zeitung*, January 28, 1926. The translation is from *The Mass Ornament: Weimar Essays*, trans. and ed. Thomas Y. Levin (Cambridge: Harvard University Press, 1995), 283.

11. Recent books on Ufa include *Die Ufa—auf den Spuren einer großen Film-fabrik*, ed. Marlies Krebstakies (Berlin: Elefanten Press, 1987); Jürgen Schebera, *Damals in Neubabelsberg...* (Leipzig: Edition Leipzig, 1990); Friedemann Beyer, *Die UFA-Stars im Dritten Reich. Frauen für Deutschland* (Munich: Heyne, 1991), and *Die Gesichter der UFA. Starporträts einer Epoche* (Munich: Heyne, 1992).

12. *Das Ufa-Buch. Kunst und Krisen, Stars und Regisseure, Wirtschaft und Politik*, ed. Hans-Michael Bock and Michael Töteberg (Frankfurt am Main: Zweitausendeins, 1992). Several related film historical signs of life also deserve mention: shortly after the Ufa exhibit shut down, the Schwules Museum in Berlin sponsored an exhibit on Conrad Veidt and Wolfgang Jacobsen edited a volume in the actor's honor: *Conrad Veidt. Lebensbilder* (Berlin: Argon/ Stiftung Deutsche Kinemathek, 1993). During the summer of 1992, the Film Museum in Potsdam presented an exhibition on Asta Nielsen, which followed the institution's 1991 appreciation of artistic influences on the Weimar films of Fritz Lang.

13. See Bitomsky's comments in an interview with Peter Paul Kubitz, "'Da hat der Krieg sozusagen die Ufa subventioniert,'" *Der Tagesspiegel*, September 10, 1992.

14. Quoted from the press booklet provided by Ostdeutscher Rundfunk Brandenburg.

15. Hans-Christoph Blumenberg, *Das Leben geht weiter. Der letzte Film des Dritten Reichs* (Berlin: Rowohlt, 1993).

16. To be sure, the study pays almost no attention to international perspectives, systematically ignoring the significant secondary literature in English, French, and Italian, in that way replicating the provincialism typical of almost every book published on film in Germany today.

17. Georg Seeßlen, "Der Endsieg des bunten Abends," *Der Tagesspiegel*, December 19, 1992.

18. See Ray Müller's directorial portrait, *Die Macht der Bilder: Leni Riefenstahl* (*The Wonderful Horrible Life of Leni Riefenstahl*, 1993), a film whose apparent deference to the energetic, defiant, and resolutely unrepentant filmmaker in fact questions and at times seriously undermines the director's self-representations.

19. *zitty*, January 7, 1993, 172.

A somewhat-longer version of this essay appeared as "Mountains and Modernity: Relocating the *Bergfilm*," *New German Critique* 51 (Fall 1990): 137–161.

1. Siegfried Kracauer, *From Caligari to Hitler: A Psychological History of the German Film* (Princeton: Princeton University Press, 1947), 257–258. Further references to this book will appear parenthetically in the body of the text with page numbers.

2. See, for instance, David A. Cook, *A History of Narrative Film*, 2nd ed. (New York: Norton, 1990), 129–130n. The author describes the genre as "an exclusively national phenomenon . . . which exploited the Germanic predilection for heroic scenery and winter sports. . . . These were all fiction films, stunningly photographed on location . . . which relied heavily upon spurious sentiment and inflated plots for their dramatic effect. Nevertheless, they enjoyed quite a cult among the German audience, and according to Kracauer, their popularity was a harbinger of the heroic and irrational appeal of Nazism." For similar accounts that rely on Kracauer, see Eric Rhode, *A History of the Cinema: From Its Origins to 1970* (New York: Hill and Wang, 1976), 197–198; and Ulrich Gregor and Enno Patalas, *Geschichte des Films 1895–1939* (Reinbek bei Hamburg: Rowohlt, 1976), 61–62. For comparative perspectives regarding the genre and its presence in other national cinemas, see Pierre Leprohon, *Le Cinéma et la Montagne* (Paris: Susse, 1943). During the 1920s, numerous mountain films also were produced in Austria and Switzerland.

3. Susan Sontag, "Fascinating Fascism," in *Under the Sign of Saturn* (New York: Random House, 1981), 76.

4. Kracauer characterized the genre's intended audience less approvingly in his notice, "*Der Heilige Berg*," *Frankfurter Zeitung*, March 4, 1927, reprinted in *Von Caligari zu Hitler*, ed. Karsten Witte (Frankfurt am Main: Suhrkamp, 1979), 400: "There may be here and there in Germany small youth groups which attempt to counter everything that they call mechanization, by means of an overrun nature worship, i.e. by means of a panic-stricken flight into the foggy brew of vague sentimentality. As an expression of their particular manner of not existing, the film is a masterpiece" (trans. by Thomas Y. Levin). The mountain films reviewed by Kracauer in the *Frankfurter Zeitung* include Arnold Fanck's *Das Wunder des Schneeschuhs* (*The Miracle of the Snow Shoe*), June 16, 1921; William Karfiol's *Firnenrausch* (*Glacier Fever*), March 30, 1924; Max Frankl's *Die Gefahren der Berge* (*The Dangers of the Mountains*), November 15, 1924; Fanck's *Der Berg des Schicksals* (*The Mountain of Destiny*), April 9, 1925; Johannes Meyer's *Der Wilderer* (*The Poacher*), March 20, 1926; and Mario Bonnard's *Die heiligen drei Brunnen/Symphonie der Berge* (*The Holy Three Fountains/Symphony of the Mountains*), April 20, 1930.

5. Joseph Goebbels, *Michael*, trans. Joachim Neugroschel (New York: Amok, 1987), 70. The autobiographical novel was apparently written in 1923 but not published until 1929.

6. For discussions of the master narrative at work in *From Caligari to Hitler*, see Thomas Elsaesser, "Film History and Visual Pleasure: Weimar Cinema," in *Cinema Histories, Cinema Practices*, ed. Patricia Mellencamp and Philip Rosen (Frederick, MD: University Publications of America, 1984), esp. 59–70; Philip Rosen, "History, Textuality, Nation: Kracauer, Burch, and Some Problems in the Study of National Cinemas," *Iris* 2, no. 2 (1984): 71–75; and Patrice Petro, *Joyless Streets: Women and Melodramatic Representation in Weimar Germany* (Princeton: Princeton University Press, 1989), 9–17. For West German contributions to long-standing debates in the Federal Republic about Kracauer's theoretical and methodological assumptions, see *Siegfried Kracauer. Neue Interpretationen*, ed. Michael Kessler and Thomas Y. Levin (Stuttgart: Stauffenburg, 1990). Among the numerous East German discussions of Kracauer (and Weimar film theory in general), see Jörg Schweinitz, "Die Grundlagen des filmtheoretischen Denkens Siegfried Kracauers," *Beiträge zur Film- und Fernsehwissenschaft* 34 (1988): 111–126; and Peter Wuss, "Kult der Zerstreuung: Kracauers Filmkritik als Gesellschaftskritik," *Film und Fernsehen* 18, no. 1 (1990): 45–47.

7. Kracauer's discussion of *Das blaue Licht* (*The Blue Light*, Leni Riefenstahl, 1932) would seem to pose an exception; its protagonist, after all, is a woman. Still, he overlooks Junta's erotic attraction and the sexual frenzy she catalyzes among the community's young males. (We see, for instance, the innkeeper's son lie in wait for Junta like a beast of prey and attempt to rape her.) Instead, Kracauer claims that the villagers' active hostility toward her stems from their superstition. Because this woman, "a sort of gypsy girl [sic]," seems to enjoy sole access to the blue light, people consider her a witch (*From Caligari to Hitler*, 258).

8. Wilhelm Spickernagel, "Der Kinematograph im Dienst der Heimatkunst," *Hannoverland* 6 (1912): 234; quoted in Willi Höfig, *Der deutsche Heimatfilm 1947–1960* (Stuttgart: Enke, 1973), 153.

9. See Fanck's letter of April 24, 1972, in *Fanck—Trenker—Riefenstahl: Der deutsche Bergfilm und seine Folgen*, ed. Klaus Kreimeier (West Berlin: Stiftung Deutsche Kinemathek, 1972), 4: "I admit without reservation—even today at the age of 83—to my heroic conception of the world and in this respect I share the good company of almost every great German mind from centuries before Hitler." Among Fanck's many film books, see his autobiography (whose title derives from a formulation by Béla Balázs), *Er führte Regie mit Gletschern, Stürmen und Lawinen. Ein Filmpionier erzählt* (Munich: Nymphenburger, 1973). See as well the Fanck career interview and homage in *Filmhefte* 2 (Summer 1976). For a sympathetic biographical account that appeared in conjunction with a Fanck

television retrospective, see Hans-Jürgen Panitz's film, *Wer war Arnold Fanck?* (NDR/BR/Omega Film, 1989).

10. Fanck employs an insistent rhetoric of quantification to elucidate his popular appeal in the letter to Kreimeier quoted earlier, stressing the "millions" of enthusiastic viewers who have applauded his films, the "many thousands" of otherwise-hardnosed critics who have praised his work.

11. Arnold Fanck, "Der Kultur-Spielfilm," *Nationalsozialistische Monatshefte* 147 (June 1942): 361ff. See also the unsigned Fanck-portrait, "Der Mensch in der Natur. Die Filmarbeit Arnold Fancks," *Der Deutsche Film* 3, no. 1 (July 1938): 3–5. Even the most beautiful images of nature, Fanck would lament in his autobiography, do not seem capable of entertaining and captivating a popular audience for longer than twenty minutes (*Er führte Regie mit Gletschern*, 131).

12. This is not to say, however, that it met with universal applause; on the contrary, it had quite a few detractors. Béla Balázs's apologia, "Der Fall Dr. Fanck," carefully addresses elements of the *Bergfilm* ridiculed by critics, making it clear that the genre had many enemies. The essay originally appeared as the foreword to Fanck's film book, *Stürme über dem Montblanc* (Basel: Concordia, 1931), v–x. It is reprinted in the second volume of Balázs's *Schriften zum Film*, ed. Wolfgang Gersch (Munich: Hanser, 1984), 287–291. All citations are taken from this latter source.

13. Notice from December 19, 1926, quoted in Arnold Fanck, *Das Echo vom Heiligen Berg* (Berlin, 1926), 7.

14. W. S., *Die Rote Fahne*, November 19, 1929.

15. *Die Rote Fahne*, February 5, 1931. Quoted in *Fanck—Riefenstahl—Trenker*, E8.

16. See Fanck's own documentations of the press response to *Der heilige Berg* (quoted in note 13), *Die weiße Hölle vom Piz Palü* (Berlin, 1929), and *Die Tochter des Samurai* (Berlin, 1938) as well as the materials assembled in *Fanck—Riefenstahl—Trenker*. The director's obsessive collecting of approving words as well as his hypersensitivity toward detractors remind one of Hans Jürgen Syberberg.

17. For details regarding Balázs's work with Riefenstahl, see Joseph Zsuffa, *Béla Balázs: The Man and the Artist* (Berkeley: University of California Press, 1987), 217–230; and John Ralmon, "Béla Balázs in German Exile," *Film Quarterly* 30, no. 3 (Spring 1977): 12–19. Balázs was not the only prominent leftist active in the production of mountain films. The dramatist Friedrich Wolf, working under a pseudonym, coscripted Fanck's *SOS Eisberg* (1933). See Wolf's account, reprinted in "Friedrich Wolf und der Film: Aufsätze und Briefe 1920–1953," ed. Ruth Herlinghaus, *Beiträge zur Film del und Fernsehwissenschaft* 33 (1988): 50. Before emigrating to Paris, Paul Dessau collaborated on the music for Fanck's *Stürme über dem Montblanc*, *Der weiße Rausch*

(*The White Ecstasy*, 1931), and *SOS Eisberg* as well as Max Obal's *Abenteuer im Engadin* (*Slalom*, 1932) and Andrew Marton's *Nordpol-ahoi!* (*North Pole - Ahoy!*, 1934).

18. See note 11. After World War II, Fanck would repeatedly enlist Balázs as a character witness, using the leftist Jew to debunk ideological critics and their attacks on his films. Cf. Fanck's vehement comments about Siegfried Kracauer in his letter to Klaus Kreimeier of April 24, 1972, cited in *Fanck— Trenker—Riefenstahl*: "Because 'Kracauer' is a pure Jewish name [*ein rein jüdischer Name*], I would like to let him in on something which he surely does not yet know: that the vast majority of my films were in fact financed by Jews and produced by Jewish companies; that all of those involved did not even have the foggiest notion that they were helping to lead the masses into the arms of Hitlerism."

19. "Der Fall Dr. Fanck," 288. For a similar formulation, see the unsigned review, "*The White Hell of Piz Palü*," *Close Up* 5, no. 6 (December 1929): "Other mountain films we have had, but we have never had mountains—almost personifiable, things of wild and free moods, forever changing."

20. "Der Fall Dr. Fanck," 290.

21. Ernst Bloch, "Alpen ohne Photographie (1930)," in *Literarische Aufsätze* (Frankfurt am Main: Suhrkamp, 1965), 498. See also Georg Simmel, "Die Alpen," in *Philosophische Kultur*, 2nd rev. ed. (Leipzig: Kröner, 1919), 134–141. Simmel had a crucial intellectual influence on both Balázs and Kracauer.

22. Kracauer, *Theory of Film: The Redemption of Physical Reality* (Oxford: Oxford University Press, 1960), 297.

23. Cf. Ulrich Gregor and Enno Patalas, *Geschichte des Films*, 61; also, Rainer Ruther, "Le Heimatfilm un genre typiquement teutonique," *Cahiers de la Cinémathèque* 32 (Spring 1981): 131. The influential Nazi film critic Oskar Kalbus also characterizes Fanck (albeit positively) as an anti-modern and anti-urban spirit, in *Vom Werden deutscher Filmkunst. Der Tonfilm* (Altona-Bahrenfeld: Cigaretten-Bilderdienst, 1935), 37.

24. Fritz Walter, "Im Ufa-Palast am Zoo läuft *Die weiße Hölle vom Piz Palü*," *Berliner Börsen-Courier*, November 16, 1929.

25. See Thomas Brandlmeier, "Arnold Fanck," in *Cinegraph*, ed. Hans-Michael Bock (Munich: edition text + kritik, 1984ff.). Fanck, points out Brandlmeier, was the fifth person to buy the newly available Arriflex camera in 1938 (E4).

26. Lucy von Jacobi, "*Die weiße Hölle vom Piz Palü*," *Tempo*, November 16, 1929. The critic even goes so far as to grant the mechanical apparatus a supernatural status: "A remarkable miracle of our times, this camera, a divine extension of our weak human eyes." In a review of *Stürme über dem Montblanc*, *Lichtbildbühne*, February 3, 1931, the critic praises both Fanck's monumental nature scenes and his impressive images of an observatory, as if the two were of the same

cast. Reprinted in *Fanck—Riefenstahl—Trenker*, E4. There is an unquestionable relationship between the mountain film and later Nazi films about flying. Heinz Paul's *Das Wunder des Fliegens* (*The Wonder of Flying*, 1935), for instance, features the star flyer Udet reflecting on his past exploits while we see clips from Fanck films of the twenties and early thirties. The final sequence involves yet another rescue mission by Udet in the mountains.

27. William Vaughan, *German Romantic Painting* (New Haven: Yale University Press, 1980), 66.

28. See Hans Feld, "Der Fanck-Film der Aafa," *Film-Kurier*, February 3, 1931. Quoted in *Fanck—Trenker—Riefenstahl*, E6. See also the cinematographer Sepp Allgeier's account, *Die Jagd nach dem Bild*, 2nd rev. ed. (Stuttgart: Engelhorns, 1931), especially his description of location shooting on *The Holy Mountain*: "Sometimes we had to lend a bit of a helping hand when nature did not provide us with camera-ready footage" (62). Cf. Joachim Kroll, "Die filmische Landschaft," *Der Deutsche Film* 3, no. 6 (December 1938): 148. For Kroll, landscapes maintain a photographic interest only to the degree in which they reflect human presence.

29. pe, *Lichtbildbühne*, February 3, 1931. Quoted in *Fanck—Trenker—Riefenstahl*, E3.

30. Immanuel Kant, *Observations of the Feeling of the Beautiful and Sublime*, trans. John T. Goldthwait (Berkeley: University of California Press, 1965), 47.

31. Cf. Simmel, "Die Alpen," 140. Brandlmeier observes that Fanck's compositions frequently lack a middle ground (E2).

32. Fanck, Trenker, and Riefenstahl all stress the athletic element in their film work. In this regard, their career reflections frequently echo Werner Herzog's descriptions of the physical hardship, on-location vicissitude, and heroic struggle that ensue in one's endeavors as a director. Herzog's work shows a clear indebtedness to mountain film rhetoric and iconography. See, for instance, his films *Die große Ekstase des Bildschnitzers Steiner* (*The Great Ecstasy of the Sculptor Steiner*, 1974), *Herz aus Glas* (*Heart of Glass*, 1976), *Gasherbrum—Der leuchtende Berg* (*The Dark Glow of the Mountains*, 1984), and *Schrei aus Stein* (*Scream of Stone*, 1991).

33. Fanck called his documentary film of 1921, *Kampf mit dem Berge* (*Battle with the Mountain*), a "symphony of the Alps." Brandlmeier claims Fanck is at his best when engaging in formal and abstract experimentation, proceeding to note that the director's use of authentic locations and photographic realism also anticipate the *Neue Sachlichkeit* (E3). For a similar discussion that considers Fanck and Ruttmann in the same breath, see Hanno Möbius and Guntram Vogt, *Drehort Stadt. Das Thema "Großstadt" im deutschen Film* (Marburg: Hitzeroth, 1990), 42.

34. Wolfgang Ertel-Breithaupt, *Berliner Tageblatt*, August 31, 1933; quoted in *Fanck—Trenker—Riefenstahl*, E23.

35. Kracauer, *"Der Heilige Berg,"* reprinted in *Von Caligari zu Hitler,* 400.

36. See, for instance, Noël Burch and Jorge Dana, "Propositions," *Afterimage* 5 (Spring 1974): 43–46; and Thomas Elsaesser, "Film History and Visual Pleasure," 70ff.

37. For annual production figures, see "Chronik 1895–1930," in Ilona Brennicke and Joe Hembus, *Klassiker des deutschen Stummfilms 1910–1930* (Munich: Goldmann, 1983), 236ff. The inordinate vitality of the era's film culture inheres as well in the large amount of media attention devoted to it. A 1930 survey by Erwin Ackerknecht lists more than 160 film periodicals (including three daily trade papers) that had appeared in German-speaking countries. See Heinz B. Heller, "Massenkultur und ästhetische Urteilskraft: Zur Geschichte und Funktion der deutschen Filmkritik vor 1933," in *Die Macht der Filmkritik. Positionen und Kontroversen,* ed. Norbert Grob and Karl Prümm (Munich: edition text + kritik, 1990), 37.

38. In general, the widespread emphasis on Weimar's film artists and the relative neglect of its popular audiences blur the fact that works by even the most renowned auteurs like Lang, Murnau, and Pabst regularly occasioned elaborate publicity campaigns, extensive media coverage, and gala premieres. For this reason, I question the tendency in some Weimar film scholarship to privilege a few art films and to set them apart from the era's popular culture. How are we otherwise to explain, for instance, that the two biggest German box office hits for the 1929–1930 season were Fritz Lang's *Frau im Mond* (*Woman in the Moon*) and *The White Hell of Piz Palü?*

39. f. t. g., "Gletscher-Märchen," *Frankfurter Zeitung,* November 15, 1929.

40. Hans Feld, *Film-Kurier,* November 16, 1929.

41. Cf. Carsten Zelle, *Angenehmes Grauen. Literarhistorische Beiträge zur Ästhetik des Schrecklichen im achtzehnten Jahrhundert* (Hamburg: Meiner, 1987).

42. Cf. Joseph Goebbels, *Michael,* 62:

We people of today are expressionists. People who want to shape the
outside world from within themselves.
The expressionist is building a new world within him. His secret and
his power reside in his ardor. . . .
The soul of the expressionist: a new macrocosm. A world of its own.
Expressionist sense of the world is explosive. It is an autocratic sense
of being oneself.

43. Cf. Linda Williams's comments on similar dynamics in the classical horror film, "When the Woman Looks," in *Re-Vision: Essays in Feminist Film Criticism,* ed. Mary Ann Doane, Patricia Mellencamp, and Linda Williams (Frederick, MD: University Publications of America, 1984), 83–99.

44. Petro, 33.

45. See note 34. It is interesting how with the coming of sound and the addition of a voice-over narrator to foreign versions of *The White Hell of Piz Palü*, we find similar complaints about an extraneous and foreign element destroying the film's effect. Reviewers took issue with the traveloguish commentary of Graham McNamee that was added to the film's North American release. See George Blaisdell's review in *The International Photographer* 2, no. 10 (November 1930): "The employment of McNamee as a lecturer on this marvelous subject provides partisans of silent pictures with the most potent arguments yet furnished them" (20). Even more disdainful is James Shelley Hamilton's notice in *Cinema* 1, no. 8 (December 1930): "For certain stretches one may look . . . and marvel, with no distraction, but always at the most engrossing points comes that voice, pepping the thing up in choicest MacNameese, applauding the heroic 'manoeuvers' of the rescuers, prodding on the enthusiasm like a Texas Guinan, till it reaches its climax of eloquence and blah" (42).

46. Cf. Patricia Mellencamp's observations about the blindspot of *From Caligari to Hitler*, "Oedipus and the Robot in *Metropolis*," *Enclitic* 5, no. 1 (Spring 1981): 25–26: "What is not in psychoanalysis' 'field of vision' as well as Kracauer's, except in absence or negative opposition, was female sexuality, the figure of woman, women's sex."

47. To quote Klaus Theweleit: "Powerful forces seem to be at work here." The ocean and mountain will, as the mother prophesies, never wed. In this regard, the film's ultimate denial of Diotima's fantasy resembles the virulently contrastive logic of soldier males. The defensive passages of their discourse, relates Theweleit, "are consistently organized around the sharp contrast between summit and valley, height and depth, towering and streaming. Down below: wetness, motion, swallowing up. Up on the height: dryness, immobility, security." See *Male Fantasies. Volume 1: Women, Floods, Bodies, History*, trans. Stephen Conway et al. (Minneapolis: University of Minnesota Press, 1987), 249.

48. *Das Echo vom Heiligen Berg*, 43. Cf. Thomas Jacobs, "Der Bergfilm als Heimatfilm: Überlegungen zu einem Filmgenre," *Augen-Blick* 5 (1988): A rather banal plot line echoes the mother's wisdom, "the fateful impossibility that incompatible principles might ever unite" (24). In a close analysis that accords a decisive visual and narrative role to Diotima, Jacobs ultimately casts issues of gender aside; indeed, sexual difference is conspicuously absent in his conclusions about the film's critique of modernity and its links to blood-and-soil rhetoric.

49. -ap-, *Vossische Zeitung*, March 2, 1931. *Fanck—Trenker—Riefenstahl*, E8.

50. Another analysis of the film comes to a decidedly different conclusion, stressing how the exchanges between Hella and the meteorologist lack overt eroticism and parallel the chaste and "comradely" gender relations propagated by the pre-fascist "Bündnische" youth movement. This reading, however, conveniently leaves the final sequence and its curious terms of closure unmentioned.

See Beate Bechtold-Comforty et al., "Zwanziger Jahre und Nationalsozialismus: Vom Bergfilm zum Bauernmythos," in *Der deutsche Heimatfilm. Bildwelten und Weltbilder*, ed. Wolfgang Kaschuba (Tübingen: Tübinger Vereinigung für Volkskunde, 1989), 44.

51. For an extended analysis of this film, see my essay, "Fatal Attractions: Leni Riefenstahl's *The Blue Light,*" *October* 48 (Spring 1989): 46–68.

52. See Zsuffa 202–206. Cf. the director's autobiographical account in Leni Riefenstahl, *Memoiren* (Munich: Knaus, 1987), 137–152.

53. Cf. Kracauer's formulation in *From Caligari to Hitler*, 259.

54. For descriptions of Riefenstahl's experiments with filters, time-lapse photography, and lighting, see Peggy Ann Wallace, "An Historical Study of the Career of Leni Riefenstahl from 1923 to 1933," diss., University of Southern California, 1975, 360ff.

55. *Metropolis* has given rise to much recent discussion centering around the relationship between women, nature, and machines in Weimar culture. See Mellencamp (note 46) and Andreas Huyssen, "The Vamp and the Machine: Fritz Lang's *Metropolis,*" in *After the Great Divide: Modernism, Mass Culture, Postmodernism* (Bloomington: Indiana University Press, 1986), 65–81; and Peter Wollen, "Cinema/Americanism/the robot," *New Formations* 8 (Summer 1989): 7–34.

56. Mellencamp, 33.

57. Theweleit, vol. 2, 416. See also Gisela von Wysocki's compelling analysis, "Die Berge und die Patriarchen: Leni Riefenstahl," in *Die Fröste der Freiheit. Aufbruchsphantasien* (Frankfurt am Main: Syndikat, 1980), 70–85.

7: Too Lovely to Be True

This essay was first published as "'The Situation Is Hopeless, But Not Desperate': Ufa's Early Sound Film Musicals," in *Weimar Cinema 1919–1933: Daydreams and Nightmares*, ed. Laurence Kardish (New York: Museum of Modern Art, 2010), 44–59. It appears here with the kind permission of the Museum of Modern Art.

1. Thomas Elsaesser, "Film History and Visual Pleasure: Weimar Cinema" in *Cinema Histories, Cinema Practices*, ed. Patricia Mellencamp and Philip Rosen (Frederick, MD: University Publications of America, 1984), 71.

2. See Lotte H. Eisner, *The Haunted Screen*, trans. Roger Greaves (Berkeley: University of California Press, 1969). Weimar cinema, writes Elsaesser, "has never been a particularly popular cinema. It has always been something of a filmmakers' or film scholars' cinema" (81).

3. To this day, many observers persist in equating Weimar cinema with Expressionist film—a mighty feat of abbreviation, both reductive and

inaccurate, given that of the more than 3,500 German features produced during that era only a handful of them bear the earmarks of the period style. For a detailed and differentiated account of German Expressionist film, see Jürgen Kasten, *Der expressionistische Film. Abgefilmtes Theater oder avantgardistisches Erzählkino? Eine stil-, produktions-, und rezeptionsgeschichtliche Untersuchung* (Münster: MAkS, 1990).

4. The philosopher Karl Jaspers, in his important 1931 diagnosis of the precarious final years of the Weimar Republic, wrote that people have "been uprooted. . . . It is as if the foundations of being had been shattered. . . . The foundations of life quake beneath our feet." See *Die geistige Situation der Zeit* (Berlin: De Gruyter, 1931); published in English as *Man in the Modern Age*, trans. Eden and Cedar Paul (New York: Anchor, 1957), 2.

5. *Ungleichzeitigkeit* is the key concept of Ernst Bloch's seminal analysis *Erbschaft dieser Zeit* (Zürich: Oprecht & Helbling, 1935); published in English as *Heritage of Our Times*, trans. Neville and Stephen Plaice (Berkeley: University of California Press, 1991).

6. The formulation derives from Karl Kraus's often-quoted phrase, "Die Lage ist hoffnungslos, aber nicht ernst, verzweifelt, aber nicht hoffnungslos." See *"Erlaubt ist, was mißfällt." Karl Kraus zum Vergnügen*, ed. Günter Baumann (Ditzinger: Reclam, 2007).

7. The comparison to Lubitsch comes from Karsten Witte, "Too Beautiful to Be True: Lilian Harvey," trans. Eric Rentschler, *New German Critique* 74 (Spring–Summer 1998): 38.

8. See Rudolf Arnheim, "Escape into the Scenery (1932)," in *Film Essays and Criticism*, trans. Brenda Benthien (Madison: University of Wisconsin Press, 1997), 190. Speaking of recent German features, he says, "there is little of note as regards the development of sound film—as is the case everywhere in contemporary film production."

9. Cf. Witte's seminal essay on German revue films, "Visual Pleasure Inhibited: Aspects of the German Revue Film," trans. J. D. Steakley and Gabriele Hoover, *New German Critique* 24–25 (Fall–Winter 1981–82): 238.

10. Anton Kaes, "Film in der Weimarer Republik: Motor der Moderne," in *Geschichte des deutschen Films*, ed. Wolfgang Jacobsen et al., 2nd rev. ed. (Stuttgart: Metzler, 1993), 39–98.

11. See Georg Seeßlen, "Das Unterhaltungskino II: Das Spiel mit der Liebe—Aspekte der deutschen Stummfilmkomödie," in *Die Perfektionierung des Scheins. Das Kino der Weimarer Republik im Kontext der Künste*, ed. Harro Segeberg (Munich: Fink, 2000), 95–96.

12. Ufa's early sound musicals include *Melodie des Herzens* (*Melody of the Heart*, Hanns Schwarz, 1929), *Liebeswalzer* (Wilhelm Thiele, 1930), *Die Drei von der Tankstelle* (*Three from the Filling Station*, Wilhelm Thiele, 1930), *Einbrecher*

(*Murder for Sale*, Schwarz, 1930), *Ihre Hoheit befiehlt* (*Her Grace Commands*, Schwarz, 1931), *Nie wieder Liebe* (*No More Love*, Anatol Litvak, 1931), *Bomben auf Monte Carlo* (*Monte Carlo Madness*, Schwarz, 1931), *Der Kongreß tanzt* (*The Congress Dances*, Erik Charell, 1931), *Zwei Herzen und ein Schlag* (*Two Hearts Beat as One*, Thiele, 1932), *Das Lied einer Nacht* (*One Night's Song*, Litvak, 1932), *Quick* (Robert Siodmak, 1932), *Ein blonder Traum* (*A Blonde Dream*, Paul Martin, 1932), *Ich bei Tag und Du bei Nacht* (*Day and Night*, Ludwig Berger, 1932), *Ich und die Kaiserin* (*The Only Girl*, Friedrich Hollaender, 1933), *Ein Lied für Dich* (*A Song for You*, Joe May, 1933), *Walzerkrieg* (*The Battle of the Waltzes*, Berger, 1933), *Saison in Kairo* (*Cairo Season*, Reinhold Schünzel, 1933), and *Viktor und Viktoria* (*Victor and Victoria*, Schünzel, 1933).

13. Arnheim, "Hans Albers (1931)," in *Film Essays and Criticism*, 220.

14. Arnheim, "Sound Film Gone Astray (1932)," in *Film Essays and Criticism*, 42.

15. Siegfried Kracauer, *From Caligari to Hitler* (Princeton: Princeton University Press, 1947), 205.

16. Béla Balázs, *Theory of the Film*, trans. Edith Bone (New York: Dover, 1970 [original date of publication: 1945]), 204.

17. Ibid., 194.

18. In his scathing review of *The Congress Dances*, Arnheim calls the film "a gumdrop" and mockingly cites approving words about it that appeared in the *Lichtbildbühne*: "What's been concocted is a confection that will tickle the palates of the unknown millions to whom this film is dedicated, like manna from heaven" (Arnheim, "Partly Expensive, Partly Good [1931]," in *Film Essays and Criticism*, 175).

19. Arnheim, *Film*, trans. L. M. Sieveking and Ian F. D. Morrow (London: Faber & Faber, 1933), 171. In 1931, two influential analyses of the commercial film apparatus's regressive workings appeared in German translation: Ilja Ehrenburg's *Die Traumfabrik. Chronik des Films* (Berlin: Malik, 1931) and René Fülöp-Miller's *Die Phantasiemaschine* (Berlin: Zsolnay, 1931).

20. Arnheim, *Film*, 176.

21. Bloch, *Heritage of Our Times*, 25.

22. Ibid., 26.

23. Ibid., 36.

24. "Zapfenstreich bei der Ufa," in Hans Sahl, "*Und doch . . .*" *Essays und Kritiken aus zwei Kontinenten*, ed. Klaus Blanc (Frankfurt am Main: Luchterhand, 1991), 99.

25. Klaus Kreimeier, *Die Ufa-Story. Geschichte eines Filmkonzerns* (Munich: Hanser, 1992), 208.

26. Notable endeavors in this vein include contributions on Ufa operettas by Thomas Koebner, Jörg Schweinitz, and Corinna Müller in Thomas Koebner, ed., *Diesseits der 'Dämonischen Leinwand.' Neue Perspektiven auf das späte Weimarer*

Kino (Munich: edition text + kritik, 2003), 341–408; Michael Wedel's well-researched and comprehensive monograph, *Der deutsche Musikfilm. Archäologie eines Genres, 1914–1945* (Munich: edition text + kritik, 2007); and Corinna Müller's *Vom Stummfilm zum Tonfilm* (Munich: Fink, 2003). In English, see Elsaesser, "It's the End of the Song: Walter Reisch, Operetta and the Double Negative," in *Weimar Cinema and After: Germany's Historical Imaginary* (London: Routledge, 2000), 330–358.

27. The bicycle race between two window washers in *A Blonde Dream* recalls the opening sequence of *Kuhle Wampe*, but with a difference: The friends are having fun, which cannot be said of Bertolt Brecht's desperate jobseekers. Villa Blitz, the country squatter's hut in *A Blonde Dream*, likewise, brings to mind the homeless community outside of Berlin called Kuhle Wampe. The life of the disfranchised in the Ufa feature was decidedly at odds with the situation presented in Slatan Dudow's short documentary, *Zeitprobleme. Wie der Arbeiter wohnt* (*Contemporary Problems. How the Worker Lives*, 1930).

28. Witte, "Wie Filmgeschichte schreiben?" *epd Kirche und Film* 34, no. 12 (December 1981): 12.

29. Described in Kracauer's article, "Not und Zerstreuung: Zur Ufa-Produktion 1931/32," *Frankfurter Zeitung*, July 15, 1931.

30. The titles of several films from 1932 were even more unabashed in their attempt to suggest uplift: Carl Boese's *Man braucht kein Geld* (*You Don't Need Money*) and Kurt Gerron's *Es wird schon wieder besser* (*Things Are Getting Better Already*).

31. Lilian Harvey and Willy Fritsch, the German dream couple, appeared together in a dozen films between 1926 and 1939. As stars, however, their popularity was limited to German-language audiences. And, without question, the chemistry between them is not exactly explosive. When they come together at the end of films, their union is invariably sealed with a kiss, but the viewer remains hard pressed to imagine that it might lead to further intimacy. More than anything they are comrades, very much along the lines of Ben Barr Lindsey's *The Companionate Marriage* (1927), an American guide to domestic designs that was quite popular at the time in Germany.

32. Film critic Curt Riess's voluminous panegyric about the stars and productions of classical German cinema echoes the song's title. See *Das gab's nur einmal. Das Buch der schönsten Filme unseres Lebens*, 2nd rev. ed. (Hamburg: Verlag der Sternbücher, 1957).

33. Kracauer, *From Caligari to Hitler*, 208.

34. Fritsch would also play double roles in Ufa's *The Battle of the Waltzes* and *Amphitryon* (Reinhold Schünzel, 1935).

35. Kracauer, "Kunst und Dekoration," *Frankfurter Zeitung*, October 13, 1931.

36. Arnheim, *Film Essays and Criticism*, 176.

37. Witte, "Too Beautiful to Be True," 38.

38. Schweinitz, "'Wie im Kino!': Die autothematische Welle im frühen Ton-film," in *Diesseits der 'Dämonischen Leinwand,'* 373–392.

39. Willy Haas, *"Ich bei Tag und Du bei Nacht,"* *Film-Kurier,* November 29, 1932.

40. The protagonists of Ufa's *A Blonde Dream* calculate the cost of a better life in minute detail.

41. Kracauer, "Cult of Distraction: On Berlin's Picture Palaces," in *The Mass Ornament: Weimar Essays,* trans. and ed. Thomas Y. Levin (Cambridge: Harvard University Press, 1995), 328.

8: The Management of Shattered Identity

This essay first appeared as "The Place of Rubble in the *Trümmerfilm,*" in *The Ruins of Modernity,* ed. Julia Hell and Andreas Schönle (Durham, NC: Duke University Press, 2010), 418–438. It is reprinted here with the kind permission of Duke University Press.

1. Most filmmakers who worked in this vein, submits Kirsten Burghardt, sought to create the impression of a documentary verisimilitude by employing realistic images of ruined houses and rubble mountains. See "Moralische Wiederaufrüstung im frühen deutschen Nachkriegsfilm," *diskurs film* 8 (1996): 243.

2. Wolfgang Schivelbusch, *Vor dem Vorhang. Das geistige Berlin 1945–1948* (Munich: Hanser, 1995), 15.

3. Schivelbusch, 28–29.

4. See Bettina Greffrath, *Gesellschaftsbilder der Nachkriegszeit. Deutsche Spielfilme 1945–1949* (Pfaffenweiler: Centaurus, 1995), 51–137.

5. Fifty percent of the forty-seven German features that premiered between 1946 and 1948 are set in the shattered streets of a contemporary big city—more often than not, Berlin.

6. Greffrath, 161. Indeed, contemporary reviewers generally praised these films for their refusal to point fingers.

7. Gertrud Koch, "Nachkriegsfilme als Werke der Restauration: Einige Thesen zur Ideologie des 'Trümmerfilms' in Deutschland," *epd Kirche und Film* 31, no. 2 (February 1978): 6–9.

8. See Lotte H. Eisner, *The Haunted Screen,* trans. Roger Greaves (Berkeley: University of California Press, 1969).

9. This is also the case with the French poetic realist classics of the late 1930s and early 1940s, such as Henri-Georges Clouzot's *Le Corbeau* (*The Raven*, 1943), as well as Marcel Carné's *Hotel du Nord* (1938), *Le Jour se lève* (*Daybreak*, 1939), and *Les Visiteurs du Soir* (*Night Visitors,* 1943). See Thomas Brandlmeier, "Von

Hitler zu Adenauer: Deutsche Trümmerfilme," in *Zwischen Gestern und Morgen. Westdeutscher Nachkriegsfilm 1945–1962*, ed. Jürgen Berger et al. (Frankfurt am Main: Deutsches Filmmuseum, 1989), 55.

10. Helmut Käutner, "Demontage der Traumfabrik," *Film-Echo*, June 1947; reprinted in *Käutner*, ed. Wolfgang Jacobsen and Hans Helmut Prinzler (Berlin: Spiess, 1991), 113–114.

11. "Stimmen aus Parkett und Rang. Man mag keine Ruinen," *Der Spiegel*, January 4, 1947.

12. Prominent DEFA documentaries from 1946 include Kurt Maetzig's *Berlin im Aufbau* (*Berlin Being Rebuilt*), Joop Huisken's *Potsdam baut auf* (*Potsdam Rebuilds*), Richard Groschopp's *Dresden*, and Kurt Maetzig and Max Jaap's *Leipziger Messe 1946* (*Leipzig Fair 1946*).

13. Staudte's original scenario was toned down by the cultural attaché of the Soviet sector. The script had ended with Mertens hunting down and killing a war criminal; the revised ending demanded that the guilty be called to justice without permitting the hero to fulfill his homicidal desire.

14. An alternative title that was used in the early screenings of the film was *Der Mann, den ich töten werde* (*The Man I'm Going to Kill*).

15. Egon Netenjakob, "Ein Leben gegen die Zeit: Versuch über WS," in Egon Netenjakob et al., *Staudte* (Berlin: Spiess, 1991), 24.

16. The October 16, 1946, issue of *Sonntag*, in which a review of the film appeared, featured a lead story about the execution of Nuremberg war criminals. See Christiane Mückenberger and Günter Jordan, *"Sie sehen selbst, Sie hören selbst . . . " Eine Geschichte der DEFA von ihren Anfängen bis 1949* (Marburg: Hitzeroth, 1994), 42.

17. Guntram Vogt, *Die Stadt im Kino. Deutsche Spielfilme 1900–2000* (Marburg: Schüren, 2001), 420.

18. Walter Lennig, "Ein Film der deutschen Wirklichkeit," *Berliner Zeitung*, October 17, 1946.

19. Mückenberger and Jordan, 44.

20. Wolfdietrich Schnurre, *Deutsche Film-Rundschau*, November 5, 1946; reprinted in *Wolfgang Staudte*, ed. Eva Orbanz (West Berlin: Spiess, 1977), 104–105.

21. Brandlmeier, 34. The author is more favorably disposed toward the cycle than most of his peers; he considers several rubble films to be minor masterpieces.

22. Greffrath, 142.

23. The only rubble films in which Jewish victims of the Third Reich assume a significant role are Kurt Maetzig's *Ehe im Schatten* (*Marriage in the Shadows*, 1947), *Morituri* (Eugen York, 1947), Herbert B. Fredersdorf and Marek Goldstein's *Lang ist der Weg* (*Long Is the Road*, 1949), and Josef von Baky's *Der Ruf* (*The Last Illusion*, 1949).

24. Sebald, "Air War and Literature," in *On the Natural History of Destruction*, trans. Anthea Bell (New York: Random House, 2003), 10.

25. Sebald, ix.

26. Sebald, ix.

27. The film is available as a special feature on the DVD edition of Irmgard von zur Mühlen's *Berlin Ruine 1945—Metropole 2000* (Berlin: Chronos-Media, 2000).

28. Another notable non-German rubble film by an exiled filmmaker was Fred Zinnemann's *The Search* (1948).

29. Hans-Christoph Blumenberg, *Das Leben geht weiter. Der letzte Film des Dritten Reichs* (Berlin: Rowohlt, 1993), 82.

30. Rubble figures strongly in a host of postwar features by noteworthy international directors, such as Leo Lindtberg, Akira Kurosawa, Carol Reed, Andrzej Wajda, and Alain Resnais.

31. Theodor W. Adorno, "What Does Coming to Terms with the Past Mean?" trans. Timothy Bahti and Geoffrey Hartman, in *Bitburg in Moral and Political Perspective*, ed. Geoffrey Hartman (Bloomington: Indiana University Press, 1986), 114–129.

32. See Anson Rabinbach, *In the Shadow of Catastrophe* (Berkeley: University of California Press, 1997), 9. Additional important postwar prospects include Martin Heidegger's "Letter on Humanism" (1947), Erich Fromm's *Man for Himself* (1947), and Max Picard's *Hitler in Our Selves* (1947). Numerous literary texts also addressed the burden of German guilt, as well as a host of periodicals, such as *Der Aufbau, Der Ruf*, and *Die Wandlung*.

33. Friedrich Meinecke, *The German Catastrophe*, trans. Sidney B. Fay (Boston: Beacon, 1950), xi. All further references from this source will be cited by author and page number in the body of the text.

34. Karl Jaspers, *The Question of German Guilt*, trans. E. B. Ashton (New York: Capricorn, 1961), 14. All further references from this source will be cited by author and page number in the body of the text.

35. Brandlmeier, 33. "The creation of a culture of redemption," submits Robert Shandley, "was the initial and perhaps primary work" of the rubble films. See *Rubble Films: German Cinema in the Shadow of the Third Reich* (Philadelphia: Temple University Press, 2001), 182. See also Elliott Stein's assessment of *The Murderers Are Among Us* in "Rubble Indemnities," *The Village Voice*, April 10, 2002: "An uneasy mix of shadowy expressionism and doc verisimilitude, this stark film offers little in the way of political analysis, although its moral indignation is somewhat convincing."

36. Susan Sontag, *On Photography* (New York: Farrar, Straus & Giroux, 1977), 11.

37. Heinz Lüdecke, "Es kommt auf die Einstellung an," *Bildende Kunst* (July 1948): 14. Cf. Béla Balázs, *Schriften zum Film. Band 2. Der Geist des Films*, ed. Helmut H. Dietrich and Wolfgang Gersch (Berlin: Henschel, 1984), 71.

38. The timecode markings refer to the American DVD edition of *The Murderers Are Among Us* released in 1999 by Icestorm International and First Run Features.

39. Sebald, 50.

40. Lüdecke, 12.

41. Sebald, 53, 60.

42. Lüdecke, 12.

43. Werner Fiedler, "Der Weg durch die Trümmer," *Neue Zeit* 17 October 1946; reprinted in *Wolfgang Staudte*, ed. Eva Orbanz (Berlin: Spiess, 1977), 97.

44. *Der Morgen*, June 29, 1946 (quoted in Vogt, 419).

45. Hubert Spiegel, "Deutsche Gesichter—Fotografien von Henry Ries aus dem zerstörten Berlin," *Frankfurter Allgemeine Zeitung*, July 4, 1998.

46. F. L. [Friedrich Luft], "*Die Mörder sind unter uns*," *Die Neue Zeitung*, October 18, 1946.

47. André Bazin, "The Evolution of the Language of Cinema," in *What Is Cinema?* trans. Hugh Gray (Berkeley: University of California Press, 1967), 37.

48. Schivelbusch, 30.

49. Peter Schjeldahl, "Inspired Lunacy," *The New Yorker*, October 1, 2001, 117.

50. Annie Bourneuf, "The Angel of Photography," Senior Honors Thesis, Harvard College, 2001, 40.

51. In the German Democratic Republic, rubble films will quickly give way to the constructive designs of DEFA's antifascist retroscenarios. In some noteworthy cases (particularly the films of Konrad Wolf), these productions will offer differentiated tableaus of people between the fronts faced with hard political and moral choices. In less estimable and more typical instances, socialist realist orthodoxy will become a form of state surrealism; films will remake the world in the shape of heroic Potemkin villages that commingle what J. Hoberman has termed "strict idealization and naive, almost goofy idealism." See Hoberman's *The Red Atlantis* (Philadelphia: Temple University Press, 1998), 16.

52. Béla Balázs, "Der Fall Dr. Fanck," in *Schriften zum Film, Band 2*, ed. Wolfgang Gersch (Berlin: Henschel, 1984): 287–291. Eugen Klagemann, Staudte's cinematographer, had in fact produced photographic stills for various mountain films of the Weimar and Nazi eras.

53. Upon her return, she says to Mondschein, "It's so hard to forget," but this will be her sole reference to wartime hardship.

54. See Erica Carter, "Sweeping Up the Past: Gender and History in the Postwar German 'Rubble Film,'" in *Heroines without Heroes: Reconstructing Female and National Identities in European Cinema, 1945–1951*, ed. Ulrike Sieglohr (London: Cassell, 2000), 102.

55. For valuable insights on the pertinence of the Eurydice myth for postwar discourse, see Julia Hell, "The Angel's Enigmatic Eyes, or The Gothic Beauty of

Catastrophic History in W. G. Sebald's 'Air War and Literature,'" *Criticism* 46, no. 3 (Summer 2004): 361–392.

56. Netenjakob, 24.

57. Carter, 91.

58. See the film script in Peter Pleyer, *Deutscher Nachkriegsfilm 1946–1948* (Münster: Fahle, 1965), 181: Susanne and Hans walk toward the camera until they fill the frame space and the ruins in the background are no longer visible.

59. Greffrath, 173.

60. Alexander and Margarete Mitscherlich, *Die Unfähigkeit zu trauern. Grundlagen kollektiven Verhaltens* (Munich: Piper, 1967), 19.

61. Jeanpaul Goergen, "Aufnahmen beglaubigter Kameraleute," *Filmblatt* 19/20 (Summer/Fall 2002): 28. See also Brewster S. Chamberlin, "*Todesmühlen*. Ein früher Versuch zur Massen-'Umerziehung' im besetzten Deutschland 1945–1946," *Vierteljahreshefte für Zeitgeschichte* 29, no. 3 (July 1981): 420–436.

62. Aleida Assmann and Ute Frevert, *Geschichtsvergessenheit. Geschichtsversessenheit. Vom Umgang mit deutschen Vergangenheiten nach 1945* (Stuttgart: Deutsche Verlags-Anstalt, 1999), 117.

63. Assmann and Frevert, 122.

64. Assmann and Frevert, 139.

65. Quoted in Assmann and Frevert, 118.

66. Andreas Huyssen, "Rewritings and New Beginnings: W. G. Sebald and the Literature on the Air War," in *Present Pasts* (Stanford: Stanford University Press, 2003), 156.

9: After the War, Before the Wall

A longer version of this essay first appeared as "German Film after the War and before the Wall: Seven Short Takes," in *After the War, Before the Wall: German Cinema 1945–60*, ed. Richard Peña (New York: Film Society of Lincoln Center, 2002), 1–2.

1. Cf. Nikolaus Jungwirth and Gerhard Kromschröder, *Die Pubertät der Republik: Die 50er Jahre der Deutschen* (Frankfurt am Main: Fricke, 1979).

2. See the annual listings in Hans Helmut Prinzler, *Chronik des deutschen Films 1895–1994* (Stuttgart: Metzler, 1995).

3. See, for instance, Joe Hembus, *Der deutsche Film kann gar nicht besser sein* (Bremen: Schünemann, 1961) and Walter Schmieding, *Kunst oder Kasse. Der Ärger mit dem deutschen Film* (Hamburg: Rütten & Loening, 1961).

4. See Alexander and Margarete Mitscherlich, *Die Unfähigkeit zu trauern. Grundlagen kollektiven Verhaltens* (Munich: Piper, 1967).

This essay first appeared as "Remembering Not to Forget: A Retrospective Reading of Kluge's *Brutality in Stone*," *New German Critique* 49 (Winter 1990): 23–41.

1. Scene from Alexander Kluge's *Die Artisten in der Zirkuskuppel: ratlos* (*Artists under the Big Top: Perplexed*, 1968).

2. *Brutality in Stone* (1961), 320 meters (12 minutes), 35mm, black and white. Scripted, edited, and produced by Kluge and Schamoni; cinematography by Wolf Wirth; music by Hans Posegga; speaking voices include Christian Marschall, Hans Clarin, and Karyn Kluge. The film premiered on February 8, 1961, at the Oberhausen Film Festival and received numerous prizes. In 1963, a slightly revised version with the title *Die Ewigkeit von gestern* (*Eternity of Yesterday*) gained the distinction "valuable" (*wertvoll*) from the Film Rating Board in Wiesbaden. A subtitled DVD is available from the Edition Film Munich. For initial responses to the film, see Walter Schmieding's notice in *Weg zum Nachbarn. Protokoll der VII. Westdeutschen Kurzfilmtage* (Oberhausen: Oberhausen Film Festival, 1961); and Enno Patalas, "Der Kurzfilm sucht die Wirklichkeit," *Filmkritik* 5 (March 1961): 138. Patalas stresses the film's documentary impetus: "The creator confronts reality as an interpreter. He no longer remains content with recounting 'dramas of everyday events'; he himself confronts reality." For subsequent discussions, see *Herzog/Kluge/Straub*, ed. Peter W. Jansen and Wolfram Schütte (Munich: Hanser, 1976), 132; and Rainer Lewandowski, *Die Filme von Alexander Kluge* (Hildesheim: Olms, 1980), 288–291.

3. For initial orientations, see Charles S. Maier, *The Unmasterable Past: History, Holocaust, and German National Identity* (Cambridge: Harvard University Press, 1988); and "Special Issue on the *Historikerstreit*," *New German Critique* 44 (Spring/Summer 1988).

4. See, for instance, *Nazi-Kunst ins Museum?* ed. Klaus Staeck (Göttingen: Steidl, 1988); and the special issue of *Tendenzen* (Munich) devoted to "Nazi-kunst ins Museum?" 157 (January–March 1987). See also the catalogue, *Inszenierung der Macht. Ästhetische Faszination im Faschismus*, ed. Klaus Behnken and Franz Wagner (West Berlin: Neue Gesellschaft für bildende Kunst, 1987). This extensive collection of essays accompanied an exhibition of fascist art in the Kunstquartier Ackerstrasse in Berlin-Wedding during the spring of 1987.

5. Quoted in Dietrich Kuhlbrodt, "Leni Riefenstahl wieder offiziell," *Die Zeit*, July 24, 1964.

6. See Christian Bauer's documentary, *Phönix aus der Asche: Hans Abich und der Filmaufbau Göttingen*, screened on the West German first channel (ARD), August 4, 1988. For a lengthy interview with Abich regarding his long career in German film and television, see Rainer Gansera, "Hans

Abich—Begegnungen, Erinnerungen und Ausblick," *epd Film* 5, no. 9 (September 1988): 20–29.

7. For statistics regarding the participation of filmmakers active during the Third Reich in postwar West German productions, see Hans-Peter Kochenrath, "Kontinuität im deutschen Film, 1966," in *Film und Gesellschaft in Deutschland. Dokumente und Materialien*, ed. Wilfried von Bredow and Rolf Zurek (Hamburg: Hoffmann und Campe, 1975): 289–290.

8. Leonard Gmür, "Zur Chronik," in *Der junge deutsche Film: Dokumentation zu einer Ausstellung der Constantin-Film* (Munich: Constantin-Film, 1967), 22.

9. For critical assessments of the postwar film malaise in West Germany, see Joe Hembus, *Der deutsche Film kann gar nicht besser sein* (Bremen: Schünemann, 1961); and Walther Schmieding, *Kunst oder Kasse. Der Ärger mit dem deutschen Film* (Hamburg: Rütten & Loening, 1961). Subsequent accounts in the 1980s have been far less critical. See, for instance, Manfred Barthel, *So war es wirklich. Der deutsche Nachkriegsfilm* (West Berlin: Herbig, 1986); Gerhard Bliersbach, *So grün war die Heide. Der deutsche Nachkriegsfilm in neuer Sicht* (Weinheim: Beltz, 1985); and Claudius Seidl, *Der deutsche Film der fünfziger Jahre* (Munich: Heyne, 1987). For an overview of film during the Adenauer era, see Eric Rentschler, "Germany: The Past That Would Not Go Away," in *World Cinema since 1945*, ed. William Luhr (New York: Ungar/Continuum, 1987), 213–219.

10. See Georg Ramseger, "1961: Ist der deutsche Film am Ende? Rede zur Verleihung des Deutschen Filmpreises am 25. Juni 1961 in Berlin," in *Deutscher Filmpreis 1951–1980*, ed. Manfred Hohnstock and Alfons Bettermann (Bonn: Bundesminister des Innern, 1980), 52–58. Klaus Kreimeier analyzed the West German situation at length in *Kino und Filmindustrie in der BRD. Klassenwirklichkeit nach 1945* (Kronberg: Scriptor, 1973). See also Michael Dost et al., *Filmwirtschaft in der BRD und in Europa. Götterdämmerung in Raten* (Munich: Hanser, 1973).

11. Cited as translated in *West German Filmmakers on Film: Visions and Voices*, ed. Eric Rentschler (New York: Holmes & Meier, 1988), 2.

12. Kluge acknowledged this point in an interview. See Rainer Lewandowski, *Die Oberhausener. Rekonstruktion einer Gruppe 1961–1982* (Diekholzen: Regie, 1982), 86.

13. The essay appeared as "Was wollen die 'Oberhausener?'" in the November 1962 issue of *epd Kirche und Film*. Cited as translated in Rentschler, *West German Filmmakers*, 10.

14. Lewandowski, *Die Oberhausener*, 86–87.

15. The Hochschule für Gestaltung in Ulm was a postwar extension of the Bauhaus, whose historical example the young filmmakers wished to emulate. See Klaus Eder and Alexander Kluge, *Ulmer Dramaturgien. Reibungsverluste* (Munich: Hanser, 1980), 35.

16. The post-screening discussions were documented in *Der Spielfilm im Dritten Reich*, ed. Manfred Dammeyer (Oberhausen: Westdeutsche Kurzfilmtage, 1966).

17. Peter W. Jansen, "Die Wunderwaffe des Joseph Goebbels: *Kolberg*, ein Film und seine Geschichte zwanzig Jahre danach," *Frankfurter Allgemeine Zeitung*, September 27, 1965.

18. Quoted in the unsigned article, "NS-Filme in bundesdeutschen Kinos?" *epd Kirche und Film* 18 (November 1965): 17.

19. Ibid.

20. Siegfried Kracauer, *From Caligari to Hitler: A Psychological History of the German Film* (Princeton: Princeton University Press, 1947), 7; quoting Horace M. Kallen, *Art and Freedom, Vol. 2* (New York: Duell, Sloane and Pearce, 1942), 809. We dare not forget that Kracauer started out as an architect and remained throughout his endeavors remarkably sensitive to structures and streets as crucial signifiers of modernity.

21. David L. Vierling discusses the term *Zusammenhang* and the challenges it poses to an English subtitler of Kluge's films. The term, he observes, "is a mystery worth exploring. What, then, does it mean? *Zusammen*: together. *Hängen*: to adhere, to cling; to stick. *Zusammenhang*: the state of fitting together; context; association; continuity." See Vierling's article, "Quinzaine: *Die Patriotin*, Alexander Kluge: 'A Question of *Zusammenhang*,'" *Kino: German Film* 2 (Spring 1980): 22.

22. Cf. the formulation from Walter Benjamin's *Das Passagenwerk*, quoted in *Bestandsaufnahme. Utopie Film*, ed. Alexander Kluge (Frankfurt am Main: Zweitausendeins, 1983): "Even technology, and not only architecture, is in certain manifestations the embodiment of a collective dream" (426).

23. Walter Benjamin, *Illuminations*, trans. Harry Zohn (New York: Schocken, 1969), 257.

24. "The murdered," argues Adorno, "are to be cheated out of the one thing that our powerlessness can grant them: remembrance." See Adorno's essay, "What Does Coming to Terms with the Past Mean?," trans. Timothy Bahti and Geoffrey Hartman in *Bitburg in Moral and Political Perspective* (Bloomington: Indiana University Press, 1986), 117.

25. Cf. Wolfgang Staudte's comments, cited in Katrin Seybold, "Die Welt verbessern mit dem Geld von Leuten, die die Welt in Ordnung finden," in *Wolfgang Staudte*, ed. Eva Orbanz, 3rd rev. ed. (West Berlin: Spiess, 1977), 30–57.

26. See *Die ersten drei Jahre*, ed. Norbert Kückelmann (Munich: Kuratorium Junger Deutscher Film, 1968); also, Sheila Johnston, "The Author as Public Institution: The 'New' Cinema in the Federal Republic of Germany," *Screen Education* 32/33 (Autumn–Winter 1979–1980): 67–78.

27. "Autorenfilm/Politik der Autoren," in *Bestandsaufnahme*, 576–581.

28. Hartmut Bitomsky, "Der Kotflügel eines Mercedes-Benz: Nazikultur-filme," *Filmkritik* 27 (October 1983): 445.

29. See Reitz's comment in Lewandowski, *Die Oberhausener*, 136: "We were particularly interested in a sort of anti-architecture which had arisen. We were inspired by the operative beauty of the ruins."

30. *Bestandsaufnahme*, 536.

31. Quoted in Barbara Miller Lane, *Architecture and Politics in Germany 1918–1945* (Cambridge: Harvard University Press, 1968), 188. For other perspectives on Nazi architecture, see Dieter Bartetzko, *Illusionen in Stein* (Reinbek bei Hamburg: Rowohlt, 1985).

32. Lane, 215.

33. Benjamin, "The Work of Art in the Age of Mechanical Reproduction," in *Illuminations*, 240.

34. Kluge, "Thesen II," in *Bestandsaufnahme*, 535–536. Cf. the discussion, "Probleme des Dokumentarfilms," in *Ulmer Dramaturgien*, 51–56.

35. Kluge, *Bestandsaufnahme*, 213–216, esp. 214. Authenticity means atten-tiveness in the midst of distraction, a relaxed yet nonetheless critical relation-ship between spectator and film, which is mirrored in the authentic text's mode of address. A film that seeks to destroy the autonomy of the spectator, argues Kluge, "also destroys itself." In Kluge's language, the authentic text is both objec-tive ("sachlich") and biased ("unsachlich").

36. See my analysis of *Machorka-Muff* in "The Use and Abuse of Memory: New German Film and the Discourse of Bitburg," *New German Critique* 36 (Fall 1985): 73–76.

37. Kluge, *Gelegenheitsarbeit einer Sklavin. Zur realistischen Methode* (Frankfurt am Main: Suhrkamp, 1975), 216.

38. Cf. Jeffrey Herf, *Reactionary Modernism: Technology, Culture, and Politics in Weimar and the Third Reich* (Cambridge: Cambridge University Press, 1984).

39. For useful appreciations of Kluge's project in its multiple facets, see Miriam Hansen's various essays, including "Collaborative Auteur Cinema and Oppositional Public Sphere: *Germany in Autumn*," *New German Critique* 24–25 (Fall–Winter 1981–1982): 35–56; "Alexander Kluge, Cinema and Public Sphere: The Construc-tion Site of Counter-History," *Discourse* 6 (Fall 1985): 53–74; "Alexander Kluge: Crossings Between Film, Literature, and Critical Theory," in *Film und Literatur. Literarische Texte und der neue deutsche Film*, ed. Sigrid Bauschinger et al. (Berne: Francke, 1984), 169–196; and "The Stubborn Discourse: History and Story-Telling in the Films of Alexander Kluge," *Persistence of Vision* 2 (1985): 19–29. See also the special issue of *October* devoted to Kluge, ed. Stuart Liebman 46 (Fall 1988).

40. The script was published in the journal *Film* 4 (June 1966): 45–56.

41. See the summary of the film in the program of "New German Films" presented at the 1984 Berlinale: "The love story of Clara Wieck and Robert

Schumann, but also the love-hate story of Schumann and Friedrich Wieck, Clara's father, whose bond with his daughter lies beyond mere paternal love: in managing her career he seeks his own artistic self-fulfillment." The film starred Nastassaja Kinski, Rolf Hoppe, and Herbert Grönemeyer. Cf. Gertrud Koch's devastating review in *epd Film* 3, no. 12 (December 1986): "Schamoni makes a political connection between the artist's biography and the resistance against Napoleonic occupation troops: in the confused context of the film this amounts ultimately to a more pernicious form of German chauvinism" (37).

42. From an interview in *Der Spiegel*, reprinted in Staeck, 14.

43. Staeck, 15.

44. Christo, "Wrapping up Germany," *semiotexte* 11 (1982): 20.

45. Cf. Bruno Fischli, "Rekonstruktion, Retro-Scenario, Trauerarbeit, Aufarbeitung—oder was? Neue Filme über den alten Faschismus," in *Jahrbuch Film 79/80*, ed. Hans Günther Pflaum (Munich: Hanser, 1979), 63–75.

46. Saul Friedländer, *Reflections of Nazism: An Essay on Kitsch and Death*, trans. Thomas Weyr (New York: Harper, 1984), 11–12.

47. Cf. Reitz's essay, "The Camera Is Not a Clock," in *West German Filmmakers*, 139f.

48. In his voice-over, Kluge introduces Gabi Teichert as a "history teacher in Hesse, a patriot, i.e., she is interested in all of the Reich's dead."

49. Kluge uses the abbreviation RAF, which, for contemporary viewers, also brought to mind the Red Army Faction. In this way, he leaves open the possibility that one interpret the Allied air attacks on Hamburg as acts of terrorism.

50. *The Last Company*, in fact, is set during the Wars of Liberation against Napoleon.

51. *Reflections of Nazism*, 97.

52. *Bestandsaufnahme*, 473.

53. Cf. Anton Kaes, *Deutschlandbilder. Die Wiederkehr der Geschichte als Film* (Munich: edition text + kritik, 1987).

54. Alexander Kluge, *Der Angriff der Gegenwart auf die übrige Zeit* (Frankfurt am Main: Syndikat, 1985), 107.

55. Cf. Jean Baudrillard's characterization of a naive mode of "technological optimism" regarding the media and their progressive potential in "The Mass: The Implosion of the Social in the Media," in Baudrillard, *Selected Writings*, ed. Mark Poster (Stanford: Stanford University Press, 1988). For dialectical materialists, claims Baudrillard, "the media constitute a new, gigantic productive force and obey the dialectic of productive forces. Momentarily alienated and submitted to the law of capitalism, their intensive development can only eventually explode this monopoly" (207).

56. See Alexander Kluge, "Theses about the New Media," in Rentschler, *West German Filmmakers*, 30–32.

57. Kluge's and Baudrillard's quite different responses to Mogadishu and Stammheim provide a telling contrast: compare, for instance, *Germany in Autumn* to "Our Theater of Cruelty." See Baudrillard, *In the Shadow of the Silent Majorities . . . or the End of the Social*, trans. Paul Foss et al. (New York: semiotexte, 1983), 111–123.

58. See Gary Indiana's interview with Kluge, "The Demolition Artist," *Village Voice*, October 25, 1988, in which Kluge speaks of treating cinema "as a time-producing animal. I think this is the meaning of film history. Commercial cinema absorbs time—like in Hitchcock. Suspense takes time away: if a bomb is ticking under this table, it's not interesting what we say, or how we feel. It's killing time. I think to produce time is a very high ideal of all the arts" (67).

59. Kluge, *Angriff der Gegenwart*, 41–42.

11: Many Ways to Fight a Battle

This essay was first published as "'There Are Many Ways to Fight a Battle': Young Fassbinder and the Myths of 1968," in *A Companion to Rainer Werner Fassbinder*, ed. Brigitte Peucker (Boston: Blackwell, 2012), 423–440. It appears here with the kind permission of Blackwell Publishing Ltd.

1. Wolfgang Etten, "Der lange Abschied: Fassbinder und die Mythen des neuen deutschen Films," *Film-Dienst* 45, no. 11 (May 26, 1992): 6.

2. Andreas Kilb, "Rainer Doesn't Live Here Anymore," *Film Comment* 24, no. 4 (July–August 1988): 49.

3. For some conservative observers, the abbreviation RWF also brought to mind associations with the RAF, the terrorist Red Army Faction. See Holger Siemann, "Das RWF," *tip*, June 4, 1992.

4. "The Oberhausen Manifesto," in *West German Filmmakers on Film*, ed. Eric Rentschler (New York: Holmes & Meier, 1988), 2.

5. See also Helma Sanders-Brahms's recollection, "New German Cinema, jeune cinéma allemand, Good Night: A Day in Oberhausen 1982 (1982)," in *West German Filmmakers on Film*, 222: "One makes films—one can also say: one shoots them. It follows . . . that the film camera is a weapon. In class struggle. 'When the oppressors have finished speaking, then the oppressed will speak,' we knew this from Brecht, and we thought that the oppressors had spoken much too long and because we now wanted to have our say, it was logical that we identified with the oppressed whose turn it was now to speak. Shooting. Shooting films."

6. Peter Zadek's *Ich bin ein Elefant, Madame* (*I Am an Elephant, Madame*, 1969) depicted unruly high school students in Bremen and a variety of exercises in political provocation. Michael Verhoeven's Brechtian reworking of American

violence in Vietnam, *O.K.* (1970), provoked extreme reactions and, in fact, ignited a scandal that closed down the Berlin Film Festival.

7. See Hans Helmut Prinzler, "Filme der Studentenbewegung," in *Deutschlandbilder*, ed. Gabriela Seidel (Berlin: Freunde der deutschen Kinemathek, 1997), 117–142; also the collection of essays, *Kino-Fronten. 20 Jahre '68 und das Kino*, ed. Werner Petermann and Ralph Thoms (Munich: Trickster, 1988).

8. Wolfgang Limmer, *Rainer Werner Fassbinder, Filmemacher* (Reinbek bei Hamburg: Spiegel, 1981), 16–17.

9. Wilfried Wiegand, "Interview I," in *Rainer Werner Fassbinder*, ed. Peter W. Jansen and Wolfram Schütte, 5th rev. ed. (Munich: Hanser, 1985), 81.

10. Wilhelm Roth, "Kommentierte Filmographie," in *Rainer Werner Fassbinder*, ed. Peter W. Jansen and Wolfram Schütte, 5th rev. ed. (Munich: Hanser, 1985), 141.

11. Ibid., 141.

12. Thomas Elsaesser, *Fassbinder's Germany* (Amsterdam: University of Amsterdam Press, 1996), 272. *The Niklashausen Journey*, Elsaesser argues suggestively but somewhat elliptically, can be compared with contemporary young German films like Werner Herzog's *Lebenszeichen* (*Signs of Life*, 1968) and *Auch Zwerge haben klein angefangen* (*Even Dwarfs Started Small*, 1970), Hans Jürgen Syberberg's *San Domingo* (1970) and *Scarabea* (1969), Alexander Kluge's *Die Artisten in der Zirkuskuppel: ratlos* (*The Artists under the Big Top: Perplexed*, 1968), and Edgar Reitz's *Cardillac* (1969).

13. According to Wilhelm Roth, only one very poor copy of the film remained in existence after the television screening; it was stored in the WDR's Cologne archive. See Roth in *Rainer Werner Fassbinder*, 141.

14. Fassbinder's subsequent collaborations with WDR included the television series *Acht Stunden sind kein Tag* (*Eight Hours Are Not a Day*, 1972), *Welt am Draht* (*World on a Wire*, 1973), and *Berlin Alexanderplatz* (1980), as well as the films *Martha* (1973), *Wie ein Vogel auf dem Draht* (*Like a Bird on a Wire*, 1975), *Angst vor der Angst* (*Fear of Fear*, 1975), *Ich will doch nur, dass Ihr mich liebt* (*I Only Want You to Love Me*, 1976), *Die Ehe der Maria Braun* (*The Marriage of Maria Braun*, 1979), and *Lola* (1981).

15. *Das ganz normale Chaos*, ed. Juliane Lorenz (Berlin: Henschel, 1995), 187.

16. The historical Böhm had a mass following; in the spring of 1476, more than thirty thousand peasants from all over Germany followed him to Niklashausen.

17. See *Fassbinders Filme 2*, ed. Michael Töteberg (Frankfurt am Main: Verlag der Autoren, 1990), 128.

18. The character first appeared in Glauber Rocha's *Black God, White Devil* (1964).

19. See Chris Fujiwara, "Brazil '66 to '99: Taking a Tour of 'Cinema Novo and Beyond,'" *Boston Phoenix*, February 25, 1999.

20. David Barnett, *Rainer Werner Fassbinder and the German Theatre* (Cambridge: Cambridge University Press, 2005), 87.

21. Michael König, whom Fassbinder had met in the fall of 1969 at the Bremer Theater during a production of his drama, *Das Kaffeehaus* (*The Coffee House*), would later play the plagued and possessed visionary writer in George Moorse's *Lenz* (1971), a figure that would be reborn in a contemporary West Berlin incarnation as the disenchanted student activist in Peter Schneider's widely read novel, *Lenz* (West Berlin: Rotbuch, 1973).

22. The third shot, likewise, surveys a sweeping and picturesque field over which the wind flutters. In the following take, we see changes of light as clouds shift across the sky over the sea of green. Such atmospheric scenes are decidedly atypical in Fassbinder's work, which would almost without exception eschew natural settings.

23. Elsaesser, 272. The dark interiors and the sadomasochistic excesses of the domestic scenes between the errant wife (played by a possessed Margit Carstensen) and her cuckolded invalid husband seem to be modeled after similar encounters in *Antonio das Mortes*.

24. Rainer Werner Fassbinder, "Chin-up, Handstand, Salto Mortale—Firm Footing: On the Film Director Werner Schroeter, Who Achieved What Few Achieve with the Kingdom of Naples," in *The Anarchy of the Imagination*, ed. Michael Töteberg and Leo A. Lensing, trans. Krishna Winston (Baltimore: Johns Hopkins University Press, 1992), 102. For a useful English-language analysis of Schroeter's films, see Michelle Langford, *Allegorical Images: Tableau, Time and Gesture in the Cinema of Werner Schroeter* (Bristol: Intellekt, 2006).

25. Fassbinder played cameo roles in both films.

26. Elsaesser, 27.

27. See Régis Debray, *Révolution dans la révolution?* (Paris: Maspero, 1967); also, his essay, *The Long March in Latin America: Guerilla Movements, Theory and Practice* (Detroit: Radical Education Project, 1966).

28. For a description of the formative influence of the Long March within the West German student movement, see Wolfgang Kraushaar, *1968 als Mythos, Chiffre und Zäsur* (Hamburg: Hamburger Edition, 2000), 83–87.

29. The battle cry would later be used by the protopunk Berlin rock band Ton Steine Scherben and would serve as an anthem for West Berlin house squatters and activists during the eighties.

30. Cf. Elsaesser, for instance, who claims that "the surviving followers regroup, take to the hills, in order to lead, Che Guevara style, a revolutionary army to—one presumes—certain defeat" (272).

31. This is, without question, the most galvanizing and elaborately mounted sequence in an otherwise largely static and highly stylized film.

32. Elsaesser, 269.

33. See Corinna Brocher's long interview with Fassbinder, "Die Gruppe, die trotzdem keine war (1973)," in *Fassbinder über Fassbinder*, ed. Robert Fischer (Frankfurt am Main: Verlag der Autoren, 2004), 160.

34. When they meet unexpectedly, Michel exclaims, "Wahnsinn!" ("This is wild!"). They begin to brawl, much like long-lost comrades from an early Howard Hawks film (for instance, *A Girl in Every Port*, 1928) and also similar to the surprise encounter of the ex-foreign legionnaires, Hans and Harry, in Fassbinder's *Händler der vier Jahreszeiten* (*Merchant of Four Seasons*, 1971). As Michel and Günther roll around on the floor, their physical aggression is indistinguishable from homoerotic intimacy. A prolonged take shows them tumble about before settling into an embrace suggestive of exhausted lovers. The tableau is very reminiscent of the Liebestod finale between the two brothers in *The American Soldier*.

35. *Beware of the Holy Whore* mixed materials from Elvis Presley, Leonard Cohen, Spooky Tooth, and Gaetano Donizetti.

36. The telephone conversation with the mother rehearses the very similar opening dialogue of *Die bitteren Tränen der Petra von Kant* (*The Bitter Tears of Petra von Kant*, 1972).

37. See Yaak Karsunke, *Reden und Ausreden. Neununddreissig Gedichte* (West Berlin: Wagenbach, 1969). Karsunke was a friend of Fassbinder's and played bit parts in *Love Is Colder Than Death*, *Gods of the Plague*, and *Berlin Alexanderplatz*. A close follower of the Munich theater scene who often reviewed productions on the radio, Karsunke was an enthusiastic supporter and insightful observer of both the action-theater and the antiteater.

38. This is a reference to Arnold Gesell's *The Child from Five to Ten* (1946), an influential study by a prominent American expert on child development that was an international bestseller. Interestingly, Gesell and his associates also pioneered the use of film as an observational resource in monitoring the passage of children from infancy to adolescence.

39. The ironic use of Gesell's apologia for conformity intimates what will become a significant emphasis in Fassbinder's work, namely his concern about the deformative power of public institutions and the different ways in which they become internalized and all the more readily reproduced, an impetus perhaps most precisely articulated in the subtitle to *Fontane Effi Briest* (1974): "Many who have an inkling of their possibilities and needs and yet accept the ruling system in their head and, therefore, by their deeds strengthen and confirm it absolutely."

40. Costard's *Die Unterdrückung der Frauen ist vor allem an dem Verhalten der Frauen selber zu erkennen* premiered in January 1969 on ARD before its screening in October 1969 at the Mannheim Film Festival. It depicts the monotony of female domestic work and a housewife's attempt to maintain order on the home front. In that regard, it resembles Chantal Akerman's *Jeanne Dielman* (1975), although, to be sure, Costard's female protagonist is played by a man.

41. See the chapter "Stadt der Frauen: Feministische Sezession und lebenskulturelle Umbrüche," in Gerd Koenen, *Das rote Jahrzehnt. Unsere kleine deutsche Kulturrevolution 1967–1977* (Frankfurt am Main: Fischer, 2001), 233–256.

42. Kraushaar, p. 132.

43. This is an often-told anecdote. See, for instance, Christian Braad Thomsen, *Fassbinder: The Life and Work of a Provocative Genius,* trans. Martin Chalmers (London: Faber & Faber, 1997), 86.

44. Koenen, 149.

45. Quoted in *The Rolling Stone History of Rock & Roll,* ed. Jim Miller (London: Picador, 1981), 221

46. Suze Rotolo, *A Freewheelin' Time: A Memoir of Greenwich Village in the Sixties* (New York: Broadway, 2008), 217.

47. The film's editing underlines the directness of this link, for the shot of Hanna and Michel is followed by a close-up of travel brochures with the slogans "Distant lands call" and "Peru. Land of contrasts."

48. Asked by an interviewer about his reaction to the suicide of his lover Armin Meier in 1978, Fassbinder said he had considered three courses of action. The first was "to go to Paraguay and become a farmer—I don't know why I thought of Paraguay, it just occurred to me somehow. As glib as that now sounds, at the time it was not glib at all; it seemed like an altogether real possibility." The second alternative would have been to stop being interested in everything, which Fassbinder claimed would have been tantamount to insanity. Or, third, he could make a film—which is, of course, what he ultimately did—the feature and act of mourning, *In einem Jahr mit 13 Monden* (*In a Year of 13 Moons,* 1978). See Limmer, *Rainer Werner Fassbinder, Filmemacher,* 95.

49. See, for instance, Wolfgang Schepers, "Back to the Sixties?" in *Design und Alltagskultur zwischen Konsum und Konflikt,* ed. Wolfgang Schepers (Cologne: DuMont, 1998), 7.

12: How American Is It?

A much longer version first appeared as "How American Is It: The U.S. as Image and Imaginary in German Film," *German Quarterly* 57, no. 4 (Fall 1984): 603–620.

1. *How German Is It.* (*Wie Deutsch Ist Es?*) (New York: New Directions, 1980), 119–120.

2. Sheila Johnston, *Wim Wenders* (London: British Film Institute, 1981), 7. The passage Johnston refers to comes from Wenders' *Im Lauf der Zeit* (*Kings of the Road,* 1976).

3. See Karen Jaehne, "The American Fiend," *Sight and Sound* 47, no. 2 (Spring 1978): 101–103.

4. The array of possibility is wide and ranges from commercial attempts to replicate Hollywood blockbusters with big budgets, international teams, and elaborate special effects like the Bernd Eichinger production, *Die unendliche Geschichte* (*The Never-Ending Story*, 1984), to critical travelogues, such as Hartmut Bitomsky's *Highway 40/West* (1980), as well as features shot in the United States by a variety of directors, such as Hans Noever, Erwin Keusch, Vadim Glowna, and Wim Wenders. Jean-Marie Straub and Danièle Huillet, without a doubt the most unreconciled and uncompromising directors working in West Germany, completed a rendering of Franz Kafka's novel fragment *Amerika* entitled *Klassenverhältnisse* (*Class Relations*, 1984).

5. The most compelling expression of this position is to be found in Timothy Corrigan, *New German Film: The Displaced Image* (Austin: University of Texas Press, 1983).

6. See the pertinent section in *Dialectic of Enlightenment*, trans. John Cumming (New York: Seabury, 1972).

7. Timothy Corrigan, "The Realist Gesture in the Films of Wim Wenders: Hollywood and the New German Cinema," *Quarterly Review of Film Studies* 5, no. 2 (Spring 1980): 214–215.

8. The homage originally appeared as "Imitation of Life: Über die Filme von Douglas Sirk," *Fernsehen und Film* 9, no. 2 (February 1971): 8–13.

9. Among the numerous expressions of Wenders's deep regard for the director, see his obituary, "Sein Tod ist keine Lösung: Der deutsche Filmemacher Fritz Lang," in *Jahrbuch Film 77/78*, ed. Hans Günther Pflaum (Munich: Hanser, 1977), 161–165.

10. Fassbinder's early noirs, such as *Liebe ist kälter als der Tod* (*Love Is Colder Than Death*, 1969) and *Der amerikanische Soldat* (*The American Soldier*, 1970), like those of his peers, amounted to a circuitous rediscovery of a German legacy.

11. Jan Dawson, *Wim Wenders*, trans. Carla Wartenberg (Toronto: Festival of Festivals, 1976), 7.

12. Raymond Durgnat, "From Caligari to Hitler," *Film Comment* 16, no. 4 (July–August 1980): 60.

13. The filmmaker collective responsible for *Deutschland im Herbst* (*Germany in Autumn*, 1978) refers explicitly to Benjamin's notion: "In this traveling express train of time we are pulling the emergency brake." See "*Deutschland im Herbst*: Worin liegt die Parteilichkeit des Films?" *Ästhetik und Kommunikation* 32 (June 1978): 124.

14. *How German Is It*, title page.

15. Taken from a conversation between Abish and Sylvère Lotringer, "Wie Deutsch Ist Es," *semiotexte* 4, no. 2 (1982): 162.

16. Ibid. 163, 168.

17. Ibid., 11.

18. *"Images at the Horizon": A Workshop with Werner Herzog Conducted by Roger Ebert*, ed. Gene Walsh (Chicago: Facets Multimedia, 1979), 10.

19. Cf. Johnston, *Wim Wenders*, 7; Dawson, 23.

20. Dawson, 23.

21. See "Emotion Pictures (Slowly Rockin' On)," *Filmkritik* (May 1970): 252–255.

22. *Alice in the Cities* is the trilogy's first leg; its subsequent stations are *Falsche Bewegung* (*Wrong Move*, 1975) and *Im Lauf der Zeit* (*Kings of the Road*, 1976).

23. Cf. Peter Buchka, *Augen kann man nicht kaufen. Wim Wenders und seine Filme* (Munich: Hanser, 1980), 42.

24. The most dramatic instance of such a fluidity in German film history dates back to Trenker's *The Prodigal Son*. When the protagonist decides to leave his Tyrolean homeland for the United States, we see no trip and no means of conveyance. The journey transpires in essentialized terms, as a dissolve from the rocky peaks of the Dolomites to a perfectly matched image of their overseas *Doppelgänger*, the Manhattan skyscrapers.

25. See Kaja Silverman, *The Subject of Semiotics* (New York: Oxford University Press, 1983), 161.

26. Cf. Thomas Elsaesser, "Primary Identification and the Historical Subject: Fassbinder and Germany," *Ciné-tracts* 11 (Fall 1980): "The Germans are beginning to love their own cinema because it has been endorsed, confirmed, and benevolently looked at by someone else; for the German cinema to exist, it first had to be seen by non-Germans. It enacts, as a national cinema, now in explicitly economic and cultural terms, yet another form of self-estranged exhibitionism" (52). Part of the fascination inherent in the process, one might add, involves watching Germans watch others watching them; the dynamic makes clear that one's self-image very much has to do with the looks of others.

27. Richard T. Jameson, "Fassbinder's *Lola*: In the Image of Dietrich and Sternberg," *The Weekly* (Seattle), October 20, 1982. For a discussion of the dynamics attending the reception of New German Cinema in the United States, see my essay, "American Friends and New German Cinema: Patterns of Reception," *New German Critique* 24–25 (Fall–Winter 1981–1982): 7–35.

28. *Die freudlose Gesellschaft. Notizen aus den letzten Jahren* (Frankfurt am Main: Ullstein, 1983), 109.

A somewhat different and slightly longer version of this essay first appeared as "The Use and Abuse of Memory: New German Film and the Discourse of Bitburg," *New German Critique* 36 (Fall 1985): 67–90.

1. "Bitburg Briefs: A History Quiz," *LA Weekly*, May 10, 1985, 16.

2. "Bitburg," *On Film* 14 (Spring 1985): 37.

3. "Image of Blundering Fought: Can Eloquence Calm the Furor? Aides to Wait, See," *Los Angeles Times*, May 6, 1985, 17.

4. Philip Rosen, "History, Textuality, Nation: Kracauer, Burch, and Some Problems in the Study of National Cinemas," *Iris* 2, no. 2 (1984): 69.

5. See *West German Film in the Course of Time* (Bedford Hills, NY: Redgrave, 1984).

6. See, for instance, Jeffrey Richards, "Leni Riefenstahl: Style and Structure," *The Silent Picture* 8 (Autumn 1970): 19: "Both in style and in structure, the films of Leni Riefenstahl represent the peak of German film-making, a peak which it has never regained since and perhaps never will." For a survey of literature on Riefenstahl, see Sandra Bernstein and Michael MacMillan, "Leni Riefenstahl: A Selected Annotated Bibliography," *Quarterly Review of Film Studies* 2 (1977): 439–457.

7. For all the control enjoyed by Riefenstahl, who had a vast number of cameramen and technicians at her disposal as well as nearly unlimited means and access, the director complained bitterly about this particular sequence. She had wanted to track Hitler, Himmler, and Lutze from a small vehicle. Because the SA would not permit her car to enter the lane, she claims to have "lost one of the most beautiful shots." She had to move her camera elsewhere; the event admitted only certain perspectives and what she considered a less expressive vantage point. Riefenstahl's account appears in Richard Meran Barsam, *Filmguide to Triumph of the Will* (Bloomington: Indiana University Press, 1975), 54.

8. Quoted in Richard Roud, *Straub* (New York: Viking, 1972), 29.

9. See the filmmakers' comments on German directors and particularly Fritz Lang in *The Cinema of Jean-Marie Straub and Danièle Huillet*, ed. Jonathan Rosenbaum (New York: Film at the Public, 1982), 5–6.

10. Karsten Witte speaks of how the white passage allows "sound to have space to step into the image" in *Herzog/Kluge/Straub*, ed. Peter W. Jansen and Wolfram Schütte (Munich: Hanser, 1976), 182.

11. See "Terms of Dismemberment: The Body in/and/of Fassbinder's *Berlin Alexanderplatz*," *New German Critique* 34 (Winter 1985): 194–208.

12. See his essay, "Die Städte des Menschen und seine Seele. Alfred Döblins Roman *Berlin Alexanderplatz*," *Die Zeit*, March 14, 1980.

13. For an exhaustive compilation of media responses to *Heimat*, see *Presse-Stimmen*, ed. SFB-Pressestelle und die Abteilung Fernsehspiel des SFB, 2 volumes (West Berlin: Sender Freies Berlin, 1984).

14. Karsten Witte, "Of the Greatness of the Small People: The Rehabilitation of a Genre," trans. Miriam Hansen, *New German Critique* 36 (Fall 1985): 8.

15. "Die Kamera ist keine Uhr," in *Liebe zum Kino. Utopien und Gedanken zum Autorenfilm 1962–1983* (Cologne: Verlag KÖLN 78, 1984), 106.

16. See Reitz's essay, "Unabhängiger Film nach *Holocaust*?" in *Liebe zum Kino*, 98–105. See also Andrée Tournes, "Inquiry on *Holocaust*," trans. Charlotte Vokes-Dudgeon, *Framework* 12 (1980): 10–11; and the special issue of *New German Critique* on *Holocaust*, 19 (Winter 1980).

17. In a discussion about *Heimat* organized by the editors of *frauen und film* (reprinted in English as "'That's Why Our Mothers Were Such Nice Chicks' [Edgar Reitz]," *New German Critique* 36 [Fall 1985]), Gertrud Koch claims that Glasisch Karl "assumes the role of a demiurgic narrator" whose commentary "evokes a rather conventional epic mode, the tradition of the omniscient narrator who peers through windows and into the hidden rooms and tells us how it really happened" (20). In fact, though, Reitz takes care to mark Glasisch Karl as an eccentric onlooker, someone obsessed by a woman he cannot have, an individual scarred by his war experience, a person who stands at the margin of events, constantly seeking, without success, entrance to the mainstream of the community. In this regard he resembles other idiosyncratic narrative personas in Reitz's work, for instance, the young boy Torsten in *Stunde Null* (*Zero Hour*, 1977).

18. Saul Friedländer, *Reflections of Nazism: An Essay on Kitsch and Death*, trans. Thomas Weyr (New York: Harper & Row, 1984), 106–107.

19. *Liebe zum Kino*, 109.

20. Gertrud Koch, "How Much Naiveté Can We Afford? The New *Heimat* Feeling," trans. Miriam Hansen, *New German Critique* 36 (Fall 1985): 15. In a similar vein, Saul Friedländer wonders whether in a work that claims to survey and rediscover a nation's history "the masking of atrocities and shift in emphasis, meaning and values" might indeed be of a piece with recent attempts to whitewash Nazi terror. See his essay, "Bewältigung—oder nur Verdrängung," *Die Zeit*, February 8, 1985.

21. Jacques Rancière describes "the privileged mode of representation by which the image of the social consensus is offered to the members of a social formation and within which they are asked to identify themselves." See "Jacques Rancière: Interview. The Image of Brotherhood," trans. Kari Hanet, *Edinburgh '77 Magazine*: 26–31.

22. John Corry, "TV: Search for Meaning at Bitburg," *New York Times*, May 6, 1985.

23. See David Edelstein, "Bitburg: A Film by Reagan," *On Film* 14 (Spring 1985): 36.

24. Cf. Christian Metz, "History/Discourse: Note on Two Voyeurisms," trans. Susan Bennett, *Edinburgh '76 Magazine*: 23. During a film screening, claims Metz, "the public is present to the actor, but the actor is absent to the public, and during the shooting, when the actor was present, it was the public which was absent. So the cinema manages to be both exhibitionist and secretive."

25. In the course of his report, Jennings botches a series of factual details. For instance, Stauffenberg becomes "Schlaufenberg" and the attempted assassination of Hitler in July 1944 is described as having taken place in Munich.

26. The truth is, asserted Jean-Marie Straub, "that this old crocodile Reagan had wanted to manifest and celebrate there over dead bodies the solidarity and reconciliation of American capitalism with the capitalism of those who under the direction of Adolf Hitler launched a crusade against what they called bolshevism" (Straub, "Text," *On Film* 14 [Spring 1985]: 37).

27. The event generated several protest responses by rock groups, including the songs "My Brain Is Hanging Upside Down (Bonzo Goes to Bitburg)" by the Ramones and "Reagan at Bitburg" by Frank Zappa.

28. How easily one can imagine the event having given way to a Kluge-esque essay on the difficulty of commemoration in Germany, replete with documentary perspectives, eccentric commentaries, and expressive historical associations. For an analysis of the crisis state of West German film culture during the mid-eighties, see Helmut H. Diederichs, "'Filmverlag der Autoren' seit der Übernahme durch Rudolph Augstein," *epd Film* (September 1985): 22–26.

29. "Bitburg," 37.

30. A notable exception is Eberhard Fechner's three-part documentary, *Der Prozeß* (*The Trial*, 1984).

14: A Cinema of Citation

This essay first appeared as "A Cinema of Citation: The Films of Alexander Kluge," *Artforum* 47, no. 1 (September 2008): 416–423, 484. It is reprinted here with the kind permission of *Artforum*.

1. The English edition appeared as *Cinema Stories*, trans. Martin Brady and Helen Hughes (New York: New Directions, 2007). It constitutes a radical and partially reordered abridgment of the German edition, *Geschichten vom Kino* (Frankfurt am Main: Suhrkamp, 2007). The expansive German version, which has 120 stories and 351 pages (in comparison to the English-language release's 54 stories and 111 pages), is at once richer and, despite its organization into seven

chapters with thematic headings, more unwieldy. The discrepancy between the two editions confirms that Kluge does not set store by definitive shapes, but rather believes strongly in the malleability of materials for different audiences. For English-language readers, apparently, less in his mind is better.

2. *Cinema Stories*, 86.

3. Ibid., 93.

4. Understanding a film completely," argues Kluge, "is conceptual imperialism which colonizes its objects. If I have understood everything then something has been emptied out." See Alexander Kluge, "On Film and the Public Sphere," trans. Thomas Y. Levin and Miriam B. Hansen, *New German Critique* 24–25 (Fall—Winter 1981–1982): 211.

5. Kluge's work received significant critical attention in special issues of *New German Critique* (Winter 1990) and *October* (Autumn 1988), notably in the exemplary analyses of Miriam Hansen (which remain the most compelling guides through the complexities of his films), the partisan comprehensive interviews with Jan Dawson and Stuart Liebman, and, later, Peter C. Lutze's thoughtful monograph *Alexander Kluge: The Last Modernist* (Detroit: Wayne State University Press, 1998). Of Kluge's fourteen features, only three films have ever appeared in the catalogues of an American distributor; seminal titles circulated in increasingly worn-out 16mm prints administered by the German cultural agencies InterNationes and the Goethe-Institut. Until early in 2007, *Deutschland im Herbst* (*Germany in Autumn*, 1978) was the only production commercially available as a subtitled video; not a single film could be found on DVD. Even after a long overdue and warmly greeted retrospective arranged by the Goethe-Institut played in a handful of repertory cinemas, museums, and universities in late 1988 and early 1989, none of Kluge's short films was accessible to the North American public in any form.

6. A vast and an invaluable collection of Kluge's film and television works, produced with the support of the Goethe-Institut and the German Federal Cultural Foundation, is now available from Edition Filmmuseum, an exemplary series of DVDs sponsored by the Filmmuseum Munich under the supervision of Stefan Drößler. The edition can be ordered at http://www.edition-filmmuseum.com.

7. In addition, Princeton University houses the comprehensive Alexander Kluge Research Collection. Likewise, Kluge's television interviews with Heiner Müller (1988–1995) are available online, courtesy of Cornell University, with full transcripts and English annotations, at muller-kluge.library.cornell.edu/en.

8. Miriam Hansen, "Space of History, Language of Time: Kluge's *Yesterday Girl* (1966)," in *German Film and Literature: Adaptations and Transformations*, ed. Eric Rentschler (London: Methuen, 1986), 195.

9. Richard Roud, *Godard*, 2nd rev. ed. (Bloomington: Indiana University Press, 1970), 66.

10. Alexander Kluge, *Der Angriff der Gegenwart auf die übrige Zeit* (Frankfurt am Main: Syndikat/EVA, 1985), 10.

11. Tom Tykwer, "Der Testpilot der Kinematographie: Laudation auf Alexander Kluge," *Frankfurter Allgemeine Zeitung*, April 25, 2008.

12. Raymond Bellour, "[Letter] from Raymond Bellour (Paris, September 25, 1997)," trans. Lynne Kirby, *Film Quarterly* 52, no. 1 (Autumn 1998): 52, 53. Reprinted in *Movie Mutations: The Changing Face of World Cinephilia*, ed. Jonathan Rosenbaum and Adrian Martin (London: British Film Institute, 2003), 30, 32. Unlike the cinemas of John Cassavetes, Claire Denis, Nagisa Oshima, or Rainer Werner Fassbinder, Kluge's is one of speech and not of the body. His films demonstrate a general lack of interest in the body's shapes and functions; what matters above all is the mind and its thoughts and fantasies. People do not sweat in his films; sex does take place, but it is perfunctory, antiseptic, or awkward.

13. Klaus Eder and Alexander Kluge, *Ulmer Dramaturgien. Reibungsverluste. Stichwort. Bestandsaufnahme* (Munich: Hanser, 1983), 107.

14. Siegfried Kracauer, "Film 1928," in *The Mass Ornament: Weimar Essays*, ed. and trans. Thomas Y. Levin (Cambridge: Harvard University Press, 1995), 307–320.

15. There remains much to say about the ways in which Kluge incorporates early cinema in his television productions. For an incisive initial approach, see Miriam Hansen's essay "Reinventing the Nickelodeon: Notes on Kluge and Early Cinema," *October* 46 (Autumn 1988): 178–198.

16. See Christian Keathley, *Cinephilia and History or The Wind in the Trees* (Bloomington: Indiana University Press, 2005).

17. Alexander Horwath et al., "Movie Mutations: Letters from (and to) Some Children of 1960," in *Movie Mutations*, 15.

18. One of the high points of the Filmmuseum Munich DVD collection is *Reformzirkus* (*Reform Circus*, 1970), a two-hour-long unedited recording of a live discussion on the West German television station WDR in which Kluge faces increasingly harsh and openly hostile objections to *Artists under the Big Top: Perplexed* and to his film work as a whole. This stunning exchange, in which punches are not pulled, documents just how fierce the resistance was to Kluge's cinema, even right after 1968, and how in the larger scheme of things it has always represented a minority opinion.

19. Jutta Brückner, "Carmen and die Macht der Gefühle," *Asthetik und Kommunikation* 53/54 (December 1983): 226–232.

20. B. Ruby Rich, "She Says, He Says: The Power of the Narrator in Modernist Film Politics," *Discourse* 4 (Winter, 1981–1982): 31–46.

21. See, for instance, Omer Bartov, "War, Memory and Repression: Alexander Kluge and the Politics of Representation in Postwar Germany," *Tel Aviver Jahrbuch für deutsche Geschichte* 23 (1994): 413–432.

22. Forgetting extermination," in the famous words of Jean Baudrillard, "is part of extermination." See Baudrillard, "Holocaust," in *Simulacra and Simulation*, trans. Sheila Faria Glaser (Ann Arbor: University of Michigan Press, 1994), 49.

23. See, for instance, Helke Sander's reflections on what she considers to be Kluge's patriarchal predilections, "'You Can't Always Get What You Want': The Films of Alexander Kluge," *New German Critique* 49 (Winter 1990): 59–68.

24. See Anton Kaes, *From Hitler to Heimat: The Return of History as Film* (Cambridge: Harvard University Press, 1989).

25. Nicole Brenez et al., "Movie Mutations: Letters from (and to) Some Children of 1960," in *Movie Mutations*, op. cit., 19.

26. This persuasion is central to Godard's magisterial film essay, *Histoire(s) du Cinéma* (1988–1998).

27. Cf. "The Blind Director," in *Cinema Stories*: "He allowed the films that, to his regret, he had been unable to make, pass across his inner eye" (29).

28. Tom Gunning, "The Cinema of Attractions: Early Film, Its Spectator and the Avant-Garde," *Wide Angle* 8.3–4 (Fall 1986): 63–70.

29. Kluge, "On Film and the Public Sphere," 209. Cf. Kluge's seven-hour adaptation of *Das Kapital*, which picks up where Eisenstein left off many decades ago. The collaborators for this project, *Nachrichten aus der ideologischen Antike* (*News from Ideological Antiquity*, 2008), include filmmakers Tom Tykwer, Edgar Reitz, and Werner Schroeter, poet Durs Grünbein, and the philosophers Oskar Negt and Peter Sloterdijk.

30. *Cinema Stories*, 70–71.

15: The Declaration of Independents

This essay first appeared as "Declaration of the Independents: The 50th Anniversary of the Oberhausen Manifesto," *Artforum* 50, no. 10 (Summer 2012): 272–279. It is reprinted here with the kind permission of *Artforum*.

1. *Filmstudio* 34 (Spring 1962): 10. This number was a special issue devoted to lesser known national cinemas ("Die unbekannten Filmländer").

2. "The Oberhausen Manifesto (1962)," in *West German Filmmakers on Film: Visions and Voices*, ed. Eric Rentschler (New York: Holmes & Meier, 1988), 2.

3. "First Statement of the New American Cinema Group," *Film Culture* 22–23 (Summer 1961): 131–133.

4. Enno Patalas, "Die Chance," *Filmkritik* 6, no. 4 (April 1962): 146.

5. *Filmkritik* 2, no. 1 (January 1958): 24.

6. Joe Hembus, *Der deutsche Film kann gar nicht besser sein* (Bremen: Schünemann, 1961).

7. Hembus, 35.

8. Regarding the impetus and effect of DOC 59, see Michael Wedel, "Genealogie einer Bewegung. Die DOC-59 Gruppe und die Anfänge des Neuen deutschen Films," in *Provokation der Wirklichkeit. Das Oberhausener Manifest und die Folgen*, ed. Ralph Eue and Lars Henrik Gass (Munich: edition text + kritik, 2012), 161–167.

9. Alexander Kluge, "What Do the 'Oberhauseners' Want? (1962)," in *West German Filmmakers on Film*, 10–13.

10. See "Erklärung in Oberhausen (1965)," in *Provokation der Wirklichkeit*, 80.

11. See the Mitscherlichs' highly influential study, *Die Unfähigkeit zu trauern. Grundlagen kollektiven Verhaltens* (Munich: Piper, 1967).

16: An Archaeology of the Berlin School

A longer version of this essay appeared as "Predecessors: The German Prehistory of the Berlin School," in *The Berlin School Glossary: An ABC of the New Wave in German Cinema*, ed. Roger F. Cook et al. (London: Intellekt, 2013), 213–221.

1. In a radio address of 1964 that marked Kracauer's seventy-fifth birthday, "Der wunderliche Realist," Theodor W. Adorno castigated and ridiculed *Theory of Film*. See the English translation, "The Curious Realist: On Siegfried Kracauer," trans. Shierry Weber Nicholsen, *New German Critique* 54 (Fall 1991): 159–177. According to Adorno, Kracauer celebrates film's redemption of physical reality without taking into account its objects' social determinations. His realism is naive; it harbors the child's belief in the "benignness of things." "One looks in vain," maintains Adorno, "in the storehouse of Kracauer's intellectual motifs for indignation about reification" (177). In short, *Theory of Film* constitutes for Adorno a sustained exercise in sociological abstention.

2. Marco Abel, "Intensifying Life: The Cinema of the 'Berlin School,'" *Cineaste* 33, no. 4 (Fall 2008), http://www.cineaste.com/articles/the-berlin-school.htm.

3. Georg Seeßlen, "Die Anti-Erzählmaschine," *Freitag*, September 14, 2007.

4. Stefan Ertl and Rainer Knepperges, "Drei zu zwei hitverdächtig: Gespräch mit Christian Petzold," in *Gdinetmao—Abweichungen vom deutschen Film*, ed. Rainer Knepperges (Berlin: Maas, 2000), 163.

5. Olaf Möller, "Passage Along the Shadow-Line: Farocki and Others—Approaching a Certain *Filmkritik* Style," trans. Roger Hillman and Timothy Mathieson, *Senses of Cinema* 21 (July–August 2002).

6. Wim Wenders, "*Red Sun*: Baby, You Can Drive My Car, and Maybe I'll Love You (1970)," in *West German Filmmakers on Film: Visions and Voices*, ed. Eric Rentschler (New York: Holmes & Meier, 1988), 187.

7. Siegfried Kracauer, *Theory of Film: The Redemption of Physical Reality* (Oxford: Oxford University Press, 1960), 297.

8. Petzold quoted on a WDR television program by Sven von Reden and Reinhard Wulf, "Passagen—Der Filmemacher Christian Petzold," October 17, 2005. Transcript available at http://www.3sat.de/page/?source=/ard/kinomagazin/84498/.

9. See Marco Abel, "Tender Speaking: An Interview with Christoph Hochhäusler," *Senses of Cinema* 42 (February 2007), http://sensesofcinema.com/2007/42/christoph-hochhausler/.

10. Hochhäusler's *Unter Dir die Stadt* (*The City Below*, 2009), with its chilling views of Mainhattan's temples of high capital, shares this impetus.

11. "Passagen—Der Filmemacher Christian Petzold," op cit.

12. Möller, "Passage along the Shadow-Line," op. cit.

13. "Passagen—Der Filmemacher Christian Petzold," op. cit.

14. Sandra S. Phillips, "Looking Out, Looking In: Voyeurism and Its Affinities from the Beginning of Photography," in *Exposed: Voyeurism, Surveillance and the Camera since 1870*, ed. Sandra S. Phillips (San Francisco/New Haven: San Francisco Museum of Modern Art/Yale University Press, 2010), 143.

15. Michael Klier and Brigitte Kramer, "*Der Riese* (1983)," in *The Luminous Image*, ed. Gary Schwartz (Amsterdam: Stedelijk Museum, 1984), 124.

16. Marta Gili, "From Observation to Surveillance," trans. Fernando Feliu-Moggi, in *Exposed: Voyeurism, Surveillance and the Camera since 1870*, op. cit., 241.

17. Rainer Knepperges, "Die Melody," in *Gdinetmao*, op. cit., 23.

17: The Surveillance Camera's Quarry

This essay first appeared in *German Studies Review* 36, no. 3 (Spring 2013): 635–642. It is reprinted here with the kind permission of Johns Hopkins University Press.

1. *My Paris*, ed. B. F. Malkin, trans. Oliver Ready (Paris: Edition 7L, 2005; reprint of first edition, Moscow: IZOGIZ, 1933), n.p.

2. For the importance of "Leerstellen" for the films of the Berlin School in general, see Johanna Schwenk, *Leerstellen—Resonanzräume. Zur Ästhetik der Auslassung im Werk des Filmregisseurs Christian Petzold* (Berlin: Nomos, 2012).

3. Christiane Peitz, "Die Angst im Walde," *Der Tagesspiegel*, February 15, 2011. All translations are by the author.

4. Carsten Wippermann and Katja Wippermann, *Mensch und Wald* (Bielefeld: Bertelsmann, 2010), 37; quoted in *Unter Bäumen. Die Deutschen und der Wald*, ed. Ursula Breymeyer and Bernd Ulrich (Berlin: Sandstein, 2011), 15.

5. Quoted in *Unter Bäumen*, 15.

6. Wilhelm Heinrich Riehl, "Land und Leute" (1854), quoted in *Unter Bäumen*, 15.

7. In this regard, it takes a cue from Ladislaus Vajda's *Es geschah am hellichten Tag* (*It Happened in Broad Daylight*, 1958), a work highly regarded by members of the *Revolver* collective.

8. Nino Klinger, *"Dreileben—Etwas Besseres als den Tod,"* critic.de, February 16, 2011, http://www.critic.de/film/dreileben-etwas-besseres-als-den-tod-2254/. *The Night of the Hunter* is indeed very much on the mind of many prominent German filmmakers and cinephiles. See *93 Minutentexte: The Night of the Hunter*, ed. Michael Baute and Volker Pantenburg (Berlin: Brinkmann und Bose, 2006).

9. Leo Goldsmith, "Three Lives and Only One Brutal Murder," *Reverse Shot* 30 (2011), http://www.reverseshot.com/article/dreileben/. In fact, the article's title might get things wrong, for the film shows (or at least appears to show; we do not know for certain in the second instance) *two* brutal murders.

10. Ibid.

11. Dennis Lim, "Worlds of Possibilities," *Cinema Scope* 46 (Spring 2011): 41.

12. Marco Abel, "Tender Speaking: An Interview with Christoph Hochhäusler," *Senses of Cinema* 42 (January–March 2007), http://sensesofcinema.com/2007/42/christoph-hochhausler/.

18: Heritages and Histories

This essay first appeared as *"The Lives of Others*: The History of Heritage and the Rhetoric of Consensus," in *The Lives of Others and Contemporary German Film: A Companion*, ed. Paul Cooke (New York: De Gruyter, 2013), 241–260. It is reprinted here with the kind permission of De Gruyter GmbH. I am particularly grateful to Tanja Linhardt of the Berlin office for her assistance in this regard.

1. Robert M. Emerson, *Writing Ethnographic Fieldnotes* (Chicago: University of Chicago Press, 1995), 1.

2. Joachim Gauck, *"Das Leben der Anderen*: '"Ja, so war es!"* *Stern*, March 25, 2006.

3. James Clifford, "On Ethnographic Allegory," in *Writing Culture. The Poetics and Politics of Ethnography*, ed. James Clifford and George F. Marcus (Berkeley: University of California Press, 1986), 112–113.

4. See Anton Kaes, *From Hitler to Heimat. The Return of History as Film* (Cambridge: Harvard University Press, 1989).

5. Lutz Koepnick, "Reframing the Past: Heritage Cinema and Holocaust in the 1990s," *New German Critique*, 87 (Fall 2002): 76.

6. Eric Rentschler, "From New German Cinema to the Postwall Cinema of Consensus," in *Cinema and Nation*, ed. Mette Hjort and Scott MacKenzie (London: Routledge, 2000), 260–277.

7. Georg Seeßlen, "Lacht da wer? Die deutsche Filmkomödie zwischen Otto und Männerherzen," *epd Film* 28, no. 9 (2011): 21. Comedy, Seeßlen elaborates, can be an important vehicle for the public expression of taboos, an influential forum to display the subversive capacities of language and the body within social contexts, in ways that stimulate laughter by showing how things go wrong when things are not quite right (19).

8. Randall Halle, *German Film after Germany: Toward a Transnational Aesthetic* (Detroit: Wayne State University Press, 2008).

9. As such, these critics might be seen as captives of what Dominik Graf calls the "art film prison." See Dominik Graf, Christian Petzold, Christoph Hochhäusler, "Mailwechsel. Berliner Schule," *Revolver* 16 (May 2007): 33–34.

10. Günter Rohrbach, "Das Schmollen der Autisten," *Der Spiegel*, January 22, 2007.

11. Lars-Olav Beier, "Endstation Hollywood," *Der Spiegel*, February 12, 2007.

12. Annette Maria Rupprecht, "XXL. A Portrait of Florian Henckel von Donnersmarck," *German Films Quarterly* 3 (2006): 16.

13. Wolf Biermann, "Die Gespenster treten aus dem Schatten," *Die Welt*, March 22, 2006.

14. Claudia Lenssen, "Inszenierte Öffentlichkeit: Eine Debatte um die symbolische Macht der Filmkritik," *VDK. Verband der deutschen Filmkritik* 4 (2008): 28–30. There is, Lenssen argues, a decided lack of rules governing the interaction between public relations and film criticism in Germany. Rohrbach seems to think that the role of film critics should be to present and legitimate the film industry.

15. Steve Neale, *Genre and Hollywood* (London: Routledge, 2000), 43.

16. See, for instance, the collection of representative essays edited by Ginette Vincendeau, *Film/Literature/Heritage. A Sight and Sound Reader* (London: British Film Institute, 2001).

17. Timothy Garton Ash, "The Stasi on Our Minds," *New York Review of Books* 54, no. 9 (May 31, 2007): 4.

18. Katja Nicodemus, "Unsere kleine Traumfabrik. Vor den Filmfestspielen in Venedig zeigt sich das deutsche Kino als Nostalgiebude," *Die Zeit*, August 28, 2003.

19. Cristina Nord, "Deutsche Geschichte im Kino. Die neue Naivität," *die tageszeitung*, October 20, 2008.

20. A noteworthy and refreshing departure from this tendency is to be found in Mattias Frey's recent book, *Postwall German Cinema: History, Film History and Cinephilia* (Oxford: Berghahn, 2013).

21. In this vein, Andreas Dresen has noted that the cinematic representation of the German Democratic Republic (GDR) past has for the most been dominated by filmmakers from the West; this was to a degree also the case with productions made just after the opening of the wall. In fact, it is only recently that the significant *Wendeflicks* from the GDR have resurfaced and undergone productive reconsideration. See Dresen's essay, "Der falsche Kino-Osten," *Die Zeit*, July 31, 2009.

22. Anna Seghers, quoted in Anette Horn, *Kontroverses Ende und Innovation* (Frankfurt am Main: Lang, 2005), 36. For a more general assessment of the heritage debates in the GDR, see Wolfram Schlenker, *Das "Kulturelle Erbe" in der DDR. Gesellschaftliche Entwicklung und Kulturpolitik 1945–1965* (Stuttgart: Metzler, 1977).

23. Translated into English as Ernst Bloch, *Heritage of Our Times*, trans. Neville and Stephen Plaice (Berkeley: University of California Press, 1991).

24. Anson Rabinbach, "Unclaimed Heritage: Ernst Bloch's *Heritage of Our Times* and the Theory of Fascism," *New German Critique* 11 (Spring 1977): 5.

25. There is a tension between the director's emphasis on the film's authenticity and his desire to tell a story with universal interest that could take place anywhere. In an interview with Stephan Bachenheimer on Journal DW-TV, he stresses that both of his parents came from the East and that his family maintained an intimate familiarity with life in the GDR; an uncle of his father was in fact the Head of Protocol for Erich Honecker. The set designer, he elaborates, had been in a GDR prison for two years and knew well what the Stasi world looked like. But the film, he goes on to say, is above all about "people in an extreme situation" and not necessarily just about the Stasi and the GDR. If films are to be successful abroad, he insists, they must deal with "large themes, large feelings." See "Journal Interview: Florian Henckel von Donnersmarck," accessed December 1, 2011, http://www.youtube.com/watch?v=QuIgJTmLov4.

26. Clifford, "On Ethnographic Allegory," 110, 113.

27. Wiesler initially resembles the voyeur (*Spanner*) in Alexander Kluge's *Die Patriotin* (*The Patriot*, 1979), a peeping Tom with a fixed gaze. In the process of his aesthetic education, he comes to ease up, to relax and enjoy other dimensions of what he sees and hears, to assume a perspective that is more open to and appreciative of possibility.

28. Note as well how the film uses a theater setting to introduce and reintroduce discussions about surveillance, a site of spectacle where people look at people and where we, as spectators, enjoy a privileged access to specular relations.

29. Von Donnersmarck's scenario is not altogether loyal (or authentic) in its historical reconstruction. Indeed, it takes liberties with chronology, relying for its background in great part on events and developments from the mid- to late 1970s: Wolf Biermann's expatriation in the fall of 1976, Jürgen Fuchs's *Vernehmungsprotokolle* from 1976–1977, and Robert Havemann's book of 1978, *Ein deutscher Kommunist. Rückblicke und Perspektiven aus der Isolation. Der Spiegel*'s East Berlin office was closed after the publication of the so-called *Spiegel* Manifest in early 1978 and would not be reopened until 1985. It is essential for the film's dramatic effect, however, that the narrative take place later, closer to Gorbachev's rise to power in 1985 and the opening of the Wall.

30. Especially the ubiquitous greyness is meant to replicate visual memories of the era's dreariness and drabness.

31. Philipp Lichterbeck, "Die innere Wahrheit der DDR," *Tagesspiegel*, December 5, 2004.

32. Paul A. Cantor, "Long Day's Journey into Brecht. The Ambivalent Politics of *The Lives of Others*," *Perspectives on Political Science* 40, no. 2 (April–June 2011): 68 (all quotes).

33. Cf. Clifford, 117. Von Donnersmarck does voice his admiration for *Die Legende von Paul und Paula* (*The Legend of Paul and Paula*, Heiner Carow, 1973) on the commentary to the American DVD edition. Andrea Rinke has noted the resemblance between the dance scene at the start of the inscribed theatre performance and a passage from *Alle meine Mädchen* (*All My Girls*, Iris Gusner, 1980).

34. "So viele Speichen—Plausch mit Volker Schlöndorff auf seinem sonnengelben Sofa," *Märkische Allgemeine Zeitung*, December 2, 2008.

35. Ernst Bloch, *Erbschaft dieser Zeit* (Frankfurt am Main: Suhrkamp, 1962), 13.

19: Life in the Shadows

This essay first appeared as *"Harlan: In the Shadow of Jew Süss,"* Cineaste 35, no. 4 (Fall 2010): 44–45.

1. Veit Harlan, *Im Schatten meiner Filme. Selbstbiographie*, ed. H. C. Opfermann (Gütersloh: Mohn, 1966).

2. Felix Moeller, *Der Filmminister. Goebbels und der Film im Dritten Reich* (Berlin: Henschel, 1998); it appeared in English as *The Film Minister—Goebbels and the Cinema in the "Third Reich,"* trans. Michael Robinson (Stuttgart: Menges, 2000).

3. Harlan, 245.

4. A recent German documentary that similarly foregrounds variances of opinions among siblings whose father was a prominent Nazi is Malte Ludin's

Zwei oder drei Dinge, die ich von ihm weiss (*Two or Three Things I Know about Him*, 2005).

5. See the exhibition catalogue, *"Jud Süß": Propagandafilm im NS-Staat*, ed. Ernst Seidl (Stuttgart: Haus der Geschichte Baden-Württemberg, 2007).

6. See Theodor W. Adorno, "What Does Coming to Terms with the Past Mean?" trans. Timothy Bahti and Geoffrey Hartman, in *Bitburg in Moral and Political Perspective*, ed. Geoffrey Hartman (Bloomington: Indiana University Press, 1986), 114–129.

7. Adorno, 128.

20: Two Trips to the Berlinale

The first part of this chapter appeared in a German translation as "Keine Explosionen mehr: Neuer Deutscher Film auf der Berlinale 1979–1998," in *Film-Jahrbuch 1999*, ed. Lothar R. Just (Munich: Heyne, 1999), 13–16. The second part appeared as "School Is Out? History Lessons at the 2013 Berlinale," *Artforum* 51, no. 9 (May 2013): 99-102. It is reprinted here with the kind permission of *Artforum*.

1. Gerald Clarke, "Seeking Planets That Do Not Exist," *Time*, March 20, 1978, 51.

2. See "The Hamburg Declaration (1979)," in *West German Filmmakers on Film: Visions and Voices*, ed. Eric Rentschler (New York: Holmes & Meier, 1988), 4.

3. Cf. Walter Benjamin, "Theses on the Philosophy of History," in *Illuminations*, ed. Hannah Arendt (New York: Schocken, 1966), 257.

4. This site, with its nondescript cafe and morning-to-night screenings of New German fare, is in fact referred to by many Goethe-Institut representatives as the "torture chamber" (*Folterkammer*).

5. The sole German entry in the 1998 Competition was Michael Gwisdek's *Das Mambospiel* (*The Big Mambo*).

6. Tobias Kniebe, "Höllische Provinz," *Süddeutsche Zeitung*, February 9, 2013.

7. Cf. Jan Schulz-Ojala's trenchant taking of stock after the 2013 Berlinale, "Ende gut, nicht alles gut," *Der Tagesspiegel*, February 16, 2013.

8. "I want to entertain, not to make movies for museums," Dörrie said in an interview shortly after the Berlinale in 2012. See Matthias Greuling, "Doris Dörrie: Plädoyer fürs Happy End," *Wiener Zeitung*, February 22, 2012.

9. See Graf's incisive analysis, "'Das Grauen . . . das Grauen!'" *Die Zeit*, April 27, 2012.

10. Ibid.

11. Dietrich Brüggemann, "Fahr zur Hölle, Berliner Schule!" *Artechock*, February 14, 2013.

12. Ibid.

13. See *Ein Gespräch via e-mail über die neue Berliner Schule*, ed. André Grzeszyk (Berlin: Deutsche Film- und Fernsehakademie Berlin, 2006). A slightly redacted version of the first part appeared as "Mailwechsel 'Berliner Schule': Graf, Petzold, Hochhäusler," *Revolver* 16 (2007): 7–39.

14. A notable exception among German critics was Olaf Möller who lauded *Gold* as "Monte Hellman's *The Shooting* re-imagined by way of Kafka." See his notice, "Festivals. Berlin," *Film Comment* 49, no. 3 (May–June 2013): 63.

15. See "Erklärung in Oberhausen (1965)," in *Provokation der Wirklichkeit. Das Oberhausener Manifest und die Folgen*, ed. Ralph Eue and Lars Henrik Gass (Munich: edition text + kritik, 2012), 80.

16. Rudolf Worschech, "'Mein Sieg ist eine Kette von Niederlagen': Roland Klick und seine Filme," *epd Film* 9, no. 9 (September 1992): 20.

17. *Ein Gespräch via e-mail über die neue Berliner Schule*, 13.

18. See Dominik Graf, *Schläft ein Lied in allen Dingen. Texte zum Film*, ed. Michael Althen (Berlin: Alexander, 2009).

19. André Bazin, "On the politique des auteurs (April 1957)," in *Cahiers du Cinéma. The 1950s: Neo-Realism, Hollywood, New Wave*, ed. Jim Hillier (Cambridge: Harvard University Press, 1985), 248–259.

20. Lukas Foerster, "Unseen Berliner Schule," *Some Dirty Laundry Blogspot*, February 1, 2007, http://somedirtylaundry.blogspot.com/2007/02/unseen-berliner-schule.html.

INDEX

Abich, Hans, 171, 400n6

Abish, Walter, 209, 213–214, 225

Abschied. See *Farewell*

Abschied von gestern. See *Yesterday Girl*

Achternbusch, Herbert, 10, 46, 222, 229, 319, 376n41

Adenauer era, 174, 187, 188–189, 213

Adenauer-era films, 159–165; characteristics of, 159–161, 162–164; and continuity with Nazi period film industry, 161–162, 171; displacement of guilt in, 174–176; and homeland films, 160–161, 164, 165; lackluster reputation of, 161; and New German Cinema, 162, 164, 284; reevaluation of, 284; repression of past in, 174; and role in the restoration of West Germany, 160–161; vitality of, 164–165, 284

Adenauer, Konrad, 223, 227, 250, 281

Adorf, Mario, 356; photo, 356

Adorno, Theodor W., 211; on coming to terms with the past (*Vergangenheitsbewältigung*), 174, 345; and Critical Theory, 55, 67, 318; and *Dialectic of Enlightenment*, 42, 211; and Kluge, 257, 265; on Kracauer's film criticism, 22; and New German

Cinema, 8, 284; on remembrance, 402n24; on *Theory of Film* (Kracauer), 3, 418n1; on working through the past (*Aufarbeitung der Vergangenheit*), 141, 151, 174, 343–345

Ali: Fear Eats the Soul (Rainer Werner Fassbinder, 1973), 222

Alice in den Städten. See *Alice in the Cities*

Alice in the Cities (Wim Wenders, 1974), 218–220, 411n22; photos, 208, 219

All that Heaven Allows (Douglas Sirk, 1955), 64, 222

America, 209–225; and fascination with Germany's past, 224–225; photos, 216; and positive reception of New German Cinema, 223–225; in postwar West German imaginations, 210–213; as refuge for displaced German filmmakers, 212–213; and relationship with New German filmmakers, 210–214, 221, 225; as represented in individual West German films, 209–210; as site of self-reflection, 213–214, 220, 221; as symbol of cultural imperialism, 211. See also *Alice in the Cities* (Wenders); *Stroszek* (Herzog)

American film industry. *See* Hollywood

Bitomsky, Hartmut, 410n4; and *"Filmkritik*-style," 290; on *Kulturfilme*, 84, 177; and "technological lyricism" (Hochhäusler), 294; and *Die Ufa* (Bitomsky), 76, 84

Blaue Engel, Der. See *Blue Angel*

Blaue Licht, Das. See *Blue Light*

Blind Director, The (Alexander Kluge, 1985): and all-consuming present, 263; photos, 254, 271; quote from script, 185; and return to early cinema, 267, 270–271

Bloch, Ernst: and "Alpen ohne Photographie" (Bloch), 82, 96; Blochian terminology, 80–81, 263; on distraction, 119; and *Heritage of Our Times* (Bloch), 327, 331, 333, 392n5

Blonde Dream, A (Paul Martin, 1932), 267, 394n27

Blonder Traum, Ein. See *Blonde Dream*

Blue Angel, The (Josef von Sternberg, 1930), 118, 223

Blue Light, The (Leni Riefenstahl, 1932), 108–110; 385n7; comparison of Junta to Maria in *Metropolis* (Lang), 109–110; Junta's transformation from disruptive force to icon and myth, 109, 110; participation of Balázs in, 95, 108; public screening in Nuremberg in 1963, 170

Blumenberg, Hans-Christoph, 85, 140, 326, 327

Board of Curators of the Young German Film, 172, 282

Boat, The (Wolfgang Petersen, 1981), 227, 252

Bock, Hans-Michael, 83–84, 383n12

Bockmayer, Walter, 65, 221

Bohm, Marquardt, 197

Böhm, Michael, 191–192, 194, 196, 406n16

Böll, Heinrich, 234

"Bonn Diary" (Heinrich Böll), 234

Boot, Das. See *Boat*

Borchert, Ernst Wilhelm: photos, 154, 158

Borchert, Wolfgang, 171

Bordwell, David, 22

Born in '45 (Jürgen Böttcher, 1966), 292, 332–334; photos, 334, 335, 336

Böttcher, Jürgen, 10, 292, 332–334

Brandlmeier, Thomas, 137, 387n25, 388n31, 388n33, 396n21

Brandner, Uwe, 210, 319

Brasch, Thomas, 10, 210

Braun, Harald, 143, 280

Brauner, Artur, 257

Brausewetter, Hans, 82

Brazilian Cinema Novo, 192

BRD-Trilogie, Die. See *BRD Trilogy*

BRD Trilogy, The (Rainer Werner Fassbinder, 1979–1982), 190, 252

Brecht, Bertolt, 119, 127, 188, 394n27, 405n5, 405n6; and Alexander Kluge, 265; and *Baal* (Schlöndorff), 192; citation in *Niklashausen Journey* (Fassbinder), 195; and distantiation, 260; and *The Good Person of Szechwan* (Brecht), 328; influence in *Antonio das Mortes* (Rocha), 192; in *Lives of Others* (Donnersmarck), 328; photo, 205

Brenez, Nicole, 270

Bridge, The (Bernhard Wicki, 1959), 174

Brücke, Die. See *Bridge*

Brückner, Jutta, 10, 229, 269

Brüggemann, Dietrich, 354, 360

Bruno S.: photos, 216

Brutalität in Stein. See *Brutality in Stone*

Brutality in Stone (Alexander Kluge, Peter Schamoni, 1961): as activator of memories, 183; aural signifiers in, 179, 180; awards and production credits, 400n2; as celluloid rebellion and anti-*Kulturfilm*, 177–178; comparison with *From Caligari to Hitler* (Kracauer), 173; documentation, authenticity, experimentation in, 178–181; as early example of Young German Film, 169; *Eternity of Yesterday* as alternate title for, 181, 400n2; as evocation of past and present, 169–170, 181; photos, 168, 175, 177; realism as protest in, 180–181; as reconfiguration of National

marginal perspectives in, 245, 246–247; minimizing Holocaust in, 9, 247; overview, 242–243; photos, 226, 244; and relationship to New German Cinema, 9, 243, 252–253; as sanctuary for German spectators, 247–248; significance of first episode, 243–247

Heimatfilme. See homeland films

Hellman, Monte, 355

Herlth, Robert, 81

Hembus, Joe, 48, 280

heritage films. *See* German heritage cinema

Heritage of Our Times (Ernst Bloch, 1935), 327

Herzog, Werner, 187; and fatalistic fantasies, 214–215; and Lotte Eisner, 65; and mountain film rhetoric, 388n32; and representations of America, 214, 215–217, 221; and respect for other directors, 266; and significance of circle motif, 215, 216, 217; and use of foreign landscapes, 221–222. See also *Stroszek* (Herzog)

Heymann, Werner, R., 122

Highsmith, Patricia, 222

Himmler, Heinrich, 231; photo, 233

Hippler, Fritz, 339

History Lessons (Jean-Marie Straub, Danièle Huillet, 1972): photo, viii

Hitler, Adolf: on architecture, 141, 178; in *Brutality in Stone* (Kluge, Schamoni), 179; and ceremonial march in *Triumph of the Will* (Riefenstahl), 231–232; and descent from the clouds in *Triumph of the Will* (Riefenstahl), 139; and German war guilt, 250; in *Marriage of Maria Braun* (Fassbinder), 347; in *Our Hitler* (Syberberg), 224, 252, 349; photos, 168, 177, 233, 276, 346; postwar German disavowal of, 343–345; and SA purge, 231–233; as unspoken name in rubble films, 134–135

Hitler–ein Film aus Deutschland. See Our Hitler

Hoberman, J., 398n51; photo, 297

Hochhäusler, Christoph, 285, 292, 303–304; on auteur films, 312–313; e-mail exchange with Graf and Petzold, 312, 355, 357; objectives of, 11; and "technological lyricism," 294; *See also* Berlin School; *Dreileben* (Petzold, Graf, Hochhäusler); *One Minute of Darkness* (Hochhäusler)

Hochschule für Gestaltung in Ulm. See Ulm Institute for Film Design

Hoffmann, Kurt, 161, 174, 280

Hofmannsthal, Hugo von, 45

Hollywood: and appropriation of German past, 243, 246–247; as dominant cinema, 211–212, 222–223; as refuge for emigrant German filmmakers, 210, 212; as source of enchantment and disenchantment for New German filmmakers, 210–212

Holocaust, 174, 317; absence in Kluge's feature films, 269; and Bitburg commemoration (1985), 251; in *Brutality in Stone* (Kluge, Schamoni), 183; exclusion from *Heimat* (Reitz), 9, 247–248; and President Reagan, 228; in revisionist films, 183, 184; in rubble films, 152

Holocaust (Marvin J. Chomsky, 1978), 224–225, 243, 247, 248, 349

Holy Mountain, The (Arnold Fanck, 1926), 101, 103–106; critical reception of, 95, 99; and "Diotima's Dance to the Sea," 103; disruptive female presence in, 104–105, 149; photos, 105, 106

homeland films, 94, 148, 160–161, 164, 165; photo, 276. *See also* antihomeland films

Hooligans, The (Georg Tressler, 1956), 162

Hoppe, Marianne: photo, 68

Horkheimer, Max, 67, 211, 318, 376n36

Höß, Rudolf, 179, 180, 183

How German Is It: Wie Deutsch Ist Es (Walter Abish, 1980), 209, 213–214, 225

Hugenberg, Alfred, 119

Hummer, Julia: photo, 288

One Night's Song (Anatole Litvak, 1932), 115

"On the *Politique des Auteurs*" (André Bazin, 1957), 358

Opfergang. See *Ride of Sacrifice*

Oppression of Women Above All Manifests Itself in the Behavior of Women, The (Hellmuth Costard, 1970), 200, 408n40; photo, 201 (as referenced in Fassbinder's *Rio das Mortes*)

Ortheil, Hanns-Josef, 73

Our Hitler (Hans Jürgen Syberberg, 1977), 85, 182–183, 224, 349

Ozu, Yasujiro, 266

Pabst, G. W., 118, 119, 129, 212, 351; and extraterritoriality, 377n2; as Weimar auteur, 113, 389n38

"Papas Kino" (Papa's cinema), 164, 275–276, 280–281, 284

Parfüm, Das. See *Perfume: The Story of a Murderer*

Paris, Texas (Wim Wenders, 1984), 222

Part-Time Work of a Female Slave (Alexander Kluge, 1973), 261–262

Patalas, Enno, 41, 171, 277–279, 400n2; photo, 274

Patriot, The (Alexander Kluge, 1979), 422n27; absence of Holocaust in, 269; character of Gabi Teichert in, 179, 182, 262, 269, 404n48; and New Discourse, 184; reference to other films in, 266–267; revisionist rhetoric in, 183–184; significance of opening sequence in, 183–184; talking knee of Corporal Wieland in, 179, 183, 262

Patriotin, Die. See *Patriot*

Paulsen, Arno: photo, 154

Peitz, Christiane, 304

People on Sunday (Robert Siodmak et al., 1930), 26–27, 185, 267; photo, 27

Perfume: The Story of a Murderer (Tom Tykwer, 2006), 321

Petersen, Wolfgang, 230, 322, 252

Petro, Patrice, 39, 102

Petzold, Christian, 11, 285, 304; e-mail exchange with Graf and Hochhäusler, 312, 355, 357; on *Filmkritik*, 290; and "Ghost Trilogy" (Petzold), 294; and importance of body language, 294; and mentor Farocki, 294; on reality of post-millennial Europe, 293; on significance of *The Giant* (Klier), 296–297; on *Under the Bridges* (Käutner), 292. See also *Beats Being Dead* (Petzold); Berlin School; *Dreileben* (Graf, Hochhäusler, Petzold)

Pewas, Peter, 57, 70, 135

Plenert, Thomas, 332

Plötzliche Reichtum der armen Leute von Kombach, Der. See *Sudden Wealth of the Poor People of Kombach*

Pohland, Hansjürgen, 279

politique des auteurs (author theory), 176. See also "On the *Politique des Auteurs*" (Bazin)

Pommer, Erich, 117, 120, 351

Power of Emotion, The (Alexander Kluge, 1983), 263, 267

Prechtel, Sandra, 355–356

Prinzler, Hans Helmut, 63, 292, 380n19, 396n10, 399n2, 406n7

Prodigal Son, The (Luis Trenker, 1934), 101–102, 210, 411n24

Prozeß, Der. See *Trial*

Prümm, Karl, 23

Public Sphere and Experience (Alexander Kluge, Oskar Negt, 1972), 257

Pudovkin, Vsevolod, 25, 29, 30, 371n34

Quick (Robert Siodmak, 1932), 114

RAF (Red Army Faction), 193, 262, 270, 326, 404n49, 405n3

Rabbit Films, 10, 331–332, 333

Rabinbach, Anson, 327

Rancière, Jacques, 413n21

Ray, Nicholas, 210, 265

Reagan, Ronald: and the Holocaust, 228; and participation in Bitburg ceremony,

of America, 210, 218–219, 221, 222; as
sensibilist, 51–53. See also *Alice in the
Cities*; *Kings of the Road*; *State of Things*;
Wrong Move (all Wenders)
We're Dancing around the World (Karl
Anton, 1939), 87
We're Making Music (Helmut Käutner,
1942), 139
Westfront 1918 (G. W. Pabst, 1930), 118
Wet Asphalt (Frank Wisbar, 1958), 162
White Hell of Pitz Palü, The (Arnold
Fanck, G. W. Pabst, 1929), 95, 97, 100,
387n19, 389n38, 390n45
White Trash (Uwe Schrader, 1983), 299
Wicki, Bernhard, 161, 174
Wilder, Billy, 139, 212
Willow Springs (Werner Schroeter, 1973),
221
Wir Kinder vom Bahnhof Zoo. See
Christiane F.
Wir machen Musik. See *We're Making
Music*
Wir tanzen um die Welt. See *We're Dancing
around the World*
Wir Wunderkinder. See *Aren't We Wonderful?*
Wiseman, Frederick, 290
Witte, Karsten, 2, 5, 51–57; on aesthetic
resistance, 4, 70; biographical portrait
of, 51–53; critical critics vs. new critics,
55–56; disapproval of "open writing,"
48; and "extraterritoriality," 377n2;
on film history and historiography,
56–57, 120; and *frauen und film*, 378n6;
on *Machorka-Muff* (Straub, Huillet),
412n10; on Nazi cinema, 52, 57;
photos, 39, 50; translation of *From
Caligari to Hitler* (Kracauer), 39, 54; on
Ufa musicals, 6, 126, 392n7
*Wonderful Horrible Life of Leni Riefenstahl,
The* (Ray Müller, 1993), 340, 341,
383n18

Wonder of Flying, The (Heinz Paul, 1935),
388n26
Word of Stone, The (Kurt Rupli, 1939), 141
Worschech, Rudolf, 357
Wort aus Stein, Das. See *Word of Stone*
Written on the Wind (Douglas Sirk, 1956),
60, 64–65, 380n20; photo, 58
Wrong Move (Wim Wenders, 1975), 219,
411n22
Wulf, Reinhard, 63
Wunder des Fliegens, Das. See *Wonder of
Flying*
Wyler, William, 140, 322
Wysbar, Frank, 70, 162

Yankee Dudler (Volker Vogeler, 1973), 210,
221
Yella (Christian Petzold, 2007), 294
Yesterday Girl (Alexander Kluge, 1966),
260, 266, 282; photo, 261
Young German Film: awards and
recognition, 282; critical confrontations
with the past, 188–189, 275–281;
generational discontent of, 188;
historical project of, 170, 176, 182; and
importance of short film format, 177–
178, 279; international praise for, 279;
and Oberhausen Declaration (1965),
357; overview, 7–8; photo, 281;
relationship with *Studentenbewegung*,
188, 189; and significance of Board of
Curators of Young German Film, 282.
See also *Brutality in Stone* (Kluge);
Oberhausen Manifesto (1962)
Young Törless (Volker Schlöndorff, 1966),
282, 319

Zero Hour (Edgar Reitz, 1977), 413n17
Zur Sache, Schätzchen. See *Go for It, Baby*
Zwischen Gestern und Morgen. See *Between
Yesterday and Tomorrow*

FILM AND CULTURE
A series of Columbia University Press
Edited by John Belton